Visuality and Virtuality

A right hand glove could be put on the left hand, if it could be turned around in four-dimensional space.

— Ludwig Wittgenstein, *Tractatus Logico-Philosophicus*, 6.36111

Imagine two people: one has learnt "F" like this in his youth: "Ⅎ" — the other, as we do: "F." If now both read the word "Figure," — must I say, have I reason to say, that they each see the "F" differently? Obviously not. And yet might it not still happen, that the one, on hearing how the other learned to write and read this letter, says: "I've never seen it like *that*, but always like *this*"?

— Ludwig Wittgenstein, *Remarks on the Philosophy of Psychology*, I, 97, no. 511

In describing phenomena in visual space a peculiar *element of inexactitude* [*Unbestimmtheitsfaktor*] comes into play which is absent from Euclidean geometry. The geometry of visual space is compounded out of Euclidean geometry, i.e. by combining a certain grammar with the grammar of this element of inexactitude.

— Ludwig Wittgenstein and Friedrich Waismann, *The Voices of Wittgenstein: The Vienna Circle*, 523

Images are not pictures. I do not tell what object I am imagining by the resemblance between it and the picture.

— Ludwig Wittgenstein, *Remarks on the Philosophy of Psychology*, II, 130, no. 60

Of what three strokes is a picture, of that it can be used as a picture.

— Ludwig Wittgenstein, *Philosophical Remarks*, 133

CONTENTS

PREFACE

The preparation of this book—the second in a trilogy—has been supported by three substantial awards from the Humanities Research Fund of the University of California at Berkeley, where three successive deans of the Division of Arts and Humanities in the College of Letters and Science, Ralph Hexter, Janet Broughton, and Anthony J. Cascardi, generously endorsed and underwrote my projects. An initial HRF for the autumn of 2005 allowed me to be a scholar in residence at the Getty Research Institute for the History of Art and the Humanities in Los Angeles, where I began to plan the three books: *A General Theory of Visual Culture*, published by Princeton University Press in 2011; the present book; and *Space, Time, and Depiction*, to be published in due course. My thanks to the GRI and its staff for the invitation and the intellectual, financial, and logistical support. A second HRF for the autumn of 2010 permitted me a semester of leave in order to begin the research for *Visuality and Virtuality*. Three subsequent academic appointments enabled me to present parts of the project to highly engaged audiences: as Visiting Professor of Humanities at the Ludwig-Maximilian-Universität in Munich (under the auspices of the UC Berkeley–LMU Humanities Exchange Program) in the first half of 2011, where Professor Ulrich Pfisterer was both a generous host and an ideal interlocutor; as Visiting Professor in the Department of Art History at the University of York in June, 2011, leading to a three-year part-time visiting professorship (2013–2016), during which faculty members and students at York heard and responded to working versions of several of the chapters; and as a faculty member in the fifth Stone Summer Theory Institute at the School of the Art Institute of Chicago (a series conceived and convened by James Elkins) organized in 2011 by Gustav Frank and Sunil Manghani, the results of which, including my contributions, were published by Penn State University Press in *Farewell to Visual Studies*, edited by Elkins, Frank, and Manghani. A third HRF from UC Berkeley in 2015–2016 gave me the time to finish the book. Linda Fitzgerald, Julie Wolf, and Juan Eugene de la Rosa facilitated final preparation of the illustrations. Some final expenses have been met by the George C. and Helen N. Pardee Chair at UC Berkeley. Thanks to John Onians and James D. Herbert for their incisive readings of the manuscript, and whose own work has been a constant point of reference for me. It has been a pleasure to work with the creative team at Princeton University Press: editor Michelle Komie, copyeditor Eva Jaunzems, production and design managers Terri O'Prey and Steven Sears, and designer Luke Bulman.

My colleagues at Berkeley continue to open my eyes to unconventional visions of contemporary intellectual space: Meg Conkey, Ken Goldberg, Chris Hallett, Bill Hanks, Marty Jay, Ramona Nadaff, Alva Noë, Andy Stewart, Alan Tansman, and the late Richard Wollheim, to whom the first book in this trilogy was dedicated. Students in my undergraduate courses have heard many of the ideas presented here, and they have responded with projects of their own. Graduate students in art history and other fields have been sympathetic yet challenging audiences for my sketches of topics surveyed in this book, and

many of them went on to write PhD theses (and books) that have shaped my thinking: Nima Bassiri, Todd Cronan, Scott Ferguson, Meredith Hoy, Jennifer Johung, Brian Kane, Sonal Khullar, Kristopher Kersey, Christopher Lakey, Jeremy Melius, Charles Oliver O'Donnell, Michael Schreyach, Justin Underhill, and Michelle Wang. A version of several sections of Chapter Two appeared in *Image and Imaging in Philosophy, Science and the Arts: Proceedings of the 33rd International Ludwig Wittgenstein-Symposium in Kirchberg, 2010*, ed. Richard Heinrich, Elisabeth Nemeth, Wolfram Pichler, and David Wagner (Heustenstamm: Ontos, 2011), vol. 1, pp. 191–218. An earlier version of Chapter Three appeared in German in *Einwegbilder*, ed. Inge Hinterwaldner, Michael Hagner, and Vera Wolff (Paderborn: Wilhelm Fink, 2016), pp. 55–83. Some parts of Chapter Four appeared in different form in "Bivisibility: Why Art History Is Comparative," in *Comparativism in Art History*, ed. Jas Elsner (London and New York: Ashgate, 2017), pp. 42–59.

In a book that is already long I have been sparing with reference to—let alone full engagement with—the copious scholarly literatures which have accrued to every topic I address, and to the examples of depiction on which I focus. Scholars will recognize my debts, and, I hope, forgive my summary rehearsals of intricate bibliographies. But I need to make an explicit acknowledgement. It will be obvious that I owe a sustained and systematic intellectual debt to David Summers. Several chapters in this book address his *Real Spaces*, published in 2003—a book that forced me (as no other work of art history had yet done) to rethink my approaches to images and pictures. From 2004 to 2009 sections of what has become this book were posted on my academic webpage in the form of a commentary on *Real Spaces*. At the time the commentary had become too long to publish as a review of Summers's book, as first intended. I use it here in new form. I am especially grateful to David for his permission to use a number of his exemplary diagrammatic analyses of certain effects in visual space.

In crystallizing the arguments and analysis proposed in this book, I have been beyond fortunate in my intellectual companionship. In sustained dialogues all along the way, Sam Rose and Justin Underhill demanded clarification of practically every point, whether or not they intended to do so. As a wide-ranging historian and skeptical theorist of my discipline, Sam has both encouraged me and doubted me in just the right proportions at just the right times; at every stage he has pinpointed my conceptual wobbles. He will see how his imagination of ambiguity has motivated my drive for precision. Justin has been my collaborator not only in refining the argument but also in devising many of the technical drawings and visualizations—and therefore the conceptual apparatus of this book. Solving the spatial problems together has been exhilarating.

Whitney Davis
San Francisco and London, August 2016

A NOTE ON NOTATIONS AND ABBREVIATIONS

This book develops arguments about pictorial spaces. Some of the arguments are well known. Though I have rewritten them from my point of view, they have featured in art theory and art history in the past, especially in the study of ancient pictorial arts. Some of them, however, are new; to my knowledge they have not been presented before. I advocate an analysis that is inevitably somewhat technical. I use some unfamiliar terms when I must deal with elementary processes that have not attracted the attention of earlier art theory and art writing. In particular, what I call "pictorial succession" requires laborious dissection (see Chapter Two). In other species of historical writing about pictures no one would deny the need for such analysis. And in any case I can see no way around it. To my mind the pictorial possibilities of one line on a surface must be so munificent as practically to defeat analytic explication, even though they might be readily available to visual understanding. But this is a cliché, and in this book I try to unpack it.

In putting my concepts and arguments through their paces, I use some abbreviations, and I have developed a simple system of notation. I do this for several reasons: to represent general relations as neutrally as possible; to conduct manipulations and computations in which elementary formalizations will assist in representing the analytic operations (however unfamiliar the representations might be in art writing to date); and to make it clear that the manipulations and computations can apply to cases other than the examples that I consider.

In the case of abbreviations, I have spelled each term out in full when it is first used in each chapter, and abbreviate any following uses in the text of that chapter. I hope this will aid readers who have not read through all of the chapters in sequence. In the notations, however, I have usually abbreviated in full.

NOTATIONS

| "succeeds to"; e.g., groundline (on a plane perpendicular to the line of sight) succeeds to groundplane (on a plane parallel to the line of sight).

[…|…] an operative pictorial succession in pictoriality; images and/or pictures nested in a succession; e.g., the groundline has succeeded to groundplane, and this consolidation is operative in pictoriality (groundline seen *as* groundplane).

[…{ |…}] a pictorial succession that could issue in potential realizations, designated within the curly brackets; e.g., groundline could *potentially* succeed to groundplane in certain visual circumstances.

◊ images and/or pictures (variables to the left and right of the sign) are notionally visible as perpendicular lines or planes; they meet in real, visual, and/or virtual space at right angles; e.g., [ADO | VVA] | ◊ MVA = the axis of direct observation (ADO) in visual space (succeeding to the virtual visual axis [VVA} in virtual pictorial space) meets the median vertical axis (MVA) of the depicted figure at right angles.

> is greater than; increases; increasing (in real size, in scale in the visual field). E.g., > PS = increasing size of the picture (PS) in its absolute area in the visual field.

< is lesser than; decreases; decreasing (in real size, in scale in the visual field). E.g., < ID = decreasing distance of the picture (ID = image distance) from the imaging point (IP = apex of visual angle).

ABBREVIATIONS

AC apparently continuous (in visual space); AC-pictoriality is virtual pictorial space that is apparently continuous with the beholder's visual space.

ADO axis of direct observation (sometimes called "*geradvorstellig*" or "aspective"; in one-point linear-perspective pictorial construction, the "axial" or "centric" sightline).

AOO axially oblique views of depicted objects (can equate to "foreshortening").

DC apparently discontinuous (in visual space); DC-pictoriality is virtual pictorial space that is apparently discontinuous with the beholder's visual space.

GP perpendicular guiding line (often used to construct MVA on the PP [picture plane]).

ID image distance; real distance of the plane of pictorialization or picture plane (PP) from the imaging point (apex of the visual angle).

IP Imaging point; the visual viewpoint; visual space at the beholder's standpoint; the "viewer-centered" origin and ground of the visual field; the apex of the visual angle.

MVA median vertical axis (usually of the depicted human figure).

NVP natural visual perspective — the space of "seeing," of imaging; visual space.

PF plane of the format

PP plane of pictorialization or (in the case of linear perspective) picture plane.

PS picture size; real size of the picture in absolute terms (height and width in real space) in occupying an area of the visual field.

PS : ID ratio of picture size to image distance, setting threshold(s) of "pure planarity" (TPP) and/or "emergent virtuality" in visual space.

VCP virtual coordinate plane (Summers), a virtualization of the spatial interval or "distance" between depicted objects and of indefinite spatial "depth" in pictures configured in planarity; notional depth of a virtual pictorial space on the Z-axis in X/Y/Z coordinate space; in visual space, visible VCP is predicated on AOO.

VP vanishing point.

VVA virtual visual axis; the "sightline" constructed for the implied beholder of a picture within the pictorial virtuality (in pictorial perspective, VVA = a straight line from viewpoint to vanishing point; in nonperspectival virtuality, often VVA = ADO ◊ MVA).

Visuality and Virtuality

Images and Pictures

1. ON IMAGING A PICTURE

Using a fountain pen and black ink on a rectangular sheet of cream-colored paper (about twice as wide as it is high), I draw a horizontal line (Figure 0.1). It is thin and undulating; in places it is broken where the pen did not touch the paper. For you, my reader, this line could be many things. Probably it is a line drawn on paper—at any rate a line that looks like a line drawn on paper when it is reproduced in this book. Maybe it is *only* a line. But perhaps it is a *horizon* line—the line of the horizon, the edge of a virtual world.

0.1. A line.

For me, however, the line is *not* a horizon. It is much closer than that. It is the strut of the dark woodrail fence standing out of the heavy snowfall covering an endless field in the flat farmland outside the Canadian town where I grew up.

I say *the* dark woodrail fence. Is it, then, a *particular* fence, or field—*that* fence? It is hard for me to say. I can visualize something like it. But maybe the line on the sheet of paper simply suggests the image to me—a memory? For the line certainly looks *like* such a fence in such a field to me. The image is familiar to me—palpable and real. And it is not only visual. I sense not only the shape and color of the things. I also feel their rawness and coldness—the tang of the northern wind and the bleakness of the pewter sky. As I will put it in this book, I can continue "pictorializing" in this way more or less indefinitely (Figure 0.2)—unfolding the line, what I see it *as* and see *in* it, or, as I will sometimes say, what I see it to be like and (as I will suggest in Chapter Two) what I see it *as* to be like. Here, then, are the rain-blacked and snow-softened split rails, and the sagging, rotted fenceposts; here are those bare trees; here is that rusted old iron pump. For you, however, this collocation of lines could continue to be just that: a pattern of intersecting lines, neither horizon nor fence—and certainly not *that* fence.

It happens, however, that I did not draw these lines and that I did not make this picture, though I *have* constituted this image, which perhaps you could partly share with me if you had accompanied me to London, Ontario, on a December afternoon in 1961. The picture was made by the Canadian artist Tony Urquhart, and its relation to *his* imaging is unknown to me. To be sure, Urquhart (born in 1934) was a friend of my parents, and he knows the flat, dreary snowlands quite as well as I do; that is partly

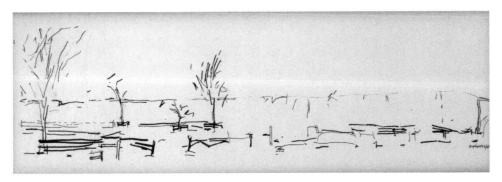

0.2. Tony Urquhart, *Fences I*, 1961. Collection of the author.

why his drawing, made when I was three years old, has been in my hands for a long time.[1] Still, what really counts for me is the pictoriality that the lines now have *for me*.

This is not a simple matter of me *versus* Urquhart. Not only do I see the drawing as something-or-other, namely, a collocation of lines that virtualizes snow, fences, and so on — snow and fences that might well be virtualized by *you* simply as what the drawing pictorializes them to be like. (Presumably you do not know Tony Urquhart, and certainly you do not own this drawing. Moreover, in all likelihood you do not have visual and other kinds of images of wintry farmlands in southern Ontario that *I* likely share in part with *him*.) I also see something-or-other in what the drawing looks like to me, namely, the bareness and spareness, the bleakness and blackness, of the fences and fields of my childhood — as if *those fences and fields* had been drawn in the world as thin inky-black lines on a broad snowy plane. Indeed, and for all I can see right now, the farm in winter that I now imagine — that I now image — as a familiar place from the visual world of my childhood simply *is* the pattern drawn by Urquhart. For me, this visual world is now indistinguishable from this drawing, which has — to use a word now much in vogue — great "presence" for me (see especially Chapter Three).

When I turn to pictorial representations that were actually made by me, sometimes I experience this kind of imagistic recursion, a complex interaction between a picture and images — images not only of the artifact itself but also of the world I take it to depict, which I can image independently (and, in the case of Urquhart's drawing, as images of something I've seen for myself). But sometimes I do not, even when my pictorialization relays images of my world, to which I must have privileged access (so one might suppose) because they are mine.

Consider two drawings that I made in London, Ontario, at roughly the same time as Urquhart made *his* drawing. I have vivid intimate images of the chunky silver candle-stick and the waxy white tapers that my mother loved to use, and of the translucent glass cylinder in which she would put the hollow green stems of the yellow daffodils

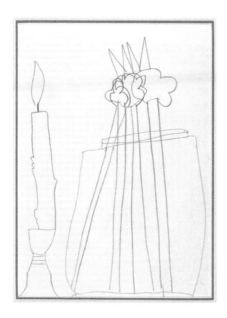

0.3. Whitney Davis, *Candlestick and Vase of Flowers*, 1963. Collection of the author.

snatched from the soft soilbanks when spring came to her garden beside our big brick house. Maybe this is because (though not *only* because) my mother kept a drawing I made of these things when I was five years old (Figure 0.3) for the rest of her life (that is, for more than forty years), and because after it came to me I have looked at it every day for many years — years long after she had left the house with the daffodils, and her children had moved away.

But a drawing I made a year earlier (Figure 0.4), when I was four, yields much less to me. I have a vague sense that it shows my mother, my father, my sister, and me, our collie, Molly, and the neighbors' mutt, Ben, whose floppy ears flapped up when he ran. I can barely visualize Ben now, and my drawing barely virtualizes him for me, though I *can* see it's him. It has just a tinge of pictoriality for me — of the pictoriality, that is, that is my seeing of my family and the two dogs in it. (*You* will likely not see *my* family and the dogs *Molly* and *Ben* until you read this; and even then, you will only see what the drawing virtualizes them to be like for you.) It is no less a picture because of that. But now I am much less able to pictorialize it than I was, I suspect, when I made it to show it off to my parents and my sister, and maybe to Molly and Ben — a picturing event of which I have no image at all. In fact, I have relied on the reports of other people who were there, as well as certain written evidence that survives from my childhood, to pictorialize Ben's floppy ears in the picture — to *re*pictorialize them. To do this, I have inquired both into the situations in which Ben's floppy ears were seen by me and into

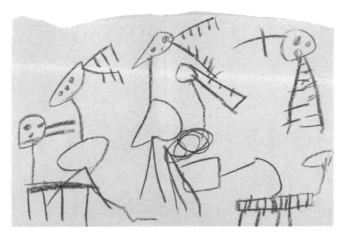

0.4. Whitney Davis, *Family with Dogs*, 1962, collection of the author.

the peculiar circumstance of including him in a picture of my family, to which he did not belong. (I still sense the peculiarity of this; it is the main residual pictorial aspect of the drawing for me now: "what's Ben doing there?" I feel sure that the drawing was made to show something: "*here's Ben with us—with me!*") What remains of this lost visual world are parameters of the "mere picture" (a concept I will develop in Chapter Two) that are partly preserved at standpoint in virtue of the inherent geometrical optics of natural vision. Holding the drawing upright at arm's length, for example, I can notice the strong affordance of "bottom" and even "ground" at the straight bottom edge of the sheet of paper, as well as the replication in the marks of the ninety-degree angle of the bottom left corner. And I can still see the two long smooth flops of Ben's ears flapping straight out virtually parallel to the ground as he ran. Note the nearly straight line, parallel to the left edge of the sheet, that constructs the lefthand side of the dog's otherwise oval face; the strict right angle of the insertion of his neck into his trunk; and the way his feet engage the bottom edge at ninety degrees (Figure 0.5). But take him out of this context in visual space and reorient him (say by laying him out flat in a strongly foreshortened affordance of the drawing [Figure 0.6]), and one might not see this *in* the drawing, or see it *of* him. Indeed, one might not see *him*—specifically Ben running with flapping ears—pictorialized at all.

2. VISUALITY AND VIRTUALITY

Visuality and Virtuality, this book, is a companion volume to *A General Theory of Visual Culture*, published in 2011, and to *Space, Time, and Depiction*, a series of historical studies that I hope to publish soon.[2] It explores the ways in which human beings have made

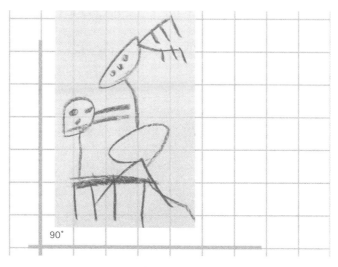

90°

0.5. Detail of dog Ben.

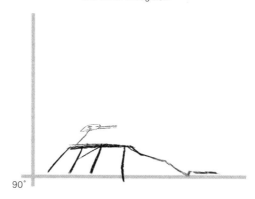

90°

0.6. Foreshortened detail of dog Ben.

different kinds of visual space by making pictures in different kinds of ways. I will try to show that the terms used in my title enable new analysis of this matter, what I call a "historical phenomenology": how "visuality" and "virtuality" relate to "images" and "pictures," and above all how "imaging a picture" (as I will often put it)—that is, using it in visual space—creates *virtual* space, whether or not this activity counts as "visuality," a visual culture, in the sense developed in *GTVC*.

In *GTVC*, I examined the question of visual succession to visuality—to visual culture—as a strictly analytic problem. The present book highlights historical variation and transformation in the imaging of pictures—a historical phenomenology. It would be impossible to be comprehensive. But I try to be as broad as my competence allows. I give considerable attention to four very different ways in which pictures have

been constructed to be imaged, to be used in visual space: Upper Paleolithic "cave art" and other prehistoric practices of mark making (see especially Chapters Two and Three); ancient Egyptian pictorialism, often described as highly "conceptual" (see especially Chapters Six and Seven); Classical Greek naturalism in figurative sculpture (see especially Chapter Eight); and early modern European and subsequent experiments in simulating natural visual perspective, notably in linear-perspective projections and in *trompe l'oeils* (see especially Chapter Nine). To a lesser extent my approach throughout has been influenced by the rise of digital image-making in present-day new media as a practice that can be said to be both "conceptual" (insofar as it is generated numerically) and "naturalistic" and even "illusionistic" or *trompe-l'oeil* (insofar as it can produce vivid simulations of visible worlds, even corporeally immersive virtual worlds, whether or not these environments simulate the kinds of objects and spaces to be found in the real visual world). The geometrical and numerical construction of pictures will be a major theme throughout. But I will not deal with today's new media head-on; the third book in this trilogy, *Space, Time, and Depiction*, will address this matter.

Despite the historical range just described, in Chapters Four and Five I need to focus on one well-defined historical topic: the supposed contrast between the ancient Egyptian mode of constructing pictorial spaces and the Classical Greek mode, despite cultural interconnections between Egyptian and Greek techniques, styles, and motifs between the seventh and fourth centuries BCE. Given the vast diversity of image- and picture-making traditions around the world from prehistory to the present day, this must be a rather local affair (albeit partly a trans-Mediterranean history). Still, it has had disproportionate significance in Western art history in the wake of Johann Joachim Winckelmann's *History of the Art of Antiquity* (1764) and Georg Wilhelm Friedrich Hegel's *Phenomenology of Spirit* (1805) and his *Lectures on Fine Art* (1820s; often called Hegel's *Aesthetics*, as recorded by several of his students), foundational writings in which the world-historical contrast was initially stated — and even though both writers grasped the historical influence of Egyptian art on Greek art and Hegel conceived Egyptian art less as the absolute opposite of Greek art than as the "middle," the dialectical "transition," between ancient "Eastern" arts (Persian and Hindu) and "Western" European arts. More recent studies of image- and picture-making in psychology, anthropology, and philosophy (in such landmark books as Margaret Hagen's *Varieties of Realism* and John Willats's *Art and Representation*) have continued to explore the contrast between "Egyptian" and "Greek" variants of pictorial virtuality, or at any rate to echo the old art-historical contrast.

It will be obvious from my subtitle (and the title of this Introduction) that I distinguish between "image," that is, *the generation of a visual space,* and "picture," that is, *an artifact in visual space that extends visual space into a virtual space of virtual objects.* (Of

course, there are images other than visual ones—a matter addressed below [§3].) In German, this distinction is not easy to make lexically: the word *Bild* can refer both to images *tout court* (including "seeing," visualization, visual recollection, and visible imagery) and to depiction, not to speak of such mental structures as schemata, and such neuropsychological events as dreams. Perhaps it is partly for this reason that so-called *Bildwissenschaft*—inquiry into the perceptual, mnemic, cognitive, and cultural varieties of *Bilder*, and the relations among them—is far advanced in German-language scholarship today. (Both Immanuel Kant and Sigmund Freud, for example, put *Bild* to use in characterizing different kinds of images as having determinate interrelations). Still, and given the fact that I write in English, it is useful for my purposes that the English language permits an idiomatic distinction between image and picture.

According to one common English use of the terms, a "picture" is simply *one kind* of image: pictures comprise a well-defined subset of the vast set of images. For this very reason, however, it can be misleading to use "image" and "picture" as wholly interchangeable terms, though the conflation can often be found in disciplines, such as art history, that focus for the most part on the subset (that is, on pictures as "images") and far less on the full set (that is, on images *tout court*). As we will see (below, §4), there are reasons for this conflation; to some extent it *enables* art-historical and similar inquiries. But in this book I will make an effort to avoid it.

As I will try to show, a picture is a complex interaction of several kinds of imaging. It cannot be wrong to identify this interaction as a kind of image in itself—to identify pictures as *a kind of interaction of kinds of images*. But the discrimination in question requires that we deal with images *beyond* the kind—with the relations between pictures, as a kind of image, and images that are not pictures and imaging that is not pictorial. By far the most important of these relations must be the interaction between "seeing," or what I will often call "natural visual perspective" (NVP), and pictorial artifacts that have been made to be visible in visual space—the domain of "images" (and imaging) and the domain of "pictures" (and picturing), respectively, as I will use the terms.

I am an art historian, and this book is art-historical. Of course, art historians have traditionally (and rightly) addressed many objects that are not pictorial, a matter briefly addressed in the final section of Chapter One. As already noted, however, my particular concern in this book is the nature of the historical relations between images *tout court* and the imaging of pictures. This entails that I do not limit myself to "pictorial art" in an aesthetical sense—to pictures that have been nominated as "works of art" in modern aesthetic ideologies and their present-day globalized offshoots (after many a critical turn and dialectical vicissitude) in contemporary artworlds, even if the artifacts in question were produced in those visual cultures (that is, even if they were produced

as works of art). In this book (as in *GTVC*) my interest in aesthetic questions will largely be limited to the etymological meaning of *aisthesis*, namely, to sensory perception and embodied awareness. Everything I want to say about images and pictures (including any artworks) can be handled in that frame.

3. IMAGES IN GENERAL AND IMAGING PICTURES

Needless to say, neither an image nor a picture needs be wholly visual, or even *partly* visual. A fully general account of embodied human imaging would need to investigate not only auditory, tactile, olfactory, and gustatory spaces—images constituted in hearing, touch, smell, and taste. It would also need to consider motor-muscular, loco-motional-positional, and autonomic-nervous spaces—images constituted in flexions, movements, and fluxes of the body in relation to itself, to other objects, to ambient environments, and to physical conditions and forces (such as the strength of the gravitational field). Indeed, it would need to explore "mental images," whatever their nature, and image(s) and imagining as a mode of human consciousness—possibly *the* mode. It is likely that all these images interact with one another in complex sequences, hierarchies, circuits, and feedback loops—what I prefer (following *GTVC*) to call "successions" and "recursions." This has been well recognized in a range of phenomenological inquiries from the late nineteenth century to the present day. At the moment of my present writing, in fact, these inquiries are not limited to psychological and philosophical investigations in the phenomenological tradition and in direct response to it. They also include historiographical critiques and diverse anthropological and historical applications undertaken not only as psychology but also as art history, cultural studies, and media aesthetics.

Still, one sometimes looks in vain for models of interactions among images—models that are well-defined enough to enable a precise analysis of certain *particular* interactions, such as the one I address in this book, namely, the imaging of pictures in visual space, especially the matter of the imaging of pictures under the visual angle constituted at corporeal "standpoint" or what I will often call the "imaging point." For whatever else might be true of embodied human imaging in general—the overall matter of the most general phenomenology—it is certainly true, I will argue, that no visible picture (more exactly what I will call apparent "pictoriality") can indefinitely survive geometrical-optical translocation of the imaging point—survive the movement, that is, of the beholder's standpoint considered literally and materially as his angle of vision.

Once we accept this thesis, we are constrained analytically to approach the imaging of pictures—or at any rate the *visual* imaging of *visible* pictures—in a way that flows not so much from *a general phenomenology of active embodied imaging as such*, valid though

it might be as an overarching philosophical framework, as from *the particular conditions of the interaction of specific successions and recursions of certain kinds of images.* This is a more narrowly analytical matter *within* general phenomenology. But it is this analysis that will — that does — connect the general phenomenology (a very mixed bag of diverse philosophies of images, imagery, and imagination) with various branches of empirical neuropsychology. Without it, these two modes of inquiry, broadly philosophical and anthropological on the one side and broadly scientific and psychological on the other, often seem to talk past one another. Each sometimes fails to generate hypotheses that can be coherently explored in the terms of the other, or even recognized at all.

Visual space in the sense that I will give to the term in Chapter One cannot be wholly assimilated to nonvisual sensory spaces, such as auditory and tactile spaces. Indeed, it cannot be identified with other *optical* spaces, such as the spaces constituted in certain endogenous events in the eyes and the visual cortex. These include the so-called Purkinje Tree, that is, visual images of blood vessels in the retina, and so-called phosphenes, luminous images — sometimes having a definite configuration, a "form" — generated without real light entering the eye. Largely autonomic, some of these "entoptics" can be induced by mechanical, chemical, and electrical means, sometimes partly framed by cultural expectations that allow for continuity — even identity — between endogenous optical events and visual space in the sense adopted here. That is, the entoptic phenomenon seems to be something "out there" in the world, as it were externalized, rather than somewhere inside the visual system *behind* the surfaces of the eyes. This possibility has been explored by anthropologists and historians working with shamanistic visual cultures, including prehistoric ones, and with picture-making traditions that might have been associated with them (see Chapter Three). Indeed, one of the pioneering studies of entoptics investigated the possibility that observations of "Unidentified Flying Objects" (UFOs) by German airplane pilots were, in fact, endogenous visual experiences linked to a cultural fantasy.[3]

To be sure, elements of my analysis might be applied to certain nonvisual pictures — to pictures, for example, that have been made to be apprehended by the hands in the dark. And it is obvious that some pictures — perhaps many — interweave visual and nonvisual modes of apprehension in attaining the full pictoriality constructed by their makers. I will sometimes touch on these phenomena. But I will not explore them systematically in focusing on my explicit topic: the specifically visual space created by pictures that have been constructed to be used visually by embodied human agents of vision. (For the sake of economy, henceforth I will not append this qualification to my every use of the term "picture.") Still, and mindful of my own criticisms of what I have called "visualist" prejudices in art history (*GTVC* 278–80), I will not take the *visibility*

of such pictures for granted. Indeed, the question of the visibility of such pictures in visual space — that is, how they are imaged — is the very historical question at hand.

Here a crucial fact of a particular recursion of images will need to be noticed: the very introduction of pictures into visual space — the "presence of pictoriality," as I will sometimes put it — integrates features into visual space that often would not otherwise be part of it. That is, features are introduced that would not be aspects of the visible world, and indeed are *not* aspects of it for any agents of vision who have not fully succeeded to the form of life in which the pictures as such were made to be used, whatever else might be visible to these people. For one succeeds to the "visuality" of a picture, and indeed to any item of visual culture, by way of the forms of likeness — emergent networks of both the visual and the nonvisual analogies of visible things — that make it salient in particular ways. (This was my argument, at any rate, in *GTVC*.) In this sense depictions might be said to supervene in the visible world. In the recursion of pictoriality in visuality, they virtualize the visual world in partly invisible ways.

Social historians of pictorial style have sometimes proposed that the visual skills needed to interpret pictures — to *see* them — might be coordinated in a "period eye," to use Michael Baxandall's version of E. H. Gombrich's general ethological theory (based on evolutionary psychology) of "perceptual readiness" or "mental set." Such socially constructed visuality might be found, for example, in a fifteenth-century Florentine merchant's ability to judge the size, volume, weight, and mass of things in visual space (and therefore their value and cost), a visual skill cultivated in commerce and banking and used by him to make sense of simulations of volume-shape produced in painter's perspective at the time. As I will argue throughout this book, however, the inverse of the equation deserves just as much analytic and historical attention (see *GTVC* 14–15, 158–60): if the merchant's commercial skills enabled him to judge virtual pictorial spaces, pictorial configurations, and depicted objects, it was equally true that pictures helped coordinate the imaging he employed in commerce, generating a complex network of forms of likeness within which *both* banking *and* painting were reciprocally organized.[4]

So far I have been making wholly apodictic statements. To begin to explicate them, let me turn to a particular context — one probably familiar to many readers — in which one might try to relate images in general to the imaging of pictures, and to the descriptive and analytical idioms that might be used to do so.

4. "LOOKING AT IMAGES" AND "LOOKING AT PICTURES"

Needless to say, one can look at all kinds of things other than pictures. But it seems that one cannot *but* look at pictures insofar as they function *as* pictures (have pictoriality):

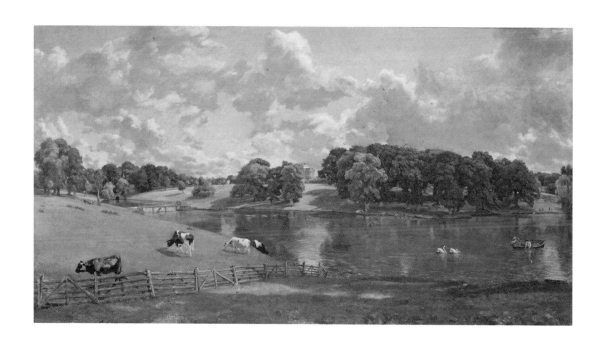

supposedly we look at pictures, looking at things in them that include not only the depicted objects and spaces but also what is often called the "form" and "style" of the depicting. If pictures are a kind of image, it seems in turn that we also "look at images" when they are pictures — the conflation, or at any rate the elision, that I have already mentioned. But I will avoid the latter locution because it obscures the economy of the very interaction that I want to put in question.

Consider a professor of art history (I am one) giving a lecture to students in a college classroom. The professor might say "look at this image" while pointing at a projected digital photograph of a painted picture (Figure 0.7), an artifact exhibited in a museum that is somewhere else — a fact perfectly plain to the students.

What exactly does the professor mean to indicate? That the students look at the projected digital photograph, certainly. But likely enough the professor's lecture is not *about* the photograph or *about* the projection (or both). The object of the lecture (and somehow *in* the lecture as it were) is the painted picture in the museum — or in a collector's home, or in the artist's studio. The students should look, then, at the painted picture (the image the professor wants them be looking at) so far as the projection of the digital photograph is an image of it (an image of an image).

Taking the students to the museum, the professor might again say "look at this image," here indicating the painting itself; the classroom lecture tried to simulate this looking. And back in the classroom, the professor — *not* being in the museum — might point out the ways in which the photograph visibly differs from the painting the students have now seen. "Look at this image" now means "look at how the photograph differs from the painting." (If the professor works in a university like my own, he might also bemoan the quality of the *projection* of the photograph of the painting: "look at this image" could mean "look at this projection of the photograph.") But in the museum, this locution might be unusual — somewhat confusing to those students who have learned that in the professor's vocabulary "images" are classroom illustrations. When pointing to an actual painting hung on the wall before their eyes, what could the professor mean in instructing them to "look at this image"?

Perhaps the professor is specifically discussing a landscape depicted in the painting: the painting is an "image" of it. The students have images of that image *both* in the painting hanging on the wall of the museum *and* in the projected photograph in the classroom. "Look at this image" tells the students to look at the painting's way of representing the landscape. (To sharpen this looking, and perhaps give it historical context, the professor could show them a photograph of the actual topography, and, of course, might summon tactile, verbal, and other "images" of it as collateral data.) But suppose, even further, that the professor is discussing the way in which the painting depicts the landscape *in perspective*, and therefore wants to point out phenomena of anamorphosis

that are inherent in any perspective projection. Here the students must deal with images within images beyond the mere imagistic relation of illustrating a picture, or even the imagistic relation of illustrating a picture's illustration of something. At the very least, they must explicitly recognize a projection of a photograph of the painting in the perspective constructed by the painter in looking at the landscape, or perhaps at preexisting pictures of it, or perhaps in simply "imagining" it.

In this tortuous context, "look at this image" could indicate that the students should try to envision a certain optical-geometric angle between the plane of the picture as projected and the visual axis of someone looking at it, regardless of where he or she might be sitting in the classroom. This person might not notice any anamorphosis where he or she is actually sitting, that is, find the perspective to be visibly distorted. But perhaps he or she can visualize how one *could* so see it, especially when the professor indicates the relevant sightlines in the room.

Better, the professor might project a digital virtualization of an anamorphosis in the picture painted in perspective projection — that is, the anamorphosis that would be visible to a student located at a particular spot in the room, or, for that matter, anywhere else, such as in the museum the students had visited, so long as *that* particular optical-geometric standpoint of *this* anamorphosis is occupied there. (If the professor has the requisite software to run the digital projection of the photograph of the painting, the digital image — in a recomputation of its size, shape, luminance gradients, and colors — could be rotated and foreshortened on an axis, simulating how the painting might look to someone viewing it a highly oblique angle.) One can "look at this image": the projection, the painting, and the anamorphosis.

Given the complexity of this entire activity — the students must deal with many relations among several different kinds of images — it would be well for the professor to be explicit about *which* image is indicated for *what* purpose in the overall consideration of the painting (and its images), and how *it* is to be imaged.

5. IMAGES AS REGISTRATIONS AND IMAGES AS REPRESENTATIONS

Adding to the complexity of the professor's classroom lecture and to the students' possible confusion, two background idioms seem to be circulating in the professor's lecture overall, and in particular in his use of locutions like "look at the image [the picture; the painting; the photograph...]." They overlap at points, likely leading to uncertainties and questions among students. And each is somewhat unsatisfactory for some of my main analytic purposes.

First, the professor might be saying that we (that is, his audience of beholders, the people in the classroom) have *an image of a picture* — that we *register* it somehow. In turn,

and in view of the fact that in the museum the painting is likely registered in a different way, one particular sense of the professor's locution (more exactly one specification of the registration in question) could be that we have a specifically *optical* registration of the picture: a "view" of it in visual space, a "seeing" and perhaps a "beholding" insofar as we see something that we realize (or that we eventually come to understand) has been generated specifically for us to look at. (To be precise, optical or visual imaging is not the same thing as a so-called retinal image, that is, the total pattern of distribution of the intensity of reflected light received by the rods and cones of the eyes at any given time. Visual imaging is the awareness of a moving, full-color, three-dimensional object-world that arises in visual processing of these intensities—an activity of the entire visual brain.) This will be the primary sense in which I will use the terms "image" and "imaging" with reference to pictures in this book: for my purposes, *an image is a space constituted visually at optical standpoint* (see Chapter One, §§1, 2). But it can be conflated with other senses of the same locution that refer to other ways of registering something that could be seen—to other registrations or "images." And it might be necessary to allow such conflations, because the registrations could be partly continuous in some ways—could be feeding into one another. Indeed, the professor's lecture seems to be rife with these conflations precisely because he is trying to get the students to recognize and assess the continuities—imagine, envision, and even *see* them.

Likely enough, in fact, there is no such thing as a *purely* optical or visual image (of a picture) that lacks within it other imagistic elements, however these may be registered. For example, we might have an image of a picture in the sense that we have a visual memory of it (the professor remembers the painting in the museum, or thinks he does, and can visualize it in recalling it to his mind's eye, or thinks he can), or a verbal description (the professor produces one such in the discourse of the lecture), or, needless to say, another picture of it (such as the projected digital photograph he uses to illustrate the painting). Still, the professor wants his students to be able to distinguish among these kinds of images in certain respects, above all with respect to pictures as he illustrates them in his lectures (on the one hand) and to actual paintings encountered by the students in visual space (on the other hand), whether or not that visual space is the visual space in which (and likely *for* which) the paintings were constructed by their makers to be used visually, perhaps by people in a different visual world.

As it happens, the professor is a student of the philosophical writings of Ludwig Wittgenstein and Nelson Goodman. According to his theoretical vocabulary, then, neither visual memories nor verbal descriptions are in fact pictures. Therefore they can never be *pictures of* a picture in the way that a photograph of it can sometimes depict it. (According to the professor in his Wittgensteinian moment, visual memories have no pictoriality, even if they can remember depictions; the professor does not *see* his

visual memory of the painting in the museum as a picture of it, even if pictures of it have affected his memory. And according to the professor in his Goodmanian moment, verbal descriptions do not depict at all; they describe.) Still, all register the picture in a definable way, and common idiom — the idiom that the students start with, and that the professor wants them to refine — allows that they are images of the picture.

Given all this, it would surely be best for the professor to be precise: in any given case to specify an optical image, a visual memory, a verbal description, or a pictorial representation (or any other kind of image), or, most likely, their kind of interaction as "images" — their interdetermination in and as a historical process.

In this book (and to use this idiom) I will address the relation between optical imaging (that is, visual space) and pictorial constructions (that is, virtual space): how they register one another; how they are registered *in* one another. Needless to say, however, other writers on this matter have been interested in the relations between pictorial constructions and visual memories (maybe "unconscious" ones), and still others have scrutinized the relations between pictorial constructions and verbal descriptions.[5]

None of these relations can be discounted. In some obvious ways and for certain critical, historical, and hermeneutic purposes, memory and discourse might well take precedence over the mere optics of the visible artifact in visual space. But for my purposes in this book, the relation between natural visual perspective and pictorial space is distinctive. *Both levels of imaging occur in visual space as a real place* — a real space in terms of which both natural visual perspective and depiction can be analyzed — and *as an interaction of images for embodied human agents of vision in that place*, however mediated by any *other* images in bodily sensation, in memory, and in discourse. Whatever else a depiction might be, it is an extension of visual space into *virtual* visual space. In dealing with pictures visible as such, this is *the only logically necessary imagistic relation to be considered*, even if it is not — is probably never — sufficient in any given case. All other relations are contingent imagistic interdeterminations.

So far I have considered one of the professor's idioms in his lecture: in his classroom illustrations, verbal descriptions, museum visits, and all the rest, he proffers "images" of the picture (and of many other items of visual culture) to the students. By way of complex mediations and conflations, and to some extent despite them, he tries to get his students to have an image of the painting — to register it. As I have already noted, however, probably his lecture is chiefly about the painting as an *image of* something: it "images" something-or-other — depicts it. When art historians say that a painting is an image, often they mean that it is a picture *of* something: it is an *X*-picture, or depiction-of-*X* (see *GTCV* 150–86).

Like the first idiom, this second idiom can sometimes be misleading. The picture is undoubtedly a *representation*. The landscape painting illustrated and described in

the professor's lecture represents the landscape, and perhaps other things such as the social relations of the people who are in part responsible for creating the land-scape's topography. (Wivenhoe Park was the family seat of the Rebow family; in the distance in Constable's painting [Figure 0.7], the landowner's daughter is depicted steering a donkey cart with a friend.) But it is obvious that representations need not be pictures, even when they are visual and visible. Consider the ways in which the professor could illustrate the painting in his lecture — represent it to the students, giving them an "image" — as well as the ways in which the painter could represent the landscape (producing an image of it) while making his painting. As I have assumed, in his classroom lecture the professor could use a digital photograph of the painting — a *pictorial* representation. But he could also use a diagram, a device often used in certain schools of "formal analysis" to identify essential visual facts about pictures, paintings, and indeed artifacts of all kinds (see *GTVC* 54–64). And in making his painting the painter could use his sketch of the landscape — a pictorial representation. But he could also use a scale map, a device often used to determine distances between points in real space. In the professor's theoretical vocabulary, it is not obvious that every diagram (including the art formalist's representation of "pictorial form") and that every map would be a picture of its objects, whether painting or landscape, though some of them might be. And even if it *were* obvious, it would still be far better to say explicitly that the students deal specifically with a diagram or with a map, especially if the diagram is a representation of a picture and the map is a representation needed to make one.

In other words, and complementing the idiom of images-as-registrations, it would be best to speak of images-as-representation by specifying the kind of representation (the kind of image) one is dealing with in any given case — a picture, a diagram, a map, a scale model, and so on. Of course, these types and functions of representation can intersect. A picture could be used in a map, a map might be a scale model, and so on. But then there is all the more reason to be explicit about the particular interactions of imaging in each case.

Some schools of psychology and philosophy have urged that vision — human seeing — is representational: an optical image, the registration of real space by human vision in visual space, is a representation (see Chapter Seven, §11). On some accounts, in fact, the representation might be specifically pictorial. But I do not explicitly need this terminology, and therefore I will not adopt it. Indeed, for the sake of clarity (and in line with a familiar idiom) I will proceed oppositely: generally I reserve the term "representation" for man-made artifacts in visual space (pictures, diagrams, maps, scale models, and so on), whether or not the imaging of them — as things in visual space — is "representational."

6. THE ANTHROPOLOGY OF IMAGES AND IMAGING PICTURES

I have described two idioms that can be found in such academic disciplines as art history, film studies, and architectural criticism and in visual-cultural studies broadly defined: images as registrations and images as representations. It would be foolhardy to claim that these idioms exhaust everything that one has meant by "image," "images," and "imaging" even in those disciplines, not to speak of radiography and ophthalmology. (To speak only of influential writings in English, in "What Is An Image?" W.J.T. Mitchell has offered a "family tree" of the many notions and connotations of "image," and in *The Domain of Images* James Elkins has charted the different arenas in which images become both objects of study and means of observation.[6]) But their idioms do relay the highly articulated ways of thinking that have constituted art history, film studies, architectural criticism, and their ilk. They identify the supposed objects of such disciplines, which supposedly "look at images," and to a lesser extent the *means* of such disciplines, which use images as their very media of inquiry — as in the professor's classroom lecture.

In art history one hears, for example, not only that a picture is an image, that is, that it depicts — and perhaps that it is a map, a scale model, and so on. One also hears, perhaps, that a *painting* (suppose it is not pictorial) is an image, that an effigy (suppose it is aniconic) is an image, or that an architectural setting for paintings and effigies (suppose it contains no representational elements beyond whatever the paintings and effigies might represent) is an image. Here "image" simply designates a phenomenon in visual space that has been produced specifically to be registered, at least in part, including visible representations. Indeed, in art history as it has expanded to include visual-cultural studies and *Bildwissenschaft* one might hear that a solar eclipse (a physical event in real space that does not occur *because* it is a phenomenon) is an image, that is, that we have an image of it or a way of registering and maybe representing it (suppose that we watch it through special sunglasses, or photograph it through a telescope [Figure 0.8]). And one might hear that the fission of mitochondria is an image (suppose that we watch it under high-resolution microscopy, or alternately as an animated digital simulation). In all these cases, and to repeat the main point, the term "image" can be replaced with a more particular and precise label: "abstract painting"; "aniconic effigy"; "solar eclipse photographed through a telescope"; or "mitochondrial fission visible under an electron microscope."

In this sense, it seems that sometimes the analytic work of the term "image" — as distinct from the terms stating an extension in a given instance — is best limited to cases in which we do not know, or cannot discern, what kind of phenomenon we are dealing with in visual space. Someone might not discern, for example, that a phenomenon in his visual space is a representation, even a picture. To take a well-known

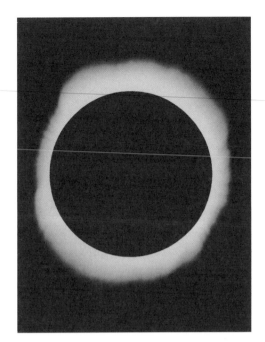

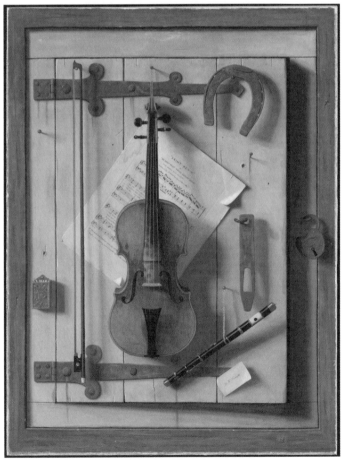

case that I will address in detail in later chapters, suppose that the phenomenon is a successful painted *trompe l'oeil* (Figure 0.9). Should the art historian, then, write of its beholders' experience of a "picture"? (*Trompe l'oeils* are often included in art-historical catalogs of paintings said to be pictures, and they have been included, with caution, in philosophical taxonomies of depiction.) In order that we not assume what remains to be demonstrated—namely, that beholders *do* see a picture, or eventually will see a picture—and in order to describe the beholders' visual space, we might best say that an "image" (a slice of visual and visible world that the *trompe l'oeil* has successfully called into being) is present or active in the beholder's visual space, but not *as* pictorial. In this case the *trompe l'oeil* virtualizes (what the beholders see as) particular real objects in space. Beholders have a visual image of—just *see*—a real violin, a sheet of music, a horseshoe, etc., hung on a cupboard door that is unlocked and slightly open.

Here we reach a well-known conundrum. To use the theoretical apparatus that I developed in *GTVC* and will refine in the present book, nothing warrants the reflexive art-historical assumption that a "succession" of an image—the phenomenon in visual space—to any such particular recognition as "picture of *X*" or "*X*-effigy" will actually occur, or, if it *does* occur, that it will occur in the same way for every agent for whom the image (resolved as the picture) can be said to be present and active. In the case of one agent, the image—the phenomenon in visual space—might succeed to "picture of *X*" (or to "*X*-effigy"), while in the case of another agent it might succeed to "the god *X*" or to "*X*-emanation," "*X*-incarnation," or "*X*-exemplification." In this book, however, I will not need to be troubled by this intriguing possibility, though it formed part of the basis of my approach to pictoriality in *GTVC* (and see Chapter Two) and it has been much discussed by anthropologists, historians of religion, and other writers, among whom a so-called anthropology of images (*Bild-Anthropologie*) has developed. This book is not primarily an anthropology of images—of their analytic classification, of their indigenous typology, ontology, and aesthetics, or of their affective and social power and agency. It is specifically about pictures in relation to imaging—an anthropology, in other words, of *those images that are pictures at the phenomenological level*. (I will take it, however, that there must be phenomenological succession here, a history in visuality and virtuality: the "mere picture" must be resolved to have the pictoriality of an *X*-depiction.) And in my definition a picture—if it is visible at all as a picture, if it is "present" as pictorial—has to be a "picture of *X*," an "*X*-picture." If it is a god-incarnation or a god-emanation—without pictoriality—then it is not a picture.

Of course, determining whether a picture is present—the anthropological *sine qua non* for my purposes—is not an easy matter, even if art historians tend to assume that what I will call "mere pictures" always depict. There are pictures that are not visible as pictures to some agents at certain standpoints. Notably these include the kind of highly

successful *trompe l'oeils* that I have already mentioned; their "deceptions" are crucially dependent on certain optical standpoints. And they might include the icons and effigies, recognizably pictorial to many agents, that are sometimes supposedly taken by particular agents in certain religious visual cultures (as it were spiritual visualities) to be divinities and other kinds of extraordinary being. Whether or not these images are dependent on certain *optical* standpoints, they do seem to require a certain perspective on the part of devotees — an imaging, envisioning, and imagining. Still, *trompe l'oeils* must almost always give themselves away as pictures to *all* agents at *some* standpoints; they become visibly anamorphic, and likely reveal themselves in tactile handling to be painted surfaces. And religious icons can almost always be described as pictures (or some other kind of representation, such as an effigy) by *some* agents at *all* standpoints. Not everyone in the group fully believes, and not every belief denies pictorial mediations. Indeed, some embrace them.

Stated another way, the *trompe l'oeil* and the religious icon — however pictorial — can function as "images" within a particular visual culture, perhaps even as kinds of images that are specifically *not* pictorial — instances of pictoriality — in that visual culture. (Pictoriality visible as such might defeat their purpose, drain them of their meaning, and compromise their power and value.) But in the natural history of these images — that is, in successions to visuality and in recursions within it — pictoriality itself must inevitably become visible (though not in the same way for everybody), and image will become either illusion specifically or icon specifically (though not, of course, to agents of a visuality within which the mere picture has been construed as a nonpictorial image). There is, then, no ultimate conflict between an anthropology of images and a theory of the imaging of pictures, even when the images in question are nonpictorial pictures in visuality. There is simply a difference in historical scope — in the actual historical moment in the phenomenological succession of pictoriality that has been consolidated in visuality. Because of the importance of this matter to any general theory of visual culture and to any historical phenomenology of images and pictures (and of imaging pictures), I pursue it in detail in Chapter Three.

7. "WORLDING" PICTURES

None of the pictorial traditions that I address — prehistoric European (Aurignacian and Magdalenian), ancient Egyptian, Classical Greek, and the rest — needs be identified with a particular human culture in the late-nineteenth-century sense of that term, that is, with a particular socioethnic group and its internally shared customs, laws, and beliefs. In principle, they can be described not only as visual cultures located in a particular historical time and place — that is, as visualities. They can also be

described as pictorial spaces that can be replicated wherever a certain kind of imaging occurs—that is, as virtualities. The former—visualities—ordinarily would be the province of so-called visual-culture studies. But the latter—virtualities—probably are better tracked and explicated in a world history of imaging and picturing, whatever this inquiry might be called.[7]

This is because pictures often *make* visual culture as much as they are *made by* it (see Chapter One, §4). By definition, this process cannot be fully grasped if one takes a given visual culture (singular) to be a *fait accompli*—as an entrenched preexisting visuality that dictates how pictures will be made and seen. It must be complemented by a history that deals with the inverse process—how picture-making sometimes *issues in* visual cultures (plural). At the very least this history would have to be comparative and inter- and transcultural (Chapter Four), and it seems to conform to certain natural-historical principles. It can help make sense not only of the continuities of pictorial configuration from the deep past to the present day—a level of continuity, for example, between Egyptian pictorial "conceptualism" and Classical Greek pictorial "naturalism" (Chapters Seven and Eight). It also helps make sense of their disjunctions—the disjunction, for example, between painted *trompe l'oeils* in early modern depiction (Chapter Nine) and computer-generated three-dimensional object-simulations in present-day new media.

Art history has long taken such continuities and disjunctions to be one of its global purviews—its mission and its mandate as world history. If this were not true, it would have splintered long ago into discrete historical anthropologies of indigenous canons of aesthetic judgment and cultures of pictorial practice. But two obvious caveats are needed. First, discrete historical anthropologies have been built into the philological and archaeological subdivisions, the "area studies," of professional art history created in the late nineteenth and early twentieth centuries—that is, into relatively compartmentalized studies of European, African, Asian, and other arts. The dominance of these professional territories has sometimes occluded the kind of considerations to be addressed in this book. Second, a world history of imaging pictures need not be the same thing as a "global" history, though substantially global histories can be identified, including histories of the "globalization" of particular visual cultures, now and in the past, and therefore, likely, of their interaction in the world—their mutual succession and feedback. As this phrasing might suggest, a world history need not always be global: as I would like to put it, it only needs to put art, pictures, and images into the world.[8]

In the present book, my central means of worlding pictures—of putting them into the world—is to reconstruct how they are imaged at standpoint.

8. THE ORGANIZATION OF THIS BOOK

Part One introduces the analytic frameworks that I will use to deal with the matters I have outlined so far. In Chapter One I set out the most general of these frameworks: namely, an analytics of visual space; an analytics of imaging pictures in visual space; an analytics of visual cultures in world history (largely based on the approach to visual culture proposed in *GTVC*); and an analytics of "abstraction" and "representationality." In Chapter Two I present a more specialized framework for the analysis of depiction — one kind of image-making activity in visual space, and the one on which I focus in this book. I develop distinctions between what I will call "radical pictoriality," "pictorialization," depiction, and "mere picture," all conceived as variations of imaging in making pictures. And I try to describe their systematic interrelations.

Chapter Three takes up the question of "presence" mentioned in the first section of this Introduction. We have seen that this book concerns the work of pictures in visual space, in imaging. In part this is a question of their visibility and visuality — how they are seen, what is seen in them, what they are seen as, what those things are like, and so on. But it is also a question of their virtuality — what they construct as a virtual pictorial space, continuous or not with the rest of visual space, and what is "present" to us in that space, or as it. In Chapter Three I explore a problem posed by the anthropology of images — namely, the status of the "presence of pictoriality," of the visibility of picture as such, in the operations of virtuality.

Part Two deals with different *kinds* of spaces (and correlated temporalities) constituted in depiction, with special reference to art-historical inquiries that have set out to describe them. These inquiries have often been dominated by the phenomena of congruence between pictorial space and natural visual perspective, especially by the issue of *simulating* natural visual perspectives in pictorial spaces.

In Part Two I approach this matter by emphasizing that there is no stable singular relation between natural visual perspective and pictorial space. Natural visual perspective is constantly changing. The eyes never stop moving, and the human body is often in motion. Therefore pictorial spaces are constantly changing, even if we are continuously inspecting one and the same material artifact in real space. It is obvious that a picture which seems to be properly proportioned pictorially at one standpoint can seem to be distorted at another standpoint close by, or to a different beholder occupying the same standpoint at a different time. And therefore — in an unavoidable recursion — natural visual perspectives are constantly changing in so far as pictures are present in them at all (the contingent question explored in Chapter Three). New visual spaces — and many other spaces of embodied awareness — are constantly being opened up by pictures, depending on one's time and place in the successions of visuality

and virtuality. It is in this domain that art historians have often hoped to describe the "presence," "agency," and "iconicity" of depiction, its "efficacy," "power," and "action." But its intricate circuitry — and by "circuitry" I mean no literalization of the metaphor in electrical, cybernetic, neurochemical, or any other terms — has sometimes been taken for granted, as if the picture in its radically external *Gestalt* simply stands determinately over and against a beholder who is always striving toward the recognition of *Gestaltung* that is there to be seen.

In Part Two I describe these successions and recursions in three registers: in terms of the inherent "bivisibility" of pictures in visual imaging, that is, as *visible* objects in visual space (Chapter Four); in terms of the "bivirtuality" of pictures in creating *virtual* visual spaces and *virtual* visible objects therein (Chapter Five); and in terms of the "birotationality" of virtual objects in pictures when imaged (Chapter Six). Flowing from my preliminary definition of picture (an artifact in visual space that extends it into a virtual space of virtual objects), these registers are analytic — ways of describing certain successions and recursions that I take to be inherent in the imaging of pictures. For this very reason, they seem to imply a world history of imaging pictures: there can be no historical situation of depiction, no picture-making practice or culture, that lacks them.

"Bivisibility" (Chapter Four) analytically designates the fact that no pictorial space is one visuality only, as well as the historical process in which this fact emerges empirically for certain beholders at standpoint (as it must in the imaging of pictures). Pictorial space is routinely visible *outside* the visuality in which it was produced, that is, in which it was made to be used visually. And different people see different pictorial spaces depending on the visuality they bring to the visibility of the depiction and the visual space that the picture demands and projects. For these very reasons, pictorial spaces can become one of the primary sites of interaction *between* visualities — different visual cultures.

"Bivirtuality" (Chapter Five) analytically designates the fact that in some respects and at one standpoint a pictorial space can seem to be substantially continuous with the rest of visual space in natural visual perspective — a seemingly uninflected optical extension of it — and to be discontinuous with it in other respects and at another standpoint, as well as the historical process in which this fact emerges empirically for certain beholders at standpoint (as it must in the imaging of pictures). And "birotationality" (Chapter Six) analytically designates the fact that all depicted objects — what an *X*-picture depicts — constitute different pictorial spaces depending on whether they are imaged when "frontalized" and/or as depicting things as "frontal" (on the one hand) or in "foreshortening" and/or as depicting things as "foreshortened" (on the other hand) and on how these angles of vision interact, as well as the historical process in

which this fact emerges empirically for certain beholders at standpoint (as it must in the imaging of pictures).

In historical successions of the imaging of pictures, then, bivisibility (the visibility of the picture to beholders outside the visuality in which it was made to be used visually) could lead *through* bivirtuality *to* birotationality (a different way of seeing the objects depicted in the picture—of using it visually). By the same token, though inversely, birotationality (such as an imagistic "foreshortening" of a "frontalized" pictorialization of an object) could lead *through* bivirtuality *to* bivisibility—a sense that the picture does not wholly square with the visuality in which it was made to be used visually (that is, in which it is made to be visible as a picture), and even that it can be used as an alternate virtuality and relative to epistemological and ontological purposes of a different visuality. In general, a succession in any one register could lead to successions in any other. In imaging pictures, bivisibility, bivirtuality, and birotationality are interdetermined in complex successions and recursions that have rarely been described in full.

And successions and recursions are unavoidable. My terms—bivisibility, bivirtuality, and birotationality—designate *inevitable historical successions in the imaging of pictures.* Above all, effectively it is impossible to prevent—to arrest or to foreclose—apparent birotationality, though birotationality can be partly corralled in the real space in which the picture is used visually. Not surprisingly, then, the rotation of depicted objects has long been identified in art-historical and other theories of imaging as the primary visual engine of the historical development of picturing—of pictorial style and tradition. Chapter Five looks at this crucial historiography.

In Part Three, and in view of the three registers of inevitable visual succession identified in Part Two, I address the technical means by which image-makers calculate the ways in which a picture can be imaged, and to some extent control them. In particular, I deal with the construction and experience of "virtual coordinate space," a concept implied by David Summers's pioneering treatment of what he has called the "virtual coordinate plane." Virtual coordinate space is a function of the way in which the picture is visible in the beholder's visual space—a highly particular function of the angle of vision, and therefore maximally beholden (we might suppose) to the vagaries of bivisibility, bivirtuality, and birotationality. But recursively the virtual coordinate plane must be computed, even envisioned, in configuring the picture: precise proportional and other virtual relations must be worked out—worked out optically, metrically, geometrically, and even numerically—in relation to the standpoints that might be and have been occupied by beholders. These computations can occur intuitively (usually in the very act of making the picture) or they can require laborious planning (often a specialist knowledge), not to speak of the fact that they are often obtained mechanically (at any rate they are implicit in the use of devices that encode and produce them).

Part Three deals, then, with the relation between the material plane (or planes) of the (mere) picture and the virtual space (or spaces) actually constructed by its pictoriality in visual space. Part Three goes into greater technical and contextual detail about particular traditions of depiction than do the earlier chapters.

For reasons to be identified in Chapter One, and already intimated in this Introduction, the analysis of virtual pictorial space in terms of coordinate planes requires that I investigate, analytically reconstruct, "what the image-maker sees" in making the picture — in putting it into the world to be seen by him and others. My model of visual space and virtual pictorial space at standpoint entails that "what the Chauvet Master, Hesire, Phidias, and Brunelleschi saw" — an Aurignacian painter, an ancient Egyptian scribe-draftsman, a Classical Greek sculptor, and a Renaissance Italian engineer respectively, all pictorialists — was in part particular to each of them alone as visual agents. In *GTVC*, I argued that this fact — this corporeal, experiential, and social condition — of visual space and artifacts made to be visible in it requires art history to "build down" from large-scale sociological analysis of group behavior and trends of viewing in visual culture. Stated the other way around, it requires art history to "build up" from individual corporealized experience at standpoint in visual space. Some respondents to these proposals have suggested that this kind of investigation is impossible. But I categorically demur; in this book I try to indicate that it flows from the most elementary analytics of visual space.

I sum up. Part One presents an analytic apparatus that enables me to describe the imaging of pictures in a certain way. Part Two deals with the inherent successions and recursions in imaging pictures that can be identified by means of this apparatus. And Part Three explores the empirical history of certain successions and recursions in imaging pictures — certain virtual spaces — that can be tracked in these terms, that is, what we might take the pictorialists and other beholders to have experienced visually in making and using the picture.

PART ONE

Analytics of Imaging Pictures in Visual Space

Visuality and Virtuality

Analytics of Visual Space and Pictorial Space

1. AN INTEGRATED ANALYTICS: AN OVERVIEW

This first chapter is devoted to the most basic and general analytic frameworks I will use throughout this book. It begins with a sketch of an *analytics of visual space* (§2) — the space in which pictures must be imaged insofar as the pictures are visible, at least according to a certain *analytics of imaging pictures* (§3). In fact, a continuity between the analytics of visual space (§2) and the analytics of imaging pictures (§3) will prove to be important; I will need most of this book to explore it fully.

For the purposes of this chapter, it suffices to say that the continuity is not simply a self-evident correlate of the obvious fact that any visible picture must be seen in visual space. (To use terms I have developed elsewhere, this involves the "succession" of pictoriality [*GTVC* 150–86].) Nor is it because certain "naturalistic" pictorial spaces are apparently continuous with visual space, a matter I take up in Chapters Three and Five. It is because the imaging of pictures — not least the apprehension of pictorial space, or "virtuality" — occurs partly in "visuality." It occurs, that is, partly in the context of a so-called visual culture. Most pictures in most historical forms of life have been constructed as artifacts to be used visually *in* that very form of life — to be visible specifically for use within its particular visuality. They are properly visible, that is, in visuality, at least according to a certain *analytics of visual culture* (§4). It follows that the analytics of visual space (though seemingly the most general issue) might *depend on* the analytics of the imaging of pictures (seemingly a narrower subject) insofar as the visual spaces in question include pictures to be imaged. (In the terms developed in *GTVC*, this is a "recursion" of pictoriality.) Visual spaces in most historical human forms of life include pictures; some of them *are* pictures. Indeed, in Chapter Two I will introduce the hypothesis that the making of pictures in human visual worlds — the technology of depiction — has contributed to the evolution of the human visual perception of real space. The analytics of *this* possibility follows from the intersection of the analytics of visual space (§2) and the analytics of imaging pictures (§3); it is a way of characterizing that intersection as a historical recursion in human evolution. (Though the hypothesis of this recursion is not unique to me, my terms allow me to state it in a particular way.)

In the previous paragraph I was careful to say that the imaging of pictures occurs *partly* in visuality — that is, that it occurs in visuality sometimes, under certain conditions in certain cases and with respect to certain features that pictures are seen to have. Historians of image-making cannot content themselves, then, simply with reporting the visual-cultural orientations — the visuality — of pictorialists in diverse contexts around the world. For part of the history of picturing occurs *outside* visual culture (§4). I will pursue this matter in more detail in Chapter Four. In this chapter it suffices

to say that we need to take account of the recursive possibility that any visual culture partly *emerges* historically in the making of pictures (and above all the virtual spaces afforded by pictures) seen at their standpoints in visual space (as described in §2). In this sense, the analytics of visual culture (§4), like the analytics of visual space (§2), can be dependent on the analytics of imaging pictures (§3). It follows that overall we need to integrate a general analytics of visual space and a special analytics of imaging pictures (§§2, 3) as the matter of a world history distinct from the anthropology of any given visual culture in which pictures have been integrated in visuality (§§3, 4). I adopt this integrated historical analytics throughout.

My order of presentation of the relevant analytics (§§2, 3, and 4) does not assume the primacy of any one analytic register over any of the other registers. As I have already intimated, each inflects all the others. The order in which they do so depends on the successions of imaging and picturing that we are dealing with: with imaging visual space; with making a picture *of* a visual space; with imaging a picture *in* visual space; and so on. It makes sense to begin with the analytics of visual space (§2); its terms do not require that every visual space always includes pictures. And it makes sense to end with the analytics of a world history of imaging pictures (§3) in visual cultures to which people have succeeded in visual space (§4). As I have noted, however, one could work the other way around: the history of the way in pictures have been imaged — the way in which pictures are present — has organized and even constructed some visual spaces in a certain way. I will indicate some of these interdeterminations in presenting each analytic.

The final section (§5) takes a step back from these successions and recursions — successions and recursions in imaging that involve the presence of pictures. Historians of art and visual culture cannot avoid dealing with visual and virtual spaces constructed by *nonpictorial* configurations that have been made specifically to be seen, to be used visually — configurations that might be described as "abstract" or as "nonfigurative," though both terms can be somewhat misleading. In a book about pictures I will not be much concerned with artifacts of this kind. But their "representationality" (to use a term developed by Richard Wollheim) helps us gauge the imaging of pictures specifically. Indeed, "abstract" representationality always threads through "pictorial" representationality even in the case of artifacts deemed to be pictures. And I believe that a preponderance of configurations in the world of putatively "abstract" art and visual form can properly be considered partly in terms of their representationality and specifically in terms of their "radical pictoriality" (Chapter Two), though this possibility is not the main theme of this book.

2. A BRIEF ANALYTICS OF VISUAL SPACE

I use the term "visual space" to denote the spatial order of visible things that is appre-hended optically by a beholder at a given standpoint, that is, the objects *in* the visual field and the apparent scales, occlusions, intervals, and distances *of* the things in the field apparent at that place (including any pictures that are visible in it) — what the world in that visual field is seen *as* there and what can be seen *in* it (Chapter Two). As noted in the Introduction, there might be other optical spaces, such as the spaces of entoptics and other endogenous visual phenomena. But visual space is the primary optical space of embodied human agents in their awareness of and action in visible worlds and in their recognition of and response to them. Therefore visual space must be one of the primary corporeal, affective, and social spaces of human agents, though it is not, of course, the only such space, or even a discrete space — a matter addressed briefly at the end of this section.

For my purposes, an analytics of visual space requires four terms: (1) *visual space* (standing in a particular relation to *real space* and *virtual space*), (2) *standpoint*, (3) *natural visual perspective* (NVP), and (4) *imaging point* (IP). These four terms are the most basic and general analytic terms I will need in this book. As I will explain (see Table 1.1), the latter three terms are analytic of the first; (1) visual space can be defined as the relation at (2) standpoint between (3) natural visual perspective and (4) imaging point. The latter two terms are analytic of the second; (2) standpoint can be defined as a relation between (3) natural visual perspective and (4) imaging point. And the final term is analytic of the third; (3) natural visual perspective can be defined in terms of (4) imaging point. At the same time, however the first three terms are analytic of the final term; (4) imaging point can be defined as a relation between (3) natural visual perspective and (2) standpoint in (1) visual space. Despite the possibility of circularity, then, the model — an analytics of visual space — is tight and robust. It will do the work that I will need of it in dealing with historical variations in the visibility of pictures — in the ways that they might be imaged.

Ludwig Wittgenstein recounted a simple example of a visual space: the way in which a person's head in the foreground of someone's visual field might appear to be touching the lintel of a doorway that actually stands in the far background and even though the two "lines" — the "circle" of the head and the "tangent" of the doorframe — might be separated by many meters in real space (Figure 1.1). (The ambiguity of visual space has been explored and exploited with unsettling élan by such painters as René Magritte. In the well-known *Voice of Space* of 1931 [Figure 1.2], where exactly are the strange spheres hovering: as giant objects above the green field in the middle distance, for example, or as small balls right in front of our face, or even as "floaters" in the humor

of our eyes? Indeed, what is the distance between them: perhaps the hindmost sphere floats over the sea in the far distance?) The circle-and-tangent of the head-and-doorframe is a phenomenon in visual space in the sense adopted here because it becomes visible for the agent of vision — for *this* agent of vision at any rate — at a certain visual angle. Wittgenstein seems to mean that it is a visual space for this agent — it is specifically *his* visual space, and maybe no one else's — because the agent sees the head *as*

TABLE 1.1. THE ANALYTICS OF VISUAL SPACE

1.1. A circle and tangent/head and doorframe.

1.2. René Magritte, *Voice of Space*, 1931. Courtesy Solomon R. Guggenheim Museum, New York (76.2553.101).

touching the doorframe. Another agent might not see it this way (he might see the lintel as far away from the head, recognizing and resolving the gap), and *his* visual space at this very same standpoint would have to be described differently. I will return to the relation between visual space and "seeing-as" in Chapter Two. Here it suffices to say that the agent would not see the head as touching the doorframe if were not the case that his visual angle at standpoint makes the circle-and-tangent visible.[1]

Possibly the head-and-doorframe should also be described as a configurational phenomenon, a configuration *of* visual space, if, that is, the participants have actively set up — staged — this spatial relation specifically in order to see it, as when we move something into position in order deliberately to create *that* specific visual space for ourselves. Certainly the phenomenon of the head-and-doorframe could be represented in *virtual* pictorial space — captured, for example, in a photograph we might take given an appropriate set-up, a *mise-en-scène*, as in my illustration (Figure 1.1), a photograph stage-managed by me and a photographer in a hallway in my office building at the university. In this terminology, then, Wittgenstein's diagram of the circle-and-tangent relation of head-and-doorframe in visual space is a virtualization of it. Indeed, the visual space could well have been configured (that is, set up specifically *as* that space) by employing virtual models of it — models that function in arraying real objects in real space. For example, a three-dimensional rendering of the head-and-doorframe could be used by an architect to determine how large an actual doorframe in the distance must really be in order to be visible as the apparent tangent of a human head in the fore-ground.[2] Of course, this rendering would have to take account not only of the distance between head in the foreground and door in the background — deriving the height of the door. It would also have to take account of the distance between the beholder's eye-level at a certain height from the ground and the phenomenon in question, that is, the plane in his visual space at which head and door become visible as circle-and-tan-gent. In other words, when the virtualization "plans" the visual space (regardless of the representational conventions of the plan) it must simultaneously *envisage* it — imagine it. This recursion will become important in later chapters, when I explore the metrical computation of virtual pictorial space.

I have been describing the virtualization of visual space — the production of another visual space that represents it. The virtual space configured in the photograph represents the visual space of the head-and-doorframe as circle-and-tangent, at least when the photograph functions in its own proper visual space — the visual space of using it to show this phenomenon in visual space. But visual space might itself be described as "virtual" in relation to *real* space, whether we refer to the visual space of the head-and-doorframe as circle-and-tangent or to the visual space in which it is represented (and therefore virtualized), such as the photograph. Indeed, visual space *is* so described by

many writers, that is, as a virtuality. And because Cartesian three-dimensional coordinate space cannot be seen, it too might properly be described as "virtual," though not as a *visible* virtuality.

For my purposes, however, these terminological intersections — they describe virtualities nested in virtualities — can sometimes be confusing. With certain qualifications addressed in §5 below, I will reserve the term "virtual space" specifically for *pictorial* spaces — spaces within which the ambiguities of visual space, such as "actual" or real-spatial distances, can be explored and exploited (Figure 1.2). There is certainly more than one kind of pictorial space. But no one kind is *more* virtual than any other kind; in my terms, a virtual space is produced whenever human beings succeed to pictoriality in visual space. In particular, virtual pictorial space need not only be contained behind the "picture plane" of the fictive "window" that is configured by linear-perspective projection constructed according to the method recommended by Leon Battista Alberti (1404–72) in 1435 (Chapter Nine). The real space in which the beholder is actually located (obviously it is also partly a *visual* space for him) can be virtualized by the picture. As we will see in Part Three, some of the most influential recursions of imaging and picturing in world history do not cleave real space and virtual pictorial space from one another by introducing a picture-window into visual space. Rather, introducing the picture into visual space virtualizes real space, often well beyond the apparent material limits of the artifact (say a painting or a sculpture) that carries out this operation (see especially Chapter Eight). Real spaces, visual spaces, and virtual pictorial spaces, then, are in constant interactive interdigitation — constantly changing with the movement of standpoint.

So far I have defined visual space as the spatial order of visible things apprehended visually by a beholder at a given standpoint. Visual space *includes* pictorial spaces: pictures are only visible in visual space. But physical events in real space do not always continue into pictorial space even if the events are visible in visual space specifically as events that *do* so continue, or should; the picture, it turns out, cannot relay or replicate them. Its space, then, is virtual; in using the picture itself in visual space, there is a *real* spatial difference that can be discovered between the beholder's visual space (that is, the space that includes the standpoint from which the picture is visible) and the visible virtual space. These relations are contingent and historical: they vary with the virtualities and visualities in question. But analysis of visual space as standpoint is essential.

Here I invoke the geometry of the visual angle in real space. I use the term "natural visual perspective" (NVP) to denote the optical geometry of the entire visual field, the array of (the) world visible at a given place and time, regardless of any visual-spatial phenomenon constituted therein, such as the head-and-doorframe seen as circle-and-tangent in Wittgenstein's example. (As we will see in Chapter Two, the visual field

might be *pictorialized* recursively, that is, acquire aspects made visible in pictures and transferred from them; natural visual perspectives, then, can often be described as what Paul Feyerabend has called "natural projections."[3]) As a phenomenon in visual space, the head-and-doorframe seen as circle-and-tangent requires a certain angle of a beholder's vision in relation to real objects of certain real dimensions, all situated at certain real distances from one another — a geometrical optics in real space, or, alternately stated, the optics of the geometry of real space. In these terms, visual space is a natural visual perspective. And natural visual perspective gives us — affords us — visual space. A beholder might not see the space constituted by the head-and-doorframe as circle-and-tangent — see the head as touching the doorframe. But natural visual perspective is the condition of the possibility of this image.

Though I have used the terms of geometry and optics to describe it, natural visual perspective is the fully embodied seeing of a full-color and moving world of recognizable objects and states of affairs. In psychophysiological terms it depends on processing certain luminance gradients in reflected light. Still, one rarely can see things in visual space *as* pure luminance gradients, if ever; if one is so seeing the world, it must be in a natural visual perspective — a full-color moving world of objects — attained in processing photoreception. But for the purposes of understanding virtual (pictorial) spaces used in visual space, we need to analyze natural visual perspective — apprehension of a full-color moving world of recognizable objects and states of affairs — in geometrical-optical terms. I do this by stipulating that every natural visual perspective has an "imaging point" (IP) correlated with it, namely, the apex of the visual angle in the syntheses attained by binocular stereoscopic color vision in human beings. For my purposes, natural visual perspective subtends geometrically in all its richness and repleteness — its richness and repleteness of light, of color, of motion, of recognizable objects and states of affairs — from the imaging point. (For the moment I simplify; for one thing, neither full or "normal" color vision nor stereoscopy can be assumed physiologically [see Chapter Nine, §10].)

Recursively, then, I will call the complex of natural visual perspective and imaging point (NVP + IP) "natural vision"; natural vision is NVP at IP, or the visibility of things at standpoint. As I use this formulation, I will be agnostic about the contributions of "nature" and "culture" to the visibility of things. The term "natural vision" need only imply that NVP and IP are *inherently correlate*: any NVP must have an IP. It is obvious, however, that IP can be manipulated — that the physical location and social occupation of the standpoint can be constructed and controlled in a visual culture (even as a *material* culture, that is, as an "architecture") and thus as a "visuality." Perhaps it is less obvious that cultural practices of depiction might determine NVP, which is often treated analytically in vision science as *prior* to the depictions imagined within it and produced for it.

But the possibility of the succession of a visuality in vision — the constitution of NVP as visuality in the theoretical sense — is a fundamental recursion, albeit always partial and provisional. As in *GTVC*, I will attend to it throughout this book.

Precisely because I have defined NVP + IP as analytic of both visual space and standpoint, the term "standpoint" as I will use it does not simply denote the optical point at which visual space is organized (that is, NVP + IP). (The optical point can be treated analytically as a geometric point. Usually it *has* been so treated in geometrical optics from Arab science to Cartesian philosophy and beyond.) It also denotes the *place* — a geographical and topographical "spot" that is usually somewhere on the Earth — where the image-maker is situated corporeally as an observer, beholder, or "viewer." The imaging point cannot be disaggregated from the human body in its place — it cannot be *dis*embodied — even if the body at that spot can attain *many* natural visual perspectives. In the full sense, then, "standpoint" means "how NVP + IP is oriented — what particular visual space it affords — for a human beholder who is corporeally located and active in real space (usually on the Earth)."

Many writers use the term "standpoint" to denote the "point of view" of a beholder in the extended general sense (evidently metaphorical) of "outlook" or "worldview," whether or not this beholder must occupy a certain particular place or spot (and no other) in order to replicate this outlook or worldview as natural visual perspective, or in it. We will need to explore the relation between imaging point in the corporeal optical-geometrical sense and standpoint in this sociopsychological sense, sometimes called "perspectivism." As I have already intimated in the Introduction, the imaging point need not be the standpoint specifically of visuality (that is, visual culture) (see §3); one must *succeed to* that horizon of standpoint, and it operates recursively *at* standpoint. For this very reason, standpoint in my sense (the place of natural visual perspective at imaging point) and standpoint in the perspectivist's sense (outlook or worldview) need to be distinguished.

So much for a brief analytics of visual space. Before proceeding, I will make some comments about its scope and limits.

As noted in §3 of the Introduction, visual space is not the only kind of phenomenal space — of images, imaging, and image-making. A general account of human imaging would need not only to investigate auditory, tactile, olfactory, and gustatory spaces. It would also need to investigate spatialized corporeal experiences of temperature, humidity, altitude, gravity, and airflow, and possibly correlated motor-muscular, locomotional-positional, and autonomic-nervous spaces (sometimes called kinaesthetic spaces). The relevant academic specialists can explore how one might describe the standpoints, if any, of auditory and tactile spaces, that is, auditory and tactile images. But the concepts of natural visual perspective and imaging point belong specifically to

the analytical terminology of geometrical optics. And it would seem that, by definition, this terminology cannot be applied without extensive modification and supplementation to auditory spatiality (though there is a geometrical acoustics) and tactile spatiality (though there might be a geometrical haptics). Indeed, natural visual perspective and imaging point can be described *physiologically*, in the terminology of geometrical optics, simply in virtue of the structure of human photoreception by way of the lenses of the eyes. Whether or not other sensory spaces — images other than visual images — can be given physiological descriptions in terms of a geometrical-sensuous architecture (an issue I am not competent to address), *visual* spaces do have *both* a geometrical architecture that is sensuous (namely, photoreception by the eyes) *and* a sensuous architecture that is geometrical (namely, sensitive surfaces and lenses that structure photoreception) — a specifically geometrical-*optical* architecture in the case of visual spaces, the images of the kind addressed in this book.

These considerations do not entail, of course, that visual space is wholly independent of tactile, auditory, and other spaces. In particular, visual spaces and tactile spaces — the spaces constituted by pressures on the body and by its activities of touching, whether guided visually or not — are inextricably interdigitated and interdetermined. Indeed, certain kinds and features of pictures in visual space have conventionally been said to have "haptic" qualities and to display "tactile values."[4] And visual space can be complemented — even expanded, perhaps contradicted — by auditory spatialization, and oriented, reoriented, and disoriented thereby and therein.

Above all, then, visual space is not disembodied. To the contrary, because visual space depends on standpoint (it subtends from imaging point as natural visual perspective), it is one of the horizons of integrated imaging, of spatialization, on the part of a human body at standpoint, and including that body's tactile, auditory, and other sensations at that place and in that situation of embodiment. And it is always accompanied at standpoint — defined — by kinaesthetic awareness of fluxions, flexions, and movements of the body, involuntary and willed, including actions that might be undertaken to navigate one or more of the spaces of sensation.

There are many ways to deal with this complex phenomenology. Some address sensory spatializations and kinaesthetic awareness as they can be organized in particular media and by a particular technics (and possibly as an aesthetics), and given certain parameters of the body. But for my purposes in investigating how people have made *pictorial* spaces, there is one relation that cannot be sidestepped under the conditions of any medium and technics, namely, the relation between visual space on the one hand and bodily movement and especially bodily locomotion on the other. (Movements such as turning the head can occur at standpoint, which can therefore become the place of more than one visual space or, more exactly, the place of a continuum of visual

spaces in a rough arc of 180 degrees. But locomotion shifts the body from one place to another; as we move about the world, visual space is constantly being sidestepped as it were.) For bodily locomotion is the relocation of standpoint, and by definition relocation of standpoint entails the reconfiguration of visual space.

In my approach to the phenomenology of visual space, I have tried to be as straight-forward as possible. I will not attempt to relate my concepts of visual space, natural visual perspective, standpoint, and imaging point (Table 1.1) to the terms, proposals, and concepts advanced in formal phenomenological psychologies. Another and a different book would be required — one I am not equipped to write. But readers might notice resemblances between some of my terms and some of those of Edmund Husserl, which in turn deeply influenced Maurice Merleau-Ponty and other phenom-enological thinkers who are cited by art historians and image theorists more routinely than Husserl tends to be.

In setting out basic "naturalistic" considerations that provided the preliminary plat-form for his phenomenology — he said explicitly that they were *pre*-phenomenolog-ical — Husserl used the term *Standpunkt* to denote the physical location of the human body. At *Standpunkt*, the body apprehends (perspectivally) the aspects of things oriented spatially in such a way as to be visible to the body there. It apprehends what he called the "profile" (*Profil*) or "adumbration" (*Abschattung*) of the things. For Husserl, then, the body (the "ultimate central here") is the "zero point" (*Nullpunkt*) of this orientation and of all other orientations that it might take up, that it can "induce in virtue of its faculty of free mobility." In moving, I make a new "here" — a movement that "is funda-mental," as Elizabeth Behnke has written, "for the constitution of a shared spatial world as an intersubjective 'system of locations' into which individual, 'merely subjective' perspectives fit; though I myself am always 'here,' I can exchange standpoints with another person so that now I have the same thing-appearances the other formerly had."[5] (For the moment, I will reserve judgment about the extent and even the possi-bility of this "exchange" and "sameness.") As the apex of the visual angle in natural visual perspective, "imaging point" can be defined as the specifically visual and indeed geometrical-optical component of this "zero point."[6] According to Husserl, the posi-tion of the body at physical standpoint and the (visual) world that is given to it there is the natural situation of human spatiotemporal consciousness, aware more or less distinctly (or able to become aware more or less distinctly) of many things beyond and outside what is perceptually available at standpoint — a "constant halo around the field of actual perception." Husserl called this domain (zero point and its halo) the "natural standpoint" (as sometimes translated) or "natural attitude" (*natürliche Einstellung*). "I am conscious of a world endlessly spread out in space," he wrote, "endlessly becoming and having endlessly become in time. ... I can change my *Standpunkt* in space and time,

turn my regard in this or that direction, [and] forwards or backwards in time; I can always obtain new perceptions and presentations, more or less clear and more or less rich in content, or else more or less clear images [*Bilder*] in which I illustrate to myself, intuitionally, what is possible or likely within the fixed forms of a spatial and temporal world."[7] And in an elaboration:

> Each Ego has its own domain of perceptual things and necessarily perceives the things in a certain orientation. The things appear and do so from this or that side, and in the mode of appearing is included irrevocably a relation to a here and its basic directions. All spatial being necessarily appears in such a way that it appears either nearer or farther, above or below, right or left. This holds with regard to all points of the appearing corporeality, which then have their differences in relation to one another as regards this nearness, this above and below, etc., among which there are hereby peculiar qualities of appearance, stratified like dimensions. The Body then has, for its particular Ego, the unique distinction of bearing in itself the zero point of all these orientations. One of its spatial points, even if not an actually seen one, is always characterized in the mode of the ultimate central here: that is, a here which has no other here outside of itself, in relation to which it would be a "there."... In virtue of its faculty of free mobility, the subject can now induce the flow of the system of appearances and, along with that, the orientations. ...The same Body which serves me as means for all my perception obstructs me in the perception of it itself and is a remarkably imperfectly constituted thing.[8]

For Husserl, these elementary considerations—quite physical or literal and naturalistic or realistic—were merely the beginning, the first moves, of a psychology that then proceeds to take up a properly "phenomenological standpoint" or attitude.[9] He wrote:

> In the natural attitude we simply *effect* all the acts by virtue of which the world is there for us. We live naively in perceiving and experiencing. ... In the phenomenological attitude ... we *prevent the effecting* of all such cogitative positings. ... Instead of living *in* them, instead of effecting *them*, we effect acts of reflexion directed to them; and we seize upon them themselves as the *absolute* being which they are and with which everything which is meant or experienced in them and which, as so meant or experienced, is inseparable from their own being.[10]

In criticism of Husserl's phenomenology, Theodor W. Adorno argued that it must leave the world unchanged, even as it claims to know — to investigate — how world is given to and grasped by the human subject. Husserl, Adorno wrote,

> … may have borrowed the word [*Einstellung* or "attitude"] from the language of photography. … [The phenomenological attitude] claims to take possession of reality intact, by isolating its objects and fixing them with the Medusa's glance of a sudden "ray of vision" as if they were set up and exhibited in the studio before the photographic lens. Like the photographer of old, the phenomenologist wraps himself with the black veil of his [*epoché* — the "reduction" undertaken in phenomenological method], implores the objects to hold still and unchanging and ultimately realizes passively and without spontaneity of the knowing subject, family portraits of the sort of that mother "who glances lovingly at her little flock." Just as in photography the *camera obscura* and the recorded pictorial object belong together, so in phenomenology do the immanence of consciousness and naïve realism.[11]

Adorno's remarks strike me as somewhat unfair to Husserl: far from "imploring [the] objects to hold still," Husserlian phenomenology addressed the constitution of objects — of the visible world and its halos — in and as the mobility of standpoint, a model that would seem to be more choreographic, cinematic, and kinaesthetic than "photographic." But set this aside. My antidote to the supposed risk of "naïve realism" in phenomenology in general is a specifically *historical* phenomenology — an analytic reconstruction of the never-totalized successions *to* pictoriality (and recursions and resistances *in* them) as perceived at standpoints embedded in a historical form of life and in emergent "visual cultures" that are partly constituted *by* pictures. Moreover, all bets might be off concerning "naïve realism" when the "camera obscura" (visual perception) photographs a "recorded pictorial object" (things and states of affairs in visual space) which is itself a picture. Precisely because the picture is a picture, it must be partly discontinuous with the rest of visual space, and it cannot always be disambiguated — recognized and understood, despite uncertainty about what is depicted — in a naïve way, to which it is inherently resistant. (I consider these matters in Chapters Two, Three, and Five.) We really see the picture *and* we really see what it depicts — not so much naïve realism as a historically variable succession to a stratified virtual reality of which its agents or subjects are more or less fully aware insofar as they see the picture as such, and that inherently opens itself to visual doubt and alternative pictorializations.

Obviously the analytics of visual space is a much larger topic than a history of the ways in which depictions construct virtual spaces, introduced *into* visual space; that is, into the visual field within which the picture is visible to us. Often enough, our

visual space does not contain any pictures. As we will see, however, the possibility that it *might* contain pictures — indeed, that it might *be* a picture — is ever present. In the end, then, and as already noted, it might turn out that we need an analytics of depiction in order to understand the visual spaces constituted in most human communities. It could be, after all, that a given visual space is nothing other than the space of a picture, even if the visual space is much wider than the material extension of the pictorial arti-fact. The pictorial artifact introduced into visual space can pictorialize the *entire* space (see Chapter Two) in such a way that *everything* in the visual space subsists in meaningful relation to the depicted things: everything is part of the picture, *in* it.

In this regard, I compare a well-known (though obscure) claim of Husserl's:

> The spatial physical thing [*Raumding*] which we see is, with all its transcendence, still something perceived, given "in person" [*in seiner Leibhaftigkeit*] in the manner peculiar to consciousness. It is not the case that, in its stead, a picture [*Bild*] or a sign [*Zeichen*] is given. ... A picture-consciousness or a sign-consciousness [*bildlich-symbolischer oder signitiv-symbolischer Vorstellung*] must not be substituted for perception. Between *percep-tion*, on the one hand, and *depictive-symbolic* or *signitive-symbolic* objectivation, on the other hand, there is an unbridgeable essential difference.[12]

In the present project, on the one hand I deal with the perception of "spatial physical things" that are pictures, and, on the other hand, with a perception and consciousness of world that includes pictures of it, whether the picture is physically present as a "spatial physical thing" or not. Husserl's anti-representationalist point in the passage just quoted would be that the picture I see in the actual field of perception is not given to me perceptually as a second-order picture *of* it; it is given to me as the *Raumding* it is for me perceptually, a visual space extended for me by it. Nevertheless, in virtue of that very extension my visual space now includes aspects that it would not otherwise have. And such aspects can be perceived elsewhere in the world once the world has been extended virtually by pictures. Put another way, the space of the picture is not necessarily limited to the material extension and physical boundaries of the *Raumding* it is. This can be a perceptual succession in vision as such — how the world comes to look, and what it is like, when we make and understand pictures of it.

Indeed, Husserl argued that the perception of "depictured realities" — realities that are analogous to looking at what is depicted in an actual picture visible as such — is a "component in normally considering the perceptually presented depictured world," that is, an element of ordinary perception of visual space, though ontologically speaking "the depicturing picture-Object [*abbildene Bildobjekt*] is present to us *neither as existing nor as not existing* ... but as quasi-existing" — what he called a "neutrality modification"

[*Neutralitätsmodifikation*] of that "normal perception [which] posits [being and world] in unmodified certainty."[13] This is not the naïve realism of perceptual consciousness, matched by the supposedly naïve realism of the phenomenology that describes it. Rather we might call it a "self-neutralizing realism"—an openness to quasi-reality, that is, to virtuality and its world-making experiment, and a cognitive capacity to conduct transformations within it and to transfer them from it to world as a whole.

Husserl saw neutrality modifications in both the aesthetic and the scientific attitude toward the perceptual world. I suggest not only that the "modified" consciousness of world as picture-object partly derives from real pictorialities, but that aspects of the naïvely "real" (neutral) perceptual world derive from them also. The world becomes picture-like in specific ways that depend on the succession to particular pictorialities—seeing, envisioning, and imagining particular pictures. This is not a flight of philosophical fancy. It describes what many communities of image-makers have evidently sought to achieve—effectively *have* achieved—when they put pictures into view. Indeed, as soon as pictures become present in a human form of life—appear in visual space—they make it impossible to be completely certain where virtual pictorial spaces really begin and end, or even to recognize and care about any such hard-and-fast demarcation.

3. A BRIEF ANALYTICS OF IMAGING PICTURES IN VISUAL SPACE

As in *GTVC*, in this book I deal with what I call the "successions" of imaging and picturing and their historical "recursions." Whether these successions and recursions should be described as natural, social, or cultural processes (or as an admixture) is a wholly secondary question. For above all they are *historical* processes. Here I assume not only that natural successions and recursions in human life are largely *social* histories (see *GTVC* 335–37). I also assume that many social successions and recursions need not result in *culture*, even in the contexts of the immediately prehuman and the modern-human forms of life that have evolved in the past few hundred thousand years (see *GTVC* 326–35; below §4). I am well aware that these assumptions cut against received wisdom, both in the natural sciences and in cultural studies, notably their common wish to draw a line between the domain of nature (including society) and the domain of culture (including mind). But so be it.

There are several successions in question. They include: (1) the succession of "representationality" (virtual "thingliness" constituted in configuration [below, §5]); (2) the succession of "formality" (the awareness of configuratedness, of having-been-formed, as such) (*GTVC* 45–74); (3) the succession of style and what I have called "stylisticality," that is, seeming-to-be-in-a-style (*GTVC* 75–119); (4) the succession of visible

(if maybe unreadable) legibility and "readability" (*GTVC* 120–49); (5) the succession of diverse pictorialities, including the succession of pictorialities outside depictiveness (what I call "radical pictoriality" [see Chapter Two]) as well as the succession of depiction (*GTVC* 150–86); (6) the succession of the iconography of motifs and the recognizability of symbols (*GTVC* 187–230); and (7) the succession of mere visibility and "visuality," the analogical intelligibility of configuration in a partly invisible network of salient "forms of likeness"—a network that can be known as such ("this is how *I*/*we* see things"), though probably only in part (*GTVC* 322–40).

There might well be other successions besides the ones I have mentioned, and some possibilities are considered at some length in *GTVC*. All operate recursively: they feed recognitions and resolutions back into the options for reducing earlier ambiguities and/or creating more of them as the case might be. And they use *new* recognitions and resolutions to discriminate new ambiguities and options for reducing and/or increasing them as the case might be. Usually, then, they do not terminate in permanent totalizations. (To be sure, art-historical art theory and its offshoots in visual-culture studies have tended to assume such totalization—to reify it in doctrines of, for example, "significant form" in formalism [*GTVC* 51], "symbolic form" in iconology [*GTVC* 237–38], and of "visual culture" in the recursions of visuality in vision.) Finally, all interact. They are "interdetermined" in constituting discriminable aspects of an artifact as a visible whole. Or so I have claimed in *A General Theory of Visual Culture*.

In this book I could not claim to describe *all* feedbacks between imaging in general and picturing in particular. In natural vision, they are unlimited. Empirically there are as many feedbacks of visuality and virtuality as there are human agents of imaging and the pictures they make. In fact, I will assume that there are no *logical* limits to the recursions and the visible compounds that issue from them, such as pictures—though in fact there must be ecological, physiological, computational, and social constraints.

4. A BRIEF ANALYTICS OF VISUAL CULTURE IN WORLD HISTORY

The interminable feedback of imaging and picturing that I have described so far is not the *only* question to ask of the world history of visual culture, or for it to answer. (Certainly it is not the only question that world *art* history asks.) To date other questions have often taken priority (see Chapter Four). But it must be addressed *in* world history. In fact, it can *only* be addressed in world history. The reason for this can be set out as follows.

In the strictest sense, the very definition of a visual culture is that a visuality has been stabilized by someone, or alternately that a group of people have collectively stabilized a visuality. His or their vision has been fully acculturated, and indeed visible

things might have achieved "culturality"—the aspect of being visible *as* one's visual construction in his form of life (*GTVC* 322–40). Such visual acculturation can be characterized, in turn, as the wholesale recursion of pictoriality (and the other successions of our experience of artifacts made to be seen) in natural vision, in seeing the world as we naturally do, namely, as a coherent and intelligible order of visual space in which we recognize objects and the conditions and relations of things—an order that enables us to pursue the tasks and fulfill the purposes of our form of life in the vast network of analogies that we have built up in order to "visibilize" this very world. In the recursion of visuality, people see the visual world in terms of the forms of likeness that they have constituted to visibilize things in their form of life. But this image of the world—this world-picture—is not usually experienced in visuality *as* the picture that it in fact *is*. It is simply the imaging of world as such. It would be most exact to say that visuality is *post*-pictorial seeing: it is seeing after pictures and the other relevant successions (mentioned in §3) in the visibility of artifacts made to be used visually.

Still, our certainty in seeing is not exclusively *dependent* on visuality or visual culture. If a visual culture has been fully consolidated for someone or for a group of people, the recursions of picturing and imaging and of the other successions mentioned in §3 must have been completed (*GTVC* 187–230). A cycle must have fully turned, and a feedback loop finally and completely closed. As I have urged in *GTVC*, however, these successions and recursions are rarely completed, if ever. Pictures, especially, cannot always be assimilated wholesale into the visuality that produced them, or for which they are produced (*GTVC* 150–86). (To be sure, the dominant theory in art history for the past seventy years, what might be called "positive iconology," supposes that they *can* be assimilated, almost always. I believe that this doctrine goes too far [*GTVC* 230–76].) Pictures remain fully visible as ambiguous objects of natural vision. I will return to this dual or double visibility—this "bivisibility"—in Chapter Four. Indeed, in visual space we are almost always in transit—in the *cyclings* of the cycles or the *loopings* of the loops of historical successions in natural vision, especially when pictures and other artifacts that require the visual successions are present (*GTVC* 277–340).

Strictly speaking, then, there is no such thing in real life as a visual culture. A visual culture is an analytic construct—a device of art-historical and affiliated social and cultural theory. We use the construct to make analytical sense of observed continuities and discontinuities between different human experiences of visual spaces, and to analyze their variety and transformation. In visual space, human beings are almost always *building* culture, not simply living in it reflexively as a preexisting order of things. (In *GTVC* 277–321 I have tried to model this visual-culture-building as literally as possible.) In this book, I perforce continue to use the term "visual culture" to designate emergent cultures of natural vision—its successions to networks of forms

of likeness in visuality. But my emphasis will always be on the *emergence* of aspective interdeterminations in natural vision and especially of totalized networks of forms of likeness that govern how what is seen is visible.

It follows that historians of artifacts in visual space — of the immense variety of real cases — usually end up dealing with the territories *between* visual cultures in the analytical sense. (To apply the analogy of biological systematics, they deal with the constantly transmutating variety of life in a meadow, a jungle, or a wetland, not with the taxonomy of the stable lifeforms that ostensibly have fully "adapted" to each such ecology, and that can be said to characterize it. For there is no such thing as full adaptation to any ecology — only the historical process of adapting [or not] in this and that respect.) And this is the topography of world history as well, or it should be at any rate. It is only in that frame that historians can assess the ways in which agents of vision are always on their way *into* visualities and on their way *out of* visualities — unbounded mosaics and indefinite series of visual cultures, sometimes discrete, sometimes over-lapped, sometimes interconverted. At no point does any agent of vision come to rest at one pole — in the visual space of visibility *simpliciter* (as the "myth of the innocent eye" would have it) or in the visual space of visuality *tout court* (as in the myth of "cultural constructionism") (*GTVC* 230–33). The historical cycle never ends.[14]

5. A BRIEF ANALYTICS OF ABSTRACTION AND REPRESENTATIONALITY

Most of the man-made configurations addressed in this book are pictorial. But they cannot *only* be pictorial. They have visible features other than pictoriality, some of which may be essential to *imaging* their pictoriality. And some are not pictorial at all, though they might be classed with depictions to which they bear a form of likeness. Such nonpictorial configurations — "nonfigurative" marks and shapes, "abstract art," and others — have a role to play in the consideration of pictorial representation. In fact, pictoriality is partly built on nonpictorial aspects of the configuration, including formality and style (see *GTVC* 45–119).

Moreover, *nonpictorial* configurations can create virtual visual space. They need only possess what Richard Wollheim has called "representationality," namely, the visual property (the attribute in imaging) of being seen *as* something that extends the mere marked surface or the mere worked shape into a virtual state of affairs, a world of visible conditions and relations seen *in* the configuration — the world, for example, of the shapes and fields of color in the virtual space of *Lumen Naturale*, a 1963 painting by Hans Hofmann (Figure 1.3).[15] (In Chapter Two, I will consider the involutions of seeing-as and seeing-in with specific reference to pictorialization and pictoriality.) According to Wollheim, representationality typically involves the sensation that a two-dimensional

configuration, a drawing or painting, has spatiality and even *depth*—that in our visual space it has virtual voluminousness, virtual *three*-dimensionality, even if notionally it might be absolutely flat. (Of course, the artifact has actual physical volume and relief sensible to touch—real three-dimensionality, as in the impasto of painting. But the *virtual* volume could not be fully detected by touch.) Wollheim himself used "representationality" mostly to describe virtual (or "fictive") depth in ostensibly two-dimensional *pictorial* arrays, such as the paintings by John Constable and William Harnett illustrated in the Introduction (Figures 0.7, 0.9). But it can be extended to all imaging that virtualizes configuration, whether pictorial or not, such as *Lumen Naturale* (Figure 1.3). This configuration might be "pictorialized," but likely it does not become visible to most people *as* pictorial at first glance, especially within a historical form of life in which a dominant form of likeness of the painting is the practice of "abstract art." Nevertheless, representationality can readily shade into pictoriality—be pictorialized in the beholder's activity of using it visually.

Table 1.2 offers a general taxonomy of configuration in these terms. In the first and broadest register, the taxonomy juxtaposes representationality with an "avirtualism" that is not the same as "abstract" representationality in configuration. In the second and narrower register, it includes many ostensibly "abstract" configurations (Hofmann) and all "pictorial" configurations (Constable, Harnett) as types of representationality.

The first register in the taxonomy recognizes that configurations made to be used visually might not virtualize in the first place, whether "abstractly" or pictorially; they do not configure a visible world (especially a pictorial world) that optically extends our visual space into its virtual space even if we cannot move into it in real space. We might describe such wholly avirtual configurations as "absolute abstraction," the proper opposite of "representationality" understood (as in Table 1.2) to include "abstract" possibilities of spatial virtuality. Pure avirtual configuration simply *adds* an object of vision—what the sculptor Donald Judd might have called a "specific object" (Figure 1.4)—to the visual space that we inhabit and navigate, as it were contributing to the space and furniture of the world but not tending to *re*spatialize it.[16] As a three-dimensional thing, arguably Judd's *Untitled* (Figure 1.4) partly just "sits there." In two-dimensional configurations such as drawings and paintings, in principle an image-maker can construct what I will call the "threshold of pure planarity" in which no virtual space opens up visually—no representationality transpires. In an important sense, in fact, paintings and drawings are constructed out of bits—for example, lines and brushstrokes—that are avirtual in any and all optical resolutions at which pictoriality does not emerge, such as in extreme close-up. (As we will see in more detail in Chapter Seven, the ratio of "picture size" to "image distance" is the fundamental parameter of pictoriality.)

1.4. Donald Judd, Untitled (1967). Museum of Modern
Art, New York (682.1971).

TABLE 1.2. THE IMAGING OF CONFIGURATION: A TAXONOMY

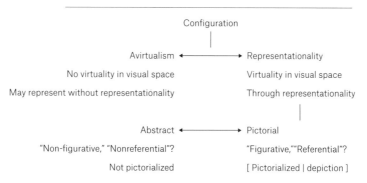

Configuration

Avirtualism ←——————→ Representationality

No virtuality in visual space Virtuality in visual space

May represent without representationality Through representationality

Abstract ←——————→ Pictorial

"Non-figurative," "Nonreferential"? "Figurative,""Referential"?

Not pictorialized [Pictorialized | depiction]

In general, however, avirtuality and representationality (encompassing both "abstract" and pictorial virtuality) should be treated as notional poles on a continuum of constant visual successions and feedbacks. A spatializing effect might be attributed to Judd's *Untitled* depending on the degree to which it has, say, the visual aspect of "hanging there"— even the representationality of "jutting out rigidly from the wall" or "soliciting us to place an object on its 'shelf'."[17]

Let us move to the second register of the taxonomy. As Table 1.2 indicates, and as mentioned, representationality in the extended sense inheres not only in pictorial configurations in the ordinary sense. It also inheres in configurations like the painted formations explored by Hans Hofmann (Figure 1.3) and in the sculptural constructions of David Rabinowitch (Figure 1.5).[18] In art criticism and art history, such configurations have conventionally been called "abstract."[19] But they are far from abstract in the terms of Wollheim's visual psychology, because they have visible representationality in visual space. They have *abstract representationality*, we might say, because the virtuality made present by the configuration lacks pictoriality— on first glance at any rate, or absent pictorializing activity. But in fact, Hofmann's paintings often give us the sense that certain shapes and color-fields have palpable three-dimensional extensions that seem to be "behind" and "beside" other shapes and color-fields suspended in the same virtual space. (Of course, if the "behindness" and "besideness" is imaged to be the behindness and besideness, say, of certain clouds in a certain sky, then the configuration has pictoriality in a sense to be explored in Chapter Two, whether or not it attains pictorial representationality— functions as a *depiction* of those clouds in that sky.)

What such abstract representationalities might *figure*, what their representationality virtualizes "abstractly," requires interpretation. (According to Wollheim, it requires specifically psychoanalytic interpretation.) Some of Rabinowitch's sculptural constructions, such as his 1965 *GravitationalVehicle for Kepler and Euclid* (Figure 1.5), might figure the order and structure of processes and relations in such external arenas as celestial mechanics, music, and architecture without *depicting* the material objects that are visible in those worlds (such as planets, musical instruments, and the façades of buildings) and perhaps without *referring* to them (if there is reference at all, it is primarily to celestial mechanics, not to planets, or only secondarily to planets). Still, figuration may work *through* reference, and vice versa. Rabinowitch's constructions might figure the order and structure of processes and relations that are not *unique* to celestial mechanics— celestial mechanics is not the theme or topic of the sculptures— partly by referring to some of its objects, such as planets, because they exemplify the orders and structures in question, such as orbits. At no moment, however, does the sculpture become a *picture* of celestial mechanics, of planets, or of orbits; its figurative and referential work remains nonpictorial, even though the sculpture constructs virtuality in

visual space. Stated positively, the sculpture can figure and even refer to many things without simply picturing any one of them precisely because it constructs a particular abstract representationality — a rich and replete field.

Abstract representationality converts along a continuum into *representational* representationality, that is, depiction. Here the same questions of figuration and reference and their interactions must arise. If someone paints a picture of planets, should the configuration be seen as referring to their orbits, as figuring the general processes and relations of celestial mechanics, as both, or as neither? We must look for configurative and other evidence to answer this question — to see in this case how the picture of planets virtualizes their orbits, or the nature of celestial mechanics, or both, or neither.

Many of my proposals in this book could be transferred readily to abstract representationality *qua* virtuality, though I deal principally with pictorial representationality — virtual pictorial space — already constituted, visible, and used as such. For example, my analysis of pictorial "bivirtuality" (Chapter Five) and a complementary analysis of "birotationality" in the objects imaged (Chapter Six) might be rewritten to cover bivirtuality in representationality *tout court,* whether it is abstract or pictorial. (The "bivirtuality" in question is the apparent part-continuity and part-discontinuity of *any* virtual space with a beholder's visual space, not the fact that the virtuality is either "abstract" or "pictorial" for him.) Moreover, we must succeed visually both to abstract representationality and to pictorial representationality; a virtuality in configuration seems to be more or less "abstract" or to be more or less depictive simply in virtue of the degree to which and the ways in which we pictorialize the configuration. And pictorialization is a succession within "radical pictoriality" — an activity that occurs in natural vision whether the visual affordance is typed in advance as either abstract (say, a work of "abstract art") or pictorial (say, a painted portrait). In the next chapter I turn to this succession.

Radical Pictoriality

Seeing-As, Seeing-As-*As*, Seeing-As-As-*As*...

1. RADICAL PICTORIALITY

As a function of the physics and psychophysics of the visual field, human imaging conforms to the laws of light and geometrical optics as the primate nervous system has adapted to them in hominid evolution. But imaging does not *only* conform to the laws of light, luminance, and the visual angle in the ecologies to which it is adapted and habituated. It works recursions in them: namely, and for my purposes, what I will call the recursions of "radical pictoriality" and "pictorialization," which need not involve the making of artifacts, and possibly the recursion of depiction, which does produce artifacts. Historians of material and visual cultures, especially historians of traditions of pictorial art, chiefly concern themselves with depiction, especially with its feedback into imaging—that is, with so-called visuality (*GTVC* 183–226). But depiction cannot be fully understood without considering the primary feedbacks of radical pictoriality and pictorialization.

In successions of radical pictoriality, the autonomic capacity of natural vision to virtualize what it sees, we *re*visibilize aspects of visible things in the very activity of seeing them. We remake them visually into something else (or sometimes *bigger* or *closer*), whether or not these activities succeed to depiction (Table 2.1).[1]

TABLE 2.1. BASIC MODEL OF RADICAL PICTORIALITY IN THE SUCCESSION OF IMAGING

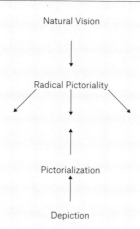

Consider the famous Müller-Lyer illusion, in which two parallel lines that are equal in length appear to be unequal (Figure 2.1): I see the equal lines *as* unequal. In the usual grapheme that relays the illusion, in fact, the *top* line AB appears to be quite a bit longer than the *bottom* line CD (a feature of the illusion which is not always spelled out

explicitly), though exactly *how much* longer or longer *in just what way* might be difficult to say, even if a difference in length seems plain.

I can try to *see* the illusion itself—the fact that the two unequal lines are really equal. That is, I can try to see what I see these features of the grapheme as—equal lines as unequal—*as* equal. I might do this geometrically by setting the figure into a grid that shows me that the lines have the same lengths (Figure 2.2), that is, by making a kind of picture of the optical stimulus, the grapheme itself. (This picture, of course, shows something I don't actually see in the grapheme—the equal length of the lines.) I might be able simply to visualize this configuration, that is, what I would get if I visualized the grapheme set in the requisite grid. But likely I will have to *draw* it in order to see it well enough to confirm that it shows the salient equality of the two lengths. In turn, the result could be rendered perspectively to turn a visual and graphic demonstration in ordinary plane geometry into one in natural geometrical optics (Figure 2.3), though once the visible metric identity of the grid-squares is lost in the perspective configuration, if indeed it is lost, the geometric proof of the "illusion" will *also* become invisible, as does the illusion when "in perspective."

Without drawing anything at all, however, I can also image the lines pictorially, giving pictoriality to them by virtualizing—by revisibilizing—what I see the lines as (namely, unequal in length) *as the lengths of something-or-other in particular*: AB as, say, the bottom keel of a short canoe seen from just below and CD as, say, the top of a huge skyscraper seen from high above. (Call this Figure 2.1': it cannot, of course, be readily *illustrated* in any printing of the grapheme, though possibly it could be pictured by me in a drawing of it.) Now it might seem to me that it is *CD* that is the longer line and *AB* that is the shorter. I have visibilized *a certain particular unequalness in* the grapheme seen as having unequal lines: its unequalness is the unequalness of certain particular lengths I have virtualized, namely, the short canoe and the huge skyscraper. This "radical pictoriality," as I will call it, is quite distinct imagistically from my imaging of the grapheme in the first-order reflexes of vision, for there the lines, though unequal, were quite *differently* so visually (that is, AB > CD). It is "radical" because it is bound neither to the real configuration of the lines, which are actually equal, nor to anything that they really depict, for the grapheme does not depict anything at all and I am completely free to see any number of *other* things in the lines. (I use the modifier "radical" in the term "radical pictoriality," then, with analogy to its sense in atomic chemistry, not in politics. Every electron in the outer shell in an atom [for example, oxygen] in the ground state is paired with an electron spinning oppositely. In a free radical, however, the atom has at least one *unpaired* electron in the outer shell, and can have independent existence [for example, hydrogen peroxide].)

2.1. Grapheme of the Müller-Lyer Illusion.

2.2. The grapheme of the Müller-Lyer Illusion set in a grid.

2.3. The grapheme of the Müller-Lyer Illusion in perspective.

Of course, I have not disambiguated the metric fact that AB and CD are equal from the visual sensation that they are unequal. But I *have* reduced and reversed the illusion, or more exactly what I first saw the grapheme as. (*Ex hypotheosi* I did not initially see the illusion *per se*—see the grapheme as the illusion it is.) For in the Müller-Lyer illusion as I reflexively see it, it is CD that seems shorter than AB—not AB shorter than CD, as in my radical-pictorial *re*imaging. Or at least I have reduced and reversed *an* illusion, namely, the grapheme seen as just the relation between the lines that is staged visually in the Müller-Lyer illusion specifically, an event of "seeing-as" that has the deleterious property of being quite wrong metrically.

TABLE 2.2. RADICAL PICTORIALITY IN THE MÜLLER-LYER ILLUSION AND ITS VARIANTS

Grapheme

Natural Vision | ←——— Radical Pictoriality

(A){M-L illusions [AB > CD]} | (B){non-M-L illusions [AB < CD]} | (C){no illusion[AB=CD]}

| Figure 2.1 | ? | ? | Figure 2.1' | ? | ? | Figure 2.2 | ? |

It would seem, then, that I can image *two* readily differentiated kinds of illusion (radical-pictorial imagistic virtualizations) in the grapheme: one array in which AB is longer (the Müller-Lyer illusion as it is usually described) and one array in which it is shorter (my radical pictorialization) (Table 2.2). Put another way, I can see the stimulus in only one reflexive way, that is, the way in which the illusion, unseen as such, overrides the metric "reality"; nevertheless, it has at least *two* radical-pictorial horizons. More exactly, it has two indefinitely large *sets* of the radical pictoriality of the unequal lengths of the two lines (assume, again, that I do not *see* them to be equal), namely, set (A){ AB > CD } (the illusion usually described) and set (B){ AB < CD } (the illusion as I can revisibilize it in radical-pictorial imaging). Moreover, if I can visibilize a proof of their equality (for example, Figure 2.2), arguably I can go on to populate a set (C) { AB = CD } with radical pictoriality recursively derived from measuring and diagramming the stimulus, exposing the illusion.

Of course, my underlying visual ability to discriminate any one line as visibly shorter (or longer) than any other must have neurophysiological limits, usually called limits of visual "acuity."[2] Still, my acuity does not limit my active visual dealings with the configuration *as it is visible to me* with whatever degree of acuity I have in this situation of seeing. Certainly it is sufficiently sharp and resolved for me to virtualize *many* different lengths in lines of the size and width of Figure 2.1 as printed on page 53 of this book. But we must remain open to the possibility — whether natural or cultural or both — that some people could visually differentiate *more* (or less) *finely unequal* line-lengths than I can, and therefore that (1) they could visibilize aspects of the lines, and kinds of radical pictoriality in the lines, that must be *invisible* to me and that (2) that they could coordinate and communicate these aspects in depiction of *their* Müller-Lyer grapheme(s). By the same token, their practices in depiction recursively might enable them to see more (or less) finely unequal line-lengths than I can. As Ludwig Wittgenstein wrote, "There could be people who recognize a polygon with ninety-seven angles at first glance, and without counting."[3] This possibility underwrites strong historicist claims in art history and visual-cultural studies. But it could also be fully compatible with "naturalist" claims for variations in vision — for its speciation (see *GTVC* 11–41, 187–92).

For the moment, what counts analytically is that the two sets of differently visible unequal lines, (A) and (B), remain empty until I actively populate them with radical-pictorial members — revisibilizations of *particular* inequalities in the lengths of the lines to which I succeed visually by virtualizing them as the lengths of something-or-other I can see them as, a visual succession from the first-order reflex in which I *already* see the grapheme as some one member in (A){ AB > CD }. Regardless of neurophysiological and psychophysical limits on visual acuity in imaging the lines as visibly longer or shorter, there would seem to be *no salient limits on radical pictoriality in imaging a line, whatever its visible length, as having the length of something-or-other in particular.* For the fact that in (B){ AB < CD } I can image AB as the keel of a canoe and image CD as the top of a skyscraper, revisibilizing (A){ AB > CD } in a newly particular virtualization, does not prevent me in (B) from *reimaging AB and CD as things *other than* a canoe and a skyscraper *while still virtualizing CD as longer than AB in just that particular relative length* (that is, the relative length virtualized in [B]{ AB-canoe < CD-skyscraper }), and regardless of my ability to measure the proportion (as in [C]).[4]

Radical pictoriality is not limited by acuity at all (though what can be seen at all is a condition of radical-pictorial revisibilization). It is limited only by visual "imagination" — the *autonomization* of reflexive imaging, as I would like to put it, in active self-virtualizing recursions of human vision. When sheep are slung in hammocks with their heads and eyes fixed in such a way that projected slides of faces will be reflected directly into their retinas, the sheep will "recognize" the faces. According to Arthur

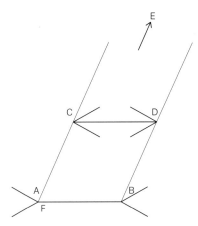

2.4. Grapheme of the Müller-Lyer Illusion in parallel tracks.

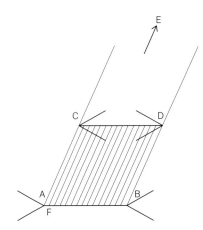

2.5. Grapheme of the Müller-Lyer Illusion in parallel
tracks—geometric demonstration.

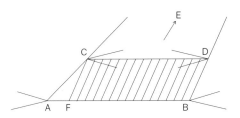

2.6. Grapheme of the Müller-Lyer Illusion used to
depict a tabletop.

Danto, this shows that they can see and interpret *pictures*, for the slides are depictions (for us). I do not think the experiment shows any such thing. The slides probably have no pictoriality in the optical situation that is set up in the experiment, even if the experiment shows that sheep do recognize faces when they see them. But if *we* were slung in hammocks and our vision was fixed in this way (as in the grueling scenes of visual "conditioning" and "deconditioning" in Stanley Kubrick's 1971 film *A Clockwork Orange*), we could radically pictorialize the stimulus. In this sense our seeing is potentially autonomizing in the (re)reflexive visual activity itself—the activity of seeing.[5]

Thus there are as many members of (B){ AB < CD } for me as there can be radical-pictorial images of the relation between AB and CD virtualized by me and (re)visible to me in the configuration relative to my first-order reflex in spontaneously seeing the configuration as some *one* member in the set (A){ AB > CD }. In sum, though the illusion of inequality is an insuperable fact of the reflexive visibility of the configuration to me, it is a malleable matrix for my *imagination* of it. This is especially true if radical pictoriality eventually succeeds to depiction as such.

For example, recalling Figure 2.3, picture AB and CD as same-size transversal ties on receding railroad tracks apparently converging perspectively at E, a far point on the right side of a virtual horizon line in the distance (Figure 2.4). The tracks could not really converge. (I might picture this fact of optics and plane geometry as such [Figure 2.5], as I did in picturing the fact of the equality of the length of the lines [Figure 2.2].) But in imaging it can seem that they do, *precisely because the ties seem unequal*. Under the perspective pictorialization, if I can succeed in visibilizing the grapheme in this way, I see the unequal lines *as* equal—equal in transversal length in their unequalness in the spatial recession that I have virtualized.

Again, picture the lines CA and DB as two of the four edges (with AB and CD) of a rectangular tabletop (albeit a very rickety one) that we want to set up (Figure 2.6). While quadrilateral, this tabletop cannot really be rectangular, yet another fact that I could picture (for example, in the proof visible in the triangle CAF in Figure 2.6). But when I admit the radical pictoriality of this "tabletopness" in the imaging of ABCD, it can seem that way. For in this pictorialization AB and CD can be seen as the-same-in-length *as* sides-of-the-rectangle in which CA and DB *are* visibly the same length.

In turn, I might *depict* this tricky tabletopness (or at any rate a painter like Paul Cézanne might do so [Figure 2.7]), preserving and even heightening my visual sense of having ambiguous and interacting compound views of the table in rectangular plan, in quasi-isometric diagrams of its sidedness, *and* in a perspectival recession. Here I might graphically set out certain pictorialities *both* of the illusion of linear inequality (partly as it can be "perspectival") (Figure 2.3) *and* of the plane (Euclidean) geometry of rectangular areas (including the way *they* can be perspectival) (Figures 2.5, 2.6), so long

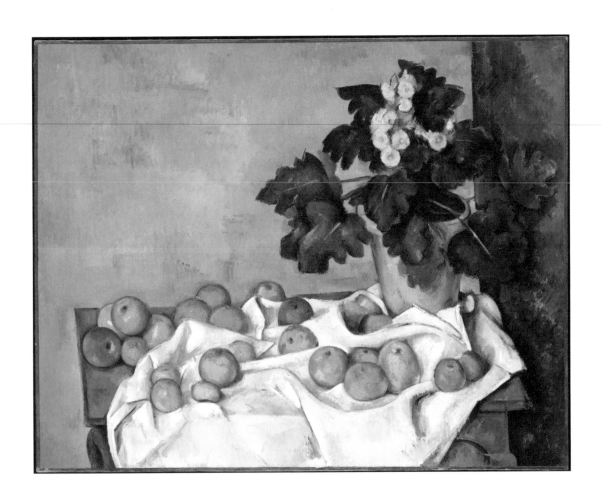

as I *image the picture itself* under a visual angle that deviates no more than about forty degrees from an axis perpendicular to the surface. (Many basic software programs for digital-image processing allow simulations of this rotation. At too great an oblique angle of viewing the rectangular picture, CAF will not be seen as lying "in" the table, as what has been pictured about it; it may be seen instead as a mere effect or by-product of the beholder's obliquity. It becomes a radical pictoriality of *imaging the picture* as distinct from a radical pictoriality in the imaging recoordinated as the depiction to be seen.) For radical pictoriality, of course, is a visual parameter of depiction in both the imaging that succeeds to depiction (Table 2.1) *and* the imaging that investigates it (see Table 2.5).

TABLE 2.3. BASIC MODEL OF RECURSIONS OF "SEEING-AS" IN RADICAL PICTORIALITY

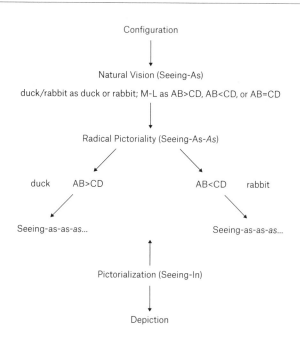

2. SEEING-AS, SEEING-IN, AND "SEEING-AS-*AS*"

As my use of the language of Wittgenstein's aspect psychology might have suggested, radical pictoriality is not so much a visual affordance of things (the apparent unequalness of AB and CD in the interaction between the stimulus and our perceptual habits) as it is a visible *aspect* of things (the particular longness or shortness of AB relative to CD).

It certainly enrolls an awareness that we are seeing something *as* something—a line as shorter *because* it has canoe-likeness (or whatever) for us. But this should be distinguished, as Table 2.3 suggests, from first-order "seeing-as" understood to be the default reflexive condition of vision: simply seeing the rabbit *or* the duck, for example, when presented visually with the "duck/rabbit grapheme" popularized by Joseph Jastrow (figure 2.8) and cited in turn in Wittgenstein's *Philosophical Investigations*; seeing short AB *or* long AB; and so on.[6] For *everything* must be seen as something in particular, even if the "something" is not a recognizable object or state of affairs; all affordances are apprehended as arrays with certain aspects, often readily recognizable, and most usually as a visible world of recognizable objects and states of affairs. (Certainly they are not *seen* as what they must be optically at retinal photoreception: a luminance gradient. Or if they *are* so seen sometimes, it is in a radical pictoriality of the visible—not in first-order seeing.) Having seen rabbit, on another occasion I might see duck. But the point of identifying radical pictoriality as a succession and recursion in first-order seeing-as (Table 2.3) is that on the very occasion of seeing the rabbit (or duck) I can visually work to see a *duck* (or rabbit)—an effort in which I might succeed or might fail, presuming that I undertake it in the very first place.

Indeed, the oscillation of the two seemingly stable pictures embedded in the duck-rabbit grapheme (often described as a reflexive "Gestalt switch" between rabbit and duck, or as "bistable") is really incidental to this point. It is just one of many possible active outcomes of radical pictoriality in imaging the configuration. In fact, it is an outcome that has been carefully staged graphically in the grapheme, which tricks the eye in the manner of a true optical illusion (though it is not). Its configured dual depictiveness (depicted duck and depicted rabbit have been pictorially managed, as

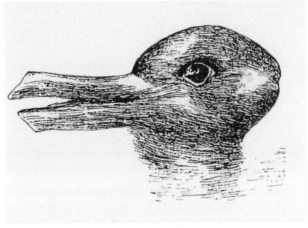

2.8. The Duck-Rabbit Grapheme. (From Joseph Jastrow,
Fact and Fable in Psychology [London, 1901], 295.)

bistable, to be coextensive and thus "switchable") recursively affects one horizon of radical pictoriality (duck can be *re*visibilized as rabbit, or vice versa, partly in virtue of the dual depictiveness of the grapheme as configured).

But we should not mistake this effect of depiction with radical pictoriality *tout court*. In inspecting the grapheme, and regardless of what I immediately see it *as* and what I might know it to be *qua* depiction (however unitary, dual, or multiple), I could just as well work visually to see a *white* duck as a black one — what I happen to see the duck I see in the grapheme to be. Or I could work visually to see a duck with a rabbity eye, or a rabbit with a feathery neck, whether or not whiteness, a rabbity eye, or a feathery neck are *depicted*, that is, whether or not the duck or the rabbit I see the configuration as being is depicted to be white. (Indeed, I radically pictorialize these things precisely *because* the configuration can be taken — can be seen as — depictively ambiguous about whether the duck is white or black, or both, or neither.) Moreover, and equally important, I could work to see neither any duck (white or black) nor any rabbit (black or white) in the duck-rabbit grapheme. Instead I could work to see a head of garlic or a sprouting onion, to name radical-pictorial virtualities that the grapheme can have for me (on occasion and with some effort) despite my fair certainty — given its sociocultural history and visuality as known to me — that it does not depict these things at all, and evidently did not for Jastrow, Wittgenstein, and other commentators.

In the usual account of the phenomenology of the duck/rabbit grapheme, I do not see the rabbit in the duck, but the duck/rabbit grapheme *as* rabbit or duck. That is, I see rabbit (one depicted object) or duck (another depicted object) in the duck/rabbit configuration. (As noted, however, I might see whiteness in the duck [it is seen-in *as* a white duck, despite the many black areas of the configuration] or, indeed, the rabbit-ness in its eye.) In a widely read analysis, Richard Wollheim called this involution by the name "seeing-in." In virtue of what he took to be the "twofoldness" of pictorial representation (and perhaps overly impressed by the dually depictive configuration of the duck/rabbit grapheme), seeing-in was specifically localized by Wollheim in *our imaging of depictions*. ("Twofoldness" refers to the joint if sometimes oscillating visibility of graphic configuration on the one hand [in this case, the duck/rabbit grapheme as a dually depictive configuration] and the virtual objects depicted on the other hand [in this case, duck or rabbit].) To be sure, the duck/rabbit grapheme is probably not a good example of twofoldness in Wollheim's sense. Precisely because of its dual *depictiveness*, we might tend to see it *only* as duck or rabbit; that is, duck or rabbit is seen in the configuration, which has little or no visibility *other than* in the two pictures it stage-manages graphically. When it is not duck it is rabbit, and vice versa. Or if it does, these unclassified visibilities have rarely been remarked in commentary, though the pictorialist had to consider them.[7]

If I see a rabbit *in* the grapheme, I can also work to see it *as*, for example, a white rabbit in the shade *or* a black rabbit with a white spot on its nose (short AB *or* long AB) (Table 2.3): the configuration can be differently (re)visibilized depending on the radical pictoriality the object seen-in the configuration (what I see the duck-rabbit grapheme as) has for me. In the white rabbit, the spot on the nose is a patch of fur. But in the black rabbit, it is a splash of light — radical pictoriality that I can transfer to the duck(s) I can revisibilize as well. Is the white spot a splash of light falling on dark feathers beside the duck's eye, or feathers of the light-colored duck visible just beyond the shadow falling on it? I can work to see the grapheme seen-as a duck in either way, working to see the dark- or light-colored ducks in it. With Wollheim, I can properly say that I see a (depicted) light-splashed black rabbit in the grapheme when I see it as a rabbit. But the point here is that I could work to see it as a (depicted) white-spotted rabbit too. If successful, I would now see white-spottedness in the black rabbit where I had seen it as light-splashed. Seeing-in constitutes a particular "pictorialization" in the configuration — the white-spotting in the configuration that I see as a rabbit (or duck) pictorializes the color of fur (or feathers) *or* the brightness of light (in relation to patches of shade). But this pictorialization is secured, temporarily stabilized, in the face of the radical pictoriality *of* the configuration when seen-as that pictorialization. For I could see the pictorialization as other things too.

As previous paragraphs might have suggested, then, radical pictoriality in my sense could be defined as "seeing-as-*as*." However something is seen-as (for *everything*, as noted, must be seen as something), I can see it *as* something with new aspects — aspects perhaps sufficient to constitute a *different* thing for me to recognize. (Of course, I need not do so, for in seeing-as I *already* see something in particular, albeit not in the particular way I might revisibilize it.) And I can see *that* something as something, and so on, in relays of seeing-as-as-*as*, seeing-as-as-as-*as*, etc. However clumsy, these locutions enable us to notice the specifically recursive involution of radical pictoriality in imaging *whether or not we are imaging pictures and whether or not depiction recursively affects it*. When I see the line AB as shorter than CD, I am seeing AB as, say, canoe-like; if I did *not* see AB as canoe-like (seeing-as-*as*), then perhaps AB would be seen as *longer* than CD.

Seeing-as-*as* does not depend on "twofoldness" in Wollheim's sense, even if seeing-in may devolve from our conjoint ("twofold") visual awareness of the drawn or painted mark (such as a "long" or "short" line) and the object it depicts (such as the keel of a canoe). For seeing canoe-likeness in AB-seen-as-shorter-than-CD does not mean AB *depicts* a canoe, though sometimes AB could do so. It means that AB can have certain respects of canoe-likeness for me, whether or not I render the keel of a certain canoe in the line AB when I draw it and, if I *do* render this canoe, whether or not I depict these

very aspects of it. Radical pictoriality *precedes* depiction, even though there may be recursions in which depiction might contribute it to natural vision, when, for example, I see a real tabletop *as* as-if-painted-by-Cézanne, a radical pictoriality of that real-life as-if-"still-life" for me.[8]

In sum, radical pictoriality reconstitutes objects that are already visible, revisibilizing them in particular visual virtualizations. As Wittgenstein might have said, it puts them in a new light by actively assigning new visual aspects to them, not only allowing them but visually *enabling* them to dawn on us.[9] This work does not supersede seeing-as, or differ from it in kind. It is simply its continued active ramification, including its emergence into our awareness of it — a recursive autonomization (as I have put it) of imaging that might be called "aesthetic" (and certainly is "imaginative"), though it is not restricted to the efforts we make in seeing artworks. Stated another way, though radical pictoriality is a reflexive adaptation of vision, it is not the first-order reflex of reflected light stimulating the receptors of the visual cortex and usually issuing in the visual recognition of objects (seeing-as). Rather it is a reflex that can arise as a response to it, as it were *re*reflexive — the self-recursion of our recognition of objects. For in recognizing objects, we sometimes need to *re-cognize* them by revisibilizing them.

3. DEPICTION AND THE IMAGING OF PICTURES

I can readily see a smudge in the sky as a cloud, or even as having certain aspects of a camel: I see the smudge as a cloud-camel. And in radical pictoriality, I can try to see the cloud as a camel (*not* just a cloud) or, as might be, I can see the cloud-camel that I see the smudge in the sky to be as dark (not light) or very large and far away (not smaller and closer) (as-*as*). As the visual activity of virtualizing seeing-as, radical pictoriality can be said to "pictorialize" things: we visually *make* things have virtual aspects for us in visual space. Of course, the smudge / cloud itself is constantly changing in visual space, whether because of its own inherent mutability or because of mine, or both together. (In Chapter Nine, I consider a fifteenth-century Italian pictorialist, Filippo Brunelleschi, who imported this real-time phenomenon into a picture.) Indeed, I could cease to see it as a cloud; perhaps the smudge in the sky is a smear on my sunglasses, which is not what I had initially seen it as. And even having virtualized a cloud-camel (as-*as*), I could virtualize other things too — revisibilizing the smudge, whether cloud or smear, as something *other* than a camel (as-as-*as*). What, then, if I take a visual interest in the virtuality that I have visibilized, specifically looking out for it?

What I have been calling "pictorialization" (Table 2.2) is the succession of radical pictoriality in *its* revisibilization — its *re*virtualization (see *GTVC* 150–55). Having once seen a particular camel in a cloud (I have virtualized the cloud in that particular

radical-pictorial way), I can try to see it in the clouds, which are never quite the same, wherever and whenever I glance up at the sky. I can try visually to make *any* cloud have cloud-camelness — the very cloud-camelness, in fact, that I have seen. And I can try to see the short-canoe-like AB (one radical-pictorial member of the set [B]{ AB < CD }) in the Müller-Lyer illusion every time I encounter it, despite differences in the way the grapheme might be drawn, its size, its color, and so on. And I can try to see the white-spotted rabbit-in-the-shade in the duck/rabbit grapheme (it might be easy to see in Jastrow's variant of the grapheme [Figure 2.8] but less easy visually to revirtualize in less detailed versions). And so on.

If radical pictoriality (seeing-as-*as*) is *re*reflexive with respect to the first-order reflex of seeing-as, pictorialization might be described as *trans*reflexive ("seeing-as-as-*in*") and therefore as its increasing autonomization and hence its increasing intentionalization: it involves active selection *of* radical pictoriality, even a selection *among* radical pictorialities. A cloud-camel with particular aspects becomes my autonomous visual object, even as I am aware (aware precisely in virtue of the radical pictoriality I have constituted) that the cloud is not really a camel and that the camel could be other than it is. I have pictorialized a cloud-camel as something to be seen in the world, even if the world contains no such thing outside the radical-pictorial recursion. It might seem that I can simply imagine the cloud-camel — *image* it in the sky as the smudge I see there. But an imag(in)ed cloud-camel is not a *depiction* of a cloud-camel unless or until I have imaged the cloud specifically to see the particular camel I can virtualize it to be — visually to use the imag(in)ed cloud as that camel. In turn, pictorialization becomes depictive — it precipitates a depiction (Table 2.3) — when I visibilize something specifically in order for a particular virtuality to be seen in it: when I image the *cloud* just to see the cloud-camel that I can make it become, despite its other visibilities and possible virtualities. For I can certainly use the cloud-camel that I can visibilize in the cloud as a way specifically to see a camel — perhaps, in fact, the *only* way to see just it.

Depiction becomes a picture in the received art-historical sense, a physical artifact that relays a virtual space displayed to beholders, when I replicate these successions not only visually but materially. Probably I cannot actually make a cloud. But I *can* make a cloud-camel in any number of ways. Indeed, as soon as I draw a single visible mark on a surface (Figure 0.1), I have done everything that is materially necessary for the entire succession-recursion of depiction to occur. A complete model of the succession shows that usually my manipulations of materials and media — especially of marks — have *stimulated* the autonomization of imaging described in this chapter (Table 2.4). The entire succession is triggered by making marks that pictorialize in our imaging of them — that have radical pictoriality which we can recursively see the marks as rendering, or can visibilize them to render. And all marks can do so to

the extent that *they* are autonomous affordances in the visual environment. We spontaneously transmute their "standing out" into "standing for."

TABLE 2.4. COMPLETE MODEL OF SUCCESSIONS OF PICTORIALITY IN IMAGING

Pictorial Marks

↑

Natural Vision

↓

Radical Pictoriality

↙ ↓ ↘

↑

Pictorialization

↓

Depiction

↓

Mere Picture

Still, even an artifact made as pictorial need not actually *depict*—be depictive. To depict is to coordinate a particular autonomized pictoriality in someone's imaging of things—one's own or others'—and to do so *for* that imaging in the sense already considered, that is, for its own sake in virtualizing something. In making material marks and working material shapes, one can set out to do this deliberately. One does it by creating, resolving, selecting, sorting, and replicating radical pictoriality in a succession that leads to its visible virtualization: we see it as the virtuality that the configuration has been produced to support, and we use it in just that way. And one can often be successful in this. But many pictures *fail* to pictorialize, to render anything to beholders, especially those beholders who do not succeed to the picture's visuality, its particular historical network of forms of likeness—the intended visual culture of the picture in the field of "bivisibility" (Chapter Four).

What I call a "mere picture," then, is a depictively marked artifact awaiting someone's imaging of its pictoriality, a process that includes the investigation and resolution of radical pictoriality, *not* depictive, that the configuration—the affordance—might be imaged to have. This imaging might well attain the depiction the artifact was

intended to have. Or it might not. To adapt a term from Simon Blackburn's philosophy of language, a mere picture can be "wooden": morphologically it is a picture (and has no other causal explanation of its existence), but it has no pictoriality, at least for a particular beholder encountering it at a given time and place.[10] An unknown quotient of depiction in human history (likely a vast quotient) probably is partly or even wholly wooden for some or many beholders, including the makers of the pictures in question. Therefore many pictures ("mere pictures" in the sense adumbrated here) do not fully belong to visual culture (compare Chapter One, §3); they cannot be fully seen by people who image them to have the visible virtualities that have been deliberately made *to be* seen by them. In this sense, the field of "bivisibility" includes not only different virtualities ascribed to the same picture by different visualities — as it were the duck/rabbit case — but also the possibility of mere picture, that is, the possibility that one or the other or both configured virtualities have *no* visibility in *any* visuality. Drawing on an influential art-historical analysis by T. J. Clark, in *GTVC* (216–29, 324–26) I used the example of Édouard Manet's *Olympia* (painted in 1863). When it was exhibited in the Paris Salon of 1865, many critics evidently failed to recognize seemingly obvious — visually self-evident — stylistic and iconographic successions in Manet's construction of the pictoriality, such as his reference to Titian's earlier *Venus of Urbino* displayed in the Louvre nearby. Of course, in this example the painting *Olympia* had *some* depictive aspects for the critics, though not all the aspects probably configured by Manet to be recognized and used by his beholders.

Of course, the virtual visibles also need to be *really* visible. So far I have described the precipitation of depiction in the "pictorializing" successions of the radical pictoriality of natural vision. But if a picture is indeed created, it can become a material affordance *to* seeing — and it must be imaged. Obviously, then, and as I have already noted in passing several times, we must consider the *imaging of pictures*. As already suggested, the radical pictoriality of mere pictures must be pictorialized in such a way as to relay the coordinated depiction, for the picture was *made* as a coordination of a *certain* pictorialization that could be seen in it and that ideally it should be seen-as-*as*. Detailed exposition of this process is unnecessary. As Table 2.5 indicates, it can be modeled as symmetrically inverse to the process of pictorialization modeled in Tables 2.2 and 2.4 (though it is, of course, a recursion *within* it). Natural vision images mere pictures — even marks and shapes — in such a way as to pictorialize them despite nondepictive radical pictorialities that we can make in response to them. For we can see marks and mere pictures as many things (and see-in and see-as-*as* with respect to them) without at all seeing the things (or without seeing *all* the things) they depict. Ideally, then, Tables 2.4 and 2.5 are fully transitive mutual recursions. But *empirically* they might not be. In fact, usually they *are* not, even if the slippage and disparity is not salient in many social uses

of depiction, which are often coordinated in advance to take account of disjunctions in real standpoints of imaging them. Much of the historical phenomenology of pictures considered in the remainder of this book flows from this elementary consideration.

TABLE 2.5. COMPLETE MODEL OF THE SUCCESSION OF IMAGING PICTURES

Depiction

↑

Pictorialization

↓

Radical Pictoriality

↑

Natural Vision

↓

Mere Picture

So far I have suggested that a picture is *the visible intentionalization of radical pictoriality* in the succession of pictoriality. If this is correct, then one must be able to recognize that relay — literally *see* it — to "get" the picture, visually to pick it up or pick it out. But if the picture — the *mere* picture — is our only evidence, how do we do this?

Radical pictoriality becomes an aspect of visible things, and depiction is an aspect of an artifact — a mere picture. But they are not the *only* aspects of those things. The cloud seen as a camel has cloud-aspects too, and so does the cloud-camel. And a *painted* camel has paint aspects, even if some of them have been replicated to relay a certain pictoriality — the camel-aspects — to be imaged in them. The visible history and our imaging of these *other* aspects (aspects with which pictoriality is "interdetermined" [*GTVC* 9–10, 36–42]) give us a lot to go on in recognizing the pictorializations that organized the successions in question. To apprehend the form and style of the artifact, to see *them*, is in part visually to abduct how it was brought into being and what can be inferred from that visible history about what is (and is not) depictive in the mere picture, namely, that a particular imaginable aspect or set of aspects of the marks was produced in order to preserve this very configuration *as* pictoriality (formalized and stylized as such). Stated

most generally, we can use the formality and stylisticality of the marks to see their pictoriality, and vice versa, in successions of nested interdeterminations.

Overall, then, the question of discerning a picture-maker's intentions can be shifted from the place in which it has commonly been asked—the supposed problem of *discerning what the maker's picture means.* It can be refocused on what actually decides that issue, namely, the problem of *discerning what marks the maker effectively intended to preserve* and for what reasons and purposes. To preserve a pictoriality of a mark is to intentionalize toward depiction. And this directedness can be visible to a beholder—ordinarily it *is* visible—in virtue of the handling of the entire interdetermined array of aspects of the artifact, not limited to its pictoriality, and especially when the mark must be translated or transferred to another context and sometimes remediated. Of course, this will not eliminate all pictorial ambiguity and all questions about the pictorialist's intentions in marking. But it is enough to ensure, usually, that we are on fairly firm ground. Generally there can be no other cause of the depiction than *its* pictoriality. Most radical pictoriality that I could virtualize in it in imaging it will in the end be visibly inconsistent with the evidence of its making, conservation, history, and use. This is not an opaque or private matter of something going on in the cortical recesses of the visual brain—a black box. It is an eminently manifest and public matter.

What the Chauvet Master Saw

On the Presence of Prehistoric Pictoriality

1. THE *EARLIEST* PICTURES?

I began this book with an example of a picture, *Fences I* by Tony Urquhart (Figure 0.2), that has great "presence" for me, and we will continue to encounter such objects in later chapters. But the presence that a virtual pictorial world and virtual depicted objects might have for me would seem to be distinguishable from the presence that the picture as such has for me. It would seem to be distinguishable, that is, from what I will call the "presence of pictoriality"—even if these fields overlap and likely oscillate in complex successions. In this chapter I will address this matter using the examples of prehistoric pictures—pictorialities that we might take to be maximally remote from present-day beholders in terms of the worlds they virtualize in visual space.

I will deal specifically with Upper Paleolithic "cave art" in southwestern Europe, especially from the cave of Chauvet in the Ardèche, France, which is decorated with magnificent paintings of animals made in ochre (the so-called red paintings in the forward part of the cave) and charcoal (the so-called black paintings, mostly in the deeper part of the cave), as well as engravings of animals and stencils of human hands. This site of human pictorial activity is one of the earliest known expressions, if not *the* earliest known expression, of the twenty-thousand-year-long span of Upper Paleolithic visual cultures in southwestern Europe. The well-known decorated caves of Lascaux (in the Dordogne, France) and Altamira (in Santander, Spain) are much later. And for initial purposes I will take it to be among the earliest uncontroversial cases of human picture-making in world prehistory.

Some scholars have questioned the early dates given to Chauvet. But I will accept the dates secured by direct dating not only of materials deposited in the cave (charcoal and bones found on the floor), but also of marks on the walls, such as "torch wipes" and some of the paintings made with charcoal (as yet the red ochre paintings cannot be directly dated). According to the most recent forensic analysis available at my time of writing, human activity in the cave (including the painting of the pictures) transpired in two different periods separated by a stretch of time when the cave might have been inaccessible. Most of the datable (black) paintings were made during the first period of activity, dated from 37,000 to 33,500 years ago, and it seems plausible to suppose that the red paintings were made then too. During the second period, from 31,000 to 28,000 years ago, another group of people visited the cave, apparently looked at the paintings by the light of torches and left behind torch marks (enabling a direct dating of their incursion[s] into the cave), and possibly two charcoal drawings.[1]

For my purposes, it is not necessary to establish whether the paintings were made over many decades, or even many centuries, by many people or in concentrated bursts of activity at a handful of times and possibly involving very few pictorialists. The

available methods of dating probably cannot attain the requisite temporal resolution to settle this question definitively, and for reasons I have set out elsewhere I am wary of dating pictures on stylistic grounds (see *GTVC* 75–119). I will, however, posit the existence of a painter I will call the Chauvet Master, and I will attribute one particular act of painting and picture-making in the cave to his hand. He might have made other paintings and other painters might have worked alongside him, but neither of these possibilities is relevant to my purposes. And even my narrow attribution serves less as a historical fact about the suite of paintings that survive in Chauvet than as a descriptive convenience for analytic purposes. As we will see, the historical action that I will attribute to the Chauvet Master comes down in the end to the making of one single line. *Someone* had to make this line — and that someone is my Chauvet Master.

The pictures in Chauvet, I said, are among the earliest "uncontroversial" cases of picture-making in world prehistory. (Because this chapter is about the very presence — the visibility — of pictoriality then and now, this is not a trivial matter, though a search for origins is not the goal.) There are earlier *marks* deliberately made by hominins, such as the marks on the bones from Bilzingsleben published in 1988, which were made by a *Homo erectus* people living around 350,000 BP; I illustrate Artifact 1 (approximately 30 cm. long) from the site (Figure 3.1).[2] But most present-day observers have not taken these marks to be pictures. Indeed, some scholars might want to suppose that picture-making partly defines an Upper Paleolithic "creative explosion" (to use John Pfeiffer's phrase) that was one dramatic facet of the "arrival of the modern mind," to borrow the title of an exhibition of "Ice Age art" held at the British Museum in 2013 — a creative explosion that featured above all "the miracle at Chauvet," to use the overblown words of Ernst Gombrich (compare Chapter Five).[3]

Obviously, however, this notion skates on thin ice. If the marks of *Fences I* have full pictoriality for me, why not the marks of Bilzingsleben for *Homo erectus*? As Ludwig Wittgenstein put it, "of what three strokes is a picture, of that it can be used as a picture."[4] This need not imply that the marks were initially made *as* a picture, or even as "strokes." (Indeed, as already noted in Chapter Two, there could be visualities in which marks fully pictorialize for some beholders in the past and the present, though for you and me there is no picture there at all; no pictoriality shows up for us.) In the case of Bilzingsleben it was not entirely clear on the initial discovery of the marks that they were made intentionally as marks to be visible in any way — visible as strokes, as picture, or as anything else. Some commentators argued that they could have been created by cutting and slicing to deflesh the bone, not to incise it. (Evidence has since accumulated that the incisions do not have this kind of mechanical origin.) Nonetheless, this would not be at all decisive: as we have seen in Chapter Two, in a process of replicating radical pictoriality the marks — however produced as incisions in the bone — could be

"seen-as-*as*" something-or-other (say the stripes of an animal) that was in turn pictorialized, "used as a picture" (for example, to record, invent, or display what such stripes look like, at least as rendered by incisions in a bone). But it is difficult for us to say what (or which?) pictures might have been made and seen at Bilzingsleben, that is, what the marks might have been used visually to do pictorially, though *we* can find radical pictoriality and pictorialize the incisions. In this respect they subsist at the opposite pole to the pictoriality available to me in *Fences I*, for I can describe to you some of the horizons of its meaning in specifically pictorial respects.

The same can be said of sundry engraved marks found on many other Middle Paleolithic artifacts, such as the two engraved pieces of shale-like ochre from Blombos Cave, South Africa, dated to about 70,000 BP, and the roughly contemporary 259 fragments of deliberately incised ostrich shell found in the Diepkloof Rock Shelter in the Western Cape, South Africa. Such marks have been understood by paleoanthropologists and popular commentators to be "intentional" and, more important, possibly "decorative" and / or "symbolic" and / or "nonutilitarian" (therefore supposedly "art" or art-like—a fallacy I need not engage here).[5] Of course, these categories are just as tricky as pictoriality. While pictures can be both decorative and symbolic, most decorations and symbols are not pictures. Moreover, pictures are not *wholly* symbolic. According to standard iconological theory, in fact, the symbolic dimension of a pictorial motif is the termination of an iconographic succession, and need not be attained by all beholders of the form (indeed it is likely attained in full by very few of them); neither a deliberately made mark nor a visual motif, however iconic or pictorial, is in itself a symbol (*GTVC* 187–229, and see Chapter Two, §§2, 3). All of these "engravings" might have something to tell us about perceptual and cognitive development in the Middle Paleolithic and the emergence of modern humans (*Homo sapiens*) about two hundred thousand years ago; in paleoanthropology they have been widely discussed in this respect. But none of the chief forensic publications has claimed in an absolutely unqualified way that the marks were specifically pictorial, as logically distinct from "decorative," "symbolic," etc. This may be largely because no one seems to be willing to say what they depict, if they depict anything at all.[6]

Still, I will not deny the *radical-pictorial potential* of some of these artifacts, perhaps all of them ("of what three strokes is a picture, of that it can be used as a picture"; and see Chapter Two). Consider, for example, the engraved fragment of bone from the Mousterian ("Neanderthal") site of Bacho Kiro in Bulgaria, probably incised between 47,000 and 41,000 BP (Figure 3.2). To my knowledge no expert commentator to date has claimed that it was a picture. As illustrated here, following the original publications, it would appear simply to be a pattern of deeply incised zig-zag lines. We have no evidence for its intended orientation at or its orientations to standpoint—that is,

3.1. Artifact 1 from Bilzingsleben, c. 300,000 BP.
(After Whitney Davis, *Replications: Archaeology, Art
History, Psychoanalysis* [University Park, PA: Penn
State University Press, 1996], fig. 5.17.)

3.2. Drawing of the engraved bone from Bacho Kiro,
Bulgaria, Mousterian, c. 47,000—41,000 BP. (After
Whitney Davis, "The Origins of Image Making,"
Current Anthropology 27 [1986], fig. 8b.)

3.3. Drawing of the pattern engraved on bone frag-
ment no. 2, Oldisleben, Germany, Micoquian (Middle
Paleolithic), c. 135,000—80,000 BP. (After Robert G.
Bednarik, "Micoquian Engravings from Oldisleben,
Germany," *Rock Art Research* 23 [2006], fig. 3.)

for its imaging point (IP) in natural visual perspective (NVP). But Alexander Marshack established that the maker did not pull the tool out of the groove at the end of each line (one of the "zigs"), but instead turned the object around in his hands to continue gouging a pendant line (the correlate "zag"). And if *we* turn it around—as we know its maker did, and as other prehistoric beholders could have done—a radical-pictorial phenomenon can occur for us, though Marshack did not notice it: the zig-zag marks might be pictorialized to depict a human figure (at left) striding over jagged terrain![7]

Something similar might be said for one of the engraved fragments of bone (no. 2) from the site of Oldisleben, Germany, dated to between 135,000 and 80,000 BP (Figure 3.3). Described by Robert G. Bednarik as "what is in all probability the oldest currently known iconographic composition," its arrangement of five straight lines and a small round pit can be pictorialized as a human figure, "and indeed as a male human figure"—pictorialized as a human figure, that is, if the artifact is oriented in visual space in a particular way.[8]

I have pictorialized these graphemes—perhaps made them into depictions—by choosing to illustrate them in the relevant spatial orientation on the page. Did their makers adopt and use these very same orientations pictorially in visual space? Obviously it would help to know whether the motifs were originally displayed and handled in visual space in the privileged orientation (or orientations) and resolution (or resolutions) that were necessary, though not sufficient, for the very possibility of the pictorial successions from marks to "figure striding over mountains" and to "male human figure."

As distinct from all these deliberate "engravings," certain other Middle Paleolithic objects (we might even call them "found objects") have been treated by some scholars as figurative sculptures, because some of their natural features were supposedly pictorialized by prehistoric people. The so-called Makapansgat Pebble is a red-brown jasperite pebble that was brought from elsewhere in the region into the Makapansgat Cave in South Africa about three million years ago by Australopithecines, possibly by the individual whose skeleton was found in the same level of the deposit in the cave. It has been seen by some modern beholders to resemble a hominin face, from a certain angle at any rate.[9] To my eyes the face-resemblance is not very robust. Nonetheless, to depict a face a shape need not closely resemble it. More important, resemblance—the phenomenon of looking face-like—is not the whole story of depiction; many things resemble other things without depicting them. More to the point would be the original reason for transporting the pebble to the cave. Did its curator seek to preserve and display the face-likeness that had been noticed elsewhere, using it visually—for example, by handling and observing it in visual space in the salient orientation—as having the look of a face and whatever forms of likeness the face-like look of a pebble might have possessed in the Makapansgat form of life?

In the case of the much-discussed Acheulean "incised pebble" from Berekhat Ram in the Golan Heights, dated to around 230,000 BP (Figure 3.4), the excavator has suggested that a cobble (approximately 4.5 cm. high) that resembled a female human body was deliberately "enhanced" by grooves to bring out the resemblance, pictorializing it — specifically by carving out the seeming neck-line of the figure. In the words of Marjolein Efting Dijstra, then, the pebble is a "natural image that was artificially exploited after it was met with the cognitive capacity for seeing-in." In the terminology of the present book, when pictorialized — if it was — it was imaged to be a female body having such features as a neck-line; the vague resemblance of pebble *to* body might have motivated a radical-pictorial potential *of* the body-in-the-pebble, the neckline, which was then secured in the grooving.[10]

The pebble from Berekhat Ram may make a stronger case for prehuman pictoriality than the engravings on the bones from Bilzingsleben. But I am not going to try to decide the point. On balance, I find it plausible to suppose that pictures were made by modern humans (*Homo sapiens*) as it were "from the beginning," that is, well before the supposed creative explosion around forty thousand years ago, which is spectacularly exemplified for us at Chauvet. (Of course, pictures could have been made in profusion in open-air, sunlit contexts outside caves and rock-shelters in materials that have not survived. They also may have included body ornamentation and picture-gestures, such as a scout might make to indicate the identity of an animal in the brush without

3.4. The "figurine" from Berekhat Ram, c. 230,000 BP.
(After Davis, *Replications*, fig. 5.14.)

speaking its name aloud.[11]) Pictures could, then, have no meaningfully defined point of historical origin *within* the horizons of modern human life (*Homo sapiens*) — what Stephen Davies has called its "psychological modernity," including its social institutions and highly articulated spoken languages.[12] I have reviewed some possibilities of such an origin in this section, none of them conclusive, but I can offer no material evidence for this. For all intents and purposes, pictures become definitively visible (to us at any rate) for the very first time at Chauvet — where we see "uncontroversial examples" of prehistoric depiction, precisely because the presence of their pictoriality is undeniable. Or so it seems…

2. THE EARLIEST *PICTURES*?

In turn, I have assumed the "iconographic succession" at Chauvet (*GTVC* 187–229): the process in which the pictures depicted something for the Chauvet Master and any other people who made them to be used *as* pictures, a "representation of 'what is seen'," to borrow Wittgenstein's words.[13] Some prehistorians would call this the question of the "meaning of the art"; some art historians treat it as a question of the "patterns of intention" of the picture-makers that are understood in practice by beholders.[14] But these categories are too gross — too quick to be totalized — to capture the complex recognitional histories in question. In the iconographic succession, recognitions of form, expression, motif, and style succeed (in recursive interactions) to recognitions of symbol, meaning, and intention (as well as other aspects of the work) that constitute the sense and status of the configuration — sense and status both *revealed by* the visual and other uses of the configuration (in succession) and (in recursion) *defining* its visual and other uses. The general question of "what the picture depicts" can coherently apply at many stages of the full notional succession — indeed it can apply throughout it. But the answer will vary depending on the *actual* stage of succession attained in the case of any particular picture-maker and/or beholder — for example, "what Hesire saw," "what Phidias saw," and "what Brunelleschi saw" (Chapters Seven, Eight, and Nine). (What the Chauvet Master saw will concern me later in this chapter.) According to classic iconological theory, then, it is routinely possible for a beholder to recognize a motif (to recognize, for example, that the picture depicts thirteen men seated at a table) but to fail to see the symbol (that it depicts the Last Supper). In my terminology, it is routinely possible for a beholder to succeed only partially to the network of analogies, the forms of likeness, that constitute the way in which the configuration was made to be used visually. In the case of the pictures at Chauvet, it seems that *we* are such beholders. Our problem, then, is a problem of evidence and inference — of what we

need to discover as historians in order to reconstruct an Upper Paleolithic pictoriality functioning in its visuality.

But now, for the sake of wider argument, I must challenge the grounding assumption and wholly invert the considerations reviewed in the previous section. Stated most simply, maybe the pictures at Chauvet were not *pictures* at all—not even for their makers and beholders, and indeed *especially* not for their beholders. More exactly, maybe they had no presence *as* pictures—as having visible pictoriality. As noted in the Introduction (§6), this issue lies at the heart of a long-running conversation between iconology, the general arena in which most analysis of supposed prehistoric pictures has been conducted, and a certain "anthropology of images" that is in turn related to phenomenologies of presence. The conversation might be described as a dispute, and to some extent it is. But more likely, as we will see, it is a miscoordination of concepts. Images can have iconologies and pictures can have presence.[15]

Consider the painted bison at Chauvet, or the so-called Panel of the Lions in the End Chamber of the cave (Figure 3.5), one component of which I will attribute to my Chauvet Master (below, §5). According to one notional version of an anthropology of images and phenomenology of presence (it might be called a "strong" version), nothing would guarantee that these marks were seen *as* pictorial by Chauvet's prehistoric makers and beholders. Perhaps they were something else.

On the one hand, perhaps the configurations made the *marks* visible as such, alike in some ways to the grooves on the walls that were made by cave-bears sharpening their claws or perhaps marking territory. (Bears hibernated in the cave for about ten millennia, the last four of which coincided with the first period of human activity, though this does not entail, of course, that the two species were occupying the cave at the same time.) The human image-makers were aware of the bears, and took account of their claw-marks; as the forensic team at Chauvet has proposed, seemingly some of the painted compositions were built up from the claw-marks, sometimes over them, and possibly as responses to them.[16] It seems far-fetched to say that the astonishing bison and lions of Chauvet might simply have been seen wholly *as* skeins of marks visible as such—as marks. But claw-marks could have been seen *in* them, for the man-made configurations materially incorporated them. (And even if they had not, claw-marks could be a salient and indeed constitutive form of *likeness* of the lines that had been laid down as "bison" and "lion.") Moreover, the pictures (*qua* paintings and engravings) certainly had to start life as marks—as starter lines that did not yet virtualize a bison or a lion, even if the maker intended to secure that pictorialization (see Table 2.4). Insofar as these lines remained visible—did not disappear into the final depictive configuration taken as a-picture-of-*X*, an *X*-picture—they could have had their own discrete visibility. I will return to this possibility.

On the other hand, and more central to the anthropology of images, the marks
could have been taken simply to *be* what they make virtual in visual space in the caves,
that is, the things *we* take them to depict. One did not see someone's paint-marks, or
a painted drawing of a bison or a lion. One saw **BISON** or **LION**. (Henceforth I use
bold capital letters to designate a supposed presence of this kind — a being, somehow
real and alive, in virtual space.) As in iconographic and iconological interpretations, a
range of anthropological possibilities have been suggested in this respect — hypotheses
about what kind of being or entity was made present, real, and animate in visual space.
Perhaps one sensed bison-spirit; or the bisonic emanation of the artist; or the bisonity
of the cave, or of one's own body in being there, which may have entailed experiences
relayed in hallucination, trance, and dream and synthesized with the experience of
sensory spaces. "These pictures are not pictures in our sense," the prehistorian Josef
Augusta asserted in 1960; "they are themselves the object depicted" (Figure 3.6).[17]

(Before moving on, I should notice what might be called a "weaker" theory of pres-
ence than Augusta's. As Andrew Harrison has pointed out, "claims of presence are liter-
ally true when representation is by exemplification," when, for example, such prop-
erties as grace and elegance "can be depicted ... by their being exemplified within
the representation itself, by quite literally being made present to us in the represen-
tational work."[18] But this weaker theory does not square with the main trend of the
anthropology of images at issue in the present context. Phenomenologically speaking,
BISON necessarily exemplifies properties of bison, its visual and aesthetic character-
istics, because it really *is* **BISON** — not a "representational work" that contingently
manifests them. It has the grace and elegance of the creature itself, not of the pictorial
configuration of its visual likeness — or so it might seem.)

Prehistorians, whether they have proposed an anthropology of images or a phenom-
enology of presence in today's terms, have long been attracted to the notion affirmed
by Augusta. Why?

For one thing, the illusionistic qualities of cave art have long been noted. They were
enhanced in several ways, including by the image-makers' use of natural forms said to
resemble other things, a process mentioned in the preceding section; by the quasi-cin-
ematic animation of the drawings, paintings, and reliefs when one moves around them,
casting flickering lamp- and torchlight across them and/or when sunlight activates
them; and by the kinaesthetic corporeal immersiveness of the entire experience that
might be inferred, including its auditory, olfactory, and motor-muscular stimulations
in making sounds and music, lighting fires, dancing, and other activities possibly staged
in the caves.[19]

To be sure, the so-called naturalism of Paleolithic image-making — the mimesis
based on keen observation of nature that is sometimes called "realism" — should not

be overdone. Upper Paleolithic depiction has sometimes been explicated as a highly particularized and accurate visual encyclopedia of animal appearance and behavior that eventually enabled human image-makers to gain genetic control over other species — what I have described elsewhere as the "pictorial regulation of animal numbers." But as R. Dale Guthrie has shown in a full survey of Paleolithic pictorial zoönomy, many unskilled and slapdash drawings were also made, such as could hardly have delivered reliable empirical knowledge.[20] This could pose significant problems for a "strong" anthropology of presence: creating stable illusions is not easy.

Still, a highly immersive, multisensory, and animated virtuality (as in present-day virtual-reality games) does not *require* mimetic transcription of the natural appearance of real things. What it does require, as we will see in more detail in Chapter Five, is that the virtual space constructed by the image-maker — in this case by making certain marks on surfaces — is experienced by embodied human agents, by beholders and participants, as maximally *continuous* with the rest of visual space and possibly in a wholesale *conversion* of visual space into a virtual space populated by the beings co-present there with the human agent of vision — **BISON, LION**. In some theories of presence developed in relation to Martin Heidegger's existential ontology, the requisite phenomenon has often been said to involve our potential ability to touch, handle, and use the thing as being "present-to-hand" (*Vorhanden-sein*). But for the sake of the wider theory, I would not impose this requirement. As Hans Ulrich Gumbrecht has put it, "what is 'present' to us ... is in front of us, in reach of and tangible for our bodies."[21] Gumbrecht's formulation is helpful because it relaxes the criterion (for present-to-handedness) of practically-using-by-actually-handling. But everything depends on the phenomenal successions of this "tangibility." **BISON** might well be — probably must be — in front of us, or before our eyes, and tangible for our bodies. One might even reach toward it. But actually *touching* a real thing and experiencing a virtual thing *in vision* might well contradict one another phenomenally, perhaps cancelling each other out, and lead as much to the corporeal experience of a "representing" as of a making-present.[22]

Overall, a range of the formal and spatial qualities of prehistoric configurations — but certainly not *all* of their qualities — might incline us to think the pictures "are themselves the objects depicted." As a correlate of visual illusion, virtual animation, and spatial immersion, social contexts of magic, ritual, and, most recently, shamanistic visionary practices have been proposed for cave art and other prehistoric and indigenous visual cultures — visualities in which depiction was a technique *of* imaging, not an end in itself, the thing *to be* imaged. There are several versions of this idea. According to one influential account, a participant was absorbed by and/or transformed into the animal with which he was continuous, immersed, in sensory space — as it were his avatar. In

rock paintings made by the southern San peoples of South Africa (from prehistoric times into the nineteenth century), "human-animal composites symbolize the transformation undergone by the shamans or the visions seen in the trance."[23] If we adopt a theory proposed by David Lewis-Williams and his collaborators in the late 1980s, endogenous images in the visual cortex (entoptics) were "externalized" into pictorializations—what Lewis-Williams has called "construals"—then recursively accepted as one's (transformational) identity and/or avatar, partly in virtue of the original endogenous image. The transformation itself occurs in an altered state of consciousness, in the San case brought about by "trance dancing" (an element of shamanic ritual initiation) and in other cases, notably in the Americas, by the consumption of psychotropic substances.[24] More recently, Lewis-Williams has suggested that the Paleolithic cave wall was a kind of "membrane" in which the spirits or "ghosts" of great animals—avatars? ancestors?—were virtualized.[25] But not *as pictures*.

Pictoriality must be *involved* in the image. But the key point is that supposedly the depiction itself was not a visible feature of the resulting visual space. The visual space was a space of *pure visuality*—not pictoriality. (I should make it clear that I am synthesizing a "strong" anthropology of images for the sake of the arguments of this book, not faithfully reporting any particular version in the scholarly and popular literatures.) In order to virtualize a bison-spirit, someone's or something's bisonic identity, and/or the bisonity of self-sensation, the marks had to relay **BISON**, not bison-pictures: one aim of an anthropology of images, we are told, is to move "beyond representation."[26] Stated another way, the picture comes *before* the presence established in sensory space. Indeed in Lewis-Williams's model the picture is *between* presences that relay the inner image-world of entoptic forms and trance visions into the outer image-world of an avatar or of a spirit in the cave (and vice versa), and it operates specifically to effect this transfer of images—the "presences"—without being *seen* to be doing so by beholders.

I am sympathetic to Frank Ankersmit's supposition that when we are dealing with such objects as figurative paintings "presence is apparently a quality of the representation rather than of what it represents," a "compliment we pay the representation"—a "supervenient property" that we grant to it "from the outside." (Ankersmit uses the example of the painter Karel Dujardin's *Le diamant* of c. 1660—a tiny painting of a "dull landscape" that for him has "explosive presence," like Urquhart's *Fences I* for me.) Ankersmit contrasts this case with everyday objects that are present-to-hand (to use Heidegger's terminology), such as the chair I am sitting in while writing these lines, which have the presence of "being-present-to-us as things in the world." As an object in our everyday world, the painting on the wall might—must—be present-to-hand in this way. But the explosive landscape is (re)presented. "What grants presence to a landscape," Ankersmit urges, "is different from what grants presence to a painting of

3.7. Monodigital flutings in Room 3, Cave of Gargas, Aurignacian. (After Davis, *Replications*, fig. 3.2.)

3.8. Detail of the engraved "Panel of the Mammoths" in the Cave of Gargas, Aurignacian. (After Davis, *Replications*, fig. 3.11.)

that landscape." Still, the latter kind of presence seems to depend on the precondition that the beholder of the painting takes it *to be a picture*. And this is the very matter put in question in the strongest anthropologies of presence — of its indigenous ontologies.[27]

3. THE PRESENCE OF PREHISTORIC PICTORIALITY

So far I have described the anthropology and phenomenology of the immersive, animated, enactive virtual spaces of caves such as Chauvet as sites of vivid images "beyond representation," perhaps organized by a shamanistic culture (though this specification is not essential). This important theory has wide application throughout the worldwide history of art and visual culture. But it risks throwing the baby out with the bathwater. It is not true that the depictive operation as such — the visible picture, the presence of pictoriality — entirely *disappears*. Indeed, in a well-defined sense pictoriality must be visible as such. And in Upper Paleolithic cave art it often is; what one *sees* — sees *as* vividly present — is the picturing activity.

Far from sweeping participants from presence to presence before, between, and beyond representations — the image-world that the anthropology of shamanistic visuality proposes — Upper Paleolithic image-making often seems instead to keep the pictorial process visible. Consider the so-called finger or digital flutings at the decorated cave of Gargas in the Haute-Pyrénées, France, dated to around 25,000 BP: ubiquitous marks (found in many caves in southwestern Europe and Australia) made by swiping one or more fingers through the moist clay that often covers the surfaces of the cave walls (Figure 3.7).[28] They can sometimes resolve into pictures, but in partial and unstable ways that continually foreground the *act* of marking and the *emergence* of depiction. Indeed, a recent reinvestigation of the digital flutings has cast doubt on earlier scholars' attributions of depictive values to some of the flutings.[29] This only reinforces the question of the presence of pictoriality. And it does not inherently help the theory of presence before, beyond, outside, or without representation: it is hard to see how the flutings could make **BISON** present — how we could make the claim — if we cannot plausibly take them to be visibly bison-like. Of course, in the case of the well-known fluted bison at Gargas (Figure 3.7, middle left), no other marks, pictorial or not, intermix with the picture that emerges. But each mark in the bison could have pictorialized in *other* directions; indeed, many of the supposed pictures are variations of the same sweeping gesture, conducted through the material in slightly different ways. Deeper in the cave, dozens of figures intertwine with each another and with many other lines, scratches, and scrapings (Figure 3.8).

In Magdalenian contexts, admittedly about ten thousand years later than Gargas, these practices sometimes seem to underlie social rituals — perhaps even games — of

visual and tactile acuity and recall, of comparing, compositing, recombining, sorting, and maybe counting, of recognition, discrimination, and variation, in general of re-cognition, that depended literally on constructing, deconstructing, and reconstructing pictures. The engraved plaquettes from La Marche (Vienne), Saut-du-Perron (Loire), and Gönnersdorf (Rhineland) were made rapidly in great quantity (many dozens have been recovered from the sites mentioned) and involved multiple makers (many different "hands" have been identified in the engravings) who employed a repetitive iconography and self-reiterating graphisms (sometimes called "double-lining"—tracking one line with another line engraved alongside it). They often display networks of lines crossing one another and, if closely inspected, visibly lying over and under one another. Pictures of animals, real or imaginary, emerge in these networks; they too are often superimposed, and often over- and/or under-engraved with many other lines (Figures 3.9, 3.10). The social purposes of making the engravings remain unknown. Because many plaquettes were deliberately broken, it has been suggested that the engravings, pictorial or not, were ritually "killed."[30] The configurations—pictorial or not—often seem to resist ready recognition; they are hard to see. But perhaps that was part of the point: "presencing," if any, was challenging and arduous visual and tactile work that permitted many outcomes, many interpretations of what was visible and might be (radically) pictorialized.[31]

At La Marche, the plaquettes were found as detritus (a secondary reuse in a revetment for a hearth), though they may have been made and used (possibly around the hearth) in the naturally lighted rock shelter in which they were found. At Gönnersdorf, the plaquettes (mixed with chunks of quartz, quartzite, and hematite, and with fragments of animal bones) were found in what the excavators have described as thematic "concentrations" or clusters on the floor of a circular hut. The hut seems to have been seasonally occupied by two different human groups who are thought to have traveled to the site from different regions.[32] Inside, these people might have gathered around the firepit and passed the plaquettes around amongst themselves. Inherently this allowed one to turn or "spin" the pictures, enabling perspectives from different angles—and creating new pictorialities. Different pictures embedded on a single plaquette often share some of the same *lines*, for example, but they can only be imaged—made visible as pictures of different creatures—in inverse planes of the artifact. In handling and inspecting the plaquettes (and no doubt talking about them), these ingenious effects likely must have been visible as such. (Eventually, the Gönnersdorf plaquettes seem to have been laid down as a kind of flooring.)

Plaquette 1 from Andernach (Rhineland) is an intriguing example of these successions (Figure 3.10). If we turn or spin it, we find that a "third" head can emerge. Quite different both from the horse's head visible in profile in one view and from the profile

horse's head in the plane 180-degrees inverse to it ("upside down"), it seems to be the head of a wolf-like beast rendered from "above," as if we are looking down upon it. It can be seen, then, whether one looks at the plaquette "upright" or "upside down" with respect to the other figures. Oddly enough, the excavators did not see this third head as one of the depictions visible on the plaquette (at any rate they did not mention it); perhaps they reasoned that if it could be seen from *all* vantages of orientation it was not deliberately made to be seen at *one* vantage, as with the other figures. For me, it virtu-alizes in striking volume, modeling (hatching), and even foreshortening — so striking that perhaps the excavators rejected it as a possible *prehistoric* pictorialization and took it simply to be radical pictoriality on their part, if they saw anything at all.[33]

In order to constitute the emergent head as a merely radical-pictorial horizon of the marks coincident with it, the engraver had to make several graphic calibrations. For instance, the righthand leg of the mammoth's hindquarters that is visible in the "upright" view creates its lefthand "ear" (though it is in the plane inverse to it) even as it graphically replicates the *horse's* ear that is visible in the same orientation. By contrast, the hatching of the muzzle of the emergent wolf-like head creates the ruff of the horse visible in the "upside-down" view as well as the *mane* of the horse visible in "upright" view. (And/or vice versa in both cases.) Because the relation of the wolf-like head to the *other* lines and figures can only be seen in *each* case from *different* vantages, it must have been stage-managed. It was put there, one might judge, to be seen as having been pictorialized, though in visible tension with the opposite possibility that it is, in fact, *not there at all*. No other causal account of the generation, organization, and configuration of the marks, *qua* marks, makes sense of what is plainly visible. The optics of radical pictoriality in natural vision are continuous enough between the past and the present for us to infer its visibility at standpoint, though not its "meaning" at standpoint: given the graphic coordination of the emergent head, the plaquette from Andernach could not *not* have had visual activation in multiple reorientations and rotations.

4. PRESENCE THROUGH REPRESENTATION

How might the "strong" anthropology of images accommodate all this? — the possible visibility, the presence, of *bison-picture(s)-in-the-marks* as analytically distinct from the presence of **BISON** in the visual space in which the picture was visually experienced? It turns out, I think, that we can have our pictorial cake and eat it too.

The "strong" anthropology of images only requires the succession (A):

(A) [BISON | bison-image | **BISON**].

In (A), the powerful preexisting cultural image of bisonhood, bisonity, etc. (that is, BISON—a network of forms of likeness perhaps embodied in many other tokens and practices) is made virtual—a presence—in visual space in the cave, that is, as **BISON**, the "thing itself."

By contrast, the activity of presencing a bison through visible pictoriality requires the succession (B):

(B) [marks | bison-pictoriality | **bison-picture**].

In (B), a particular pictorialization of the mere picture and radical pictoriality draws a particular bison-picture out of the field of possibilities open to the pictorialist when he begins to draw and that might remain partly co-extensive with the final depiction, if not co-*visible* with it. Stated more fully:

[B1] [marks | { BiSoN, *or* bIsOn, etc. }]

[B2] [marks | BiSoN, *not* bIsOn, etc.]

[B3] [marks | BiSoN]

[B4] [marks | **BiSoN**]

(My notation—different mixtures of capital and small letters—represents the pictorial particularity of *this* or *that* bison having *these* or *those* particular aspects.) This pictorial succession moves through [1] the range or the set of depicted "bisons" { BiSoN, bIsOn, etc. } that could be drawn out of any existing marks (pictorial and not) and from new marks (pictorial and not) as they are laid down, and including radical-pictorial possibilities, to [2] the particularization of a pictoriality (*this* possible bison BiSoN, not *that* bIsOn) that [3] begins to emerge in relation to this field, to [4] the finalization of *that* depiction (*this* bison) as present in visual space. One worked graphically and visually with *certain* marks to pictorialize *them* as they emerged (in relation to radical pictoriality) to be a (certain) bison BiSoN, to depict *it*, making it present as the picture **BiSoN**.

But analytically it is evident that successions (A) and succession (B) are not *two different, discrete, and opposed successions*. Rather they are *one succession* (C) that involves the *recursion* of visible pictoriality in the presencing of BISON *as* **BiSoN**.

(A) [BISON | bison-image | **BISON**]

(B) [marks | bison-pictoriality | **bison-picture**]

(C)

> [diagram: a dotted line spans the top. Below it, two vertical lines descend — the left with an upward arrow, the right with a downward arrow — leading to the row below.]

BISON marks ⟶ bison-pictoriality { BiSoN, or bIsOn, etc. } **BiSoN**

> [below: a downward arrow and an upward arrow connected by a dotted line]

In working with the marks, one virtualizes the particular **BiSoN** that *those* marks make present in visual space (that is, BiSoN, *or* bIsOn; biSoN, *not* bIsOn; etc.). We can admit that a preexisting visuality — a culturally privileged and expected image (BISON) — can have a powerful effect on the pictorialization (BiSoN) as presenced (**BiSoN**). A shamanic image-maker in an Upper Paleolithic decorated cave might have fully intended and expected to visualize **BISON**. In (C), then, the preexisting image (BISON) — the intended cultural "meaning" — precedes the picture-making in the succession and remains active within it. But the resulting presence is not a reiteration of the preexisting image, now bodied forth in visual space — a pure projection, externalization, or enactment. It is of necessity a *new* image — a particular new presence **BiSoN** — in very virtue of its succession through particular operations of pictorialization and visible pictoriality in visual space, whether or not they remain visible as such *throughout* the succession — and they need not. That is to say, the new image is not simply the unitary virtual enactment of established, expected, and shared cultural meaning — culturally privileged preexisting images. Rather it is a historical succession to it — the *pictorially achieved visual content* of the culturally expected meaning. Pictorial succession is, therefore, a required condition for the possibility of shared content or meaning in a culturally privileged image. We might revise — indeed fully *invert* — the slogan from Augusta with which we started. Rather than simply say of the images that "these pictures are not pictures in our sense: they are themselves the object depicted," we could equally say these images are "pictures in our sense: they are themselves what the picture depicts," the presence of a particular pictoriality — pictoriality presenced.

When properly integrated along these lines, the phenomenology of pictoriality and the anthropology of images break away from what I have called the "positive

hermeneutics" of classic pictorial iconology, in which an image, concept, symbol, or discourse works its way smoothly through the pictorial succession to be virtualized in visual space, made present as content or meaning. Rather, both the phenomenology and the anthropology preserve the "negative hermeneutics" of pictorial and iconographic successions — possibilities of disjunction, resistance, ambiguity, multiplicity, partiality, and failure to signify (*GTVC* 187–229). At the same time, they also differ from orthodox visual-culture studies, which tend to assume that visuality *governs* pictoriality — that visual cultures (established networks of culturally privileged images and their forms of likeness) are the explanation of pictorial representation rather than a description of one form of their possible presence (see *GTVC* 230–76). Finally, it supplements an anthropology of pure presence: it analyzes the phenomenal history that pure presence must have in its pictorial succession. On my account of this history, pure presence would be nothing but the recursion of a particular pictoriality — a certain BiSoN — fully succeeding to thing depicted (**BiSoN**). But general theory predicts that this succession is never totalized and terminated. It is a field of fluctuating intensities and potentials.

At this point we can derive two further analytical propositions. First, the distinction between representation and presence can be misleading *when pictures are present* in visual space. The distinction is too gross to capture the relevant phenomenal successions and recursions, whether they issue in representation *or* in presence *or* in their oscillation, alternation, and interdetermination — the empirical point that historians attempt to adjudicate on the evidence. The pictorial successions and recursions must be unfolded fully enough for the presence of the (depicted) thing to be secured *in the very presence of pictoriality*. In this respect, Chauvet and Gargas seem to be the two sides of the very same coin of Upper Paleolithic image-making. In an analytical sense, neither is fully possible without the other. This is true even if one might broadly characterize Chauvet as a visual space of *pictorial recursion* (illusionistic, immersive, enactive; pictures succeeded to presence of things depicted) and Gargas as a visual space of *pictorial succession* (resistant, ramified, ambiguous; pictures retaining presence before, beyond, and around things depicted) — quite distinctive material and sensory environments in which the presences of shamanistic visuality, if there were any, have very different kinds of visibility.

This leads to the second proposition: varying the *conditions of visibility* (as will be guaranteed by the all-encompassing *bivisibility* of all possible visual cultures [see Chapter Four]) enables the image-maker to create these interacting kinds of presences — the presence of pictoriality; the presence of virtual beings — in different ways, and to control, vary, and mesh them to yield an immense variety of possible outcomes, from Chauvet-style illusion to Gargas-style picture puzzle.

5. A THIN RED LINE: WHAT THE CHAUVET MASTER SAW

At Chauvet, the pictorialist I would designate as the Chauvet Master made a painting in the End Chamber. It presents two lions, male and female, slinking side-by-side through the brush — one way of pictorializing the bear clawmarks between which the lions were placed (Figure 3.5). (The Chauvet Master might have made other paintings too, but we need not pursue the issue.) The lions were painted in black in a few sweeping, fluent lines: two lines for the male (in back relative to the beholder's standpoint, and equipped with a scrotum), plus a short curve for his ear; a few more lines for the female (in front, and slightly smaller than her mate). (Close inspection suggests that orange-red lines — maybe natural, maybe man-made — were used partly to set the black lines of the lions, which partly trace beside and partly superpose them.) The engravings of mammoths that are also visible on this part of the cave wall were made later, though how much later cannot be determined (I do not need to attribute them to the Chauvet Master); they lie over the lions, though they also respond, it seems, to their dorsal lines. The lions themselves were reworked, whether at the time of their making by the Chauvet Master or in a later episode, either by him or by someone else; for example, a thick engraved line scrapes over and partly obliterates the black line that creates the lower jaw of the female. Finally, all of these figures seem to have been placed in relation to reddish stains on the rock surface and to its natural bulges, notably a hump that helped create the rounded mass of the female's rump, which is probably supposed to be moving in a specific action: the pair of lions is likely engaged in a typical leonine "mating rub."[34]

There is, however, another line I have not mentioned: a thin red line stretched *between* the lions, running from the male's ear, between the two lions' dorsal lines, and curving downward between their rumps. What is this line? Likely it was the *first* line to be drawn on this area of the cave wall; the black lines of both lions cross right overtop it at two points — at the male's ear and at the female's lifted rump. I will attribute it to the Chauvet Master, though this is not essential; the Chauvet Master could have simply found it there. The red line did not necessarily have to start life as a *lion-picture*, relaying the maker's image of LION and perhaps intending to presence **LION** in the visual space of the cave. It could have simply been a red line taking off from the red blots, repli-cating *their* outlines, tracing around the red tip of the bulge in the rock, and navigating some other small red blots. In fact, *two* red lines join up in the middle — at this point, maybe *only* at this point, suggesting a lion-likeness, or, alternately, if imaging LION and presencing **LION** had already been intended from the beginning, giving the required pictorialization of a *particular lion-likeness in line*, notably the possibility of representing and presencing the mating rub.

In the opinion of Jean Clottes, then, the red line was a "compositional" guideline (perhaps providing stronger reason to attribute it to the Chauvet Master): it situated the lions on the surface relative to blots, clawmarks, and rock shapes; it spaced them relative to one another; and, finally (and now succeeding to presence), it helped animate them.[35] As such, it had to remain visible to the Chauvet Master for a well-defined phase of the pictorial succession, namely, during the making when the pictorialization of these two LIONS (call them LiOnS) emerged in the painting of the black lines and possibly in relation to radical-pictorial potentials of the existing fissures, bumps, and blots in the surface. And therein lies the *pictorial problem for presence*, a possible resistance: the red line is (or at any rate initially *was*) neither lion's outline, let alone the lions' movement, though it helped set up these effects in the pictorial succession to the final recursion in the presencing of **LiOnS**. The Chauvet Master both needed it and needed to dispose of it, despite its seemingly high visibility.

I should say that the red line is more highly visible *in the photograph*, a high-resolution digital photograph by Jean Clottes. It is quite bright, with a cool, yellow tone, and it enables *us* to see most, or even more, of what the Chauvet Master could see in the dimmer but still relatively cool-yellow light of the small lamps he almost certainly used — illumination we can reconstruct by simulating five such lamps in front of the painting (Figure 3.11). This particular reconstruction simulates a visual space that is probably dimmer than what the Chauvet Master actually needed in order to make the painting — for example, to control the dorsal lines of the LiOnS as situated and spaced by the red line. (Of course, a fluent pictorialist, like our Chauvet Master, can draw lines practically by touch alone — by "feel.") But even at this low level of illumination the difference between the red and the black lines is visible — between a visible "compositional" operation of pictorialization and the (depicted) presence virtualized therein.[36]

We can, then, infer an operation on the conditions of visibility, as our second hypothesis predicts. Specifically, we can simulate brighter, hotter, and redder conditions of torchlight (Figure 3.12); we know that torches were used in the cave, to experience its visual space, during the second period of human activity (perhaps by people who had nothing to do with the people who made the paintings) and, I suggest, during the activity of beholding the paintings made during the first period by the Chauvet Master and his fellow pictorialists (if any). Under these conditions of illumination, the red line goes near-*black*, becoming virtually indistinguishable from the black lines laid down after, around, and over it. (The orange-red lines seemingly used to set parts of the lions' outlines entirely disappear.) And at the point where the presence of pictoriality as such had its greatest capacity to resist and disperse the full unified presencing of LION in and as **LiOnS** — at the rising-and-falling rump of the female lion

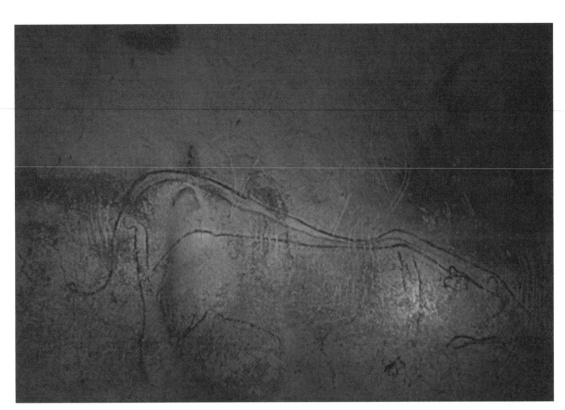

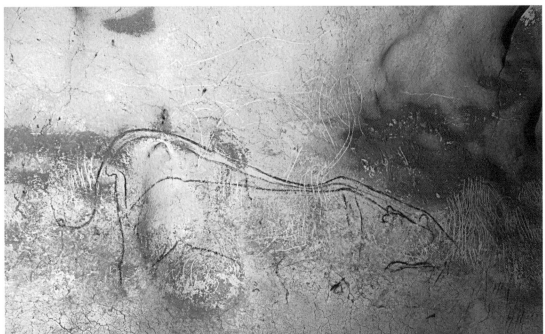

in her estrus—the virtuoso Chauvet Master carefully changed some of the red line *into* black, that is, overpainted the red line *with* black, consolidating the crucial effect of the lionness's rump in motion. Strictly speaking, this superimposed black line is the *only* line I need to attribute to him: it is the act of a master who saw the problems and potentials and knew exactly what to do with and about them. So managed—the Chauvet Master saw along the way what *not* to preserve, to replicate, in the succession of the emergent picture—pictoriality now succeeds smoothly to **LiOn**-visibility, the presence of **LiOnS**.

Several questions arise from these simple results. They imply that distinctive and successive, though possibly alternating, regimes of illumination (dimmer and brighter) might have been used to construct, to modify, and to finalize the succession of a pictorial presence ([presence of pictoriality | presence of virtual beings]), and to experience it in visual space. The image-maker well understood, or at any rate found out along the way, what could be done and what could not be done effectively in each regime—what could become visible by way of them—and how they meshed. Analytically, I have given the best case I can for presence *through* representation, but only as one possible result of managing pictoriality, Chauvet-style—a particular kind of recursion in which pictoriality recedes. There are other possible results in other directions. Like the Magdalenian engravers later on, image-makers at Gargas could hardly have gotten many of their marks to resolve in presences like Chauvet's. Playing freely with pictorialization presenced as such, they seem to have been working hard *not* to construct Chauvet-style illusions.

There is a very fine line between pictures visible as such and the virtual worlds they relay, create, and modify. But fine line or not, we must constantly move back and forth across it while keeping it in view—just as all image-makers have always done in practice in making and using pictures.

Bivisibility, Bivirtuality, and Birotationality

Bivisibility

Between the Successions to Visuality

1. BIVISIBILITY AND VISUALITY

In this chapter, I will distinguish between the *visibility* of things made to be used visually, such as pictures, and their *visuality*. I will distinguish, that is, between the network of analogies (what I have called the "forms of likeness") within which certain formal, stylistic, pictorial, and cultural aspects of the thing were used visually (and in other sensory channels) by its primary makers and beholders in a historical form of life, on the one side, and, on the other side, the likelihood that the same thing continues to be visible to other people who can encounter it visually outside that network.

To take the examples considered in Chapter Three, present-day historians have little grasp of the ways in which artifacts were used by the Aurignacian people who made the paintings of Chauvet around thirty thousand years ago (Figure 3.5) or by the Magdalenian people who incised the plaquettes of La Marche, Gönnersdorf, and Andernach about fifteen millennia later (Figures 3.11–3.13). Despite the powerful "presence" of some of these configurations — whether it is the presence of pictoriality as such, or the presence of animate beings virtualized in visual space, or of both — we have little or no idea of their analogical significances. Nonetheless the paintings and engraved plaquettes remain visible to us (and to any other beholders who encounter them visually) in mere virtue of the geometrical optics of natural vision. To be sure, perhaps they cannot be visible to us in exactly the *same* ways as they were visible to the people who made them. In Chapter Three I had to assess the possibility that what *we* take to be visible pictures in Chauvet were visible to their original users in a different way — perhaps as incarnations of spirit animals in the visual space of the cave. In the case of the plaquettes, the bewildering tangle of superimposed incisions that we encounter visually might have been resolved by their makers as palimpsestic — as meaningful stratigraphic coordinations between the positions of the marks and their pictorialities. We can reasonably infer that people activated the configurations by turning the plaquettes around. But the purpose of this activity — whether a literal game, a visual test, or something else — eludes us, and to that extent we cannot readily say "what it was like" for the original participants.

To take another example (one to which I will return in Chapters Six and Seven), Egyptologists have little idea what the module of proportion employed in canonical depictions produced in ancient Egypt in the Old Kingdom (from about 2600 to 2100 BCE) might have analogized for their Egyptian makers and beholders (Figure 4.1; see Figures 6.3, 6.4). Metrologically the module is one and one-third handbreadths, the width of a fist; in the Old Kingdom, the total height of the depicted standing figure to its hairline was eighteen such units. (At this juncture I pass over numerous complexities and variations.) Of course, the unit might simply have shown its own metrological

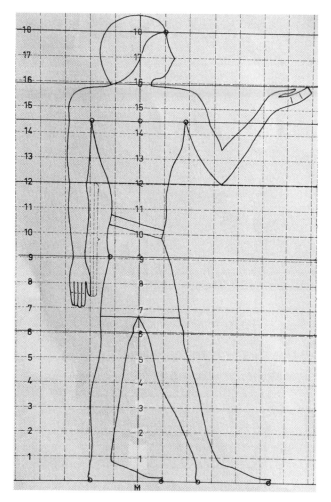

4.1. The ancient Egyptian canon of proportions.
(Justin H. Underhill.)

value on the plane, that is, one and one-third handbreaths or "one fist." But this would simply displace the question. What did one "fist" represent on the plane — visualize, make visible, virtualize, "presence," analogize, signify — when used to make a depiction of a human figure?

Elsewhere I have proposed that the unit pictorially relayed the all-pervading power of the king in maintaining the order of the cosmos, and to an extent in creating it: that the relevant analogy of the handbreadth was literally the hand, the fist, of the king seen as wielding the instruments of his domination.[1] On this account, in the visuality of canonical Egyptian depiction — the mode of its visibility in context — the all-pervading

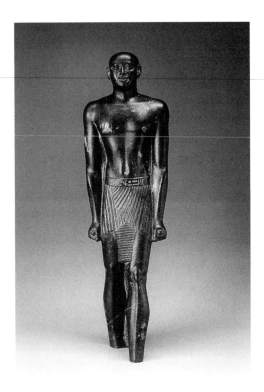

4.2. Statue of Khonsu-ir-aa, Twenty-fifth
Dynasty. Boston Museum of Fine Arts (07.494).

power of the king would be plainly visible in the very proportions of well-constructed figures, whether or not they depicted the king. Admittedly my proposal was speculative. I could not cite an ancient Egyptian pictorialist who *said* that the proportional system figured the all-pervading power of the king. Indeed, I proposed that the well-constructed picture simply *was* that enunciation. More exactly, the well-composed figure would "look right" in a certain particular way, namely, as "king-shaped" and perhaps even "fist-like." The plausibility of this suggestion lies in its ability to account for the visual evidence, that is, what is visible to us, as having been the result of a visuality on the part of the Egyptian makers and beholders. I described the visibility of the module. But I had to *infer* its analogy—its visuality. When some Archaic Greek sculptors replicated a late version of the Egyptian canon of proportions (Figures 4.2, 4.3), the units of the system—their "one-and-one-third-hand's-breadth-ness"—were likely visible to them, for they explicitly duplicated the measure in question. But its "fist-likeness" might have remained wholly invisible to them.[2]

This argument might not appeal to philologists. It is hard to know, however, what else art historians should expect to derive from the only kind of evidence that is often available, namely, the evidence of the artifacts themselves. The ancient Egyptian pictorialist was not Le Corbusier writing *Modulor* in the late 1950s: so far as we know, he did not write any treatises on proportions to explicate his graphic and sculptural practices, though we will see that he did produce working drawings and demonstrations

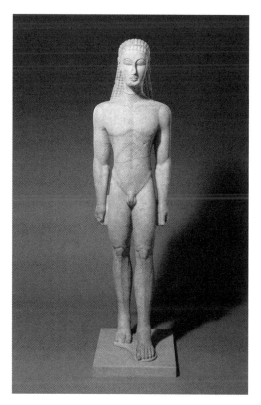

4.3. The Metropolitan *Kouros*, c. 590–580 BCE.
Metropolitan Museum of Art, New York (32.11.1).

that displayed his compositional calculations and probably enabled him to teach them to others (Chapter Six). Still, as Erwin Panofsky argued in 1921, proportional systems must relay a theory, involving a conceptual and symbolic purpose; in virtue of their calculated metric-numerical identity, they cannot be regarded simply as visual products of aesthetic intuition alone.[3] In this regard a plausible hypothesis about a determining analogy in the Egyptian case must be better than nothing.

Along with many other things, things made to be used visually have *both* visibility *and* visuality for any human agents who encounter them, including the agents who made them to be used visually. As ontology, this is straightforward; it is a mere truism, preceding historical phenomenology. Visibility and visuality are not opposites. Rather, visuality is one historical species of visibility. It is one way in which the visibility of things has been organized, namely, in terms of particular forms of likeness that things are seen and understood to have in a historical form of life. As I will put it in this chapter, then, any object of visual culture always has "bivisibility"— visibility *both* inside *and* outside the visuality, or more likely *between* the visualities, in which it was made to be used visually and that might be taken to be normative (regulative) in understanding the meaning (and/or construing the intention) of its visible features in context. But "understanding the meaning" (and/or "construing the intention") are partly thwarted by the general fact of bivisibility. Some aspects of the visible/visual object have been interdetermined in a visuality to which its agents have historically succeeded, and some

aspects — while perfectly visible — have not, though they might be interdetermined in visualities to which the agents have *not* succeeded and/or to which *other* agents have succeeded. Any actual objects of visual culture, such as pictures and artworks, and any actual subjects in visual culture, its human agents, are always in the middle of these successions and recursions.

Because of bivisibility, art history — often it defines itself as an attempt to reconstruct historical visualities — is inherently comparative. Inaugurally it works *from* the visibility of its objects (including their visibility among historians and other beholders today) to other possible visibilities, especially to the visuality attributed to the primary agents of the object's original uses in visual space in a particular form of life in the past. As we will see in more detail in Chapter Six, Egyptologists reconstructed the Egyptian canon of proportion by moving between the handful of guide marks that sometimes remain visible on unfinished Egyptian pictures and a full metrological correlation developed by the modern scholar, not visible as such in the finished pictures though encoded (I have suggested) in the analogies of Egyptian metrology and iconography (that is, in the deep analogy — the "fist-likeness" — of a basic pictorial unit and the attributes of divine kingship, each interdetermined by the other in its symbolism). It is a nice feature of this example that the guide marks, though visible to the pictorialists in making the pictures, would *not* have been visible to beholders of the finished works in visual space. (In the previous chapter I examined a similar possibility in the case of the "thin red line" in the painting of a pair of lions by the Chauvet Master [Figure 3.5].) If my hypothesis is right, ideally the beholders would simply *see* the fist-likeness of the well-constructed figure as "presenced," maybe knowing little about the way in which it had been achieved pictorially.

In its comparative procedure, art history not only moves between visibility in the present (partly caught up, needless to say, in present-day visuality) and visuality in the past. It also moves between and among visibilities and visualities *in the past*. Indeed, these comparisons are conducted not only by present-day historians. In the field of bivisibility *all* agents of vision conduct them continuously, weaving in and out of emergent networks of the aspects and analogies of things — networks that enable them visually to understand and to use the features of things that are visible to them in constantly shifting fields in visual space, a space in which no image remains the same for long. (In a sense, bivisibility is to visuality as primordial bisexuality is to homo- or heterosexuality: it is the condition of possibility, not only of succession to a sexuality — at least temporarily normative for its agent and subject — but also of inflections of it, resistances to it, and withdrawals from it in horizons of comparison. Just as one succeeds to a particular sexuality in resolving primordial bisexuality in a particular

way, however provisionally, so one succeeds to a particular visuality in resolving bivis-
ibility in a particular way.)

The hypothesis of bivisibility entrains three corollaries. First, it permits us to move
between invariantist approaches ("universalist" or "essentialist") to natural human
vision and historicist approaches ("constructionist" or "culturalist") to visuality in
visual space—approaches that do not need to be polarized. Second, it suggests
that bivisibility—an immanent condition of what is visible—finds actualization in
cultural interactions. In succeeding from one visuality to others, a human agent of
vision passes through (though might always remain partly within) bivisibility, or the
way in which the object can (and sometimes must) be used visually both inside and
outside any number of partly disjunct networks of analogy. Putting together these
two points, we derive a third corollary: bivisibility is both *trans*cultural and *inter*-
cultural; it is *both* the phenomenal field in which succession to visuality takes place
and the historical structure of any particular succession. This entails that comparison
operates not so much in an opposition between two (or more) distinct orders of
visual succession (*this* picture-in-that-visuality versus *that* picture-in-this-visuality)
as in an interthreading of them (*this* in *that* picture, *that* in *this* picture)—a complex
spiral (G.W.F. Hegel's model of "knowledge on the move," as Margaret Iversen and
Steven Melville put it) that might best be described as a "double helix" in which emer-
gent visualities are constantly reshuffled and recombined.[4]

2. BIVISIBILITY AND VISUALITY IN *WORLD ART STUDIES*

A pioneering publication helps make these general points more concretely. Published
in 2008, *World Art Studies*, edited by Kitty Zijlmans and Wilfried van Damme, identifies
five "concepts and approaches" that can be grouped under the rubric of "world art
studies." In the order in which they appear in *World Art Studies*:

1. The historiography of "global approaches to art" from J. J. Winckelmann (1717–68)
and before to the present, including such great comparative conspectuses as the *Propyläen
Kunstgeschichte* published in Berlin in twenty-four volumes between 1923 and 1944.
Here we can learn how the questions I have broached so far have been formulated by
various writers, past and present. This information is needed by specialists, though it
might not solve any theoretical problems.

"Global approaches to art" must include the question whether *art history* is global
or globalized, and if so whether this is desirable in the study of art as global. This
must be distinguished from the question of art as "panhuman"; even if art-making is a
panhuman phenomenon, as the editors of *World Art Studies* assert, art history need not
be global(ized), as James Elkins argues in his contribution to *World Art Studies*.[5] To be

sure, "global approaches to art" in the past (for example, in the *Propyläen Kunstgeschichte*) have often taken it for granted that a global(ized) art history is needed to handle the supposed panhuman fact of art. Elkins worries about the intercultural implications of this assumption, such as the possibility that it forecloses the possible contributions of "indigenous aesthetics" and obscures possible variations in indigenous ontologies and epistemologies of value, of the identity of objects, of representation and presence, and so on (see Chapter Three). From the point of view of the present chapter, however, these matters are tangential. My concern is not with the panhuman identity (or not) of art or the globalization (or not) of art history. It is with world art studies defined as addressing historical successions to visuality in the field of bivisibility.

2. "Multiple perspectives on the study of art" worldwide, whether or not art is a global phenomenon—any approaches, that is, that are not strictly art-historical in historiographical, methodological, and professional terms and contexts. Some of these inquiries—in such arenas as ecology, geography, and anthropology—might be oriented toward natural human vision, some toward visual cultures or visuality; some toward both; some not sure. All can contribute to a theory of bivisibility.

3. "The bioevolutionary basis of art-making and [art-]perception." Here, historians of visuality as ordinarily conceived—that is, as historians pursuing the history of the objects and subjects of visual culture—know that they are probably in alien territory. (Indeed, David Hulks has made the point that this territory has often been "ring-fenced" in world art studies.[6]) Under this rubric, the Darwinian aesthetician Ellen Dissanayake writes about the natural selection of what used to be called the "sense of beauty" and which she tends to call "making [things] special."[7] And John Onians describes "neuro-arthistory," namely, how the human neural processing of visual affordances such as pictures and artworks is habituated ecologically—how visuality is a historical product of the way in which things are visible in topographies of light and luminance, season and rainfall, flora and fauna.[8] Onians's brand of historicism echoes the environmental determinism of pre-Kantian historians, notably Montesquieu and Winckelmann. But it proposes to *explain* cultural systems of art-making. In most theories of visual culture, by contrast, cultural systems explain the art-making. As we will see, however, the theory of bivisibility readily integrates these seemingly opposed possibilities.

4. "Comparative approaches" to art—the art history in which one clarifies pictorial structure in ancient Egyptian art, for example, by comparing it to Archaic and Classical Greek sculpture and relief, regardless of any circumstantial interconnections between Egyptian and Greek pictorialists. In Chapter Five, I will examine the historiography of this paradigmatic art-historical comparison.

5. "Intercultural exchanges"—an updated version of established art-historical comparativism. Visuality cannot always be identified with a *single* cultural tradition. It

can be constituted in intercultural contact, exchange, negotiation, and mutual display and performance. Indeed, art historians — assuming the field of bivisibility — have long been adept at identifying syncretistic, dialogic, and hybrid intercultural visualities: they have been the object of art-historical expertise.

Given this range of "concepts and approaches," one might think that *World Art Studies* simply manifests an unresolved tension between vision and visuality. In particular, the bioevolutionary and the intercultural approaches seem to be polarized. Admittedly, and as the eclecticism and pluralism of *World Art Studies* might be taken to suggest, world art studies is somewhat uncertain about its place in this seeming clash of frameworks. But in fact there is considerable coherence and consistency, whether or not the authors in *World Art Studies* recognize it, or, as in some cases, whether or not they *want* to recognize it. For the bioevolutionary approach addresses vision *and visibility* and the intercultural approach addresses *visibility and* visuality. *Prima facie*, then, there is a domain of convergence, namely, the field of visibility or, more exactly, of bivisibility — how something might be visible outside-and-inside its visuality.

On the one side, the Darwinian Dissanayake does not write *only* about how natural selection has shaped the sense of beauty such that human beings might be genetically programmed to appreciate certain shapes, forms, and colors in certain ways. She *also* writes about the way in which they make certain shapes, forms, and colors *to be* visible *for* this sense, and in all kinds of different ways. (While natural selection shapes the vision, the *visibility* of phenomena that would provoke the aesthetic reflex must vary with materials, makers, styles, and, indeed, with culture and visuality: one could imagine a visual culture, for instance, that sometimes deliberately makes configurations to *block* certain reflexes of aesthetic appreciation.) The eco-neurologist, Onians, does not write *only* about how the visual brain gets myelinized in response to the topography of luminance to which it must habituate. He *also* writes about how varying topographies of luminance might correlate with different artifacts, or artifacts differently *visible*.

On the other side, the interculturalists in *World Art Studies* do not write *only* about the contacts and clashes of visualities that have taken place (and are now taking place) in globalized flows of artifacts and visual practices. They *also* write about the deterritorialized, hybrid visibility of things under such transcultural conditions as climate change — an ecology in a sense as well-defined as Darwin's and neurology's.

Schematically:

Bioevolutionary = vision and ***visibility + visibility*** and visuality = Intercultural.

Bioevolutionary = vision *of* **the visible + the visible** *in* visuality = Intercultural.

Given the domain of convergence, we can derive a more economical model:

Vision and *visibility* + *visibility* and visuality = Vision ⟵ bivisibility ⟶ visuality.

What is visual (for example, the wavelength of the light reflected by a particular pigment, or "color") is not sufficient to determine what is visible (someone had to paint something using that pigment to relay that particular color — or something else). By the same token, what is visible (the painting which uses that pigment for color) is not limited to visuality (the forms of likeness, visual or not, of that color used in this painting). Given the visibility of that wavelength of reflected light, the painting using that pigment can be seen by anyone sensitive to that wavelength. But given the forms of likeness of that pigment for some people, the painting is visible as a painting (or more exactly the painting that it is in their form of life) to them alone. For example, it might be a color-*schemed* painting in which the scheme has particular representational and symbolic valence (see *GTVC* 292–306). The painting is (and must be) visible in *both* ways, and either way can (and ordinarily does) succeed to the other, though never in a way that can be fixed for all agents: hence, bivisibility. That is:

...Visuality ⟵ Vision ⟵ Bivisibility ⟶ Visuality ⟶ Vision...

I can see the picture *because* I can see the [color { | color-scheme }], and vice versa. It is clear, however, that these successions and recursions — threading the wavelength of reflected light through the valences of color in a painting, and vice versa — are not "given." They are *histories* of imaging the painting.

3. BIVISIBILITY AND CULTURAL INTERCONNECTIONS

Now we can return to a historical example broached in §1, namely, the visual/visible similarity — indeed, the part-identity — between well-proportioned figures in canonical Egyptian pictures (Figures 4.1, 4.2), on the one side, and, on the other side, the proportions of the human figure adopted by some Archaic Greek sculptors (Figure 4.3). Egyptian and Greek societies had been intercommunicating from the seventh century BCE (at such crossroads as Samos in the Cyclades and Naukratis in the Nile Delta) to the Macedonian conquest of Egypt and throughout the Ptolemaic and Roman periods. (And of course they had been intercommunicating long before that too.) In 1978, in an effort to help resolve an art-historical debate that had simmered for decades, Eleanor Guralnick demonstrated that certain Archaic Greek *kouroi* (such as the large *kouros* in the Metropolitan Museum of Art [Figure 4.3]) employed the canon of proportions

used by many Egyptian sculptors in the late period, that is, in the centuries immediately prior to and contemporary with the Greek sculptors of *kouroi*.[9] Indeed, following the trans-Mediterranean inquiries of Helene Kantor (of the Oriental Institute at the University of Chicago) from the 1940s onward, the entire eastern Mediterranean, Levant, Near East, and northeast Africa had increasingly been conceptualized as a vast arena of artistic "interconnections" in the second and first millennia BCE, as William Stevenson Smith put it in 1965.[10]

Still, "interconnection" is a descriptive term; it denotes an apparent empirical finding of comparative research such as that which posited a so-called International Style in the ancient Near East and eastern Mediterranean world in the mid- and later second millennium BCE.[11] But *interpreting* "interconnection" is another matter altogether. If it is clear, after Guralnick, that certain Archaic Greek sculptors deployed the units and techniques of the later Egyptian canon of proportions, it is much less clear that they adopted its underlying metrology and accepted its ontotheological symbolism, its ideology of replicating a right order of the cosmos through its representation at every scale—if indeed they knew anything about them.[12] In the field of bivisibility they might perhaps study Egyptian techniques (possibly in Egyptian sculptural workshops) and certainly they must have seen the units in the results, for they replicated them. As I have already noted, however, they may not have understood the Egyptian forms of likeness, such as the network of "king's'-fist-likenesses" that I have proposed to reconstruct.

Thirty years after Guralnick's study, different art historians still give different weights to the "fact" of the interculturality of *kouroi*. In a treatment of Archaic Greek sculpture published in 2008, Andrew F. Stewart did not mention the Egyptian connection at all. Indeed, he suggested that the primary purpose of *kouroi* lay in consolidating *Greek* cultural bonds—presumably in giving expression to a visuality in the strongest sense.[13] By contrast, four years later, Richard T. Neer assumed a matrix of bivisibility and explicitly described *kouroi* as a "creative adaptation of, and reference to, Egyptian styles—an 'Africanizing' element in the 'Orientalizing' revolution" in the Greek world. (It should be noted, however, that two years earlier in a more extensive account of *kouroi* Neer did not mention their "reference to Egyptian style." Instead, he examined the specifically Greek forms of likeness that the statues might have had at the time, what contemporary Greeks could see them *as* and see *in* them, perhaps suggesting that for him the visible interculturality of *kouroi* belonged *only* to bivisibility: its specifically intercultural aspects had not fully succeeded to Archaic Greek visuality, his primary historical object.[14]) An empirical finding of comparative research—Guralnick's confirmation of "Egyptian" proportions in the "Greek" *kouros*—remains undisputed (by Stewart and Neer at any rate). But, as we see, it

finds two quite different places in two different art historians' descriptions of Archaic Greek sculpture. But my very point here is that in theory this difference—perhaps a disagreement, though not explicitly registered as such by Stewart and Neer—is practically inevitable. Mine is no recipe for reconciling the facts of the case in point. It is only to say why there *is* a case in the first place; namely, the historical succession of Egyptian and Greek visualities through the field of bivisibility into the particular visibilities that "Egyptian-like" *kouroi* could have for any *particular* Egyptian and for any *particular* Greek with respect to any *particular* kouros in any *particular* visual space.[15]

4. BIVISIBILITY AND COMPARISON

To *answer* this question in a realistic way, and as I argued in *GTVC*, we would have to track the positions of all agents of vision vis-à-vis a vast array of objects available to their empirical visual life. Clearly this is an impossible task, albeit one that we might advocate for heuristic purposes, for as I noted in the Introduction, it might prove useful to build down from grand sociologies and general culturologies—highly insensitive to the diversity and especially the incompletion and nontotalization of aspectual successions—to more modest and minimal units of historical process. Fortunately, to model this state of affairs for heuristic purposes we only need two exemplary objects (call them Object 1 and Object 2), as in the familiar "compare-and-contrast" juxtapositions that are often called "Wölfflinian" in view of one of Heinrich Wölfflin's ubiquitous methods of "formal analysis" (*GTVC* 3–15).[16]

Conducted as explicit inquiry, the aim of the comparison—analytic and historical interpretation of the juxtaposition of 1 and 2—is to determine whether Objects 1 and 2 should be judged by us (and might be judged by other agents now and in the past) to belong to the *same horizons of visuality or to different ones* and to the *same horizons of visibility or to different ones.* (If the objects are *exactly alike* for the observer at the level of *both* visibility and visuality, they could be said to be "indiscernible," an unusual but instructive phenomenon [see *GTVC* 20–26, 292–302]. But judging sameness or difference involves complex shading, tuning, and weighting; ordinarily what is actually observed is neither absolute phenomenal identity nor utter nonidentity.) That is, we assume the field of bivisibility and then proceed empirically to examine possible historical successions to visuality. Here several distinct outcomes are possible—which lead to different results, and to different kinds of art history (Table 4.1).

TABLE 4.1 THE DOUBLE HELIX OF COMPARISON IN THE FIELD OF BIVISIBILITY

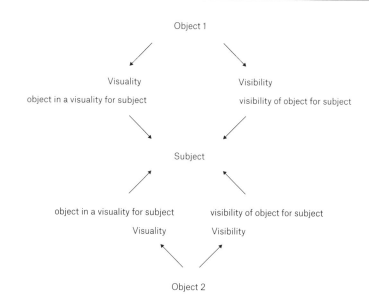

If we find that both objects (1 and 2) belong to the *same* horizon of visuality, then there is a "real" cultural coherence between them. It is analytically valid to ascribe them to the same visual culture, for example, *either* to the ancient Egyptian visual culture *or* to the Archaic and Classical Greek, or, to take a more recent version of the famous polarity (see Chapter Five) that has been developed by David Summers, *either* to the "planar" mode of construction of Egyptian depiction (Chapters Six and Seven) *or* to the construction of "virtuality" in Classical Greek pictorial representation (Chapter Eight). Most art history has sought this cultural coherence. And it has tended to find it, because it has tended to work within it from the start: with collections, corpora, and canons of objects that have been preassigned — attributed — to the same visual culture on anthropological and archaeological grounds, and/or by supposed criteria of form, style, and iconography. If the two objects are found to belong to *different* horizons of visuality, of course, they do not belong to the same visual culture. Ordinarily they would be assigned to different inquiries, even disciplines, such as Egyptology on the one side and classical archaeology on the other. Straightforward enough.

But these two options do not exhaust the possibilities, especially those explored in the interculturalist art histories already mentioned. If we find that one or the other of the objects, say 2, belongs to *both horizons of visuality as different* (an instance of what might be called "bivisuality"), then there was a "real" historical contact, an

interconnection, between visualities in the use of that object — disjunct networks of analogy that have partly intersected in the visual life of some users of the object and perhaps merged in some visible aspects of the object for them. An economical explanation would be that our bivisual object (2) was partly created in explicit relation to the visuality particular to the *other* object (1), although in the end they do not fully share that visuality. Deploying a variety of biological, linguistic, and economic metaphors (notably concepts of hybridity, translation, negotiation, and exchange), this finding has characterized much of present-day globalized comparativist visual-culture studies. Indeed, its chief finding about visual-cultural process — perhaps its general theory — might well be the multi- or intercultural nature of bivisuality.

All these are results of comparing objects. But this is done in the context of the visibility of the objects *to* historians, both past (indigenous) and present (academic).

If we find that objects 1 and 2 belong to the *same* horizon of visibility for the subject, the agent of vision, say the "planar" species of pictoriality understood as a horizon of the visibility of pictures for us, then there is a visual coherence between them, maybe *as* "Egyptian" if we attribute these aspects of the objects to Egyptian makers, that is, as having been made and maybe intended by them. But we have already seen the problem here: the two things might look alike, but this says nothing about the historical forms of likeness in which they were used. The comparison does not *produce* historical data. It demands historical assessment.

If we find that objects 1 and 2 belong to *different* horizons of visibility, say the "planar" species of pictoriality on the one side and the "virtual" on the other, the comparison may be uninformative about forms of likeness, but for inverse reasons. Whereas we are tempted to attribute the same visuality to highly like-looking things, we're less tempted to attribute it to very different-looking things.

Both of these results are unfavorable to comparativism. It would seem that either we get *too much* of the historian's visuality, the ascription of his way of seeing to agents of visuality in the past, or we get *too little* of the compound and merged multi/intercultural visualities in which historical agents made the things they used visually. Too much: For many decades, the "Egyptian" aspect of Archaic Greek *kouroi* was not really *seen* by some classical archaeologists. Or if it was seen, it was not treated as a visible feature of the sculptures to be described in terms of a real historical succession to an intercultural visuality in the field of bivisibility. Most likely this was due to the succession being historically and hermeneutically irrelevant to the classical archaeologist's preferred sense of the "Greekness" of Greek art. Too little: even though the hybrid visibility of Egypto-Greek *kouros* proportions has been identified empirically, the depth of its interdetermination of the full range of the many visible aspects of the relevant *kouroi*, of their visuality, remains historically indeterminate. As we have seen, there is

no scholarly consensus about how Archaic Greeks saw the "translation"—how they made sense of it visually, if indeed they did. And there might never be a consensus. Every new description of *kouroi* will find its own balance.

Still, the very hypothesis of multi-/intercultural (bi)visuality, whether visible or to us or not, seems to involve activities of comparison in the field of bivisibility, at least for certain agents of vision. The makers of Egyptianized *kouroi* could not have made them in the first place if they could only register the objects visually within the aspective horizon of *one* of its visual-cultural frames, namely, the "Greek" frame. The "Egyptian" aspects of the *kouroi* would have been invisible to them. But this is historically impossible: they could not have produced the objects without proximate Egyptian models that they must have known and seen to be "Egyptian."

The empirical question, then, is *how Egyptian* the "Egyptian" aspects of certain *kouroi* were for them: to what degree, if any, and in what way, if any, did the Greek makers of Egyptian-style *kouroi* recognize—even if they revised—the Egyptian forms of likeness in which the proportions of statues had been determined in Egypt and replicated in certain *kouroi* in the field of bivisibility in Greece? To be sure, *other* Greek beholders—not the makers who must have used some kind of Egyptian model to make some *kouroi*—might have failed to see anything "Egyptian" at all in the field of bivisibility. And some makers might have replicated the "Greek" visibility (and therefore the visuality) of Egyptian-style *kouroi* without seeing and without using the intercultural interrelation as such. But this is only to say, and to repeat, that different historical agents are differently positioned in the historical successions to visuality, multi- and intercultural or not, in the double helix of their field of bivisibility, even when all of them ostensibly participate at some level in the same visual culture(s). It will likely be impossible to describe all of their differences (and individualities) in minute particulars. But it would be worthwhile—historically informative—to track the nature of visual experience in the field of bivisibility specific to those Greek beholders who visually used "the creative adaptation of, and reference to, Egyptian styles" (as Neer has it), a succession to intercultural visuality, and those who did not, including those who could see the proportions but none of their "Egyptian-ness." A general theory of visual culture predicts that these groups would use the objects in different ways—to express an "Africanizing" identification, for example, or, alternately, to express a "pan-Greek" aristocratic sensibility that perhaps did not recognize this identification *in* its visuality, though it must have historically succeeded *to* its visuality partly by way of it.

There is a final possibility in comparison, then—the broadest. If we find that one or the other of our two exemplary objects belongs to *both* horizons of different visibility, then description and interpretation can proceed from the analytics of comparison in

the entire field of visibility and visuality. This is the most desirable position: it is the most open to the full range of historical possibilities in the visual field.

Say we find that Object 2 constructs *both* "planarity" *and* "virtuality"; one can look at it and use it in both ways, though perhaps at different standpoints. The possibility is not at all far-fetched. As we will see in Chapter Five, many early twentieth-century comparativists did not fully entertain it: canonical Egyptian pictures were created, they thought, in a planar visuality that was historically specific to the mode of "pre-Greek" visual awareness. But more recent historians have identified several respects in which canonical Egyptian depiction, however planar, might sometimes have constructed optically "naturalistic" pictoriality, even illusions, in certain contexts in visual space.

In theory this should lead to a set of well-defined historical and hermeneutic questions: Did Egyptian pictorial configuration have planar aspects in ways that Egyptological descriptions have overlooked? Did Egyptians virtualize pictorial configuration in ways that can be described in terms of such supposedly non-Egyptian horizons of the visibility of pictures as "perspective"? Indeed, was Egyptian planar-virtual pictorial configuration integrated in a network of forms of likeness in which it had particular visual sense and use? — even in a particular historical *intersection* of culturally specific forms of likeness, a hybridization or a translation? As we will see in subsequent chapters, the likely answer to these questions is Yes, Yes, Yes, and Possibly: as Summers has shown, art theory has overlooked the "virtual coordinate planes" in canonical Egyptian planar depiction; these planes were rendered visible in and as perspectival effects; they were constructed to be visible as visual spaces that had definite sense and use in a certain network of analogies in the Egyptians' form of life; and they might have issued historically in part from a long-term cultural interaction between Neolithic north African traditions and the monumental art of the pharaonic Egyptian state.

To sum up. In addition to identifying visual cultures in terms of the networks of analogy that constitute them, and as a means of doing so, I take mapping the field of bivisibility to be the work — predicated and pursued in the double helix — of a productive comparativism in world art history. To traverse the loop of vision-as-historical, as having-a-history, we proceed round and round on the double helix, interminably. Often and ordinarily we try to contextualize objects in the cultures, the visualities, to which they belonged. At the same time, and equally important, we seek to open different strata of visibility — if only by reimagining and redescribing them — in relation to the horizons of visibility most familiar to us culturally. Therein lies the ethical foundation of comparativism: in the way in which we seek analytically to recognize the diversity and variety of other beholders whom we can never actually become.

Bivirtuality

Pictorial Naturalism and the Revolutions of Rotation

1. AC/DC: THE COORDINATES OF PICTORIAL VIRTUALITY

Human picture-makers have long been able to construct highly immersive virtual worlds. Perhaps these creations have become more common in the age of "new media" today. But some of the most striking examples might in fact be very ancient. As we have seen in Chapter Three, an impressive suite of highly animated and strikingly naturalistic paintings of lions and other large animals in the End Chamber of the Grotte de Chauvet in the Ardèche, France, has been dated to the early Upper Paleolithic period around 32,000 BCE (Figure 3.5). There is here a mimetic simulation of the visible conformation and behavior of the real beasts in the wild (or so it has appeared to some present-day archaeologists and art historians), that was perhaps intended by its makers to be used as such, that is, as a visual-virtual space retaining aspects of certain real-visual spaces. Indeed, a spatial world configured in pictures—a virtual space in the sense adopted in this book—can sometimes seem to be the very *same* space as the beholder's physically navigable visual world, that is to say, the world within which any virtual space must be visible and open to exploration by touch and other senses. But obviously not all pictures are like this. Far from attaining *trompe-l'oeil* "illusion," many would seem not to be trying to attain—to have no intention of attaining—the corporeally immersive naturalism putatively found at Chauvet.

On the one hand, then, some pictures, or at least some parts of pictures, virtualize a world of things and spatial relations that is optically ordered in much the same way as the *rest* of visual space. In such pictures, depicted objects appear to have natural volume(s) and/or surface aspects, that is, the visible features they would actually have in real space at the imaging point (IP). And depicted spaces appear to have equally natural recession, occlusion, and/or transparency, all illuminated with the same light source(s) that illuminate the whole of the visual space. (Needless to say, this can be very difficult to achieve: given the typical reflectance of pigments, the intensities of luminance generated within a painted picture are often much less bright than those of the bright[er] objects and spaces it depicts, and the *gradients* of luminance must be more compressed.[1]) Such pictures include the *trompe l'oeils* already mentioned (or those local parts that "deceive the eye" at any rate) and certain kinds of geometrical projections, often constructed using a high degree of "naturalism" in the rendering of depicted objects—an optically convincing mimeticism or "realism"—and effects of foreshortening (including its suppression when needed) that are consistent with the optical foreshortening of the rest of visual space at IP. These pictures might be said to have "AC-pictoriality": they are pictures, or parts of pictures, in which virtual space is *apparently continuous* with visual space. Indeed, in the most extreme and dramatic cases,

as already intimated, they are pictures in which virtual space might not even be visible as such—as picture. They simply extend visual space.

On the other hand, some pictures, or some parts of pictures at any rate, virtualize a world of things and spatial relations that has a visibly *different* optical order from the rest of visual space. Unlike most real objects encountered in visual space, including the physical artifact that is the picture itself, depicted objects here may seem to be "flat" (or alternately to be "sliced" or "sectioned" on a plane or planes) and/or "folded" and "unfolded." And depicted spatial intervals may seem to be "compressed" (to the extent of appearing entirely depthless), "stretched," and/or twisting. These pictures might be said to have "DC-pictoriality": the pictorial space, or parts of it at any rate, is *discontinuous* with the rest of visual space in certain visually palpable ways, including color and luminance, spatial depth and interval, and the scale, shape, and orientation of things within it.

In subsequent chapters I will examine one of the best-known historical traditions of picture-making in which DC-pictoriality plays a prominent role, even a dominant one, namely, what has been called "canonical" or "formal" depiction in ancient Egypt (Chapters Six and Seven). "Egyptian"-style pictures do not function as (or at any rate they have not usually been considered to be) a transparent "window" through which we look into an optically natural continuation of our visual space within the frame, or beyond it. Instead they seem to serve as *portals* that allow their beholders to pass visually—and maybe *only* visually—from the optical-spatial order of the world in which IP is really located into virtual worlds that visibly differ from that order, perhaps drastically so. Thus they can act as *hinges* that turn the image-maker and viewers *out* of their world and *in* to depicted worlds. And vice versa: they might allow agents and powers in the virtual world to pass into the mundane world in which the picture is seen.

It might be tempting to identify "AC-pictures" and "DC-pictures" as two distinct natural kinds of pictures—two species exemplified, to take the cases mentioned already, by the early Upper Paleolithic murals at Chauvet (arguably AC) and by canonical Egyptian depiction (highly DC). Such a distinction of pictorial species has frequently been made in art theory and art history. But it would be preferable to speak of "AC-pictoriality" and "DC-pictoriality." As we will see in Chapters Six and Seven, which focus on ancient Egyptian depiction, most pictures *mix* AC-pictoriality and DC-pictoriality to produce particular compounds of the two. AC in some respects and DC in others, overall they can be said to be "AC/DC," though in a different way—sometimes a unique way—in each case. Strictly speaking, then, most pictures could be called "bivirtual," as the title of this chapter has it—apparently continuous with the rest of visual space at IP in some ways and discontinuous with it in other ways.

Adding to the complexity, the specific admixture of AC-pictoriality and DC-pictor-
iality in a given picture — its AC/DC identity or "bivirtuality" — varies with stand-
point. Notoriously, for example, AC-pictoriality can depend on imaging the picture
within a well-defined zone of standpoints in real space — a zone *outside* of which
AC-pictoriality (especially its construction of a convincing illusion of natural visual
space) will break down. In the case of pictures constructed as perspectival projections,
AC-pictoriality will become more DC if the visual axis in imaging the picture deviates
sufficiently from the central perspectival axis (the virtual "sightline" from the implied
viewpoint to the vanishing point), that is, if the picture is imaged at a highly oblique
angle (when it is installed, say, high on a wall above the eye-level of a beholder on the
ground). By the same token, though less commonly remarked, DC-pictoriality some-
times demands to be imaged at carefully managed standpoints where the virtual world
will be maximally visible as informatively *different* from the rest of visual space — for
example, as "flat" and "frontal." Of course, it follows that what is "AC" in a picture at
one standpoint in visual space might well become "DC" at another standpoint, and vice
versa — presenting complex recursive and reciprocal relations that can sometimes be
anticipated and built into a bivirtual pictorial compound by its makers. These trans-
formations occur not only as results of physically shifting the angle of vision from one
location to another, that is, by a real spatial change of standpoint. As we saw in the
case of the lion pair at Chauvet (Figures 3.5, 3.15, 3.16), changes in illumination at
one and the same location — the brightening of darkening of the picture — can cause
AC-pictoriality to become more DC, or vice versa, the consequence of a *temporal*
change at standpoint, whether or not apparent as such to beholders.

However slight these transits might be, and regardless of the representational value
and figurative significance they might come to have, both transits (that is, AC to DC
and DC to AC) are more or less inevitable in most pictures that have any considerable
size at IP — that occupy most of the *area* of the visual field relative to the visual angle
irrespective of the absolute size of the picture and its absolute distance from stand-
point. Picture-makers must, therefore, determine the distance at which the picture
will occupy an area of the visual field that will enable the intended pictorial bivirtu-
ality — one of the crucial computational operations of picture-making, if not the most
essential. This is not the same thing as specifying the visual angle itself, though such a
determination must also occur; even under a *constant* visual angle, a picture can have
greater or lesser AC and DC pictoriality — different bivirtual compoundings — at
different distances from IP, each distance setting the correlated area-size of the picture
and the resulting bivirtuality in visual space. I will turn to these technical matters in
Part Three.

2. PICTORIAL NATURALISM

In the world history of imaging that has been narrated within art history, the concerns mentioned in the previous section have often been focused on so-called *naturalism* in depiction. Though definitions vary, I will take "naturalism" to be the capacity of a picture visually to virtualize the objects and environments that it depicts as we would naturally image them extrapictorially in certain well-defined respects, though usually not in *every* respect. In this sense naturalisms can be found throughout the broad territory of compound AC/DC-pictoriality — pictorial bivirtuality. This territory can extend at most standpoints in visual space *between* absolute *trompe l'oeil* on the one hand and "absolute abstraction" on the other (for the latter, see Chapter One, §5). (Though "natural," one of the natural conditions of imaging some pictures, *trompe l'oeil* is not *naturalistic* because *trompe l'oeils* are not seen to be rendering anything pictorially — just as absolute abstraction does not.) Therefore all pictures ordinarily have a quotient of naturalism.

Still, this point might not be immediately helpful for an art historian's descriptive purposes, precisely because there are so many variants of pictorial bivirtuality in visual space — as many variants, in fact, as there are individual pictorialities at standpoint. Conventionally, then, art historians have often used the terms "naturalism" and "naturalistic" to designate pictorialities that are *far more AC than DC* — pictorialities that seem to be much closer than others to the threshold defined by *trompe l'oeils*, which cannot be visually discriminated from the things they depict. In fact, as we will see in more detail in the following sections, it has often been tempting to affiliate a high naturalism *only* with AC-pictoriality, and to describe DC-pictoriality as *un*naturalistic. Indeed, DC-pictoriality has sometimes been said to derive from *imaging* — from natural vision and visualization — that is not naturalistic.

I will resist this temptation, however. *Trompe l'oeil* does indeed depend on AC-pictoriality, albeit AC-pictoriality handled in such a way as to suppress pictoriality in so far as possible at IP, perhaps in the service of vividly "presencing" the depicted object as a being in visual space (see Chapter Three). And DC-pictoriality does tend to "abstract" the picture from the rest of visual space. But we will see that DC-pictorial effects can be more "naturalistic" than one might think (that is, they can be converted in imaging to have AC-pictorial effects), and, conversely, that AC-pictorial effects can be less naturalistic (they can be converted in imaging to have DC-pictorial effects). Indeed, neither AC-pictoriality nor DC-pictoriality is naturally inherent in any mere picture: no mere picture is essentially an AC-picture or a DC-picture. AC- and DC-pictoriality are produced in the natural vicissitudes of pictoriality in visual space. And it barely makes sense to classify particular visual spaces as such — natural human imaging itself — as

more or less naturalistic (or as more or less "schematic," "conceptual," and the like). In imaging, visual spaces can *become* more or less naturalistic depending not only on the way in which radical pictoriality is constituted in them (Chapter Two), but also on the way in which pictorial bivirtualities—diversely AC/DC at IP—are integrated into them, extending and transforming them.

It might not be wrong to understand certain highly naturalistic styles of drawing, painting, and sculpture to have greater quotients and coordinations of AC-pictoriality than other styles, which are understood to have greater quotients and coordinations of *DC*-pictoriality. This can be convenient art-historical shorthand. But it should not be assumed on the basis of the mere "look" of the picture—assumed, that is, as a self-evident fact of visible configuration that needs no demonstration, though it might demand critical evaluation and historical interpretation. Rather, the nature of a pictoriality has to be established by investigating the visible aspects of the pictures at the corporeally possible and at the intended locations of standpoint. And here, as noted, we can assume not only the essential bivirtual compound of AC/DC-pictoriality. We can also assume continual transits between its poles and between recalibrations of it.

What, then, lies behind the tendency to describe *certain* AC-pictorial effects constructed in *certain* traditions of picture-making as more "naturalistic" than other effects of AC/DC-pictoriality in other traditions? The very fact that we can ask this question shows that the term "naturalism" has not simply designated AC-pictoriality as such. It shows that the term has often been restricted to a handful of variants in which AC/DC-pictoriality has been coordinated—certain historical styles of pictorial bivirtuality.

3. CLASSICAL GREEK AND OTHER NATURALISMS

As intimated in the previous section, ever since the publication of J. J. Winckelmann's *History of the Art of Antiquity* in 1764, if not before, visual cultures from ancient Inner Asia, the ancient Near East, and Egypt to the Greco-Hellenistic, Roman Mediterranean, and medieval and modern European worlds have been thought to persist in two kinds of image-making—even natural kinds or *species* of image-making. The first kind has been defined as "schematic," "abstract," and/or "conceptual," to use some common terms. In his *Lectures on Fine Art* in the 1820s and early 30s, G. W. F. Hegel called it "symbolic," relaying what he had called the "Abstract form of the Understanding" in his 1805 *Phenomenology of Spirit*. (Of course, the terms "schema" and "schematic" have both Kantian philosophical meanings and twentieth-century psychological meanings, sometimes taken up by art historians and art theorists. And regardless of Hegel's vocabulary, the term "abstract" has been used by historians of modern arts to refer

specifically to *nondepictive* configuration.) Like Plato, Winckelmann identified it with ancient Egyptian civilization, as did Hegel, who took Egyptian art and architecture to consist in "unconscious" forms of Symbolic Art, more developed than the symbolic arts of ancient Persia and of Hindu India but less developed than what he called "Classical Art" (Greek) and "Romantic Art" (modern).[2] But this kind of "Egyptian"-style image-making can supposedly be found in many (if not all) of the pictorial arts of any civilization that has not been affected in the field of bivisibility by what E. H. Gombrich called the "great awakening" of the "Greek revolution."[3]

The second kind of image-making — or, more precisely, pictures made in imaging of the second kind — has been defined as "naturalistic," as simulating the optical appearance of things in natural visual perspective. (This is *not* the definition of naturalism advocated in the previous section, however.) Naturalistic depiction in this sense has been identified with Classical Greek painting and sculpture and with subsequent classicisms and neoclassicisms in the Hellenistic, Roman, and European worlds that descended from Classical Greek styles. More broadly, it refers to depictions that supposedly incarnated the "Greek way" of conceiving the relations between natural vision and picture-making by means of a self-consciously critical awareness and eventually a scientific investigation of standpoint, and of human life and mind as the measure of the world, including the figuration of its gods. The "Greek way," as Edith Hamilton called it, is really, of course, in part also "modern" and "European."[4]

It is not always easy to relate modern "realist" arts to Classical sources; often it could be fruitless to try to do so. Still-life and genre painting in seventeenth-century Holland, landscapes by John Constable and other British artists of the eighteenth century (see Figure 0.7), and figurations of contemporary social life by nineteenth-century French and German painters often did not depend on reproducing Classical styles and motifs, and Hegel did not or would not have classified them as "Classical Art" in his tripartite system of the history of the arts. But any description of naturalistic depiction in the sense intended in the received art-historical taxonomy has to include such modern painterly realisms — realisms therefore construed partly as historical effects of the "great awakening" of image-making in Greece, even when they did not use Classical Greek modes of *picture*-making. In Gombrich's history of art, then, Constable's realism could stand for the *spirit* of naturalism — experimental and self-critical — originally achieved by Archaic and Classical painters and sculptors in Greece.

According to Hegelian art history, the contrast between the "Egyptian" and the "Greek" kinds of image-making — between conceptual and naturalistic horizons of picture-making — is categorical, even though in dialectical terms Egyptian art in a sense occupies what Hegel called a "middle place" between ancient Oriental and Greco-European stages of Spirit, functioning as a historical transition between them.

The contrast distinguishes disjunct and even discrete integrations of subjectivity in the world-historical development of human consciousness. To be specific, the "Egyptian" mode of image-making is supposedly the result of a partial and imperfect grasp of the way in which human consciousness has constituted the objects of its natural vision, and to some extent it remains subject to objects constituted as powers and forces wholly external to it. According to Hegel, such monumental creations as the pyramids and Great Sphinx at Giza (Figure 5.1) and the "Colossi of Memnon" at Thebes had devolved from a non-self-conscious "artificing" (the product of a *Werkmeister*, a "master-craftsman") that "does not know itself *as* itself in its objects"—an uncritical, primitive phase of Spirit.[5] To use the formula Hegel developed in his *Lectures on Fine Art*, Egyptian symbols only "indicate a meaning [*Bedeutung*] that they do not contain"; "meaning and shape present, equally with their affinity, their mutual externality, foreignness, and incompatability." It is for this structural reason that Symbolic Art in Egypt inevitably defeated the Egyptian mind, wherever and however it searched—and supposedly it searched ceaselessly—for a clear conception of itself and the world. On the one side, the "meaning" is "measureless [in fact, 'sublime'] … and cannot find in concrete appearance any specific form corresponding completely with this abstraction and universality." And on the other side, the forms, the shapes, merely proliferate the "abstract determinacy … equally well in infinitely many other configurations."[6] In famous remarks on the sphinx (Figure 5.1), for example, Hegel wrote:

> The Sphinx may be regarded as a symbol of the Egyptian Spirit. The human head looking out from the brute body exhibits Spirit as it begins to emerge from the merely Natural—to tear itself loose therefrom and already to look more freely around it; without, however, entirely freeing itself from the fetters Nature had imposed. The hidden meaning—the Spiritual—emerges as a human face from the brute. … But conversely, the human form is also disfigured by a brute face [here Hegel alluded to the Egyptian divinity Anubis, the jackal-headed god of the underworld]. Out of the dull strength and power of the animal the human spirit tries to push itself forward, without coming to a perfect portrayal of its own freedom and animated shape, because it must still remain confused and associated with what is other than itself.[7]

As this and many other passages make clear, Hegel and Hegelian art history understood canonical Egyptian figurations in painting and sculpture to be abstract and symbolic partly because they often used the natural organic forms of plants and animals, as well as the natural forms of inorganic matter, to represent *human* life. AC-pictorial or not, these pictures, then, were not sufficiently anthropomorphic. By contrast, like

5.1. Nicolas-Jacques Conté, *The Great Sphinx*,
c. 1798–1801. (From *Description de l'Égypte*, vol. 15
[Paris, 1822], pl. 11.)

5.2. *The Apollo Belvedere*, postcard, c. 1907–14.
Collection of the author.

Greek literary and dramatic mimesis, Classical Greek painting and sculpture (Figure 5.2; see Figures 5.5, 5.18) supposedly produced its self-conscious naturalism in an anthropomorphic theodicy—the representation of gods and other cosmic forces and powers in a form maximally intelligible to human beholders (and aesthetically meaningful to them in the constituting forms of likeness) because maximally continuous with them, visibly modeled on themselves as they naturally see themselves (embodied) in visual space. As Hegel wrote, in the "free and animated" form of a human being, "free individuality constitutes the content and form of the representation. For the person is what is significant for himself and is his own self-explanation; ... and the whole range of his spiritual and visible appearance has no other meaning but the person who, in this development and unfolding of himself, brings before our contemplation only himself as master over his entire objective world." Indeed, Hegel declared with utter finality that "the human soul has its peculiar organs, and the body of a brute cannot be its domicile."[8] As Jon Stewart has well put it, then, "The Sphinx sheds its pelt and tail; its paws are transformed into hands and feet; it stands upright and is metamorphized into the Greek sculpture of the god as self-conscious Spirit."[9]

Needless to say, there was some historical sleight of hand in Hegel's account: it polarized the *non*anthropomorphic products of Egyptian image-making, its crystalline monuments and theriomorphic representations of gods, and Classical Greek sculptures of *human* athletes and victors. Moreover, Hegel knew that Doric architecture in Greece was "geometricized"; in certain formal and technical respects it was quite "Egyptian," even if the true Doric temple, as a figure or representation, was supposedly Greek in spirit. Indeed, Hegel cited Winckelmann's identification of technical and formal continuities and communications between Egyptian sculpture and the *pre-Classical* stages of Greek sculpture — a genealogy known to the Greeks themselves (see Chapter Four) and one that Hegel himself acknowledged only to dismiss it as irrelevant to his philosophical history of art. Such amnesias and dubious assertions paled before the power and sweep of Hegel's dialectical narrative, overriding art-historical evidence when needed. It gave the specifically anthropomorphic naturalism of Classical Greek visual culture an *epistemological* primacy over more primitive non-self-conscious products of human consciousness. Supposedly, Greek sculptures and dramatic spectacles served as concentrated self-reflexive windows onto human identity, as if the image-maker were opening his eyes *on himself*. By contrast, Egyptian image-making supposedly lacked this self-passage, whatever it might have allowed the Egyptians to symbolize about the world — about alterity.

Two hundred years later, it needs no demonstration that critical self-consciousness in image-making, and specifically in making self-conscious use of pictures in imaging the world, was not achieved by the Classical Greeks alone as the unique achievement of their civilization, or, to put the matter the other way around, that non-Greek civilizations (notably the Egyptians, who were supposedly aware of the problem) were incapable of overcoming "the breach between meaning and shape [*Bedeutung und Gestalt*] in the inadequate development of their artistic intuition."[10] Pictorial bivirtualities other than the kind compounded in Greek sculpture can achieve epistemologically parallel results, though the relevant ontologies of picture and world might be quite different from the ontology of Greek mimesis.

Hegel's phenomenology required that art, what he called the "sensuous form of idea," was born in human acts of modeling the world in a form that inherently "conveys man's central position in the universe, a position from which he produces unreciprocated portrayals of other things," to quote Michael Inwood's commentary on the introduction to Hegel's *Lectures on Fine Art*. Writing of prehistoric Magdalenian imaging, Inwood says, then, that "[t]o see the absolute as a bison is, in Hegel's view, as disorienting as seeing a bison when one looks in the mirror."[11] **BISON**, that is, in Magdalenian Europe around 15,000 BCE (Figure 5.3); **LION** in the Nile valley in the late fourth millennium BCE and later (Figure 5.1; and remember the **LiOnS** of Chauvet [Figure 3.5]); **JAGUAR**

5.3. Painting of bison from Cave of Altamira,
Magdalenian. (From Henri Breuil and Émile Carthailac,
La caverne d'Altamira [Monaco: Imprimerie de Monaco,
1906], pl. 25.)

5.4. Were-jaguar mask, Olmec, tenth–sixth
centuries BCE. Metropolitan Museum of Art, New
York (1977.187.33). Bequest of Alice K. Bache, 1977,
open access collection.

in Olmec Mexico in the eighth century BCE (Figure 5.4); and so on.[12] As a statement of Hegel's view, this is fair enough, even when human beings use *depictions* of animals and other nonhuman entities to refer to human identities in social life—identities that can be multiform and mutable.

In Hegel's view, the Absolute simply *is* the totalized self-consciousness of human beings as worldmakers, that is, as self-conscious in relation to "the whole of the other"; it was the Hegelian project, as Peter Fenves has put the point, "to secure self-knowledge and self-recognition by showing that knowledge and recognition are mediated by the whole."[13] But the Absolute in this specifically Hegelian sense was dialectically mediated by the anthropomorphic figuration produced by the Classical Greeks as the medium of their self-consciousness of worldmaking. Indeed, supposedly Absolute self-consciousness developed historically out of Greek self-consciousness. At a crucial crossroads, then, Hegel's phenomenology assumes the consequent. If we *subtract* specifically anthropomorphic form from the self-conscious naturalism of pictures and other symbols, we can conceive a dialectical moment in which people would indeed "see the absolute as a bison," to use Inwood's formulation, at least when the bison-picture (especially its quotient of AC-pictoriality) compels awareness of bison in visual space—makes **BISON** present, to use the terms of Chapter Three. For even if the picture-maker did not make the bison-picture *as* a representation of himself in one of his social likenesses, and even if he understands it to have causes in addition to his own agency, there must be a moment (as we have seen in Chapter Three) in which he must be aware that the **BISON** in visual space—fully real and absolutely other—is also *pictured*, that it is a product of his pictorializing activity in the succession of its presence in visual space. Indeed, the theory of AC/DC pictorial bivirtuality requires no less than this: discontinuity of visual and pictorial space proves succession of picture as such.

4. THE "STANDARD MODEL" AND REVOLUTIONS OF ROTATION

I have briefly described the world-historical *Ur*-contrast promoted within Hegelian *Geistesgeschichte* between the ancient Egyptian variant of pictorial construction—of pictorial bivirtuality—and the Classical Greek variant. In the previous chapter, we encountered the narrower (but highly relevant) question of cultural contact between Egyptian and Greek visual cultures from the eighth to the fourth centuries BCE. But if I have recalled the putative contrast and mentioned the historical connection, I have not yet addressed the imagistic nature of the visible differentiation of the Classical Greek pictorial procedures from the Egyptian—the visual transformation.

In this section, I review a relevant historiography of this specifically developmental matter. What I will call the "standard model" describes long-term transformations in

pictorial structure *not only* from ancient Egyptian drawing, painting, and sculpture to Classical Greek, *but also* from Greco-Hellenistic pictorial art to later traditions of pictorial art in the West. Worked out partly in "structural research" (*Strukturforschung*) or "structural analysis" (*Strukturanalyse*) in art history, it tells a world-historical story of the *rotation* of images, sometimes defined more narrowly as the rotation of established pictorial configurations. Winckelmann and Hegel did not lay out their narratives in these terms. But art historians writing in their wake identified four phases in the unfolding of pictorial structure — phases punctuated by three revolutions of rotation, as I will put it (Table 5.1).

TABLE 5.1. THE STANDARD MODEL: THREE ROTATIONS
IN THE TRANSFORMATION OF PICTORIAL STRUCTURE

Phase 1. "Ground-zero" frontality of depicted objects

(ancient Egyptian, "pre-Greek," pre-Classical) ⟶ Rotation 1.

Phase 2. ⟶ Three-, four- and many-sidedness; foreshortening of depicted objects;

"ancient perspective"; *contrapposto* (Classical Greek and classicistic) ⟶ Rotation 2.

Phase 3. ⟶ Reorientation toward surface plane of pictorialization (later Roman

and Byzantine, medieval, Trecento) ⟶ Rotation 3.

Phase 4. Perspectively unified picture plane, a "virtual window," spatially coordinating

foreshortened figures in freely rotating (360-degree) *contrapposto* (late medieval and

early Renaissance).

A bare-bones summary of the standard model: Modulating the variants of pictorial construction used in ancient Egypt, the ancient Near East, and in earlier periods in the Greek world, late Archaic and early Classical Greek artisans devised a *rotation away from frontality*. (Frontality might be called the "ground zero" of rotation — the starting-point for the "Greek revolution" — because supposedly it required no specifically pictorial operations of rotation recursively supervening in visualization.) This first revolution of rotation (Phase 1) occurred specifically in the *contrapposto* configured in "many-sided" Classical Greek paintings and sculptures of the human body (Figures 5.5, 5.18) (and in certain preceding Archaic intimations) and in the construction of certain "perspective" effects of foreshortening in drawing and painting (Phase 2; to be considered in Chapter Eight). For my purposes in this book, the major theorist of frontality was the

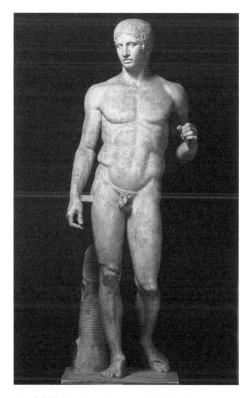

5.5. Polykleitos, *Doryphoros*, c. 430 BCE, Roman copy.
Archaeological Museum, Naples (6011).

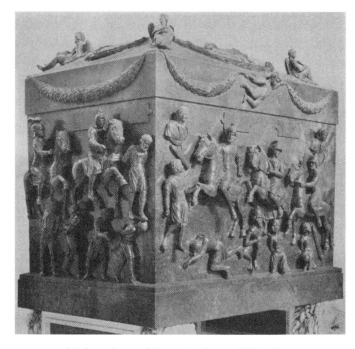

5.6. Sarcophagus of Helena, late Roman, 325 CE. (From
Aloïs Riegl, *Die spätrömische Kunst-Industrie* [Vienna:
Staatsdruckerei, 1900], fig. 32.)

Egyptologist Heinrich Schäfer, considered in §6; the major theorist of its rotation into full many-sidedness was the Classical art historian Emanuel Löwy, considered in §5. (In §§5, 6, I consider Löwy before Schäfer because the latter scholar followed on and offered criticisms of the former.)

In the second revolution of rotation, a *rotation away from many-sidedness* (that is, a rotation of the rotation) defined the end of the first rotational recoordination in ancient art, which had supposedly achieved its most comprehensive expression in later Classical and Hellenistic sculpture and imperial Roman replications, reconstructions, and reinvents, such as "neo-Attic" style. A planar (re)flattening—an orientation of foreshortened depicted objects toward the surface planes of the pictorialization, perpendicular to the direct line of sight—could be identified in the pictorial arts of the later Roman and Byzantine empires (Phase 3) (Figure 5.6). The major theorist of this rotation was Aloïs Riegl.

According to Riegl, late Roman narrative reliefs were more highly "optic" than their Classical Greek ancestors, even "impressionist." In particular, sculptors created effects of deep shadow by modeling the figures in deep undercutting. But from the point of view of the standard model, late Roman reliefs were considerably more frontalized than earlier relief sculpture in the Classical tradition, despite what Löwy called its persistent "relief-like" nature: most figures were positioned in a single plane and were *also* rotated toward it—an incipient unification of the "picture plane." Of course, this did not result in an "Egyptian"-style frontality. Individual figures retained some of the "naturalism" of Classical rotatedness, now configured sculpturally in a highly "optic" fashion. The depth of field, though "flattened," was more considerable than in a frontal pictorial construction. And the "virtual coordinate plane" (to anticipate terms to be developed in Chapter Eight) was handled in a distinctive way.

Nonetheless, the late antique transformation of Classical pictorial bivirtuality was great enough to warrant treating it art-historically as a *new* Greco-Roman bivirtuality, even a *post*-Classical one. Indeed, to some modern eyes it seemed to be a decline of Hellenic classicisms—a kind of artistic degeneration and cultural barbarism. But Riegl himself considered it to be a highly creative artistic development in bivirtuality that demanded historical explanation in terms of radical ideological changes in later Roman society, above all the Christianization of the Roman *Weltanschauung*. So far as the standard model was concerned, broad swathes of late antique, Byzantine, and Western medieval picture-making could be classified structurally as Phase 3, which in turn framed the art-historical question of putative classicisms in medieval art—that is, of seeming survivals and/or revivals and/or reinvents of the styles of Phase-2 "Classical Greek" rotatedness.

In the third revolution of rotation a *rotation toward the unity of the plane* (that is, a rotation of the rotation of the rotation) defined the end of late Roman and Byzantine pictorial construction and its variants in Romanesque and other medieval styles, especially Trecento Italian painting. This final tertiary rotation — seemingly it was decisive because it could subsume all possible rotational presentations on the plane — could be seen already in certain works of thirteenth-century painting and sculpture in Italy and especially in the early Italian "renaissances," the reconstructive reinventions, of Classical *contrapposto* and Roman *rilievo*. But its definitive factor was the invention of painter's perspective (Phase 4, to be considered in Chapter Nine). Though many scholars had addressed its history, the major theorist of this rotation in relation to world art history was Erwin Panofsky. Renaissance painter's perspective welcomed the Classical figure (Phase 2). For the rotation of the figure *out* of frontality (the first revolution) was now systematically equivalent to rotation *into* the orthogonally organized space (the third revolution). (Of course, this was a modern construction. It did not imagistically *require* the survival of Classical Greek pictorial bivirtuality, though it could have been partly provoked by it — for example by ancient sarcophagi that the sculptor Nicola Pisano [c. 1220–c. 1284] could have seen in the Campo Santa of Pisa.) Once the unity of the picture plane had been achieved in rotating all objects toward it (alternately in rotating them *away* from it), simulating the natural visual perspectives in which *everything* in the field is seen under one visual angle, in principle all the objects depicted in the resulting three-dimensionally virtual space could be *freely* rotated: they could occupy *any* position from the most frontal to the most foreshortened relative to the line of sight. Sometimes this means, of course, that certain planes will be fully frontal and flat relative to the plane of projection; a frontal rendering and a perspective projection of an object can sometimes be identical in visual space, and what might be seen as DC-pictorial can alternately be seen as AC-pictorial. In the specifically structural terms of the standard model, pictorial bivirtuality can go no further, though *unrealized* de- and rerotations always remain.

I said that this is a "bare bones" summary of the standard model, as general and simplified as possible in order not only to outline the world-historical narrative (a forest often lost for the trees), but also, and equally important, to identify its logic. What I have identified as three world-historical "revolutions of rotation" could be analyzed — and have been analyzed — into innumerable subphases, into fits and starts, into divergent lines of development and transformation, and into dead ends.

Most important, the standard model allows for continuing histories of rotation in relation to the rotational coordinations already made available. But these histories differ structurally from the threefold unfolding that differentiates the four world-historical phases already identified:

5. Any *further* rotation must (*de*)rotate in relation to the notional possibility of 360-degree rotation of depicted objects in the unified three-dimensional pictorial space constructed in painter's perspective (Phase 4). Therefore it must (re)introduce aspects of objects-in-rotation as they could be imaged and pictured in Phases 1, 2, and/or 3. At the same time, it could partly "deconstruct" unified pictorial space (Phase 4). Therefore it can (re)introduce and/or reconstruct kinds of bivirtuality that notionally could have been constructed in Phases 1, 2, and 3, whether or not they actually had been produced.

Such rotations might continue and ramify indefinitely in modern art — by definition *post*-rotational. But in a sense they become more predictable, even if high virtuosity is required and unexpected bivirtualities are created. They are involutions of image-making that are *already covered* by the general terms of the standard model, even if they generate pictorial configurations that have never been produced in earlier historical horizons. In the later modern European arts (later nineteenth- and early twentieth-century), the involutions in Phase 5 included modernist, Cubist, and other rotations that *re*flattened the plane of depiction relative to the tertiary perspective construction (Phase 4) and/or unfolded and *de*-unified its construction of three-dimensional virtual coordinate space, sometimes resulting in pictorial bivirtualities that could seem strikingly new, at the visual level at any rate (Figure 5.7, cf. Figure 6.18). (Responding to contemporary arts as well as to their experiences of "pre-Greek" arts supposedly generated in Phase 1, such early twentieth-century historians and critics as Roger Fry, Wilhelm Worringer, Carl Einstein, and Fritz Novotny contributed to the formal analysis of what Sam Rose has called a "global post-Impressionism."[14]) Later twentieth-century pictorialists have (re)generated hyporeal virtual pictorial spaces, eventually including the possible "immersion" of the imaging point of a fully rotating observer in a fully rotatable three-dimensional virtual coordinate space. These possibilities have been dramatically enhanced by electronic processing of the digitally coded information in pictures that enables the rapid recomputing of virtual pictorial space to adjust smoothly to any rotations in the beholder's visual space.

Any such "modern" pictorial bivirtuality, that is, any AC/DC compound in Phase 5, has distinctive aspects — its own historical phenomenology. Strictly speaking, there are as many variants of pictorial bivirtuality as there are pictures, or, more exactly, as there are pictures being imaged — pictorialities. But the tertiary rotation (that is, the transformation from Phase 3 to Phase 4) supposedly achieved the all-encompassing, unrestricted possibility of a full 360-degree rotational transformation of any depicted object (whether frontalized or specifically foreshortened) set in virtual coordinate spaces that can *also* be freely rotated relative to IP (and sometimes physically *incorporating* IP). For

5.7. Oswald Herzog, *Rotation*, 1928. (From Heinrich
Schäfer, *Ägyptische und heutige Kunst* [Berlin: W. de
Gruyter, 1928], fig. 45.)

this reason, what has been sometimes been called the "birth of pictorial space" and even
the "origin of perspective" likely will always have a special place in the world history
of picture-making as narrated in the standard model. By the same token, however,
we should give equally sustained analytic attention to the putatively primal condition
(Phase 1) of supposedly *non*rotated pictorializations of objects—more attention to it,
at any rate, than has sometimes been granted in studies of the "naturalistic" bivirtual-
ities that supposedly developed out of it, notably the so-called naturalism of Classical
Greek painting and sculpture (Phase 2).

The standard model has usually been deployed to chart the developmental history of
successive phases of visual culture in the West. (When dealing with non-Western tradi-
tions of depiction, its preponderant tendency has been to treat them as instantiations
of Phase 1—of frontal image-making.) But it is also a general phenomenology. The
successions and involutions can be described as rotational actions in imaging beyond
the most comprehensive of which any *further* rotation must lead to virtualizing aspects
of depicted objects that could already have been imaged in previous coordinations of
rotation.

To some extent, then, the standard model has always hedged its bets not so much on
its critical force as on its status as world art history. Sometimes it resists its own Hegelian
historicism—a teleological narrative of three revolutions in depiction that punctuated
the visual life of the peoples who produced the styles in question (for example, in the
process of the Christianization of imperial Roman visual culture as experienced by
the makers and beholders of the relevant transformations). For the standard model
(except in its most extreme variants) must suppose that re- and de-rotations always

occur continuously in imaging, namely, as rotations of the visual axis at IP away from the virtual rotatedness of *depicted* objects constructed within a pictorial bivirtuality that is visually available — made to be imaged. The picture might be entirely static and completely fixed; it might not relocate spatially in overall visual space at IP, and its visible physical configuration might remain unaltered over time, or in the duration of an act of beholding at any rate. Nonetheless in the very simplest acts of passing by the picture, coming towards it, and moving away from it, a fully embodied, active, and mobile beholder must rotate many things as the picture depicts them. And he must thereby reimage *them* (which pictoriality can probably tolerate up to a certain limit) and reimage *it* (risking a breakdown of pictoriality relative to the visible persistence of the mere picture). And any reimaging, however slight, potentially generates new aspects of the object under rotation — the *depicted object* and the *object that is the depiction* cannot be severed from one another — that recursively could be integrated in pictorial bivirtuality. The empirical question — the question for the historical phenomenology of pictoriality — is whether they actually were, and if so how.

5. *NATURWIEDERGABE* IN ANCIENT GREEK SCULPTURE

Many scholars have commented at length on the contributions of Riegl and Panofsky to the standard model; no elaboration is needed from me. But for the purposes of this chapter, Löwy and Schäfer deserve attention; they are less familiar to most art historians working outside the study of ancient Egyptian, Near Eastern, and Mediterranean arts. In virtue of his treatment of "naturalism" in particular, in this section I focus on Löwy.[15]

A lifelong friend of Sigmund Freud, Löwy pioneered the study of the rotations in imaging that supposedly motivated the major styles of ancient Greek sculpture. He set forth his main ideas in *Die Naturwiedergabe in der älteren griechischen Kunst*, published in 1900 and revised by him for its English translation in 1907, which was given the title *The Rendering of Nature in Early Greek Art*.[16] He based these ideas partly on his investigations of the inscriptions that related to individual Greek sculptors, and sometimes named them. Indeed, he had comprehensive knowledge of stylistic attribution in the corpus of Greco-Roman sculpture — of stylistic variation and what I have called "stylistic succession" (*GTVC* 75–119) — and later he turned to similar problems in the attribution of Greek vase paintings.[17]

We can translate Löwy's *Naturwiedergabe* not only as the "rendering of nature" but also as its "reproduction," "restoration," and even "return." According to Löwy, the question of pictoriality in *der älteren griechischen Kunst* was not only archaeological — a question of *early* Greek art, as the English translation of Löwy's book had it (*älteren*

5.8. Child's drawing with two eyes in the profile view of a face. (From James Sully, *Studies of Childhood* [London and New York: Longmans, 1895], fig. 14.)

should be rendered "earlier"—an important nuance). It was also a *psychological* question of the oldest—the primordial—mode of image-making in which Greek picture-making had initially been constituted, and which persisted *throughout* its history from the ninth and eighth centuries BCE (and even before) to the fourth and third centuries BCE (and well thereafter). As Louis Rose has put it, according to Löwy ancient Greek draftsmen, painters, and sculptors "not only contributed to the store of remembrance" in human culture by materially replicating their "spontaneous memory-pictures" (*Errinerungsbilder*—a term taken up from the psychologist Ernst Brücke, Freud's first mentor).[18] They also "multiplied the angles of vision" for rendering objects in pictures (especially in *sculptural* pictures, or "statuary") and under which the pictures could be seen by beholders who occupied the appropriate standpoints in visual space. That is, they "completed those images which had survived from primitive memory-pictures" in increasingly "naturalistic" terms—as more highly and diversely rotated under a greater variety of visual angles—though at the same time, and equally important, the "primitive memory forms persisted or reappeared within the classical artwork."[19] Setting out an intricate history of this development in Greek painting and sculpture, Löwy established some of the main terms for its formal analysis and stylistic periodization.

In investigating *Naturwiedergabe*, Löwy had two main ideas; his innovation lay in interrelating them and applying them to an archaeological corpus. First, what he called "memory-pictures"—an image maker's visual-mnemic images of things he has seen—primordially organize not only our visual imagination when we call something up to the mind's

eye, whether the object is real (and therefore could be visible to us in natural vision) or imaginary. The memory-pictures also organize the renderings that we will spontaneously produce when making *pictures* of these objects. To that extent memory-pictures are "schemas"—the term preferred by Löwy's student Gombrich—that organize visualization and depiction as partly distinct from natural visual perspective, though the question of the role of the schemas in natural vision cannot be cleanly separated from the question of their role in *picture-making*. In this arena Löwy built on the work of psychologists such as Brücke, making special appeal to studies of children's drawing published by James Sully and others (Figure 5.8)—an interest in kinds of evidence that Gombrich would seem to have inherited partly from him.[20] It is also possible that he was influenced by Freud's analysis of the retention (under repression) of *imagos* in dreams, parapraxes, and jokes, though he did not cite Freud.

Second, memory-pictures have a particular *form*—a psychical morphology. Defining the "typical" and readily recognizable shapes of things, they are flat and frontal, bounded by clear outlines that enclose uniform (unmodulated) planes of color and present the broadest aspect (or aspects) of the object visualized, imagined, and/or depicted (or parts of the object). (Here Löwy probably built on the work of Julius Lange on the "law of frontality" in ancient arts [Figure 6.14], though he claimed to have worked out his model independently, and echoed ideas about the ideal planes of sculptural relief advocated by the sculptor Adolf von Hildebrand.[21]) In this respect the memory-pictures (if we could actually look at them) would look like *actual* Egyptian pictures, leading to the possibility—one that gave Löwy considerable difficulty throughout his narrative—that they derive not so much from imaging in general—retinal or mnemic—but from techniques of depiction specifically, and therefore that they can *explain* picturing only by way of complex recursions (such as the image-maker's visual memory of pictures that seemed to him to be frontal in visual space). But this problem could be partly avoided by the assumption, transferred from the first main idea, that schematic memory-picturing (conceptual imaging) must be the default condition of all picture-making unless it somehow breaks the law of frontality. In this respect, not only the ancient Egyptians but also the early Greeks and picture-makers in many other cultures (as well as young children and untutored adults in *all* cultures) were psychologically "Egyptian"—essentially bound to memory-picturing, or at any rate to the grip of the law of frontality in making pictures of things. Löwy knew that the frontality of Archaic *kouroi* and *korai* derived partly from Egyptian practices. Unlike other commentators, however, he did not think that Greek sculptures *duplicated* Egyptian sculptures in a relation of imitation, unwittingly transcribing Egyptian conceptual images and building an essentially "Egyptian" pictoriality into early Greek art—a pictoriality that was later supposedly overcome in the *internal* development of natively Greek imaging.

Rather, in Archaic sculptural practices in Greece the sculptors transcribed *their own memory-pictures* of Egyptian art; "the Greek approached these originals of a foreign art exactly as he approached nature, that is, he worked from them by a process of memory, and assimilated them only within the limits of his power of conception."[22]

Löwyan schematic form consolidates the fullest rotational presentation of the object seen, remembered, and visualized—a primary mental rotation toward frontality. In turn, therefore, the *reproduction* of this completed rotation in the graphic expression—the visible picture determined by the mental image—inherently contains the possibility of rotation *away* from maximal frontality, as it were unwinding the rotation that presents in visualization as schematic form and pushing the visible depicted object through rotations that potentially turn it all the way around itself relative to any standpoint in visual space. As Löwy put it, "the mere translation of the conceptual image in graphic form contains a revolutionary germ." (*Aber die blosse Übersetzung des Gedankenbildes in graphische Form trägt einen revolutionären Keim in sich.*)[23] And this was the Greek revolution: emergences of multifaciality, *contrapposto* or what classical archaeologists sometimes call "ponderation," and foreshortening that as it were re-turned the memory-picture to the original ground of variegated impressions through which *it* had emerged. But even the most immature, untutored, or primitive picture must already be "well advanced from its most original" psychological stage (*das allerursprünglichste Stadium längst überwunden*); it displays "infinite and deliberate observation of nature transforming the purely mental images" (*es steckt selbst in den frühesten der uns erhaltenen Zeichnungen gegenüber dem rein geistigen Bilde unendliche viel geflissentliche Beobachtung der Natur*). In sum, it is the very work of pictorial art to unravel—de- and re-rotate—the work of pure *Errinerungsbilder*. Despite the flat and frontal morphology of the memory-picture as an image, the pictorialist's spontaneous starting point, depicted objects become rotations that seem to be suspended or arrested in a motion, especially when there is more than one memory-picture involved in the rendering—more than one flat and frontal view, side, or face to the depicted object. Building on the ideas of G. E. Lessing and J. W. Herder, Löwy and other contemporary theorists often called this *Pregnanz*, the "pregnance" of a rotation that would reveal additional aspects of the object and describe its change over time, "liberating" it from its frontalized image.[24]

According to Löwy, this *Naturwiedergabe*—this restoration of natural visual images, a "coming again"—occurred gradually in Greek drawing, painting, and sculpture in rotational proliferations of the specifically *unifacial* and *bifacial* frontality that had characterized its earlier/older (*älteren*) phases in pre-Classical times (Figures 5.9, 5.10), and in the Archaic period might have acquired technical reinforcement from Egyptian practice. More memory-pictures were put into the mix of picturing at the same time as more visual angles were admitted in imaging the virtual body that resulted.

5.9. A chariot team from a painted vase (the "Dipylon Vase"), Geometric period. (From Emanuel Löwy, *The Rendering of Nature in Early Greek Art*, trans. John Fothergill [London: Duckworth, 1907], fig. 3.)

5.10. Head of Hera, early Archaic period. (From Löwy, *Rendering of Nature*, figs. 24, 25.)

For example, in a sculptural style identified with the artist Polykleitos (notably the *Doryphoros*, Figure 5.5) the image-makers balanced at least three visual angles between a frontalized picture, the clear contour of a shape plainly recognizable in a primary plane, and a somewhat foreshortened virtual object, visibly suggesting aspects that could become *more* visible in rotating it in visual space (in turn soliciting real and imaginary movement around the sculpture) and in time (as if the *sculpted* body were moving). (Roman commentary had described the *Doryphoros* as *quadratus*, "foursquare," presumably translating the Greek *tetragonos*. According to Löwy, however, the seemingly foursquare virtual body was mostly imaged on *three* sides—it was imagistically configured to be *dreiansichtig*—because beholders were discouraged from inspecting the back, or prevented from doing so.)

In turn, the Lysippan style—in the 1880s Löwy had made a special study of the sculptor Lysippos—inflected Polykleitan *Dreiansichtigkeit*: it became *vielansichtig* ("many-sided") in the rotational restitutions that were admitted into the virtual object in visual space (Figure 5.11).[25] One could go no further along this rotational path

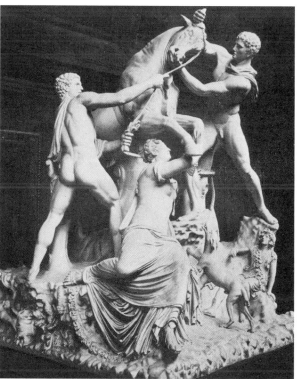

5.11. Attributed to Lysippos, *Youth Tying His Sandal*, Roman copy of mid-fourth century BCE original. (From Löwy, *Rendering of Nature*, fig. 40.)

5.12. *The Punishment of Dirke by Zethos and Amphion: The Farnese Bull*, Roman copy of mid-first century BCE original. (From Löwy, *Rendering of Nature*, fig. 43.)

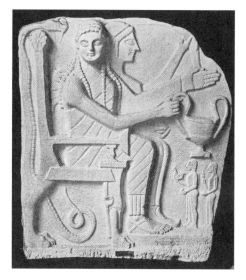

5.13. Relief from Chrysapha, Archaic period. (From Löwy, *Rendering of Nature*, fig. 13.)

except by making it more and more complex imagistically. Therefore *vielansichtig* constructions were unstable, lacking the stolidity of foursquareness: at a certain point in rendering a complex object (such as a group of interacting bodies), the sculptor can lose hold of the ability to organize a multiplicity of equally clear views, especially when they deliver quite distinctive impressions (narratives of rest and motion) and might be better served by rendering a multipart group in one plane. Here "relief"—especially using the optical and technical principles recommended by Hildebrand—could rein in the vertigo inherent in trying to rotate to all points. In Löwy's example, the figure-group known as the Farnese Bull, ostensibly *vielansichtig*, virtualizes best (and likely was visualized by the sculptor) on a single primary plane of pictorialization in visual space (Figure 5.12). It is not as far away as one might first suppose, then, from an early Archaic relief from Chrysapha, one of Löwy's examples of more or less unadulterated memory-picturing. In the earlier work, the "severe arrangement of planes in so many distinct layers ... shows, in its very exaggeration of reality, that its source is mental abstraction, not direct imitation of nature" (Figure 5.13), and in the later, "we find for the principal group [that] there is only one and that again an exhaustive point of view" organized on a single privileged plane.[26] In other words, Greek pictorial art never wholly escaped the domain of schematization, of "conceptual images"; "much that was 'relief-like' was kept in Greek art, [and] it would be no useless undertaking," as Löwy

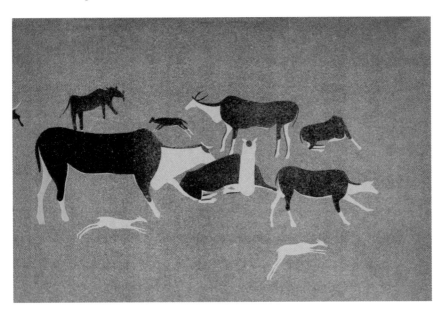

5.14. San painting from Catherine's Post Caves, Dordrecht,
Cape Colony, South Africa. (From M. Helen Tongue,
Bushman Paintings [Oxford: Clarendon, 1909], pl. 11.)

tried to show, "to determine how far the principles we have enumerated at the outset remained still in force at the close of antiquity, and thereby to sum up the development of antique art from the point of view of form." Indeed, he proclaimed, "no art has yet entirely delivered itself from those principles."[27]

It is scarcely surprising that a wide range of historians and critics with their own agendas addressed Löwy's book with interest and respect. They considered its theories and conclusions as applied not only to ancient Egyptian and Archaic and Classical Greek depiction but also to children's art, non-Western indigenous arts, medieval European art, and modern avant-garde arts.

For example, in a 1910 essay on "Bushman Painting," the English art critic Roger Fry reviewed a publication of modern European watercolor copies of nineteenth-century rock-paintings made by the San people of South Africa, using Löwy's terms to describe similarities and differences between such "primitive" art (in the modern replication) and the contemporary post-Impressionist painting he advocated.[28] On the one (and cliché) side, the child and the "primitive artist does not seek to transfer a visual sensation to paper [or to a rock-surface], but to express a mental image which is colored by his own conceptual habits." Even the "most developed" phases of Egyptian and Assyrian art "afford constant examples" of this—"ingenious compound[s] of conceptual images." On the other (and empirical) side, the characteristics of schematic form and frontality

5.15. San painting from a rock shelter in the Maluti Range, Basutoland, South Africa. (From Tongue, *Bushman Paintings*, pl. 19.)

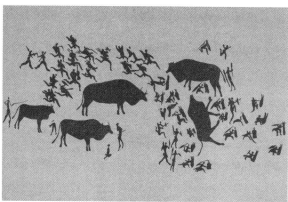

5.16. San painting from a rock shelter at Modderpoort, Cape Colony, South Africa. (From Tongue, *Bushman Paintings*, pl. 35.)

"are more often contradicted than exemplified" in San paintings (Figures 5.14–5.16), where "there is nothing truly schematic," and where rotations in the virtual pictorial space attain a "photographic verisimilitude." Lest this be taken as the impact of photography on San painters — in theory this was historically possible — Fry declared that even Paleolithic painting was more San-like than schematic. (Probably he had in mind the paintings of Altamira [Figure 5.3]; Chauvet, of course, was unknown to him.)

To reconcile the contradiction — Fry accepted without question that the San belonged to "the lowest of savages" — he suggested that they, like the Altamirans, were "so perfectly fitted to their surroundings" that they had no need to compensate for alienation by learning to "classify phenomena." In this latter practice, "a conceptual view of nature began to predominate"; and he attributed it to Neolithic peoples, often regarded at the time as quintessentially schematic in their expressions. This requires the Altamirans and the San to have been *pre*-conceptual as it were: the "retinal image passed into a clear memory picture with scarcely any intervening process" of the "conceptualising of visual images." And it requires that modern habits of drawing — when not art — must be as it were *post*-perceptual because they are still "strongly marked" by the "conceptual habit" that emerged in Neolithic times.[29] Fry's often-cited quotation of a child of his acquaintance — "first I think and then I draw a line around my think" (see Figure 5.8) — was meant just this way: this is a *modern* child speaking. The very possibility of such a statement was foreclosed to the Altamirans: hence the powerful visual naturalism of *their* lines.

In turn, the modern artist has "to some extent a choice before him of whether he will *think* form like the [Neolithic] artists [recapitulated in today's child] or merely *see* it like the Bushmen." This amounts to saying that in theory modern artists can self-consciously occupy the entire formal continuum of logically and psychologically possible pictoriality — the entire galaxy of pictorial succession. Because this is impossible, Fry's para-Löwyan world history ultimately amounted to an ideological globalization of artistic modernism: modern Westerners have the formal resources to conquer the entire pictorial galaxy, should they so choose, and the San painters, despite Altamiran powers of visualization, do not. The twist, of course, was that Fry greatly admired the San paintings as art.

To take another example of critical engagement with Löwy's ideas, the classical art historian Rhys Carpenter has recently been described as one of the most impressive formalists of the twentieth century, though his work has been overlooked outside the study of ancient Mediterranean arts. In *The Esthetic Basis of Greek Art of the Fifth and Fourth Centuries BC* of 1921, Carpenter explicated classicism in art (ancient Greek or otherwise) as a careful calibration of Löwyan "schematic" form and its "naturalistic" modification, with a preference throughout for the "abstraction" of the schema. Still,

Carpenter sharply criticized the nonrepresentational abstractions of twentieth-century modernist art as lacking the moment of *Naturwiedergabe*.[30]

To take a final example, when completing his master's thesis on the sculptures of the Cathedral of Moissac, a twenty-one-year-old Meyer Schapiro, later to become a distinguished art historian and critic, faulted Löwy: supposedly the older art historian had overlooked the principal consequences of his own findings for general criticism, notably in failing to realize that "schematizations" of form—the primal phase in any "technical series" of developments in style—have aesthetic virtues greater than any "restitution of nature" that might supervene in "geometricized" image-making. According to Schapiro, "there must be some intimate relation between the memory image and good composition." And composition, in the end, is "good" when it preserves the "nexus of parts in the memory image," its "effectiveness in consciousness" as "flattened, simple, [and] coherent." As Schapiro concluded, an artist should "*want* to draw from a concept rather than from a percept."[31]

Of course, statements of these sequences and successions in imaging that suggest an orderly progress in depiction (to be integrated into the world-historical teleology set forth in the standard model) have long been understood to be oversimplified. Questions persist about the actual rotatedness of the images involved in each stage of the Löwyan development, whether we speak of how objects were visualized for pictorialization or of how the pictures were imaged.

To take one example, some Archaic *kouroi*—free-standing statues of nude youths (see Chapter Four)—must have been approached off-axially, as their bases attest. The unifacial frontality of the figure posited by Löwy would have been *foreshortened* in visual space, and strictly speaking the sculpture visible *in situ* would lack some of the formal properties assigned to the memory-picture as the "image" that supposedly organizes the construction. Moreover, the largest *kouroi* (some are more than twice life-size) must have required observers to look up in a way that would also disrupt axial frontality, perhaps creating the sense that the figure was looking elsewhere than at the beholder (Figure 5.17).[32] In addition, regardless of their positioning on their bases, *kouroi* and related statues sometimes deviate slightly from absolute frontality, with head, trunk, or legs slightly turned away from the frontal plane established by the base in the axis of direct observation (ADO).[33] Regardless of uni- and bifacial construction, some of them likely had greater visual many-sidedness than their position in Löwy's sequence suggests. This is not a problem for the theory of pictorial *bi*virtuality; in certain respects some *kouroi* seem to have had a greater quotient of AC-pictoriality than Löwy supposed. But it sits uneasily with the Löwyan story of a visible transformation *from* DC-pictoriality *to* AC-pictoriality in Greek sculpture.

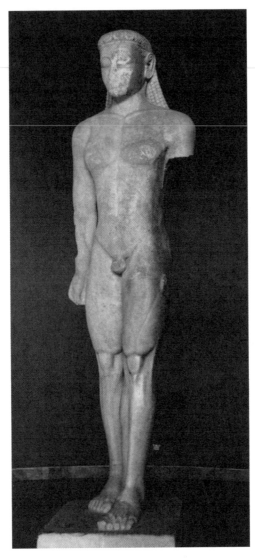

5.17. *Kouros* from the Temple of Poseidon, Sounion,
Archaic period, c. 550 BCE. National Archaeological
Museum, Athens (2720).

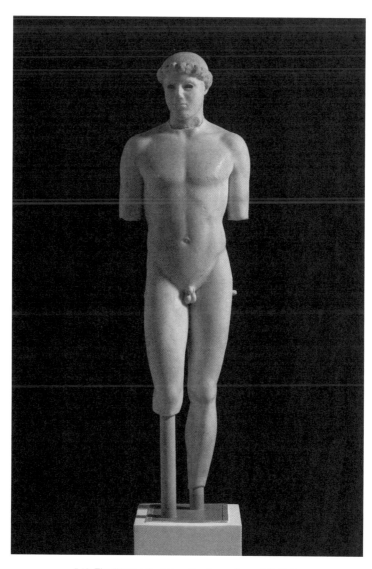

5.18. The "Kritios Boy" from the Acropolis, c. 479–75 BCE.
Acropolis Museum, Athens (689).

To take another example (Figure 5.18), the early Classical "Kritios Boy," probably made around 480 BCE, is about half life-size (86 cm. high). An observer might have been able (if tall enough) to look right over the sculpted boy's chest, head, and shoulders down to the upper curve of his buttocks, securing a many-sided perspective overlooking the front, top, and back of the figure while standing in one place. (In this visual-spatial context, the sculpture might have been a figure of homoerotic domination and envelopment.) It seems to solicit a way of imaging it in visual space — looking down over the strongly foreshortened "behind" of the boy's body even as his chest would practically be nestling up against one's own — that liberates it from frontality in ways a Löwyan sequencing again tends to miss. For here the natural visual image that is presented to the beholder in visual space would not only be the frontal image of the relaxed boy seen at a distance. It could also be the multifacial — and substantially *dorsal* — image of him relaxing into one's arms, figuring what Richard Neer has called a "new way of yielding."[34]

6. NATURWIEDERGABE, GERADVORSTELLIGKEIT, AND ANCIENT EGYPTIAN DEPICTION

In the first two decades of the twentieth century, the Egyptologist Heinrich Schäfer reconstructed ancient Egyptian techniques for managing highly frontalized depiction, building partly on the research of Ludwig Borchardt and other experts in the working methods of ancient Egyptian draftsmen and sculptors. The most important section of Schäfer's treatise *Von Ägyptischer Kunst,* the first edition of which was published in 1919, dealt with "the basic principles of the rendering of nature (*Naturwiedergabe*) in three dimensions, and how they relate to the principles for two dimensions."[35]

Schäfer's term *Naturwiedergabe* explicitly referred his own work to Löwy's. But he remarked what he took to be defects in the mnemic psychology promoted by Löwy; essentially, Löwy's thesis was "too strong" because he derived frontalized pictures from preexisting "conceptual images," however modified in the process of pictorialization. By contrast, Schäfer offered no special new theory of mental images, and accepted that Egyptian imaging — the natural vision of Egyptians, their seeing — was perspectival, like everyone's. "Although of course [the Egyptian pictorialists'] physical eye, like any normal eye, registered the foreshortenings [of things seen in natural visual perspective], they nevertheless neglect these apparent impressions and unconsciously record what their mental eye tells them, what they know about the nature of the body, or, not to lay too great a stress on the intellectual element, what lives in their imagination as reality."[36] His topic, then, was the nature of Egyptian *conceptual* pictures — the conceptual (as distinct from perceptual) method of their construction (and of their cultural

ontology) and therefore of their visibility in original Egyptian visuality. Specifically, he described Egyptian pictorial renderings as *geradansichtig-vorstellig* (*geradvorstellig* for short). In English, this complicated neologism might be translated as "depicted as straight-on-imaged," "the presentation of the straight-on view" on what I will be calling the "axis of direct observation" (ADO). So far, so good; I will be working with this proposal in subsequent chapters.

As part of his preparation for writing *Von Ägyptischer Kunst*, Schäfer made a special philological assessment of ancient Egyptian and Near Eastern evidence (such as written descriptions of ascension to the heavens), and he concluded that image-makers were well aware of the visual-phenomenal effects of recession and diminution; "of course their physical eye, like any normal eye, registered foreshortenings."[37] But these effects did not need to be pictorialized; indeed, it was Schäfer's point that what he called "pre-Greek" image-makers, including pictorialists in ancient Egypt, had no ontological or epistemological interest in pictorializing them (possibly true — given the historical context of ancient Egyptian canonical visuality) and consequently that they had little or no role and effect in the pictorial succession (almost certainly false, as we will see).

Schäfer knew that Egyptologists before him had already investigated possible cases of foreshortening and pseudo-perspectival construction in canonical Egyptian depiction.[38] Indeed, the writing of *Von Ägyptischer Kunst* followed directly on his intensive studies of Egyptian "figured ostraca" (*ostraca figurés*, *Bildostraka*, or *Scherbenbilder*), a large corpus of brush drawings on flakes of limestone that display a range of pictorial constructions (see Figures 6.21 and 6.23), sometimes noncanonical and possibly including assays in foreshortening and depth of field.[39] Needless to say, the very existence of these materials cast some doubt on Schäferian assertions about the essentials of Egyptian imaging; that is, that "pre-Greek" minds intrinsically image things in *Geradvorstelligkeit* when it comes to pictorializing them. For how could these pictures be produced at all if the Egyptians could not image things "perspectivally" when it came to pictorializing them? In his review of these artifacts in his systematic treatise, then, Schäfer sometimes tried to reduce the effects in question. Supposedly they were clumsy efforts to clarify an ambiguity in *geradvorstellig* configuration, that is, a kind of "exception that proves the rule" of *Geradvorstelligkeit*; errors generated in the struggle to picture; or simply mistakes by modern copyists imaging the ancient pictures.[40]

The two later editions of Schäfer's treatise that were published in his lifetime (1922 and 1930) expanded the range of his ancient Egyptian examples, dealing with many variations and changes in the basic principles that he had identified in 1919. Perhaps daunted by the resulting complexity, later Egyptologists often worked around his theory of the way in which the ancient Egyptians imaged objects when pictorializing them. Perhaps they were wary of Schäferian claims about children and Cubists as

partial analogs for ancient Egyptian pictorialists. But many of them tacitly accepted Schäfer's theory in the form of the cliché that an ancient Egyptian draftsman depicted "what he knew rather than what he saw," a slogan that became an enduring formula for the "conceptual image" in depiction, whether or not canonical Egyptian art is specifically denoted. This simplistic fallacy was promoted in 1940, for example, in William Stevenson Smith's fine-grained reinvestigation of the "principles of constructing the human figure in two and three dimensions" in Egyptian pictorialism in the Old Kingdom.[41] Even now it appears in textbooks of art history. But no picture can depict something known *rather than* something seen when it is rendering objects that are visible in natural visual perspective in visual space. Instead, it is finding ways — specifically pictorial ways — to know something about them in visible pictorial space, even if the features in question are virtual in that space. And simply to say that the Egyptians pictured what they saw in the way they knew it, and knew what they saw in the way they pictured it, would not really distinguish them from any other pictorialists anywhere.

In an editorial supplement to a posthumous (fourth) edition of Schäfer's *Von Ägyptischer Kunst*, published in 1963, Emma Brunner-Traut proposed to rename his basic category, and to some extent to rethink it.[42] She replaced *Geradansichtig-vorstelligkeit* with *Aspektive*, a less cumbersome term that readily translates into the English "aspective." In German the term functions as a substantive derived from *Aspekt-sehen*, "to see a coherent aspect." In English it can function adjectivally too. In making pictures, ancient Egyptian image-makers produced "aspective" pictorial renderings — or, to use the adverbial form, rendered things aspectively. In subsequent chapters, I will sometimes adopt the convenience of Brunner-Traut's term, though *geradvorstellig* is still preferable when one wants to denote the particular "virtual visual axis" (VVA) employed in canonical Egyptian depiction (Chapter Six). (It is unfortunate for my readers that *GTVC* used the term "aspective" to denote aspect-perception, or "seeing-as": in natural visual perspective — and visuality — as organized by forms of likeness in a historical form of life, one sees and depicts the aspects of things.) Still, caution is in order. In English, the term "aspective" might be read to denote "a-spective," lacking the involvement of seeing as such in picturing, as if the pictures were extra-perceptual — purely "conceptual." As we will see in Chapters Six and Seven, however, and as the theory of pictorial bivirtuality entails, aspective (however conceptual or perceptual) is not really the antecedent and opposite of perspective (however conceptual or perceptual). This polarity simply reproduces the contrast of "Egyptian" versus "Greek" with which this chapter began. Rather, it is the recursive part-succession of *aperspectival* pictoriality in constructing pictorial bivirtuality in NVP in visual space.

Birotationality

Frontality, Foreshortening, and Virtual Pictorial Space

1. BIVISIBILITY, BIVIRTUALITY, AND BIROTATIONALITY

In this chapter I abandon the "standard model" of the world-historical unfolding of pictorial structure described in Chapter Five, and develop another way of approaching the construction of space in pictorial bivirtuality, especially given the conditions of bivisibility (Chapter Four). In its history of rotational transformations in world art, the standard model describes rotations *from* an earlier and primitive frontality, sometimes identified as the default condition of all images and pictures, *to* a more advanced naturalism predicated on the integration of foreshortening in depiction and sometimes described as a revolutionary achievement of picture-making. But it is highly questionable whether the succession should be periodized in this way, and even whether it is unidirectional. Certainly the implied separation of pictorial bivirtuality into two kinds (unnaturalistic frontality and naturalistically foreshortened) is dubious. The endless permutations of apparently continuous/apparently discontinuous (AC/DC) pictorial bivirtuality permit pictorial naturalisms in which both frontality and foreshortening have roles to play in the pictorial succession—indeed, endlessly varied and mutating roles.

As I see the matter, rotational involutions can occur in a pictorial succession at *any* stage, from the most ephemeral visualization of the way in which an object might be rendered to graphic configurations virtualizing the object in pictorial space to inspection of the pictorialization in visual space. Regardless of "mental images" (such as Löwyan "memory pictures") that might be involved at any stage, in almost any translocation of standpoint in natural visual perspective (NVP) *some* frontality in any picture in visual space rotates smoothly into increasingly foreshortened transformations, and *some* foreshortening rotates smoothly into more frontal ones. (This translocation is perhaps most likely to occur when beholders, including the picture-maker acting as beholder, do not know in advance what standpoint might best secure pictoriality in the mere picture, especially the culturally privileged pictoriality intended in visuality, and test out a range of possibilities for the real-spatial placing of the imaging point [IP]. Indeed, the theory of bivisibility [Chapter Four] would predict that their uncertainty about the "right" IP is practically inevitable.) In turn, both directions of rotation can generate new AC/DC compounds of pictoriality in visual space. And in pictorialization a frontalized image (and/or rendering) can be turned to increase virtual foreshortening of the (depicted) object. Inversely, a foreshortened image (and/or rendering) can be turned to increase its virtual frontalization. In each and every resulting AC/DC compound, then, *pictorial bivirtuality is birotational—an intermeshing of frontality and foreshortening—in a particular way.*

To explore birotationality, I will focus on canonical depiction in ancient Egypt because the standard model, as we have seen in Chapter Five, has considered it to be maximally unrotated (both in the imaging involved in making the picture and in the resulting virtual pictorial space) and therefore highly discontinuous with the rest of visual space. Supposedly based on "conceptual images," Egyptian depiction was "unnaturalistic." As we will see, however, this approach overlooks several features of the phenomenology of ancient Egyptian constructions of pictorial space—how they were planned and made and how they were imaged in visual space. Of course, there have been scholars who challenged the standard approach. One such exception was the wide-ranging comparativist art historian, Richard Hamann, who in 1908 emphasized the *interaction* of frontality and foreshortening in all plastic configuration, and in describing ancient Egyptian depiction in a later book he took his own advice. He was admonished by the Egyptologist Emma Brunner-Traut for being "tolerant of the word 'perspective' to a worrying extent" in his assessment of Egyptian picture-making. In a sense, his case proves the rule.[1]

In this chapter, I offer reconstructions of the phenomenology of birotationality in canonical Egyptian depiction, noting especially the way in which it was constructed pictorially—corralled and coordinated in visual spaces that emerge in translocations of standpoint—with the help of guiding lines, grid networks, and proportional systems. In the following chapter, I will explore its more complex constructions of AC/DC virtual pictorial space—virtual space created in the elementary operations considered in this chapter—that are tightly bound to the architectonics of standpoint, that is, to the location of the beholder and his IP.

Because this chapter is quite technical, it will be helpful to give the gist here. Ancient Egyptian frontalized drawing and painting renders the surface features of an object (often depicted with careful local fidelity to optical appearances) as if laid out across its widest section(s) in a "section-contour" (Figure 6.1)—a virtualization on the two-dimensional plane of the *plane section between the two most distant plane surfaces (or their tangents in the case of objects with curved surfaces) of the real object when they are parallel to the axial line of sight.* Under most visual angles in visual space, these two "most distant" surfaces (or their tangents) likely will *not* be parallel to the visual axis, even when analyzed in terms of an overarching three-dimensional virtual coordinate space. Moreover, in visual space the surfaces, tangents, and planes in question can never *visibly* be absolutely parallel, for there is no such thing in NVP until it has recursively been virtualized as three-dimensionally coordinate; the geometrically parallel surfaces, the "faces," will be foreshortened. To "axialize" the line of sight, then, is to visualize the object such that the two most distant visible surfaces (or their tangents) are set parallel to the visual axis, and in turn such that the object—or one "face" of it at any

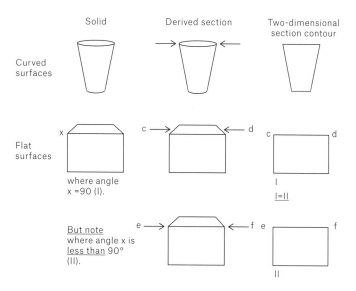

Solid Derived section Two-dimensional section contour

Curved surfaces

Flat surfaces

where angle x =90 (I).

But note where angle x is less than 90° (II).

I=II

6.1. Principle of section-contour pictorial construction of solids with curved and with flat surfaces in ancient Egyptian depiction, indicating its ambiguity.

rate—can be rendered two-dimensionally, or pictured, by way of the plane section described. In natural vision and in visualization, this almost always must entail rotating the object—a *primal rotation toward frontality* that occurs in an abstract "cubic" virtual pictorial space that coordinates the planes described. In turn, certain planes and articulations of this virtual pictorial space can be made visible in visual space, depending on the architectonics of the situation and on the visual angle.

I begin with elementary considerations about the way in which Egyptian depictions were laid out on the plane. They will lead directly into basic questions about the imagistic structure of Egyptian pictorial bivirtuality.

2. THE GUIDING PERPENDICULAR IN ANCIENT EGYPTIAN DEPICTION

Among mid-nineteenth century Egyptologists, Karl Richard Lepsius (1810–1884) had unrivaled familiarity with the full range of surviving Egyptian depictions and inscriptions known to scholars at the time. Published in twelve folio volumes between 1849 and 1856, his *Denkmaeler aus Aegypten und Aethiopen*, a massive epigraphic record of monumental inscriptions and the pictures accompanying them, has remained a standard source for generations. Lepsius was one of the first Egyptologists, if not *the* first, to interpret the networks of preparatory guiding lines sometimes found on painted

reliefs that were either unfinished or damaged. As his primary example, he used the painted reliefs in the mastaba of Manufer at Saqqara, datable to the end of the Fifth Dynasty or beginning of the Sixth (Figure 6.2).

Lepsius was right that certain guiding lines (and the grids which extended them) were correlated with a canon of proportion applied to depicted figures of gods, kings, and officials. But he was mistaken about the proportional *unit* of the canon in the Old Kingdom, which he took to be the length of the (depicted) foot of the figures. This identification forced him into what have been called "laborious" efforts to explain inconsistencies between this unit as applied to any given picture and the actual location of the guidemarks and guidelines on the plane (especially the intersection of horizontal guidemarks with the principal vertical guidelines)—perturbations due, he speculated, to historical variations in the proportional relationship of the foot-unit to other measures of height and breadth.[2]

Later scholars were not able do much better. In the early 1900s, C. C. Edgar described the unit in modern meters or, alternately and somewhat tautologically, specified it as "the side of a square" on a grid constructed on the principal vertical guideline identified by Lepsius ("the side of a square was the unit of the system, and the height and breadth of the various parts of the body were known in terms of the unit"). He provided measurements for the networks found on particular works, notably the corpus of so-called sculptors' studies in the Cairo Museum (mostly Ptolemaic in date). And he used the tautology to describe the seemingly invariant geometry of the networks, despite many irregularities in execution that could usually be attributed, he thought, to the "routine" nature of the task at hand or sometimes to sloppiness. In other words, he refrained from identifying the unit, or could not do so.[3] In 1930, Margaret A. Murray proposed that the height of the head of the depicted figure served as the unit, as in certain Classical Greek sculptural styles. Superficially this was a reasonable approach; "head"-units are common in world art. But again it was incorrect.[4]

The correct identification was not achieved until 1955, when Erik Iversen published his recognition that the unit was the breadth of the closed fist (at a transect over the knuckles across the breadth of the hand, including the thumb) as measured in a standard Egyptian metrology (one and one-third handbreadths; the "royal cubit" measured seven handbreadths and the "small cubit" six) (Figures 6.3, 6.4). In the oldest version of the canon, the unit was multiplied by eighteen to give the height of the standing figure to the hairline. On an intriguing ostracon (Figure 6.5), perhaps a pedagogical piece or a practice drawing by a student, a sketch of the head of the pharaoh Amenhotep IV (Akhenaten) is accompanied by a sketch of a closed fist, literally virtualizing the relationship implicit in the canon. On a Ramesside ostracon depicting a king wearing the Blue Crown (Figure 6.6), the two hands—one open and one clenched—might

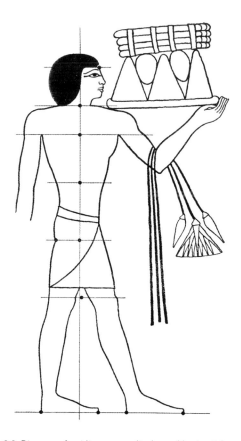

6.2. Diagram of guiding perpendicular and horizontal reference marks on unfinished relief of Manufer (Berlin 1108). (After Carl Richard Lepsius, *Denkmaeler aus Aegypten und Aethiopien* [Berlin, 1849–56], vol. 1, pl. 68.)

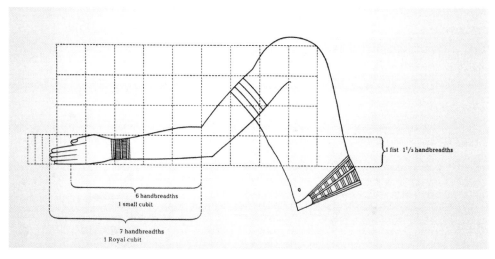

6.3. The fist as the module in the Egyptian canon of proportions. (After Sigfried Giedion, *The Eternal Present*, vol. 2, *The Beginnings of Architecture* [Princeton: Princeton University Press, 1963], fig. 311.)

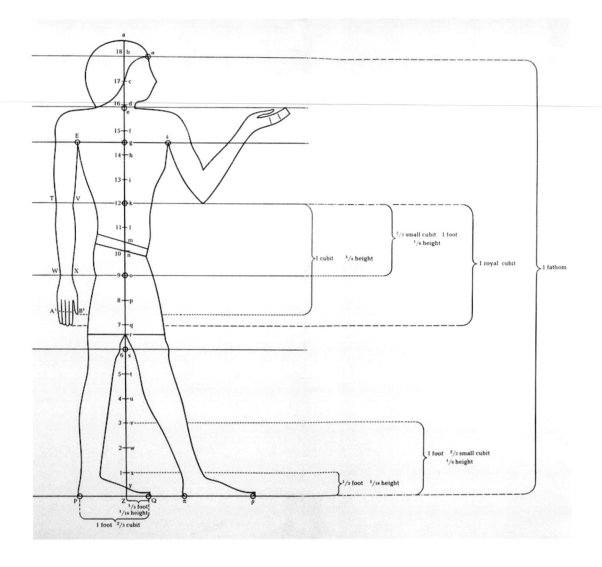

6.4. The human body and the square grid in the Egyptian canon of proportion. (After Giedion, *The Beginnings of Architecture*, fig. 313.)

have been added by the master artist to help the student understand the proportional relations: the open hand "shows the correct distance from the shoulder to the hairline or crown [and] the clenched fist describes the thickness of the neck, the distance from eye to chin, and other interior measurements."[5]

Once it became possible, following Iversen, to speak of the units not simply as "squares" (devices for producing the units in pictorialization) but as "handbreadths"/ "fists" with correlated Egyptian measures, the question of the guidelines on the plane and the proportioning of depicted figures would seem to have been resolved. All that remained was the specialized business of tracking many minor inconsistencies, historical variations, stylistic vicissitudes, and local manipulations in particular realizations of the canon — admittedly an intricate and finicky matter.[6]

In relation to the long history of research inaugurated by Lepsius, Iversen's achievement was undeniable, though later scholars (as well as Iversen himself) made many modifications. But for my purposes in this chapter, the entire approach takes us only so far. It does not offer an analysis of *imaging* in the pictorializations in question; it *assumes* the analysis. For the issue is not only the relation between guiding lines (and grids) and a canon or canons of proportion, or even the identity of the units of the canon (or canons) as represented by the guiding lines (and grids). At issue also is the relation between all the lines laid out on the plane (among other things applying a proportional canon) and canonical Egyptian pictorial bivirtuality — *geradvorstellig* or

6.5. Ostracon depicting Amenhotep IV (Akhenaten), Eighteenth Dynasty. Walters Art Museum, Baltimore (32.1).

6.6. Ostracon depicting a king wearing the Blue Crown, Ramesside period. Brooklyn Museum, Brooklyn (36.876).

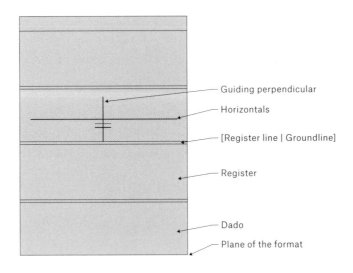

6.7. Diagram of the guiding perpendicular.

"aspective" bivirtuality (for these terms, see Chapter Five, §6). Simply put, what kind of pictorial space were the guidelines and canons helping the pictorialists to virtualize?

Needless to say, Lepsius's, Edgar's, and other pioneering scholars' lack of an accurate identification of the proportional unit was inconvenient. But for my purposes it was not fatal. For the uncertainty implicitly forced one to notice certain involutions and recursions of *geradvorstellig* pictorial succession. Let us start with the polyvalence of the principal vertical guideline in constructing the figure and stitching it into visual and pictorial space. I will call it the "guiding perpendicular" (GP) (Figure 6.7).

In two-dimensional pictorial representation (drawing, painting, and painted relief), GP is a straight line on the "plane of the format," as David Summers has called it, which therefore becomes part of what I will call the "plane of pictorialization": the vertical wallface (or the similar more or less upright surface of a pillar, stele, etc.) that has been prepared to receive the leading draftsman's preparatory marks, his outline sketches of the things to be pictured (and signs to be written), and finally the carving and painting carried out by a team of specialists in the later stages of the work (Figure 6.8).[7] (For immediate purposes we do not need to distinguish painting and painted relief. And we can postpone the question of nonvertical pictorial surfaces.) Typically this surface was more or less rectangular, though in visual space it might be foreshortened depending on its real size and the beholder's IP in NVP, a point to which I will return. Usually it was framed by dados and other borders. And it could be divided into two or more horizontal registers, more or less constant in height throughout their length (and sometimes internally subdivided horizontally and vertically), though not always of *equivalent*

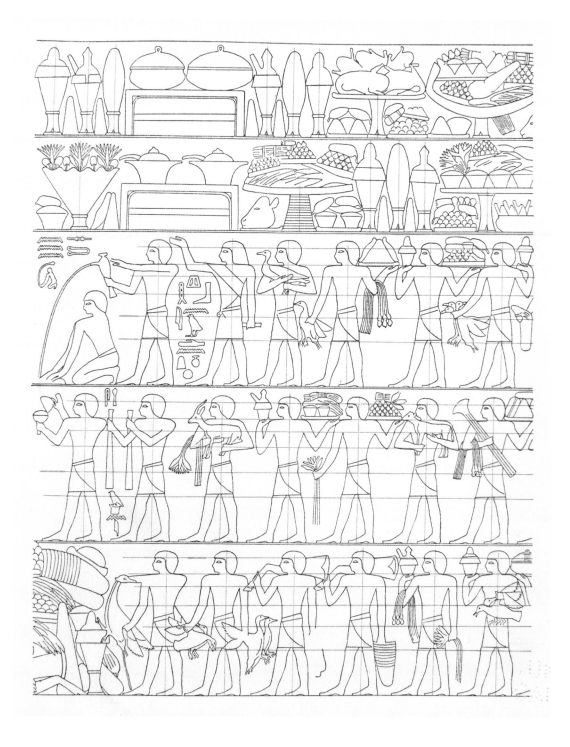

height one to the next. These are, of course, notional geometric and metric constants, not constants in visual space; obviously the registers could be foreshortened in either the horizontal or the vertical angles of vision, or both, depending on the beholder's IP in NVP. Indeed, acute foreshortening in NVP is a highly characteristic feature of paintings and painted reliefs in Egyptian tombs and temples, not least because the beholder is solicited to come close to inspect particular vignettes and read relevant inscriptions — in which case the rest of the register(s), if seen at all, must be seen at an acute angle — and because IP is often tightly constrained by the real architecture. (The relevant optical set-ups — and their effects on the visibility of pictoriality and indeed its phenomenal and aesthetic identity — are often not well captured in Egyptological epigraphy, which converts visual space into scaled-down two-dimensional representations that suppress foreshortening and enforce *geradvorstellig* visibility. But they can be simulated effectively in photographs, though Schäfer firmly recommended against doing so; Schäferian photographs of Egyptian two- and three-dimensional pictorializations would be *geradvorstellig*.) Egyptian architects and pictorialists might have stabilized these relations in "modular systems" (possibly relaying an underlying "harmonic system") that managed the ratio of the height of registers to the length of the room in the tomb in relation to the number of depicted figures.[8]

The top of each register strip served as a groundline for the figures and for objects standing on it, or otherwise positioned in relation to it. Usually the registers were never so high and the figures within them never so small that figures and objects resolved by the beholder in visual space would *not* have a spatial relation to the register strip pictorializing *as* virtual groundline, even if this relation was relatively indeterminate compared to the intervals between things placed squarely *on* the groundline. (Pictorialists sometimes added pictures *of* ground to the plane in order to clarify and specify the locations and actions of certain figures in the register, such as animals running and leaping.) Henceforth, then, I will assume the basic pictorial succession [register | groundline] and the virtual pictorial space it produced. Indeed, the groundline could virtualize as a ground*plane* extending "behind" it. But I will have to postpone consideration of this imagistic involution (that is, [register | groundline | groundplane]) to Chapter Seven. Suffice it to say here that it is a function of the foreshortening of the rectangle of the plane of pictorialization under many visual angles in NVP — precisely the kind of phenomenon in visual space that an overly rigid conception of Egyptian aspective frontality would have to overlook.

As in many ancient arts, representational matter *other* than depiction could be placed in the space of the plane of the register, notably hieroglyphs. Though read more or less sequentially on the plane, hieroglyphs could also function — as it were *co*-function — as (pictographic) depictions of objects in the virtual space inhabited by the

figures, while at the same time (hieroglyphically) describing them (for example, spec-ifying name and number) and creating the much-noted rebus-like quality of Egyptian pictography.[9] Distinguishing picture and hieroglyph is not always easy, and not always necessary and useful. (The bivisibility and bivirtuality of hieroglyphs could be a topic for a full-length book, but I am not competent to write it.) I will take it that depictions of objects were inherently open to spatializations that would not have been relevant in hieroglyphic designations of the same objects (that is, in pictographs functioning strictly as hieroglyphs) unless such spatializations refined their lexical, grammatical, and/or syntactic and semantic identity — a possibility always worth investigating.

GP has sometimes been described as "dropped," that is, produced downwards at right angles from the register line above it, using a string and plumbline. Frequently, however, it does not intersect — seem to originate in — the register line above it at all. And if it does, and even if it is *further* extended into the register below it as GP for depicted objects there (or even "dropped" through *all* registers from the topmost border of the plane of pictorialization to the lowermost), it does so without *propor-tional* implications. It does not set the vertical intervals between figures in the two (or more) registers in terms of the proportional unit used for figures within each register — a unit nonetheless common to both (or all) of them.[10]

At any rate the point is not really whether GP was actually dropped down from the register line above the figure. In strictly imagistic terms, GP is best described as "run up" from each groundline as high as was needed to proportion the figure in the vertical dimension — usually run up well into the head of the figure to the level of the ears and eyes at the least, to the hairline, to the top of the head, and/or to a point a little above the head. (In the unfinished painted reliefs in the tomb of Perneb we find instances of all these possibilities.) The issue is not trivial. Imaged as dropped (seen-as-as), GP need have little coordination with the figure beyond positioning it *horizontally* in the register relative to other figures, spacing them, and possibly positioning it vertically relative to figures in registers above and below, aligning them. Imaged as *run up through* the figure from its groundline (seen-as-as), however, GP can do more than oversee such simple operations in overall composition. As noted, it can *also* guide the virtualization of properties — visual aspects — of the figure to be rendered at the height needed in its register, namely, its proportions — the ratio of one segment of the figure traversed by GP, such as the head (2 units), to other segments, such as the thorax from shoulders to belt (5 units) or the legs from soles of feet to junction of both legs (9 units). The junction of both legs is at the mid-height of the entire figure.[11]

In the Old Kingdom, GP generally passed vertically from a point on the groundline just behind the front third of the rear foot of the figure to a point midway between the legs at the groin to a point immediately in front of the ear of the head rendered

in profile. As Lepsius originally observed, however, it does not truly *bisect* the body, even though much of the body is visibly arrayed as equivalently as possible on either side of the line, at least in the lateral *measures* of breadth if not in the area-shapes so measured. As Williams noted, likely "the lateral measurements were left more to the eye than the vertical proportions."[12] But even a merely optical effort to equalize the lateral measures on either side of GP tends to produce a somewhat unstable image of overall bilateral symmetry in the figure, *despite* its irreducible geometric asymmetry on the plane—an image, that is, at a range of IPs with visual axes more perpendicular to GP than less.

Indeed, Williams was quite sensitive to the full continuum of pictorial construction—and pictorial succession—from "optical" to plotted metric judgments. In general, as Edgar wrote, "if the subject was one of the common types, such as a seated

6.9. Perpendicular guiding lines and the first freehand
preparatory sketches with additions of washes, from
west wall of the outer chamber, Tomb of Perneb, Fifth
Dynasty. (From Williams, *Per-neb*, pl. 6.)

king, to fix the main points of the figure on the squared surface and fill in the outlines was almost a matter of routine"; or as Williams put it, "the guiding lines were often used as a matter of routine and were not taken very seriously."[13] Many compositional adjustments and aesthetic coordinations were left to the discretion of the draftsmen — to their care and talent. Still, it is not easy to find canonical configurations that definitely had been made *without* the use of GP and its horizontals and correlated indicator marks, let alone without an *image* of the figure as ideally constructed on GP. (Obviously most finished pictures obscure all traces of any guidelines used to make them.) The upper two right registers on the west wall of the outer chamber of the tomb of Perneb seem to be an example of the success of freehand (Figure 6.9): in these "bold" and virtuosic black sketches — well preserved and readily visible — no construction lines have been found apart from checkmarks made at the tip of the toes of the figures to space them on the register lines.[14] Registers in the tomb of Ne-kau-hor at Saqqara seem to be an example of the failure of freehand; though canonical overall without depending on any guidelines, slips and misalignments are quite visible.[15]

3. RADICAL PICTORIALITY AND THE GUIDING PERPENDICULAR

The very fact that GP could rarely bisect the figure (at any rate given its canonical "frontal-profile" rendering) opened up radical-pictorial and birotational possibilities for canonical pictorialists, whether or not the effects were fully integrated in canonical pictoriality. Within the Schäferian standard model, these effects must be treated as operations within aspective frontality — in *Geradvorstelligkeit*. But there are reasons to treat them as successions within Egyptian depiction that secure AC/DC bivirtuality in relation to the fact that it must accommodate oblique axes in projecting the depicted object and/or in viewing the rendering in NVP. Let us consider two such possibilities.

In *geradvorstellig* renderings of almost all kinds of objects, the straight-on axis of the view — what I call the "axis of direct observation" (ADO) — jumps from one more or less discrete frontalized section-contour to another (Figure 6.10), creating what Gerhard Krahmer called a "side-by-side" ("paratactic") arrangement of the parts of objects and a "side-changing" (*wechselseitig*) spatiality — highly DC-pictorial.[16] But in rendering the standing human figure (Figure 6.11), the "profile" construction of the thighs, lower legs, and feet and the "frontal" construction of the chest at the level of the shoulders had to be integrated in the area between the breast (the swelling of the breast and the nipple are shown in profile) and the midriff around the belly (with navel) and hip joints. In this region, the pictorialization has sometimes been said to be "foreshortened" — certainly a radical-pictorial possibility (Figure 6.12). That is to say, it seemingly rendered the abdominal area between the sternum and the pelvis on an *oblique*

6.10. Drawings of stools, tables, and beds in the Painted
Corridor of the Tomb of Hesire, Saqqara, Third Dynasty.
(From J. E. Quibell, *Excavations at Saqqara, 1911–1912:
The Tomb of Hesy* [Cairo, 1913], pl. 14).

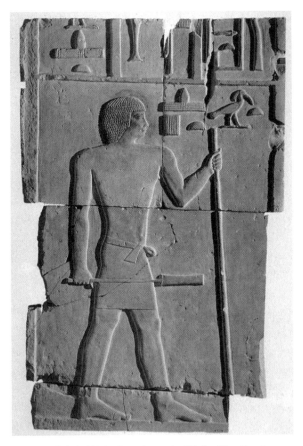

6.11. Relief of Nofer from the tomb of Nofer, Giza, Fourth
Dynasty. Boston Museum of Fine Arts (07.1002).

virtual axis—what Adolf Erman called a "three-quarter view," rendering the belly as if sitting at 45-degree angles to *both* the profile *and* the frontal section-planes below and above it. Because it did not contour the abdominal section in a fully bounded area-shape (its "left" and "right" boundaries continue the contours of the thorax from hips to shoulders), it seems paratactically undefined. In a seeming torsion, it blends in to the frontal chest and to the profile thighs rather than breaking up the trunk area with an intermediate plane or "facet." Erman said that this pictorial construction was simply "confused."[17] In turn, and not surprisingly, Schäfer found Erman's description confusing—impossible, and held fast to his concept of the *geradvorstellig* rendering. According to him, the shoulders rendered frontally are followed immediately by a fully *profile* view of the trunk from breast (or slightly above) to navel (or slightly below), preserving the strict intersection of planes at ninety degrees to one another that is supposedly characteristic of *Geradvorstelligkeit*.[18] As Sigfried Giedion correctly noted in turn, however, Schäfer's interpretation "puts the entire method of portrayal in question … a sudden jump from one plane to the other at this point [in the anatomy of the figure as rendered] is inconceivable."[19]

Still, one might suspect that the abdominal foreshortening remained within the domain of radical pictoriality—a by-product of the pictorializing procedure without being a fully *visible* aspect of the resulting depiction. It is rare to see substantial lateral displacement on any horizontal that intersects GP in this region of the body. This is not because it is not there metrically. (In Figure 6.12 it is visible, for example, to the viewer's left of the "near" side of the foreshortened rectangular plane.) It is partly because the actual breadth of the abdomen is too narrow for us readily to notice any displacement relative to GP, though the larger the figure in NVP (or the closer one's IP) the more any displacement will tend to become visible, with uncertain consequences for bivirtuality.

Indeed, we might suspect that GP was intended, in part, to *reduce* the visibility of the virtual abdominal torsion by metrically equivalencing (so far as possible) the two lateral breadths of any horizontal through GP in this region. At unit 11, the lateral extensions are equal, exactly one unit; here the figure—in its full bivisible, bivirtual, and birotational ambiguity—can be (radically) pictorialized as both flat/frontal *and* twisting/profile. At unit 10, where the lefthand lateral extension is a bit more than one unit (approximately 1.25), absolute flatness slightly recedes; the upper curve of the buttock seems to swell and swing slightly toward IP, an effect supported by the belt, which sits at about 20 degrees to the horizontal on that line. Still, the kilt helps the pictorialist to reduce—even suppress—the image in which the curve of the buttock, constructed left of GP, could belong to the right leg (the most comfortable "naturalistic" pictorialization) *as well as* to the left, where it literally might picture a deformity,

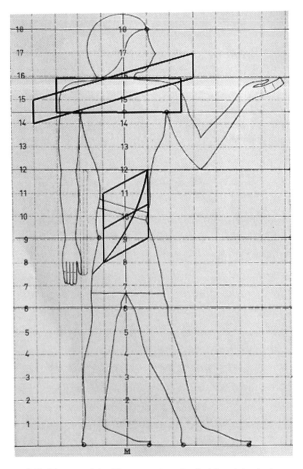

6.12. Diagram of the "three-quarters view" of the abdominal
area and of radical-pictorial foreshortening of the shoulders.

as it were, a lump beside the coccyx. One can *make* oneself image this deformation—a radical pictoriality—but the lateral (1 : 1) equalizations immediately above and below it on GP (at units 11 and 9) serve to corral it.

A second example is equally instructive. As Williams pointed out, canonical pictorialists often conformed the shoulders and upper chest of the figure in relation to the postures of the arms such that "now the front shoulder, now the other [is] nearer to the perpendicular [that is, GP]," even among figures in one register (see Figure 6.8).[20] In a radical pictoriality, this *could* be imaged as a foreshortening in depth: in a slight quasi-*contrapposto* twist in the upper part of the body, the slightly greater lateral breadth of one shoulder seems to lie in a plane *in front of* the main plane and the slightly lesser lateral breadth of the other shoulder seems to lie in a plane *behind* it. Creating

a slight optical flicker, these inequalities sometimes seem to be fortuitous; in spacing several figures on one register line, they would be difficult to avoid. And perhaps they were tolerated, even deliberately set up by the draftsman, to impart greater visual liveliness to the row of figures. But I prefer to suppose that they remained in the domain of radical pictoriality, though they could be activated in bivisibility — as I have just done, following Williams. My reason is straightforward. If this image of torsion in the figure *had* fully stabilized in pictorialization, then GP could not be pictorializing a virtual *straight* line in the body. Instead, in a straight line on the plane it would be pictorializing a curve or spiral. (In fact, if the pictorialists had wanted to stabilize the foreshortened image we might expect that they would have made consistent efforts visibly to differentiate — *further* differentiate — the lateral measures of breadth of the two shoulders in visual space.) On balance, we can safely assume that this radical-pictorial possibility was not replicated by the pictorialists in constructing GP: it would be incompatible with the *proportioning* of the figure carried out by GP.

In other words, and in sum, GP is not only a guiding line — a straight line on the plane of pictorialization that is perpendicular to the register lines which pictorialize groundlines. It is also a *picture* — a pictorialization of a virtual axis in the body. Though constructed as a line *on* the plane of pictorialization, it is partly imaged as *in* the virtual body — the main axis of its vertical upright stance and its volume on the virtual groundplane of the spatiality it seems to inhabit. (As noted, I will return to the way in which groundline pictorializes as ground*plane*, the space of virtual depth *in* the register.) Because this axis, this pictorial succession of GP, is neither ventral nor dorsal in coordinating the parts of the virtual body that extend around it on the plane (and in NVP seem to rotate around it), I will call it the "median vertical axis" (MVA) succeeding from GP [GP | MVA].

4. THE MEDIAN VERTICAL AXIS IN ANCIENT EGYPTIAN DEPICTION

Strictly speaking, MVA is the equivalent on the two-dimensional plane of that vertical axis which would be found inside a free-standing statue of a human body that has been sculpted out of an originally rectangular block and configured according to the "law of frontality" identified by Julius Lange: "Whatever position the figure assumes the rule applies that the central plane which can be supposed to lie lengthways through the human body, through the backbone, the crown, the nose, the breastbone and the sexual organs, and which cuts it in two symmetrical halves, must retain its position in one plane, and cannot be turned or bent one way or another." If this vertical median plane is cut through at right angles by a second vertical median plane, "the line of intersection of these planes ... becomes the axis of the figure" (Figure 6.13).[21] A virtual axis

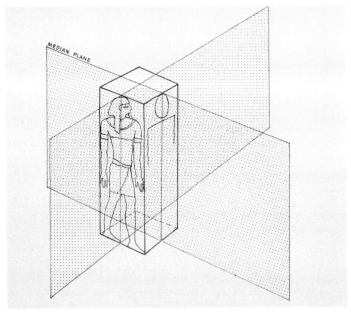

6.13. Julius Lange's "law of frontality" and the "median plane as organizing principle." (After Giedion, *The Beginnings of Architecture*, fig. 308.)

inside the depicted body, MVA can be distinguished from the virtual visual axis (VVA) of "straight-on-viewed" or *geradvorstellig* rendering and the "axis of direct observation" (ADO) that is correlated with it (continues it) in the visual space of a place (such as a tomb chapel) which has been architectonically standpointed for it (Figures 6.14, 6.15). But all are mutually coordinated. Both VVA and ADO intersect MVA at right angles (◊): VVA by definition in virtual pictorial space; ADO by design in visual space when the plane of pictorialization is more or less perpendicular to the visual axis of the beholder's IP in NVP. (I will have to return to the implications of the succession [ADO | VVA]. Though assumed as the very basis of *Geradvorstelligkeit*, that is, as constitutive of aspective frontality, it might only be realized *recursively* in visual space — that is, in imaging a space that is continuous with the *virtual* space organized in the two intersections MVA ◊ VVA and MVA ◊ [register | groundline].)

As straight lines on the plane of pictorialization, GP and MVA are (almost) identical; for much of the extension of the plane, they are the very same line. (I hedge my bets about whether GP between the top of the foot and the bottom of the kilt and GP above the head would be imaged as MVA, like a skewer run through the body. I incline to think so: [GP | MVA] probably has statical value, pictorializing how the body stands and distributes its weight.) But because GP also *pictures* MVA, we should

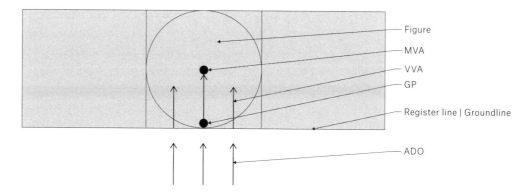

6.14. Analysis of the median vertical axis (MVA) in
the standing human figure; plan view of the axis
of direct observation.

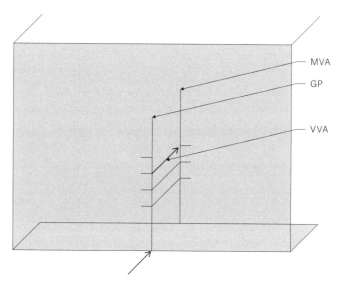

6.15. Analysis of the median vertical axis (MVA) in the
standing human figure; axonometric view of the plane
of the format.

reserve judgment about their identity in *imaging* in the pictorial succession. When
the pictorialist constructed GP, presumably he did not image it exclusively as a line
on the plane (though in pictorialization it was one of his first configurations *on* the
plane, produced *before* drawing the body), let alone imaging it as a line on the *surface*
of the body rendered on the plane, as it were a tattoo (though it could be imaged
that way—another radical-pictorial possibility). He also imaged it as the axis of the
virtual body depicted on the plane—a body to be proportioned with respect to the

height and breadth of its parts extending around MVA, rotating around it, and perhaps birotationally flickering. At a certain stage, this imaging had to take account *not only* of [GP | MVA]—that is, in ruling the vertical on the plane of pictorialization and in segmenting it horizontally in terms of the proportions of the body. In one of the special compounds of Egyptian pictorial bivirtuality, [GP | MVA] was *also* imaged as continuously perpendicular to [ADO | VVA] in visual space. For GP was horizontally segmented precisely *not* in picturing a body as imaged in NVP. It was divided in terms of the measures of the heights or "levels" (and therefore the ratios) of segments of MVA imaged *without any deformation under the visual angle*—that is, without any loss of the visibility of proportional relations (and therefore their integration into the intended pictoriality) due to foreshortening.

In §6 I will turn to the complex recursions involved here. So far, however, we can derive the recursion of the succession [GP | MVA ◊ ADO | VVA] and the unforeshortened virtualization of the internal vertical proportions of segments of [MVA | GP]. And this was the very question with which I began: what do the proportional guidelines on the plane have to do with pictorial space? We now have a partial answer. They give the three-dimensional spatiality [MVA ◊ VVA] in virtual pictorial space and its potential continuity not only as ADO in real space at standpoint. They also give that spatiality as an axis extending into depth perpendicular with [register | groundline], succeeding to what might be called a "virtual coordinate *plane*"—a phenomenon of Egyptian pictorial bivirtuality to be considered in detail in Chapter Seven.

In theory canonical pictorialists might have imaged GP as a guideline used merely to give a rigidly upright figure on the plane. Substantial deviations from this vertical would correlatively establish special actions of the body, such as bending over and twisting around. But other lines drawn at right angles to the register lines could have served equally well, or better, as guides of this kind. To construct, control, and confirm "uprightness" in geometrical and numerical terms, GP is not, in fact, the most suitable and logical instrument. A better device on the plane would be a frame of *two* lines perpendicular to the [register | groundline], enclosing the trunk of the body, intersected by at least one line perpendicular to them (that is, a horizontal), best drawn, say, from armpit to armpit through the sternum (between units 14 and 15) (Figure 6.16). Here one could control the equal height of the armpits within the resulting "box" and/or use the box to confirm that the armpits *are* at equal height. Of course, when GP is produced as a part of a grid, it can do this. But initially canonical pictorialists were often content simply to make small marks *on* GP to indicate the height of different features of the body, suggesting that they were primarily interested in the ratios that resulted. Evidently they were confident about the "trueness" they could secure on the plane by GP alone.

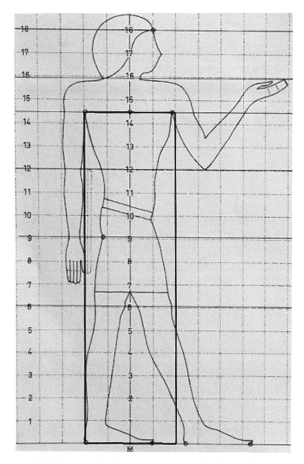

6.16. Diagram of an "uprightness control" in the standing
human figure.

Still, there is a crucial recursion here: the ratios are the ratios of a figure notionally unforeshortened in the vertical dimension, as it were its "real" extra-optical proportions. On the plane of pictorialization, this requires a not only a perpendicular that pictorializes the uprightness of the figure, but also a perpendicular that makes the ratios visible regardless of the optical foreshortening of the surfaces depicted—foreshortening that might be radical-pictorially retained and/or restored in imaging, for example in the cases of the abdominal and gluteal areas (§3). To secure this phenomenally, one must image GP not only as a line on the material surface of the plane of the format, which it certainly is, and not only as a line on the depicted surfaces of the body, which it can be at moments in the pictorial succession. One must also image it as a line *inside* the body (that is, MVA). In the succession [GP | MVA], the "extra" virtual

space (VVA) that extends a virtual line from a point on GP to the *interior* correlate point on MVA does the imagistic work: it shows that the points on GP are situated independent of foreshortenings of the sloping surfaces of the body. To be sure, the perpendicularity of this line (imaged as [ADO | VVA]) is not foreordained. It is itself a recursion within the entire pictorialization, secured, for example, by imaging GP as lying on a plane perpendicular to [register | groundline | groundplane]. If the figure were projected on *this* plane it would be wholly frontal, just like the figure that would be drawn on the forward face of a cubic block to be carved out as a sculpted figure (see Figure 6.13). The actual rendering on the plane is an intricate birotational succession in relation to this primal quasi-sculptural image. All of this necessitates our looking more closely into the question of "primary verticalization" (§6). As Giedion perspicuously noted in 1964, "the penetration into Egyptian art of the vertical as an organizing principle is overwhelming"—as "fanatical as the effects of perspective representation in the Renaissance."[22]

5. MATERIAL EVIDENCE FOR THE SUCCESSION OF THE MEDIAN VERTICAL AXIS

So far I have tried to make phenomenological sense of graphic practices and products in the field of bivisibility, bivirtuality, and birotationality and in relation to radical-pictorial possibilities. But I have engaged in strictly analytical reconstruction. It will not be easy to find material evidence—forensic evidence—for the basic succession [GP | MVA]. For [GP | MVA] is but one early stage in the succession of canonical pictoriality—imaging traversed by the pictorialization even as it involves and perhaps perpetuates radical-pictorial alternatives in birotationality. Indeed, it is a stage that literally disappears; in the end neither GP nor MVA will be visible on the plane of pictorialization. In bivisibility, some beholders might imagine their presence and some might not. Ancient Egyptian painters were not Cubists, but a Georges Braque might see their pictures as prefiguring some of his own (despite the fact that [GP | MVA] was not used in Cubist construction), if only, as Giedion put it, in "tilting the horizontal plane into the vertical."[23]

We can learn a good deal from the guidemarks and guidelines found on unfinished reliefs. (For the moment I have treated them as two-dimensional, that is, in terms of the *drawing* on the plane that would guide the subsequent carving of the picture as a *three*-dimensional relief. In the next chapter, I will factor in the succession from two-dimensional drawing to three-dimensional relief.) But the guide marks do not tell us everything precisely because the imaging involved in the pictorial succession of canonical bivirtuality, as we have seen, moves in part through *three-dimensional*

6.17. Unfinished statuettes of King Menkaura (showing red guidelines) from the Valley Temple of Menkaura, Giza, Fourth Dynasty. Boston Museum of Fine Arts (11.730).

intuitions and imaginations of visual space, including [register | groundline | ground-plane] and [GP | MVA] ◊ [ADO | VVA]—elements of a "cubic" quadration of pictorial space.

Fortunately, we can consult such evidence as unfinished three-dimensional sculptures, notably the examples found in the Valley Temple of Menkaure (Third Dynasty), which demonstrate "the successive stages through which a statue would pass to completion" (Figure 6.17).[24] Among the finds of sculpture from the Valley Temple, George Reisner excavated fifteen unfinished works that he identified as exemplifying eight stages in the production (from most to least unfinished) of a seated statuette of a king, which was recognizable as a portrait of Menkaure by the time the carving reaches State V.[25] Not surprisingly, the most unfinished (State I), roughly blocked and rubbed, displayed the sculptor's guiding lines in red paint on the hands and face, but they were still found on Stage II (for guiding Stage III). As William Peck has written, "at each major stage of completion the master sculptor would make new indications on the block in red paint as a guide to the worker who did the actual carving; this suggests that the drawing not only functioned at the outset, but continued to be useful throughout the sculptural process."[26]

In addition to such works, we can also consult the fully three-dimensional (though sometimes in part deliberately unfinished) "sculptors' studies." Presumably these artifacts served as templates, prototypes, and/or demonstration pieces for canonical Egyptian pictorial practice, though with the proviso that they survive from the latest phases of its tradition. Often the guidelines were laid down only on the unworked backs of these artifacts, on which "they are, as it were, a statement of the standard rules, exemplified by the finished work on the other side."[27] The unworked back, however, was not the plane of pictorialization, but only a plane of pictorial succession to it. The place—and space—of pictorialization was the three-dimensional whole in which back, front, sides, and top were coordinated. In theory, then, on sculptors' studies we

 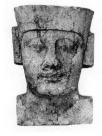

might find guidelines for certain operations that the sculptor needed to undertake in the *actual* carving, which the draftsman merely had to image along the way.

On sculptors' studies that set out (and still preserve) such lines on two or more faces/sides, what would appear as GP in painting and painted relief invariably appears as a vertical line either on the face(s) of the block to be carved or in the apposite position on the surface of the body being carved (sometimes only roughed out, sometimes quite finished), or on both. Edgar called it "Line A", that is, the "central," primary, or essential guiding line for the sculptor (Figure 6.18). Considering that the function of the lines was to guide the sculptor in cutting down *to* the curved surfaces of the figure *from* the flat faces of the block, A appeared on two or more faces in order to calibrate the cutting in the proper direction at the proper depth — that is, toward A *imaged as MVA of the figure* — while coordinating the proportions of MVA as measured *on* GP. Planes produced through [A | GP] on the faces (and perpendicular to them), then, should intersect [A | MVA] "inside" the block, that is, in the interior of the figure to be carved.

It follows that if we were to take a *horizontal* section through the block (or through the figure being carved out of it), we would find [A | MVA] at the interior intersection. Notations of *this* are rare for the obvious reason that horizontal sections are rare; there was no technical reason to produce them because A's (and correlated verticals and horizontals) on the faces of the block and surfaces of the figure were sufficient to control the carving. Thus guiding lines drawn on the *top* of heads to be carved (or on the top face of the block) seem to be intended chiefly to help the sculptor situate the lateral extremities of the figure, rather than to find MVA, even though MVA might be produced in setting out these lines (in particular the line or lines controlling the location of the ears).

On the top of CCG 33362 (Figure 6.18a), then, line *bb* and A cross where GP in two dimensions would pass just in front of the ears, as in CC 33363 (Figure 6.18b) (where the same horizontal is designated *aa* in Edgar's system). On CCG 33355 (Figure 6.18c), a horizontal through A on the top locates the front of the ears, and on the right side a vertical line locates the back of the ears. On CCG 33358 (Figure 6.18d), Edgar took the two closely spaced horizontals through A to locate "the front of ear at top and bottom respectively." There is considerable variation and slippage in these relations. On CCG 33361 (Figure 6.18e), *bb* through A is well forward of the front of the ear; there appears to be no horizontal line crossing A (in this network it cannot be what Edgar would designate *cc*, which is too far back). On the front of this work, a line on the surface "down [the] middle of headress and throat [is] not very true."[28]

But one possible example of the notation of [A | MVA], maybe unique, can be found. CCG 33373 (Figure 6.19) is the trunk of an unfinished statuette (approx. 20

cm high) of a striding man (with no back pillar), cleanly sectioned through the knees and the neck and incised on the sectioned surface of the neck with a "cross" and one short horizontal mark. Unlike the networks of lines on the back of sculptures and on the top faces (controlling the location of features of the head), this grapheme can hardly have helped, as a representation of A, to coordinate the *proportions* of the figure laid out on [GP | MVA]. But nonetheless it marks the intersection of planes produced through A *as* [A | MVA], showing in the round what GP pictures in two dimensions. I suspect that these marks were made to make this didactically visible — a three-dimensional explanation of A and all other lines.[29]

That A pictorializes MVA seems to be suggested by these traces. That MVA imaged in these lines was being visualized specifically in *geradvorstellig* aspect and its proportions so virtualized (even though it was being measured and carved in NVP in visual space) is suggested by such traces as CCG 33363 (Figure 6.18b), an unfinished limestone head of a king or a god found at Saqqara (16.5 cm. high). Like CCG 33373, it might have served as a special demonstration piece. A network of guidelines is preserved on all six surfaces. On the top, *aa* through A marks the front of the ears. On the front, A is incised from top to bottom through the middle of the headdress, forehead, neck, and chest; two lateral verticals were incised one unit distant. A horizontal black line is drawn through the headdress, picked up by a black horizontal (it should be *cc*) on the

6.19. Sculptor's study with indication of MVA (?),
Ptolemaic period. Egyptian Museum, Cairo; CCG 33373.
(From Edgar, *Sculptors' Studies*.)

back, where we also find A and its two lateral verticals. Also on the back, the outline of the head below the headdress was drawn in red. Two black horizontals passing through A and intersecting the red outline mark the middle of the forehead (*ee*) and the base of the nose (*ff*). As Edgar writes, "the surface being on a slope, the *actual* distance between the horizontal lines is more than one unit, [but] *their levels are exactly 1 unit apart*," proving that A is MVA segmented by GP in "aspective" proportion.[30] (To *see* this in visual space, one had to adopt ADO in the succession [ADO | VVA ◊ GP | MVA], ideally by locating the central axis of IP in NVP as a perpendicular to A at the point A ◊ *ee*, the point A ◊ *ff*, etc.) Of course, this would be true (if my explication of the pictorial succession is correct) of all A's drawn on the sloping surfaces of the head on the *front*. But we rarely find two or more horizontals on this line to prove that the aspective approach to [GP | MVA] was being made visible *for* imaging, at any rate during the preliminary stages of the pictorialization.

6. VERTICALIZATION IN BIROTATIONALITY

I have suggested that [GP | MVA] ◊ [ADO | VVA] can create a virtual coordinate frame within which the figure might be rendered in the proper proportions assigned to its visible area-shapes (possibly including its "virtual volume," considered in the following chapter). It *can*—but it might not. A recursion has to be assumed—an involution in imaging. A single straight line on the plane of the format must succeed to [GP | MVA] *as* parallel to the plane of the format and perpendicular to the visual axis. For notice that if *either* the straight line (at the "graphic" end of the succession) *or* MVA (at the "pictorial" end) is not pictorialized as perpendicular to the visual axis (seen-as-*as*), then it will be impossible to proportion the figure as if it were vertically unforeshortened.

Specifically, a feedback in the pictorial succession must resolve radical-pictorial visibilities of straight lines that could be pictorialized in different ways, whether in the field of bivisibility or in the construction of a different bivirtuality or in both. Let us imagine an intelligent apprentice in bivisibility (not yet fully cultured in canonical Egyptian visuality with respect to making pictures) called to assist the master draftsman in laying out a picture of a boat being towed around a pond in the tomb of Nakht at Thebes (Eighteenth Dynasty) (Figure 6.20). He might ask the master why GP is to be *imaged* as perpendicular to the groundline, though it might well be *drawn* that way, that is, using a right angle. After all, on the plane it runs parallel with other "verticals" that pictorialize some objects as "nearer" to lowermost horizontals on the plane of pictorialization and some as more "distant" from them *when these verticals are imaged as being at right angles to GP*. Presumably the master's (tautologous) answer would have to be that the human

figures are perpendicular to that bivalent vertical—they are "upright" (that is, [GP | MVA]). Still, as the apprentice might reply reasonably enough, they look rather like they're lying spread-eagled on the ground—that is, parallel with *it*!

I adopt my example advisedly. In his influential essay "Perspective as Symbolic Form," and taking the example from Schäfer, Erwin Panofsky used the painting in the tomb of Nakht to exemplify the entire "initial 'archaic' epoch" of world art history—what I have described as Phase I in the standard model [Chapter Five]—in which draftsmen and painters sought "to reduce corporeal objects to the purest possible ground plans and elevations. The spatial relationship of these objects to one another can thus be suggested either by a combination of these two formal types (as in the well-known Egyptian representation of a garden which shows the surface of the water in plan but the surrounding trees in elevation, and thus diagonal trees in the four corners); or by a juxtaposition or superposition of elevations."[31] Though true enough as far as these terms go, all relevant successions lie *within* them. "The purest possible" is not "the

6.20. Painting of a pond in the Tomb of Nakht, Thebes, Eighteenth Dynasty. (From John Gardner Wilkinson, *The Manners and Customs of the Ancient Egyptians*, new ed. by Samuel Birch [London, 1878], vol. 2, 212.)

wholly pure" or "the maximally pure." And the "combination" must integrate—partly mobilize and partly suppress—the potential "Gestalt switch" I have just noted: horizontal switches to vertical, and vice versa, in the virtual pictorial space of the combination. Stated another way, the question is not only about the "combination of two formal types." It is also about recursions that must occur throughout the supposed "reduction" that *succeeds to* the formal types. (Perhaps it is telling that in describing the painting in Nakht's tomb Panofsky mentioned the pond and the trees but not the human figures.)

Ambiguities like these are unavoidable in at least two ways. First, if the straight line that gives [GP | MVA] ◊ [register | groundline] is viewed at a highly acute angle in NVP, it can appear to tilt back slightly toward strongly foreshortened lines that are already present in visual space, notably the "horizontal" straight edges of the format and the register line(s), now visible as orthogonals. In this visual space, the ninety-degree angle of registers and GP breaks apart; even though GP remains visibly parallel to other *verticals* that are already present, in the horizontal foreshortening the angle becomes greater than 90 degrees. This enables a radical-pictorial flicker.

Slightly "horizontalized" straight lines succeeding to MVA's can be handled readily in a canonical proportioning of the figures with which they are calibrated. One simply ignores depictive implications of the acute angle, even though it is perfectly (bi)visible. Of course, if the median vertical line was actually *drawn* as an "off-true" straight line on the surface—that is, with a "tilt" toward the horizontal—immediate pictorial difficulties would arise. On a Ramesside ostracon depicting the standing figure of a king (Figure 6.21), likely sketched by an apprentice draftsman, the freehand median line was not perpendicular with the groundline, causing the sketch of the lefthand leg to be "too long" relative to the right. The neck carried the tilt into the head; though rotated to a proper parallel with the groundline, the head (which seems to have been completed by the master draftsman) has an upward tilted look—at any rate in radical pictoriality.[32] What is this king looking *at*, then?

Such an effect could be pictorialized to show how things in the virtual pictorial space fly around or fall about "in different directions" in relation to edges and [groundlines | groundplanes]. Here a kind of "wild" virtual pictorial space might emerge. Canonical Egyptian pictoriality avoided it—straightened it out, or, alternately, fenced it in, confining it to special enclosures of multidirectional virtual space that could be used for distinct iconographic and narrative purposes (notably in depicting animals in motion in the hunt, a theme of prehistoric antiquity).[33] In different visualities, however, this noncanonical bivisibility of the bivirtuality in question could be the very order of things in the world as pictorialized on the plane.

A second birotational possibility must be considered. A straight line succeeding to [GP | MVA] that is geometrically vertical on the plane of the format might nonetheless

not lie flat visually. In NVP and/or in radical pictoriality, it can seem to fall forward in front of the plane (virtually in visual space—coming into the "room" in which the beholder/IP is located) or to fall away behind it (visually in virtual space—going back into "depth"). (In another variant of pictorial bivirtuality, after all, a straight line on the plane that has exactly the same conformation as GP might pictorialize something extended from the groundline to a distant point [the so-called vanishing point] "in depth"—a matter I examine in the case of painter's perspective [Chapter Nine].) Such "recessionalized" straight lines in visual space would make it difficult for the pictorialist to construct proportions that could be seen as shared by all figures constructed on [GP | MVA]: relative to the lower segments of MVA, the higher segments of MVA would likely have to be seen as more foreshortened. And the "perspective" grid that would allow numerical construction of the proportions—a foreshortened grid on the virtual groundplane perpendicular to the plane of the format—has not yet emerged.

Needless to say, further complications could ensue in the virtual pictorial spaces that would succeed from horizontalized and recessionalized lines on the plane of pictorialization in visual space. But the overall point is straightforward. The construction of the figure in canonical aspective pictoriality requires "verticalization" of GP *as* a visible vertical straight line on the plane. Given radical-pictorial possibilities of horizontalizing and/or recessionalizing the line, this must happen in imaging [GP | MVA] *as* a virtual rotation of the straight line: imagistically one rotates lines on the plane of pictorialization *such that* a straight line succeeding to [GP | MVA] virtualizes as perpendicular to the visual axis in visual space (that is, GP ◊ ADO). As I have insisted, this must be *a highly particular succession in birotationality*.

In the cultural history of bivisibility in northeast African picture-making from the eighth to the third millennium BCE, it is not surprising to find historical sequences of picturing—historical series of pictures—within which this succession seemingly unfolded, though in fits and starts. Objects depicted in "Predynastic" pictures were substantially frontalized. But the specifically aspective frontality of canonical Egyptian depiction did not appear until the Early Dynastic period. Until then, wholesale rotation to the perpendicular was not always undertaken, though parallelizing section-contour construction could be used. Indeed, rotation to the perpendicular sometimes seems to have been actively *avoided* in order to virtualize complex dynamic spaces that partly depend on imaging things situated in them as horizontal and/or receded relative to one another, and requiring active movement and translocation of the plane of pictorialization relative to IP, such as we have seen in the case of Magdalenian engraved plaquettes (Chapter Three).[34]

Still, Predynastic pictorializations continued to be visible in the era of canonical picture-making that succeeded them and supervened in them—presumably situating

them as "precanonical" in visuality—even if it did not wholly supersede them. A major achievement of late prehistoric Egyptian pictorialization, the so-called Two Dog Palette (Figure 6.22), was buried along with the Narmer Palette (one of the works that had consolidated canonical pictorialization) in the so-called Main Deposit at Hierakonpolis, possibly as late as the Fifth Dynasty. And petroglyphs made as early as the fifth millennium BCE likely were visible to Egyptian soldiers and traders who traversed the eastern and western deserts and occasionally ventured far into the Sahara and along the southern stretches of the Nile. The same role could have been played by relatively "informal" pictorial productions, such as *ostraca figurés*, whether

6.21. Ostracon depicting a standing figure of a king, Ramesside period. Egyptian Museum, Cairo (CCG 25002).

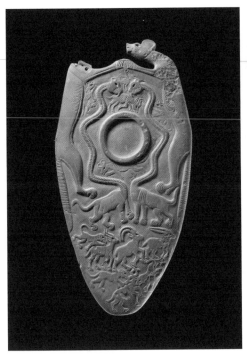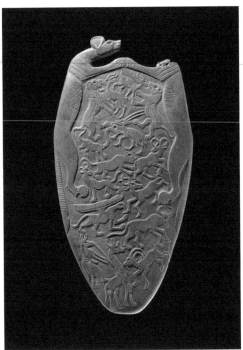

6.22. The Oxford ("Two Dog") Palette, Late Predynastic
period (found in the Main Deposit, Hierakonpolis, Fifth
Dynasty [?]); a, obverse; b, reverse. Ashmolean Museum
of Art and Archaeology, University of Oxford (AN 1896–
1908 E.3924).

their noncanonical features emerged by happenstance or in deliberate experimentation. Any such pictures could have provided imagistic prototypes in the field of bivisibility and alternate bivirtuality against which canonical pictures were coordinated *as* visibly aspective in pictorialization. Indeed, on ostraca used in teaching one can sometimes literally see the master draftsman rotating an apprentice's "incorrect" foreshortening, as it were projecting too much from the plane, to the vertical and the flat—an actual succession of "frontality" in birotationality made visible as a pictorialization. An Eighteenth-Dynasty ostracon from Deir el-Bahari bears two owls (Figure 6.23): an apprentice's work on the left, in which the bird appears slightly foreshortened and as if peering out to its left, and the master's on the right, which more correctly frontalizes, though maybe not wholly (compare an owl on a Ramesside ostracon from Deir el-Medineh [Figure 6.24]).

7. THE VIRTUAL-SPATIAL CORRELATE OF CANONICAL EGYPTIAN BIROTATIONALITY

As the primary rotation in ancient Egyptian pictorial bivirtuality, the verticalization of a straight line that succeeds to GP *de*foreshortens certain radical-pictorial ways of imaging it, corralling the optical flickers that devolve from the actual visibility of the plane of pictorialization in visual space.

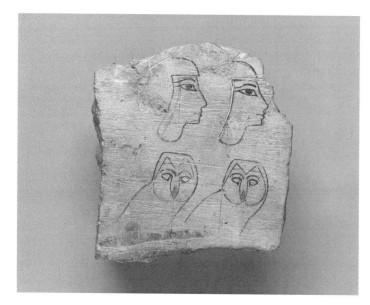

6.23. Ostracon depicting owls: a master's correction of an apprentice's drawing (?), Deir el-Bahari, Eighteenth Dynasty. Brooklyn Museum, Brooklyn (58.28.2).

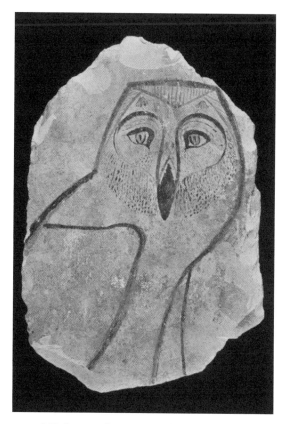

6.24. Ostracon depicting an owl, Deir el-Medineh, Ramesside period. Fitzwilliam Museum, University of Cambridge, Cambridge (3848.1943).

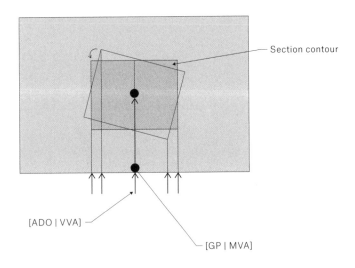

Section contour

[ADO | VVA]

[GP | MVA]

6.25. Diagram of the "invisible" rotation to the plane of the format.

But where does rotation of the emergent virtual figures that are spatialized on [ADO | VVA] ◊ MVA come to a *stop*? After all, every visible plane (visible, that is, at a given IP) could pictorialize a visibly *unique* degree of rotation relative to all of the others. Aspective pictorialization in canonical Egyptian style involves a *secondary* rotation in an invisible dimension (Figure 6.25). The most distant opposed virtual surfaces of the objects (or their tangents in the case of curved surfaces) are "turned" to be parallel with the perpendicular of [ADO | VVA] ◊ MVA that emerged in the primary rotation—a rotational orientation pictorialized on the plane by the flat section-contour of the volume so enclosed. (As Schäfer recognized, these "invisible parallel planes" are crucial to the construction of aspective configurations; his mistake was to reify them as perceptual-cognitive orientations that *determine* pictorialization rather than as results of succession and recursion, visualizations and virtualizations, in the pictorial succession itself.) Therefore ADO is virtually replicated for all points on the section-contours; foreshortened images of the picture are literally pushed to the side.

Of course, these are birotational directions—not totalizations and terminations. Canonical Egyptian depiction "parallelizes" as fully as possible, given that the pictorialist did not choose simply to *convert* all naturally curved surfaces to flat planes at right angles to one another, picturing the human body, for example, to be a blocky "Lego-like" structure. (Here one sees the pull of AC-pictoriality.) This is the phenomenological paradox—and potential—of aspective pictorial bivirtuality. The very fact that its "flatness" and "straight-on-ness" on the two-dimensional plane is imagistically organized in visual and pictorial birotational operations in the third dimension creates

virtual pictorial space not despite the flatness and straight-on-ness, but precisely *because* of it. And *despite* the flatness and straight-on-ness of the pictorialization on the plane, because it is virtual pictorial space it contains emergent "illusions" of virtual volume, of depth of field, and of distance, possibly even of recession and diminution (to be investigated in the following chapter). These complex recursions in the pictorial succession are not mere duplications or transcriptions of "memory pictures" or "conceptual images" on the plane, externalizing them — as simplified Löwyan and Schäferian strains in the standard model would have it (Chapter Five). Rather, they tolerate birotational flickers and indeed replicate them in pictorialization under well-controlled operations of construction and coordination on the plane.

Pictorial Successions of
Virtual Coordinate Space

What Hesire Saw

Virtual Coordinate Space in Ancient Egyptian Depiction

1. SUMMERS'S REVISION OF THE "STANDARD MODEL"

Influenced by the ideas of the Classical art historian Emanuel Löwy and the Egyptologist Heinrich Schäfer (Chapter Five), the most recent—and a magisterial—version of the standard model as a global narrative was offered by E. H. Gombrich in *Art and Illusion*, first published in 1960. In *Real Spaces*, published in 2003, the art historian David Summers reexamined it from the ground up. Based on Euclidean descriptions of geometric-topological transformations of shape on the plane and a quasi-Aristotelian analysis of the "abstraction" of material facture to its "notional" possibilities, he traces the transitions in picture-making from what he calls "planarity" to what he calls "virtuality." This "world art history" takes him from Middle and Upper Paleolithic prehistory to ancient Egyptian and Greco-Roman painting and sculpture to the "rise of Western modernism" in the early Italian Renaissance to the pictorial experiments of twentieth-century artistic avant-gardes. (Summers also gives accounts of planarity and virtuality in non-European traditions of depiction, but they are less systematic, and they do not have the transhistorical drive that characterizes his history of what he calls "Western metric naturalism." There is much to admire in them, but I will set them aside.)[1]

By "planarity," Summers means the more or less thorough-going coincidence of the plane of the format and the planes of the objects depicted—the "standpoint of direct observation," as he calls it. Just as Heinrich Schäfer did in *Von Ägyptischer Kunst* in 1919—I reproduce his frontispiece (Figure 7.1)—Summers takes the painted wooden reliefs from the tomb of Hesire at Saqqara, usually dated to the early Third Dynasty, as his paradigmatic example. I will follow their lead, and in this chapter explore what kind of virtual pictorial space(s) these "planar" presentations made available to their maker(s) (possibly including Hesire himself) and beholders. By "virtuality," Summers means the virtual pictorial space that was constructed, for example, not only in linear-perspective projection in the early Italian Renaissance (so-called painter's perspective) but also in the "naturalism" of Classical Greek architectural sculpture. Under the standpoint of direct observation, as Summers puts it, planar depiction—"planarity"—is "independent" of the beholder's actual standpoint; by contrast, virtuality in depiction is "dependent" (Figures 7.2, 7.3). To this extent Summers's approach and terms and my own partly coincide. Indeed, my approach and terms owe a great deal to his, and, as we will see in this chapter, they converge on a similar finding: planarity constructed in the standpoint of direct observation as "independent" nonetheless generates its own kind of virtual pictorial space—space not always well described in the standard model.

Still, there are differences to keep in mind. In this book I have been using the terms "virtual space" and "(bi)virtuality" to refer to *all* extensions of visual space into pictorial

7.1. Wooden relief from Tomb of Hesire, Saqqara, Third
Dynasty, detail. (From Heinrich Schäfer, *Von Ägyptischer
Kunst* [Leipzig: J. C. Hinrichs, 1919], frontis.)

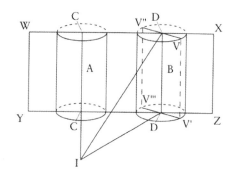

7.2. "Independence: shapes and/or virtual cylindrical
volumes in a plane with corresponding separate, perpen-
dicular points of view, relative to which any quantity or
shape in the plane may be seen most fully. In demanding
any number of points of view, the relations are *indepen-
dent* of any single point of view." (From David Summers,
*Real Spaces: World Art History and the Rise of Western
Modernism* [London: Phaidon, 2003], fig. 151.)

7.3. "Dependence: the second virtual cylindrical volume
B as if from the point of view for A, implying not only
the completion of the cylindrical volume but the detach-
ment of its contours from the plane. When contours are
detached from the plane, the plane of the format (WXYZ)
may act as a *frame*, as the limit of a *field of vision*, in
which what is seen is *dependent* on a single viewer."
(From Summers, *Real Spaces*, fig. 152.)

worlds, whether they are "independent" or "dependent" in Summers's sense. Further, I have argued that apparently continuous pictoriality (AC) and apparently discontinuous pictoriality (DC) interact (Chapter Four): every picture has its own kind of pictorial bivirtuality that constitutes it at standpoint as partly continuous and partly discontinuous with the rest of visual space. Finally, I have argued that frontalized images in radical pictoriality and pictorialization can (and sometimes must) be rotated into foreshortened images, and vice versa—that pictorial bivirtuality is usually not fixed because standpoint is usually not fixed (Chapter Six). In particular, I have proposed that highly frontalized and planar pictorializations on the plane require interrelated rotations in the pictorial succession (specifically the elementary succession/recursion [register | groundline] ◊ [GP | MVA] ◊ [ADO | VVA]), bringing the visualizations and virtualizations as it were into line with the standpoint of direct observation, and recursively constituting it. These considerations mean that at some points I would depart from Summers's account of the phenomenology of depiction, incisive and compelling though it is.

As we have seen in Chapter Five, most art historians who have explicated the historical development from planarity to virtuality in Western traditions of depiction have supposed that it was propelled by the changes Classical Greek artisans wrought on conventions acquired in part from ancient Egyptian and Near Eastern sources, or at any rate characteristic of ancient pictorial arts that preceded what Gombrich called the "Greek revolution." But Summers would relocate the rise of pictorial virtuality: it emerged, he suggests, in canonical depiction in Early Dynastic Egypt, that is, *in the production of planarity itself*. In my view, this insight is broadly correct. In a sense it *has* to be correct: a picture simply *is* a virtual space in visual space, and all virtual pictorial space has compound bivirtuality, whether or not the pictorial rendering is planar(ity). Or so I have argued in Parts One and Two.

2. THE REAL, VISUAL, AND VIRTUAL SPACES OF THE "STANDPOINT OF DIRECT PRESENTATION"

What were the visual-spatial parameters of the "the standpoint of direct observation"—of the "planarity" of *geradvorstellig* or aspective configurations as imaged in natural visual perspective (NVP)?

Here Summers has made a decisive advance on previous inquiries, including my own: he applies his description of the architectonic alignments and correlated "paths" and "centers" of ancient settlements and buildings, such as the temples and funerary complexes of ancient Egypt, to the depictions placed *within* these structures and *onto* their surfaces, or, to use my terms, produced in those visual spaces to be visible as

virtual spaces there. (His most direct predecessors in this line of thought include two great historians and theorists of architecture: Sigfried Giedion, quoted several times in the previous chapter, and Vincent Scully, though Scully did not deal with Egyptian arti-facts.[2]) The planarity of the pictures can *maintain the axiality of the lines of sight* in which they are embedded in the architectonic, architectural, and artifactual environments in which they must be imaged at standpoint.

To be specific, "the plane is maintained," according to Summers, "when each point of its surface is treated as if demanding axial address, that is, address along a notional line perpendicular to the plane of the surface itself" (351). To achieve this, the image-maker (especially when acting as picture-maker) must treat "implicit or explicit volumes as if their sections were invariably seen along lines of sight perpendicular to the planar format" of the artifact — creating a "display of defining shape most fully present in the plane at all points" (353). (Figures 7.2, 7.4). Needless to say, what I have called "section-contour" (see Figure 6.1) dramatically enhances planarity. In a sense, in fact, it literally *constitutes* it: if the "lines of sight perpendicular to the planar format" (what

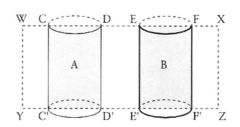

7.4. "Completion: Ambiguity of two-dimensional shapes on a planar surface as implicit three-dimensional forms: (b) shows A and B (in grey) as imaginatively completed virtual cylindrical volumes; it is as if the halves of the cylinders defined by the plane extended equally into real space and virtual space." (From Summers, *Real Spaces,* fig. 150.)

I have called the "axis of direct observation" [ADO]) were to pictorialize the surfaces (not the sections) of the objects, they might not always meet the depicted plane(s) of the objects in *virtual* perpendiculars (what I have called the "virtual visual axis" [VVA]). For obviously the surfaces of many objects might be either convex or concave tangents relative to any line of sight, including ADO. In NVP they are foreshortened even when viewed "frontally"—that is, "straight" or head-on on a line notionally perpendicular to the plane of the format. Section-contour reduces this source of ambiguity in pictorialization. (Surface detail, modeling, and shading of the object can always be added *within* the outline created by the section-contour, as if describing real surface, not section, and to some extent restoring its concavity and convexity.) And the resulting planar depiction can be calibrated to the axial alignments of address in architectonic space all around the picture, even if that space has been produced *as* the material coordination of the visual space of this very pictoriality. In this way the depiction will tend to prolong the real-spatial alignments (the real straight lines and perpendiculars of causeways, façades, corridors, and so on) as it were *at every turn in the pictured world*: the planes of depicted objects—the mere picture made visible as virtual pictorial space—will always seem to lie at right angles across the line of sight of a beholder facing the plane of the format.

Summers's analysis is far-reaching. And it is correct as far as it reaches; I have adapted it for my own purposes in Chapter Six. But powerful and persuasive as it is, Summers's model of the visual space of planarity has certain obvious limits, as he acknowledges. First, in geometrical optics—and therefore in visual space—the visual axis can only be perpendicular to the plane at *one* point. Second, the notional line of sight in planarity—the line "as if" axially addressing *every* point in the planar configuration at the *same* time—might not be feasible architectonically, or even allowed architecturally. Indeed, to my mind Summers assumes more extensive axiality of sightline in Egyptian architecture than was actually there. (Gideon noticed the role of nonaxial sightlines in Egyptian architecture, despite his emphasis on the "supremacy of the vertical" and the obvious fact, as Alexander Badawy put it, that ancient Egyptian "architectural design is conspicuous for its strong symmetry around a longitudinal axis.") I will make a less strong assumption than Summers: sightlines specifically relative to pictures (as distinct from architectural vistas, such as the longitudinal axis) often were *not* axial, or at any rate were not *only* axial, if that term is taken to denote ADO, the axis of direct observation correlated with "presentation of the straight-on view" in the depiction (Schäferian *Geradvorstelligkeit* [Chapter Five, §6]).[3]

In particular, the coordination of planarity enfolds an immanent *disjunction* between axiality configured architectonically in the visual space of the mere picture (that is, ADO) and the axiality of the virtual objects constructed in visible pictoriality (that is,

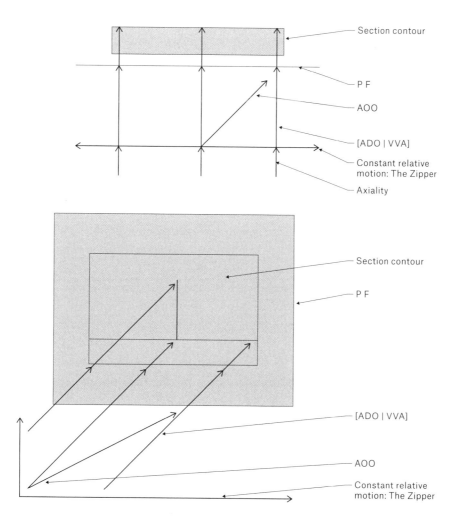

7.5. Diagrams of the threshold of pure planarity (TPP); a,
constant motion of the observer relative to the plane of
the format (P F), maintaining axis of direct observation
(ADO)—the zipper of the image; b, the zipper of the
image relative to the plane of the format, including
[GP | MVA].

VVA). It is partly for this reason that I have distinguished ADO and VVA. According
to a phenomenological explication of true planarity in visual space (Figure 7.5),
real axiality must be replicated over the entire vertical and horizontal spread of the
picture (that is, replicating ADO "at every point") *at the same time as* it must be virtu-
alized throughout the extension of the depicted world (prolonging ADO in VVA "at
every point"). In visual space, however, ADO and VVA need not visibly succeed as

[ADO | VVA] at all times and in every place. Indeed, real-spatial axes (such as the "paths" of axial alignments and correlated "centers" that orient the imaging of the picture) and virtual axes (especially VVA ◊ MVA) might visibly *diverge* in visual space. As my analysis of birotationality in Chapter Six has already suggested, this disjunction of pure planarity paradoxically creates virtual space *in* planarity.

3. THE ZIPPER OF THE IMAGE: PICTURE SIZE, IMAGE DISTANCE, AND THRESHOLDS OF PURE PLANARITY

Again, a phenomenology of imaging the picture must be taken into account. As noted, a depiction configured as planar in the sense Summers adopts cannot always be imaged axially at every point simultaneously. This can only take place in a restricted field. In many cases, the beholder must move off any given axial line of address relative to any single point on the plane in order continuously to image the planarity of depicted objects at *every* point. "Planar presentation," as Summers rightly says, "may imply *movement* on the part of the observer in the real space before the image" (353; my emphasis). (By "image," Summers designates what I mean by "picture"; the movement

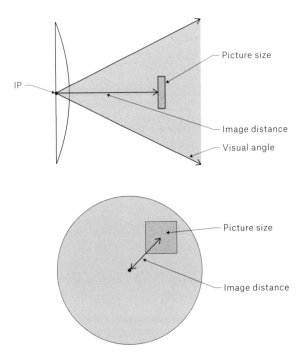

7.6. Diagrams of the ratio of picture size to image distance (PS : ID).

in question is a motion *of* the image—an activity in human locomotion.) And there's the rub. Any such motion can *dis*-coordinate [ADO | VVA] ◊ MVA even as it replicates it elsewhere. At the same time, it can generate virtual volume in the depicted world— a virtual pictorial space.

Of course, a small and compact planar presentation (regardless of the real size of the picture) might not require the beholder to move. Depending on its scale in its distance from IP, the real angle of vision at standpoint can provide sufficient "as-if" axiality for comprehensive pictorial planarity to be maintained visually.[4] This pure planarity can only be generated, however, when the beholder can image the entire picture in focus without moving his head, without actively scanning it by swivelling his eyes (saccadic eye movement occurs involuntarily), and without repositioning his body in front of the surface—a stasis in IP that might be called the "threshold of pure planarity." At a distance of about two feet from the eyes, a picture attaining it probably can be no more than two or three inches in height and width. I give this estimate not in order to provide an *absolute* measure for the threshold of pure planarity, which is a phenomeno- logical horizon only. I give it in order to dramatize the fundamental issue for pictori- alization and successions of pictoriality, namely, the *ratio* of the size of the picture (PS) and "image distance" in the beholder's visual field (ID = distance between mere picture and IP), that is, their proportion in his visual space (PS : ID) (Table 7.1) (Figure 7.6). The threshold of pure planarity can be attained in all possible proportional relations of PS : ID, that is, where > PS : > ID (size of picture increases, image distance increases), where < PS : < ID (size of picture decreases, image distance decreases), where > PS : < ID, and where < PS : > ID.

TABLE 7.1. PHENOMENOLOGICAL CORRELATIONS
OF THE RATIO OF PICTURE SIZE TO IMAGE DISTANCE

Picture Size	:	Image Distance
PS >		> ID
PS <		< ID
PS >		< ID
PS <		> ID
threshold of pure planarity		emergent virtuality
(e.g., 3" sq. at 2 feet)		(e.g., 8" sq. at 2 feet)
"independence" of the picture		"dependence of the picture"
direct axiality; frontality; ADO		off-axial; foreshortened; AOO
constant relative motion (preserves ADO) : stop-points (open out AOO)		
(the "zipper")		

Because ID can be varied considerably, PS in pure planarity has a wide range of *real* values. (Indeed, a picture can have *more than one* threshold of pure planarity.) And it is possible, perhaps routine, that many pictures (regardless of their configuration as "flat," frontal, etc.) have *no* available threshold of pure planarity. Their real size is such (and/or they are imaged at such distances) as to preclude it.

It hardly needs saying, then, that most pictures do not attain (and were not configured to attain) their notional and readily *computable* threshold(s) of pure planarity in visual space, even in the modernist arts beholden to the rather quixotic theory that picture (*qua* virtuality) should visibly relay the "flatness" of the painting (*qua* artifact).[5] Most pictures are not a few inches square and made to be held a little less than an arm's length away. (In Chapter Nine, however, I will investigate a famous counter-example — a small painting in perspective made by the architect Filippo Brunelleschi in the early fifteenth century.) And if they are larger (say, many tens of meters square, like the monumental reliefs carved on the façades of Egyptian temples [Figure 7.7]), they are not to be imaged at a distance so great as to reduce them to that apparent size in visual space: this would "invisibilize" what they depict, even if the mere picture, the artifact, might remain visible as a speck in the distance. In absolute terms, a picture need not be large at all to fall short of notional pure planarity in PS : ID. If we stick to my estimate, at about two feet from the eyes it need be no more than about eight inches square to "deplanarize." Given this, pictorialists can exploit the phenomenon of pictoriality *coming into visibility* as PS increases and ID decreases.

The proportions of picture size and image distance (PS : ID) that visually relay the intended pictoriality of a configuration can be computed by experiment in visual space — by trial and error. They permit passages of depiction imaged as planar presentations (Summers's "planarity") to intersect with passages that do *not* attain pure planarity, and/or to nest within them — bivirtual compounds that can be stage-managed in pictorialization to any degree of visible complexity. For if a picture does not fully attain its threshold(s) of pure planarity in real and visual spaces (its scale in PS : ID), whatever it may be, *it inherently constructs some quotient of virtuality* in Summers's sense.[6]

If a picture in which PS : ID is greater than the threshold of pure planarity is to maintain a high degree of visible planarity, then the mere picture and the beholder must be coordinated in a *constant relative motion that everywhere reproduces the threshold* — an interdigitation of their mutual "facing" that can be compared to the interlocking tracks of a zipper. (As already noted, Summers recognizes that "planar presentation may imply movement on the part of the observer in the real space before the image" [353].) The beholder relocates IP in order to image the picture as it "spreads out" in visual space beyond the axes at which an approximately pure planarity visibilizes at *each* standpoint. Among other possible actions, then, he might walk along beside the plane of the

pictorialization, as in the monumental parietal arts associated with the processional rituals of ancient civilizations. Or he might unreel the pictorialization before a fixed line of sight, as in some modern "panoramas." This translocation of IP might require him to move through many distinct *architectural* spaces; it has been argued, for instance, that the many rooms of a decorated Egyptian tomb chapel, each wall covered with pictorial configuration, amounted to *one* picture.[7] But the tangs of the zipper, though perhaps configured pictorially to interlock at right angles (à la *Geradvorstelligkeit*), cannot always engage fully, because beholders are not always in constant motion relative to it. Indeed, as we have seen in Chapter Six, moving along beside, beneath, and around a picture inevitably produces passages between more frontal and more foreshortened

7.7. Reconstruction of the "High Gate" between the cult palace and the first court of the Temple of Ramesses III, Medinet Habu, Twentieth Dynasty. (From Uvo Hölscher, *Das Hohe Tor von Medinet Habu: Eine baugeschichtliche Untersuchung* [Leipzig: J. C. Hinrichs, 1910], pl. 4.)

images of parts of the mere picture and the objects and spatial relations—visually mutable—that it seems to pictorialize as one goes along. In brief, *motion of the standpoint inevitably and constantly puts pictorial bivirtuality into visual birotationality.*

It might be unrealistic, then, to seek smooth and continuous zippering. Real-spatial alignments, however axial, also tend to create stationary stop-points for NVP, not least stop-points for looking at pictures. And at any stop-point, imaging a picture that does not attain the threshold of pure planarity at that location entails that some volume-shape depicted on the plane faces the observer obliquely (that is, it is viewed on what I will call an "axis of oblique observation" [AOO]) (see Figure 7.5), if it can be said to "face" him at all.[8] Therefore it cannot quite be true that "planarity and virtuality are defined in *opposition* to one another," as Summers wants to say (354; my emphasis). Rather, these birotational consolidations usually *thread together.* Summers's "planarity" and "virtuality" are simply differences in the visible location of virtual points on the planes of the format and the depicted objects relative to the visual axis in NVP, whether stationary or moving (or both)—interconverting sightlines.

Despite the qualifications I have introduced, here too Summers's analysis contributes to our understanding. As he shows, off-axial or oblique address to a depiction (AOO) configured to have "planarity" can generate "virtuality" in his sense in two distinct ways. First, it tends to produce an emergent *voluminousness,* a "virtual volume" (VV) in the objects rendered *on* the plane and *in* plane, regardless of any *real* volume that the format might possess (for example, as impasto in painting or as relief carving) (Figure 7.8). To be specific, off-axially looking at a picture constructed to afford planarity can provoke reflexive "detachment of [the] contours [of the volume] from the plane," as it were "volumizing" the depicted objects. Second, off-axial address tends to evoke an emergent spatial depth, what Summers calls the "virtual coordinate plane" (VCP) (Figure 7.9).

4. PS : ID AND VIRTUAL VOLUME

In principle a pictorialist can geometrically plan and metrically plot the visual space of virtuality, whether or not he has full control in advance of the zipper in PS : ID. Still, it is often surprisingly hard to know where emergent virtuality in planar pictorializations should be identified *as* pictorial—as having depictive value.

Consider the phenomenon of virtual volume. Canonical Egyptian depiction harbors a potential to "detach" section-contours from the plane of the format with which they are notionally coextensive (see Figure 7.3); in imaging in AOO, section-contours can rotate away from the plane of the format in ADO. In such cases, the section-contour perhaps partly *revirtualizes* as the apparent contour of the virtual *surface* of the depicted

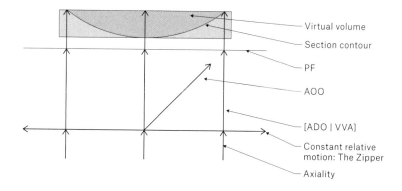

Virtual volume
Section contour
PF
AOO
[ADO | VVA]
Constant relative motion: The Zipper
Axiality

7.8. Diagram of emergent virtual volume (VV) in the zipper of the image.

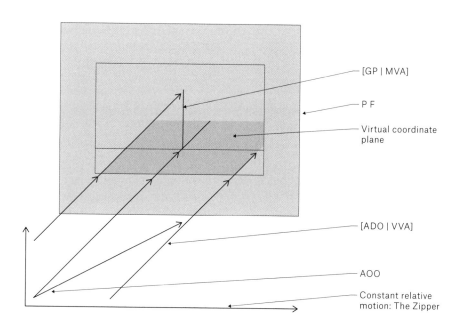

[GP | MVA]
P F
Virtual coordinate plane
[ADO | VVA]
AOO
Constant relative motion: The Zipper

7.9. Diagram of emergent virtual coordinate plane (VCP) in the zipper of the image.

object as it could be naturally visible at that IP. This would seem to be a palpable increase in AC-pictoriality—in "naturalism."

But what about pictoriality and pictorializations enabled by this? Take a picture in which PS : ID is greater than the threshold of pure planarity (the usual case), and especially a large picture relative to IP (see Figure 7.7). Did its beholder image the one leg of a depicted figure (for example) that faced him axially (ADO) to be "planar" (a section-contour) while *at the same time* imaging the *other* leg to have virtual volume ("detached from the plane") rotated toward his IP (AOO) (Figure 7.10b)? (This would seem to be a literal implication of Summers's diagram [Figure 7.3].) Indeed, did he image *both* legs to be rotated (in opposite directions) toward an off-axial stop-point of address midway *between* them (Figure 7.10c)? Or even both legs rotated (in the same direction but to different degrees) to an off-axial imaging point to the right or to the left of both of them (Figure 7.10d)? Or *all* of these, depending on the location of IP as he moved around? In other words, did he image the entire virtual object—the entire figure—continuously *folding between* voluminousness in his visual space (AC-pictoriality) and greater planarity in a virtual space discontinuous with it (DC-pictoriality)? An unstable chiastic object *simultaneously* flattening (as *section-contours* visibilize) and filling out (as *volumes* virtualize)—a kind of pulsation of the plane as it were, lively and even "lifelike"?

As my phrasing suggests, the ambiguities of emergent virtual volume in planar configuration—its visual chiasms—cannot easily be reduced to a single, unified pictoriality. Ancient Egyptian draftsmen sometimes found themselves bedeviled by the planar construction of the proper width, the virtual "thickness," of a partly occluded leg in a pair or in the suite of legs belonging to a seated human figure or to an item of furniture such as a chair (Figure 7.11). (In NVP, it would be more distant from IP.) A DC-pictorial planar approach to occlusion ordinarily did not allow pictorialists to give a visibly different width to *each* leg; despite chiastic ambiguity, *both* depicted legs likely must have been seen as *equally* virtual volumes (that is, Figure 7.10a). Still, in certain contexts the partly occluded "far" leg was sometimes thinned down. In this case, the pictorialist probably intended to show that less flesh was visible in the "far" leg than in the "near" one—maintaining *parallel* axial lines of address for the legs, even if the configuration does not attain the threshold of pure planarity. Presumably the far leg was not supposed to be seen as shriveled or stunted, as the *geradvorstellig* construction could literally be taken imply.[9] In standing figures, the two legs were ordinarily set apart, and the question of handling the radical pictoriality of the occlusion did not rise. But the question of "near" and "far" persisted: ordinarily canonical Egyptian pictorialists depicted *both* feet of the figure from the inside (that is, as if looking at the instep arch in ADO) and therefore as having two "far" feet—two right feet or two left feet

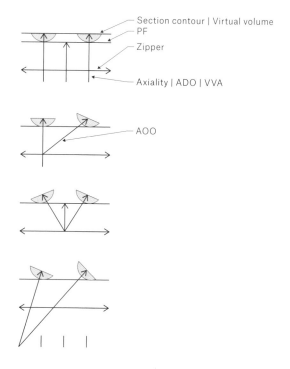

7.10. Diagrams of rotations in ADO and AOO in the
zipper of the image, including foreshortenings.

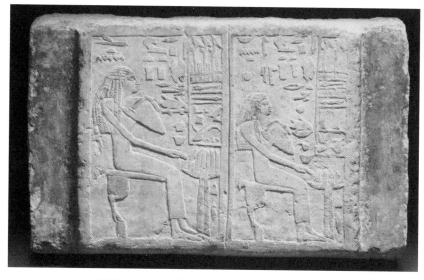

7.11. Double stela of Nytwa and Nytneb, Second Dynasty.
Musée de Louvre, Paris (E 27157).

depending on the direction faced by the figure. As Edna Russmann has proposed, this peculiarity might reflect the inertial pull of the flatness of the surface—that is, of planarity.[10] But paradoxically it can create virtual pictorial space just insofar as a "far" foot could be pictorialized as set back from the [register line | groundline], recursively contributing to the succession [GP | MVA]—a sense of the figure as a volume as distinct from a flat section. There was no way around the conundrum: depicting one or both feet as "near" could open up virtual pictorial space too.

The zippering of planarity would have been most complete in decorated tomb chapels: depicted figures in their registers are typically *smaller* than the beholder, the full height of the tier of registers is not vastly *greater*, and there is relatively little room for real locomotion. (To be sure, small pictures placed quite *low* or *high* in a tight real space can virtualize in striking ways because of AOO; in the next sections of this chapter I consider an example.) It would have been least complete in immense outdoor complexes (Figure 7.7). In these contexts, huge depicted figures (much *larger* than the beholder) were sometimes placed high above the ground, generating relatively extreme angular distortion in NVP; in an exemplary investigation, Dimitri Laboury has shown that some sculptors took account of this phenomenon and corrected for it.[11] It is not clear whether this variance in NVP differentiated Egyptian pictorial bivirtualities in Egyptian visuality: whereas tomb-chapels might have tended toward "aspective" DC-pictoriality, funerary complexes, pylons, monumental free-standing sculpture, and the like, might have tended toward "perspectived" AC-pictoriality. Even if there was little stylistic variation between pictures for tomb and for temple, the difference in their visual spaces could have distinguished them pictorially. The tomb, or the world it pictured, was seemingly conceived as a portal to an afterworld partly disjunct from the beholder's world. But temples (not to speak of towering sculptures in the open air) virtualized cosmic actors in the mundane visual world—gods and kings bodied forth in visual space as giant agents within it.

5. VIRTUAL VOLUME AND VIRTUAL SPACE

So far I have dealt with VV that can emerge in two-dimensional pictorialization, or, more exactly, in pictures—drawings and paintings—that seem to lie more or less flat on the plane. In late prehistoric (Predynastic) Egypt, paintings were made on tomb walls, and in other media, such as textiles, that survive only in fragments. Painting was the preferred medium of tomb decoration in the New Kingdom as well, but in the Old Kingdom, when the canonical conventions were consolidated, the decoration of tombs was also carried out in painted *relief*. Obviously the visual successions considered so far—successions that create virtual pictorial space—might be affected, even

effected, by any *real* visible depth(s) in the material planes of the format. As we have seen in the case of the threshold of pure planarity, the absolute metric values of these features need not be great for them to have a role in virtual pictorial space.

In considering VV in reliefs, Summers has examined the visibility of the *edges* of the section-contours of depicted objects constructed between the "top" or "forward" plane (closest to IP) and the lower, deeper, or more "distant" plane constructed by the sculptor in removing the material of the surface (Figure 7.12). (Summers calls the latter the "secondary plane"; it is roughly parallel to—"at a more or less constant actual distance from"—the former, the forward plane, which will be partly cut away. Both of these planes are parallel to the plane of the format, and the forward plane was materially identical with the plane of the format until some of its substance was cut away.) Materially these edges can be treated simply as particular regions of the continuous surface of the format, albeit regions lying at an angle to the plane of the format. But precisely in virtue of their orientation as roughly *perpendicular to the section-contour* they can have a distinct role to play in visual space. As Summers shows, their real depth (that is, from primary to secondary plane—the width of the "edge" and the "height" of the relief) can become virtual depth. And in the virtual space of the depicted world, the visual value of this "deepness" can be extended and transformed.

This intriguing pictorial succession can be illustrated by the eleven low reliefs carved in acacia wood for the tomb of the high official Hesire at Saqqara (Tomb 3506) (Figures 7.1, 7.13–7.16). Opened by Auguste Mariette in 1860 and more fully excavated by J. E. Quibell in 1911–12, the tomb has usually been dated to the early Third Dynasty (c. 2500 BCE) because its detritus contained a jar-sealing of King Djoser, presumably Hesire's monarch.[12] Originally installed in elaborately decorated tiered niches in the so-called Painted Corridor of the tomb (Figure 7.15, cf. Figure 7.23), six reliefs

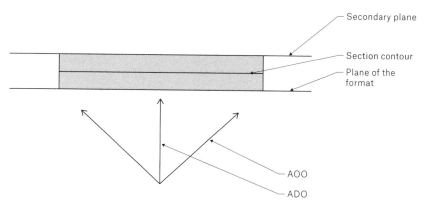

7.12. Diagram of the secondary plane and the edges of relief.

were removed to Cairo by Mariette and the others crumbled to pieces during Quibell's excavation, though he provided a description and a drawing of their appearance *in situ* (Figure 7.16). We do not know the names of the sculptors. Probably there were two of them, each responsible for particular panels in the set of eleven, which might have been produced over a considerable period of time — a series. One of them was a master; the other was less accomplished though still proficient. It has been suggested that the master was Hesire himself, proud of his status as "Master of Scribes" — a title thematized in the panels that depict him carrying the scribe's equipment, a brush and palette of inks (Figure 7.13). Whether or not Hesire carved the panels (it is unlikely he did), we could certainly imagine that he *designed* them, drawing the outlines for the carvers to follow. Regardless, he likely took a close interest in their design, manufacture, and installation in a tomb that has many other special features — architectural and decorative — that bespeak the imagination of a dominant creative intelligence. Rarely exhibited outside Egypt, the reliefs of Hesire have often been used to illustrate the conventions of Egyptian depiction (Figure 7.1). Indeed, they might have become a cliché in world art history. Nonetheless their distinctive handling of bivirtuality has often been overlooked.[13]

As Summers puts the crucial point, "We seem to see *more* of the volumes of Hesire's body than is actually stated by the wood out of which they are carved" (446, my italics; [Figure 7.17a, b]). This effect is partly due to the fact that the entire surface of Hesire's body was sculpturally modeled in order to suggest dermal, muscular, and skeletal features, even beneath his dress, and perhaps in order to individualize each portrayal. (The figure of Hesire seated at the funerary table [Figure 7.14] seems to depict him as older than he appears in the standing presentations [Figures 7.13, 7.16].) On all the panels Hesire's dress and accouterments, as well as the background (secondary plane), were probably fully painted (some fragments of paint have survived). Hesire's unclothed skin was probably left unpainted; the reddish acacia wood would have given its proper color. Moreover, Hesire's wooden reliefs display a considerable "rounding" of the outline contour down to the secondary plane.[14]

We seem "to see more of the volumes of Hesire's body," I said, partly because of the modeling of the surface and the rounding of contours. In addition, though the relief is only a few millimeters high, we tend to see Hesire's legs, as Summers notices, as having the thickness "in the round" that they would really have — that is, as they really would be in NVP if Hesire were really only about thirty centimeters tall, the height of the depicted figure. This is partly because the low relief seems "compressed" (as Summers puts it) between the primary and secondary planes, though it is still visible as having real-spatial depth. It motivates the beholder, Summers suggests, to "complete virtual volumes toward our own space *and* into virtual space, the two spaces meeting

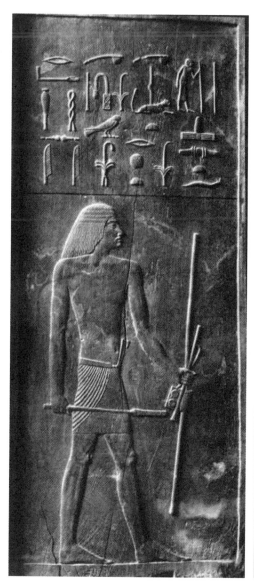

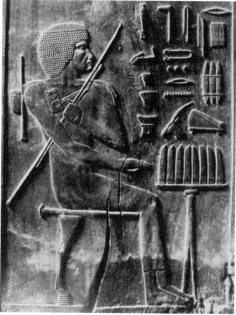

7.13. Wooden relief of Hesire standing, from Tomb of Hesire, Saqqara, Third Dynasty. (From Ludwig Borchardt, *Denkmäler des Alten Reiches (ausser den Statuen) im Museum von Kairo, Nr. 1295–1808* [Berlin: Reichsdruckerei, 1937], vol. 1, no. 1427).

7.14. Wooden relief of Hesire seated at his funerary table, from Tomb of Hesire, Saqqara, Third Dynasty. (From Borchardt, *Denkmäler des Alten Reiches*, no. 1426.)

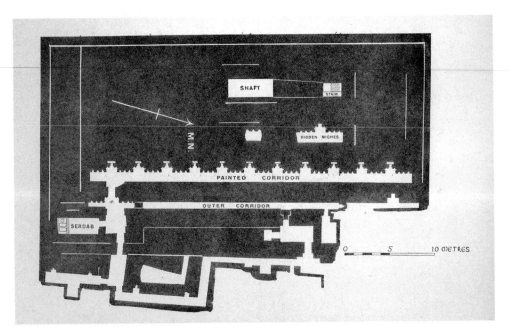

7.15. Plan of the Tomb of Hesire, showing locations of niches for reliefs in the Painted Corridor. (From J. E. Quibell, *Excavations at Saqqara, 1911–1912: The Tomb of Hesy* [Cairo: Impr. de l'Institut français d'archéologie orientale, 1913]).

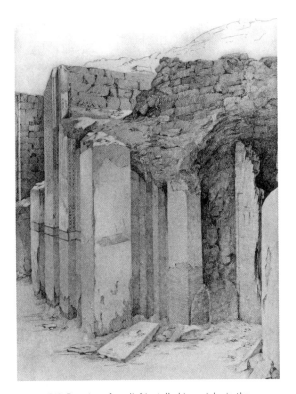

7.16. Drawing of a relief installed in a niche in the Painted Corridor. (From Quibell, *Tomb of Hesy*.)

at the secondary plane" on which the section-contour as such is pictorialized. In this emergent virtuality, the section-contour presented on the lateral plane perpendicular to ADO, which has a visible and a measurable *width*, is matched (as we would expect) by a virtual section-contour constructed perpendicular to it (on a segment of VVA in [ADO | VVA]) and probably by virtual section-contours on planes that intersect it obliquely (that is, [AOO | VVA])—overall, then, a decompression on the plane and even a "detachment" from it (Figures 7.4, 7.18).

What are the consequences of this succession in virtual pictorial space, and for it? In particular, what is the *measure* of the thickness if it is greater than the real height of the relief? And how *distant* are the points on the virtual surface the beholder completes "behind" the secondary plane?

The first question is easy to answer. In virtual pictorial space, Hesire's legs are just as thick as they need to be—having the volume-shape they need to have—in order to be pictorially commensurate with the visible width of the section-contour. (Again, we are dealing not with absolute metric values but with phenomenal values in NVP.) The second question, however, is less straightforward. In principle, the section-contour is fully visible as *measurably* distant from IP in ADO because it lies on the secondary plane of the format, which is installed in real space at some definite distance from IP. But this cannot be the whole story. If Summers is correct, the section-contour on the secondary plane is not what is produced in the pictorialization to be visible. What is visible, rather, is the virtual volume-shape of *what is pictorialized by the section-contour* when completed in visual space (on Figure 7.18, [ab | cd]). In *geradvorstellig* pictures, the virtual volume-shape is not definably distant from IP. Rather, "the contours of the body on the second[ary] plane are at an *indefinite* distance *in the virtual dimension*" (446).

In itself, VV does not set up a virtual spatial field encompassing *all* the planes in the picture. It gives thickness relative to width, or volume-shape, specifically in relation to the plane of the section-contour from which it is completed, defining the depth of points on the surface(s) of the object *on VVA* (that is, cd on Figure 7.20), though not their distance from IP on ADO. Nonetheless, here too the material dimensions of the format interact with pictorialization. In relief sculpture, the visible roundness and depth of the carving motivate beholders not only to complete section-contours, but also to try to "look around" the resulting virtual volume-shape.

Indeed, one might even imagine rotating the volume more or less freely on its MVA in virtual space. For notice a possible succession: given the phenomenal constitution of VV as described here, the two section-contours meeting at right angles within the figure (on Figure 7.18, ab ◊ cd at MVA) are not the only ones in play. Once VV succeeds in virtual pictorial space, one can envision other section-contours that are orthogonal to both of them (for example, ef on Figure 7.18). Supposedly impossible in

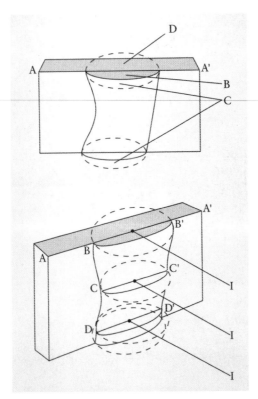

7.17. a, "Detail of Hesire's right knee, showing
compressed relief volume (B) on the planar surface AA'
completed as the virtual volumes defined by C + D"; b,
"Same detail as in a, the compressed relief and virtual
volumes demanding independent points of view; I is
always perpendicular to AA'." (From Summers, *Real
Spaces*, figs. 221, 222.)

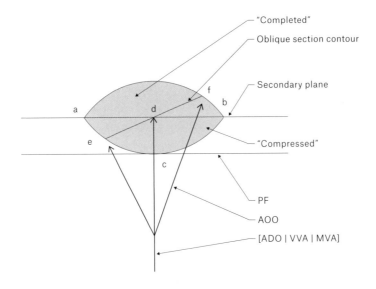

7.18. Diagram of emergent oblique section contour
in virtual volume.

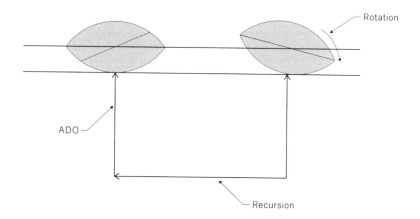

7.19. Diagram of rotation of emergent oblique section contour in virtual volume, cf. Fig. 7.10.

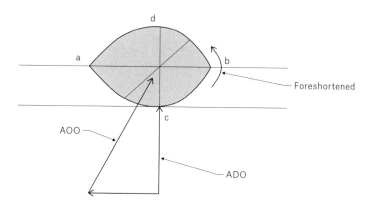

7.20. Diagram of foreshortening of emergent oblique section contour in virtual volume.

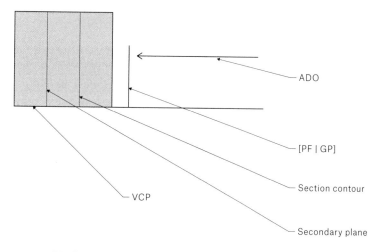

7.21. Diagram of the emergent "stage" in/of virtual volume, parallel (and partly coextensive) with VCP.

the construction of *geradvorstellig* pictoriality on the plane (according to the Schäferian account), we have already seen that they are involved in resolving radical pictoriality in its succession. They emerge into pictorialization in the case under consideration here, because VV provokes the sensation that if we were to move slightly, shifting our standpoint laterally, a bit more of the body of Hesire would come around into our view (figure 7.19). (Of course, this is a visual recursion: the sense of what we *might* see when in motion feeds back into what we *do* see at any stop-point. In Chapter Eight, I will consider how the designer and sculptors of the Parthenon frieze elaborated this possibility with extraordinary command.) Overall, then, the body seems to be very slightly foreshortened—VV situated in visual space in such a way as to continue an essential feature of NVP into virtual pictorial space (Figure 7.20).

In visual-cultural context, in visuality, another factor might have contributed to this effect in this case. As Gay Robins has pointed out, relative to the reliefs made for King Djoser in the same period, the standing figure of Hesire has rather slender proportions across the shoulders, upper arms, and midriff.[15] Among beholders who expected to see a broader section, this configuration—if visible to them in this comparative way (see Chapter Four)—could optically reinforce the impression that Hesire is very slightly turned away from the beholder. Still, these proportions, as we have seen in Chapter Six, were constructed on the *geradvorstellig* plane and its implied "cubic" virtual space, and I doubt that they were calculated in advance with an AC-pictorial effect in mind.

Every style of planar pictorial bivirtuality handles these successions—the bivisible and the birotational possibilities of emergent VV—in its own ways, depending on material media and visual-spatial contexts. Egyptian pictorialists generally preferred extremely low relief; it rarely was deeply undercut, as in the late Roman narrative reliefs addressed by Aloïs Riegl (see Figure 5.6). In this context, Hesire's sculptor presented the protrusion of Hesire's ankle bone (as we might see it in real life) and the protrusion of Hesire's calf muscles (as we might see them in real life) *on the same plane*—compressed to the same degree (relative to their tangents) despite differences in virtual distance on [ADO | VVA] ◊ MVA that in principle could be measured. (In Summers's analysis [Figure 7.17], specifically the sections BB', CC', and DD', all the points closest to IP on [ADO | VVA] on the circumference of the several completed volumes, indicated by broken lines, seem to lie in the same plane and at the same real height above the secondary plane of the relief—like the highest points on the real surface of the relief, indicated by solid lines.) Even if the compression motivates the beholder to complete virtual volume, then, it also ensures that the emergent bivirtuality exemplifies as much DC-pictoriality as AC, maintaining overall planarity by *minimizing* the number of visible planes on [AOO | VVA] ◊ MVA (for example, ef on Figure 7.18). Pictorial bivirtuality in this style embeds the AC-pictoriality of VV *within*

DC-pictoriality—an effect that helps construct the pictorial world as continuous and discontinuous with the rest of visual space in ontologically particular ways, opening into the iconographic, symbolic, and cultural "meaning" secured in and by the pictorial succession as an operation within canonical Egyptian visuality. And this occurs even if, as we will see, the effect was not fully totalized and replicated as canonical tradition.

6. THE "VIRTUAL COORDINATE PLANE" IN THE RELIEFS OF HESIRE

To engage this issue, I must pursue a further succession in this kind of pictorial bivirtuality. Given birotationality, we might expect to find AC-pictorial virtual space emerging *outside* DC-pictorial coordinations of *geradvorstellig* planarity, especially at standpoints in PS : ID in which the "frontality" of [ADO | VVA] ◊ MVA cannot be maintained. As Summers shows, even highly planarized depictions sometimes cannot avoid generating what he calls a "virtual coordinate plane" (VCP), in principle enabling a *simple groundline on the plane* to succeed to pictorialization of *depth of field behind / before the plane*. Here I return to a matter that I postponed in my discussion (Chapter Six) of the phenomenology of the [register line | groundline] on the plane.

Like VV, VCP can partly be propped on the real material extension of the format, which encourages its virtual completion. As the reliefs of Hesire have usually been illustrated, part of the original surface of each panel has been preserved on all four sides. Summers makes much of this "frame," as he calls it; he thinks it tends visually to constitute a "stage space" with Hesire standing on its "floor," an effect encouraged by the virtual volume of the figure (though recursively the visibility of the [floor | groundplane] partly encourages the completion of VV). The plane of the real floor of the stage subtends at a right angle from the material plane of the format as well as from the secondary plane (Figure 7.21), though we must remember that in AOO the intersection is not visible *as* a right angle. And it has a real measure, however short: the real distance between the primary and secondary planes of the format (or the "height" of the relief).

But obviously the floor is only *visible* on AOO, in which one can image it going back into depth behind the figure. To use Summers's suggestive formula, the virtual coordinate plane is the "ground line extended as a plane into the virtual dimension as it stands in a definite if barely explicit relation to the plane of the surface; it is *perpendicular* (or 'coordinate') relative to the plane of the surface of the format, and therefore develops from the assumed planarity of this surface" (446). In other words, there would have been visually uninterrupted continuity *on the same plane* between the real floor of the Painted Corridor in which the beholder would actually stand, the floor of the niche, and Hesire's virtual groundplane. To illustrate this, Summers models an image of the

best-preserved relief (Figure 7.13) that is available when a beholder walks northwards in the Painted Corridor of the tomb, coming up to the edge of the south wall of the niche in which the relief was installed (Figure 7.22). This reconstruction models the standpoint (IP) at which VCP in the relief starts to become visible in visual space—a standpoint that every beholder traversing the Painted Corridor from south to north would have to pass over.[16]

At this juncture, I make a slight modification in reconstructions, such as Summers's, which accept that the top surface of the "frame" (the primary plane of the format) was visible, parallel to the secondary plane; it implies, as Summers would have it, that a beholder made a small visual "step up" to the "stage space" of the picture, as it were "stepping over" a threshold *into* VCP. But the "frame" of the relief panels, though included in most photographs, was invisible *in situ*: as Quibell's report and drawing suggest (Figure 7.16), it was fully built, on all four sides, into the real walls and floor of the niche, a means of holding the panels in place. (Needless to say, this hardly hinders—rather it helps—Summers's analysis of the emergence of VCP in this set-up.) Of course, the little "shelf" of the floor of the "stage space" identified by Summers—the material extension correlate with VCP on the surface of the format—could have been visible regardless. But it might not have been visible *as such*; it might have been seen simply as a region of the *real* floor beneath the beholder, or as a region of VCP underneath Hesire, or more likely as both at once. Any of this would heighten the impression that the beholder and Hesire stand on the same ground continued *from* the corridor *through* the niche *into* the virtual world constructed on VCP and beyond.

Given the narrow width of the Painted Corridor (about one meter across), the depth of the niche (also about one meter), and the height of the figure (about 33 cm.)—that is, PS : ID in Hesire's set-up—in NVP the beholder must come upon the figure, set flush against the floor, at a very oblique visual angle in both its horizontal and vertical three-dimensional coordinates.[17] (In fact, beholders could never actually assume a head-on viewing posture correlated with the "straight-on" axes of Schäferian *Geradvorstelligkeit*, that is, ADO.)

At this steep raking angle of vision, VCP would have been *super*virtual as it were. It is not, or it is not *only*, a dimension that we can notionally complete as a correlate of virtual volume. In NVP it is, or it is *also*, a *visible thing* in virtual pictorial space. Given the height of Hesire, the overall natural interpretation in NVP—what we see—is that he is far away from us. The niches were oriented to the west, the realm of the dead, so that Hesire is, as it were, "going into the west" and/or coming out of it, an effect encouraged (for reasons already reviewed) by the sensation of slight foreshortening in his figure on AOO. In canonical Egyptian visuality, then, the beholder (presumably a celebrant of Hesire's funerary cult) was directed visually toward the afterworld virtually

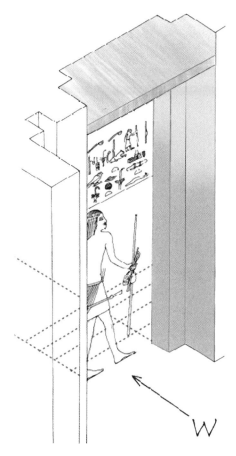

7.22. Reconstruction of the virtual coordinate plane in
the relief of Hesire standing (CCG 1427, cf. Figs. 7.13,
7.16). (Justin H. Underhill.)

present "beyond" the *visible* end of VCP, opening toward a world that was continuous
in visual space with the real space of the tomb and perhaps implying movement by the
deceased in the reverse direction — that is, the motion of the *Ka* of Hesire coming
into the same place. (The *Ka*, a person's perduring vital-spiritual "double," could come
and go from the living world.) This is presumably what Hesire saw when he designed,
inspected, and installed his portraits (the last, perhaps, only in imagination).[18]

Of course, the stop-point reconstructed by Summers — the standpoint at which
VCP first virtualizes for the beholder — is not the only angle of vision in question.
Beholders were probably motivated to bend over and peer into the niche in order to
see the figure (and, if literate, to read the inscription). And bending over — in the rela-
tive motion and pulsation of the zipper of the image — would *decrease* the steep vertical

angle of vision in AOO, kinematically constituting a far longer visible VCP. Beholders would not only seem to be "going in" to the virtual space inhabited by Hesire on his groundplane. In the motion of the image (IP in NVP), their visual space would also seem to be smoothly *extending* further and further into the distance.

Other features of the installation probably heightened the effect of virtual depth constructed in VCP. For example, intricate paintings on the west wall of the Painted Corridor and on the side walls of the niches turned the walls into *trompe-l'oeil* simulations of a tent or pavilion made of colorfully patterned textiles hanging on poles and rods, presumably the kind of shelter that would have been used in the funerary ritual (Figure 7.23). These encouraged one to see the niche-space, real and virtual, as a space *within* the pavilion, or, alternately, as a space made visible *beyond* it when its flaps had been pulled aside. Some of the lines of the architecture and decoration of the niches can be optically extended into virtual depth. For example, a line imaged from the bottom of the second innermost north face of the niche can be carried to the "nearest" point on Hesire's belt. Potentially these successions articulate the virtual depth — if only in the field of radical pictoriality — not only as a groundplane of indefinite extent beneath and behind Hesire, but also as a three-dimensional space all *around* him, as suggested on my Figure 7.22.

All in all, as a construction of AC/DC pictorial bivirtuality VCP creates a kind of perspective *in* aspective depiction in virtue of certain natural visual perspectives in imaging it. Indeed, according to Summers's world art history it was by way of VCP that planarity in real space eventually became the "three-dimensional" spatial field virtualized in so-called painter's perspective (Chapter Nine) in the potentially measurable terms of a homogeneous "coordinate space" that in turn would devolve into a general "metaoptical" spatial concept in the Early Modern period in the West. As Summers has put the point, "Egyptian painters and sculptors made choices that were to establish the basis of Western metric naturalism ... accomplished by the development of planarity into the virtual dimension, with consequences reaching to the present day" (445). Much of *Real Spaces* — several hundred pages of exposition — explores the transformations of these Egyptian choices in later image-making in the West.

All this is well and good. But how far can we go with it? Immanent in canonical Egyptian pictoriality and a radical-pictorial potential of it, VCP, I have no doubt, would have been partly *emergent* in Hesire's installation. A predictable visual-spatial phenomenon in NVP, it seems to have been architectonically stage-managed for purposes of pictorialization. One wonders why the designer would make such small reliefs, placed so low to the ground and in such deep niches that they had to be viewed at tight angles, if he had *not* visualized the AC-pictorial emergence of VCP. But Hesire's installation was unusual in this coordination of PS : ID to particular angles of vision. As we saw in

7.23. Reconstruction of the paintings in the niches of the
Painted Corridor, probably depicting a tent or pavilion.
(From Quibell, *Tomb of Hesy*, pl. 8.)

Chapter Six, ordinarily a canonical Egyptian pictorial bivirtuality deployed a line that succeeds from a *surface plane* — namely, a [register line | groundline] placed well *above* the actual bottom edge of the real surface of the wall perpendicular to the real ground on which beholders must stand. In pictorial succession in the reliefs of Hesire, however, the [baseline | groundline] of the picture is visually incorporated into (and becomes invisible within) the real-spatial groundplane of the beholder (as extended in VCP) — one of many ways in which the tomb is *sui generis*.

To be sure, Hesire was Master of Scribes, and his master sculptor was an artisan of the highest skill. Moreover, his tomb was likely built in the decades when monumental architectonic frameworks of *geradvorstellig* pictorial construction were being worked out in canonical form in the architecture and decoration of the funerary complex of King Djoser: one might take the entirety of his tomb to be an architectural and aesthetic experiment, a kind of modernism.[19] So far as we know, however, the experiment in VCP did not catch on elsewhere, despite what seem to be related experiments in spatialization, activation of the virtual movement of figures, and what Florence Friedman has called "multi-directionality" in both two- and three-dimensional Old Kingdom pictorializations — experiments in creative tension with the frame of *Geradvorstelligkeit*.[20] This was not because VCP had no place in ancient Egyptian pictorial ontology — no

207

available iconographic valence in Egyptian visuality. It was simply because the architectonics of PS : ID, the location of IP in real space, and the resulting pictorialization achieved in visual space were unique to Hesire's tomb, even if we might imagine that *this tomb* was designed partly in relation to the projected virtualization of visual space that would be created by the reliefs.

Stated another way, in the tomb of Hesire VCP emerges into visibility in visual space — it is visible *as* groundplane. It is not *merely* virtual in this case. But this requires us to ask about its status when it is *invisible* on the plane — when it is a strictly virtual dimension of the plane, coordinate with it. For even if VCP is not explicitly included (made visible) in the depiction, it can operate in the pictorial succession, especially when pictorialists know that it will or could — and does — emerge into visibility under certain angles of vision.

7. ARTICULATION AND METRICIZATION OF VCP IN FREE-STANDING SCULPTURE

How do we know when and to what extent VCP is active in a pictorial succession? How much is present, and in what planes and axes? The matter partly turns on any articulation of VCP and its metricization.

For some obvious purposes, canonical Egyptian pictorialists had to compute VCP explicitly. Working in three dimensions on a sculpture in the round, sculptors had to attend to measures on the coordinate plane in order to preserve the desired proportions plotted on the elevation(s), carrying these proportions all around the body. As we have seen in Chapter Six, guidelines were laid out on the top and sides of a dressed block of stone ready to be cut down to a free-standing mass volume. Here the sculptor constructed VCP on the top surface; the "plan" picture of the mass volume sits in a plane perpendicular with the "frontal" and "profile" pictures, the elevations laid out on the front of the block and on its sides. (All these plans and elevations were constructed pictorially, of course, in ADO, that is, as *geradvorstellig*.) These planes were *metrically* coordinated because all the pictures must be laid out using a uniform module (or potentially unifiable modules at any rate) on all the planes, whether or not the modules are also the modules of a proportional canon for the depicted object. Given this pictorial construction of the mass volume, one could see on the [plan | VCP] that the "back" or dorsal surface of the figure was *x* modules more distant from the plane on which the "frontal" picture of the figure is *y* modules high.

In principle, canonical Egyptian sculptural procedure enabled the succession of VCP not only from the plans and elevations as *drawn* in ADO. It also supported succession of VCP from the coordinates of the plotted block as *viewed* in AOO. And it could be seen

that *two* interlocked figures—a sculptural group—could be extracted from the block (or jointed from two blocks) in such a way that one figure would sit "behind" the other on VCP (whether or not materially preserved in the sculpture as a base or plinth) at a distance of *n* modules that would be visible in the plan on AOO in relation to the front and side elevations.

Let us consider a highly informative example. In 1918, Ludwig Borchardt published a unique artifact in Berlin—an Egyptian sculptor's working drawing. Laid down on papyrus, the drawing sets out the front elevation, one profile elevation, *and* plan of two figures to be carved out of one block, or at any rate combined to form a single coherent group—a sphinx with a goddess (or statuette of a goddess), much smaller than he, standing between his outstretched forward legs (Figures 7.24, 7.25).[21] (The drawing dates to the Ptolemaic period, but it was constructed in canonical Egyptian tradition.) In the elevation, the grid needed to be deployed at a considerably finer resolution for the figure of the goddess, that is, for constructing her proper proportions; four units of height and breadth are defined for every one unit used to lay out the sphinx. But there is a regular relation between the two grids; certain reference lines are shared—carried between the objects, regardless of scale. This helped the draftsman to construct such elegant formal relations (perhaps contributing to the iconography) as the way in which the chin or beard of the sphinx echoes the curve of the goddess's head, and the cloth of his headdress hangs down right to her pelvic line, at any rate as viewed on ADO.

The proportions of the sphinx's lion body were guided not only on the front and profile elevations. They were also guided on the plan, that is, *in the coordinate plane*, and to some extent *only* guided there. Possibly this was because the sculptor realized that he confronted a metric disjunction on the coordinate plane specifically: on the plan, he had to integrate the proportions of the royal (human) head, which are constructed in the frontal elevation in units larger than the units used to organize the leonine proportions. (The plan used *only* the lion's squares while the frontal elevation uses *both* the lion's and the royal squares, and indeed must carry the royal squares to a transversal shared with the plan—in turn creating a misalignment visible on the drawing. This caused some (geo)metrical difficulty for the plan; strictly speaking, at the sixth vertical from the left it should—but in the event did not—"switch" from lion's to royal squares, matching the same operation conducted at the sixth horizontal from the bottom on the elevation. Fortunately this perturbation was not structurally relevant to the essential computations conducted by the drawing.)

In the drawing, the draftsman partly envisaged the sculpture-to-be in its ideal proportional order, regardless of its real size. But partly because the real size of the sculpture-to-be can be assumed to be larger—perhaps *much* larger—than a three-dimensional object plotted at a scale of 1 : 1 by the drawing, which is only 32 centimeters

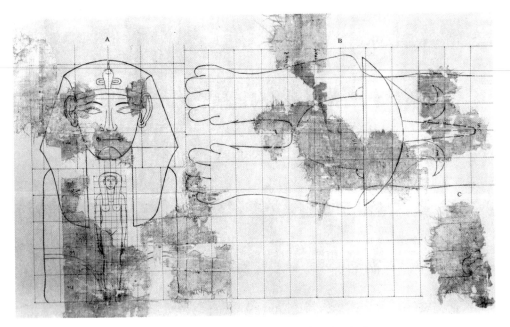

7.24. Reconstruction of a sculptor's "working drawing"
on papyrus—plan, frontal elevation, and profile
elevation for a figure group depicting a sphinx and a
goddess, Ptolemaic period. (From Ludwig Borchardt,
"Sphinxzeichnungen eines ägyptischen Bildhauers,"
Amtliche Berichte aus den königlichen Kunstsammlungen
39, no. 5 [171917–18], fig. 1.)

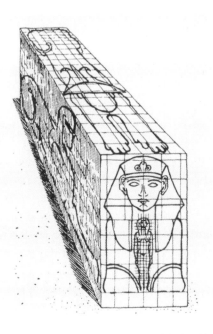

7.25. Three-dimensional reconstruction of the "working
drawing" transferred to a block. (From Heinrich Schäfer,
Von Ägyptischer Kunst, 3rd ed. [Leipzig, J. C. Hinrichs,
1930], fig. 263.)

high, the draftsman also had to consider the aspects of the sculpture-to-be in natural visual perspective, including oblique angles of vision. His goal was to construct — and despite any changes of size/scale to preserve — certain crucial three-dimensional proportions that are internal to the sphinx's recumbent body, readily plotted on the frontal and profile elevations and the plan. For example, the height of the creature from ground to shoulder equals *both* the length of its forelegs from chest to paws *and* the span between its paws — massive, blocky proportions (as it were monumental) of 1 : 1 : 1 in three-dimensional coordinate space. (To accompany his publication of the working drawing, Borchardt illustrated a limestone sphinx with roughly similar blocky proportions from the Sacred Way of the Serapeum at Saqqara [Thirtieth Dynasty], discovered by Auguste Mariette in 1851.[22])

As plotted in the working drawing, one could reproduce the sphinx at any practicable size. But relative to the beholder the desirable proportions plotted in the drawing could be best actualized in a sphinx of a *certain particular size*; namely, one in which the monumental blocky proportions would be visible *as* "cubic" (that is, 1 : 1 : 1) in a coordinate frame XYZ — a form best realized in an object that can be viewed obliquely (if only in the imagination) in a line of sight (in AOO) taking in all three angles (and as seen to be equal) at the intersection of the three relevant planes in X, Y, and Z (Figure 7.26). This suggests that the drawing envisaged an object ideally resized (scaled) to be not much taller than a beholder's likely height — indeed, as exerting its maximum formal effect of right proportions at just that scale in visual space; that is, real size relative to the beholder. (The proportions and likely beholder's ideal standpoint are well

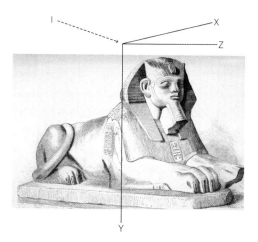

7.26. Diagram of a sphinx showing the "cubic" coordinate (X/Y/Z) frame for 1 : 1 : 1 proportions of the forward part of the body.

realized in an engraving by August Ramsthal of one of the sphinxes of the Serapeum, used in my Figure 7.26.[23]) The pictorial succession projected by the drawing as it were pauses here, resisting further abstraction from the proportionally desirable size (and specifically resisting abstraction to any *greater* size), because it would tend to degrade the complementary visibility of "cubic" proportions as visible "blockiness." This resistance cannot be overcome in any conceivable geometrical optics. Therefore we might reasonably assume that the draftsman-cum-sculptor recognized and embraced it. Superficially, the drawing could be taken to be a plan for scaling from one size to any other size. But it is also (even *instead*) a materially particular plan — a guide for realization — for figure-proportions visible as "cubic" at one particular scale, or, stated another way, for cubic proportions *qua* visible in NVP.

At the same time, the sculptor needed to consider the mutual scale — the proportions — of the *two* figures as they would be visible when resized in the sculpture realized from the working drawing. In the frontal elevation in his drawing, he cannot specify the *distance* between goddess and sphinx, though it is optically crucial. If it were short, the goddess would nestle against the sphinx's chest, and no pictorial problem would arise *regardless* of the real size of the object when realized and replicated. (The preserved fragments of the papyrus show that the goddess was *not* nestled against the chest of the sphinx, but it does not show where she *was* standing. In his reconstruction of the plan and elevations applied to the block, Schäfer therefore left her out altogether on the plan and the profile elevation.) But if it is long (and it is), she would stand between his paws, even well in front of him so far as the frontal elevation can show. Here pictorial problems could arise *depending on* the resizing. For example, if the object were replicated to be colossal, with beholders standing no taller, say, than the lion's paws, the sphinx's face, as seen at the beholder's standpoint, might be wholly obscured *behind* the goddess — a pictorialization that presumably the sculptor would not want. (Alternately, if he *did* want it — enabling a merging of the faces of goddess and sphinx in visual space — he would have had to resize accordingly with painstaking care.) Seemingly the goddess has been gridded with squares numerically proportionate specifically with the royal squares; the faces will fit together. This calibration suggests that even if the drawing was not actually plotting the "perspectival" relation in advance, the sculptor could achieve it spectacularly in the requisite resizing of the object.

In the plan, that is, on the coordinate plane, the draftsman can specify the location of the goddess right between the sphinx's "thumbs." But obviously this can also be done on the profile elevation without requiring the coordinate plane at all, which is redundant in this particular respect. Still, as I have suggested, the sculptor's drawing does — or it can — compute natural perspectival effects as a function of their emergence in

resizing at scale. This cannot be done without operations on VCP metrically organized in drawing up its plan.

8. WHAT KHNUMHOTEP SAW: ARTICULATION AND METRICIZATION OF VCP IN PICTORIALIZING ON THE PLANE

But what about painting and relief—notionally "two dimensional" pictoriality? In his account of ancient Egyptian "metric naturalism," and refining his identification of visible coordinate plane on the reliefs of Hesire, Summers has proposed that in two-dimensional pictorial construction VCP was metrically articulated: it spaced the objects on the depth plane (the plane of the Z-axis in X/Y/Z coordinate space) and carried the "standpoint of direct observation" (that is, ADO) into the emergent virtual space. Needless to say, this succession in pictoriality would bring ancient Egyptian pictorial bivirtuality much closer to Classical Greek naturalism, even to perspective projection, than most art historians—and the standard model of pictorial naturalism—have supposed.

In Chapter Six, we saw that [GP | MVA] has a kind of immanent virtual depth, namely, the virtual distance *from* the epidermal surface of the body in unforeshortened view *to* the median vertical axis inside the body. But this immanent virtual depth only *emerges* when VV is completed—what the succession of a straight line to [GP | MVA] aims to set up on the plane of pictorialization. When it *is* completed, a more definite virtual measure of depth recursively appears, namely, [VV | VCP]—the *volume* of the depicted object or figure giving the *extent and area* of the ground on which rests (that is, [register | groundline | {VV | VCP} | groundplane]). Stated another way, the span of [VV | VCP] on the Z-axis virtualizes along with the apparent thickness of VV as completed. In turn, this provides a virtual span on VCP. In principle, that span could serve as a *module*; but regardless, any multiple of the span naturally suggests that VCP continues "in depth" in just that amount. The more multiples, the greater the virtual depth.

Alert to this consideration, Summers has identified a possible example in ancient Egyptian painting. On the north wall of the tomb of Khnumhotep II at Beni Hasan (Twelfth Dynasty), a small vignette at the far west end of the second-lowest register depicts two farmhands trying to feed two young oryxes, possibly the same beasts shown being caught in the desert hunt depicted at the top of the middle of the same wall (Figures 7.27, 7.28). The scene is one of four vignettes on the same groundline; from left to right, they show the feeding of three birds, the orxyes and farmhands, four goats, and three cattle. Beyond the cattle, the same groundline continues under two vignettes of pairs of fighting bulls before transmuting into the groundline below a

procession of officials facing the large figure of Khnumhotep (he is three registers high) inspecting these and other activities on his estate. To zipper up that part of the intricate narrative arrayed on the groundline just described, the beholder must walk alongside the wall for about nine meters. The real height of our vignette (and the others on the register) is slightly below his eye-level.

Pictorial composition in canonical Egyptian wall painting and painted relief ordinarily went to great lengths to avoid ambiguous overlapping—lengths made literal both in the lateral spreading of figures (maximally separating one from next) and in the localized clumping of extreme occlusion (maximally overlaying figures with others). Still, the vignettes in Khnumhotep's tomb, as one commentator has put it, "are rather naturalistic, with the animals and their caretakers shown interwoven in realistic-looking ways."[24] In fact, according to Summers, in the vignette of feeding the oryxes VCP "accommodate[s] [the] volumes of overlapping figures by treating the virtual plane as if [it were] divided by transversal lines parallel to the plane of the format" (448) (Figure 7.29). Each of these transversals—the first and "forwardmost" is the [groundline { | groundplane }]—supposedly produces a span of virtual groundplane increasingly set back in depth. And that depth, therefore, supposedly has a particular virtual measure of *distance*; that is, a particular length of line on the Z-axis in coordinate space: "these completed volumes *triple* the distance of the articulated passage into the virtual space, [and] it is crucial to note that the virtual coordinate plane is always respected, by which I mean that the figures are always shown as if standing upon the same plane extending into virtual space from the baseline" (448, my italics). Summers models

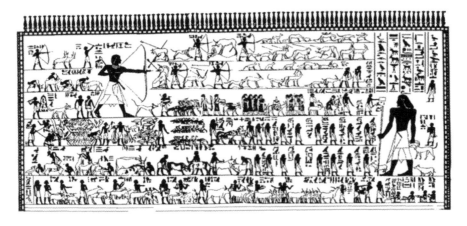

7.27. Plan of the north wall of the Tomb of Khnumhotep, Beni Hasan, Twelfth Dynasty. (From Percy E. Newberry and F. Ll. Griffith, *Beni Hasan I* [London: Kegan Paul, 1893], pl. 3.)

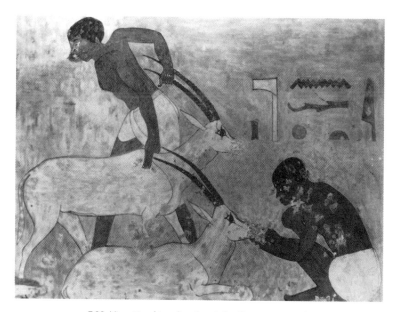

7.28. Vignette of two farmhands feeding orxyes, north wall of the Tomb of Khnumhotep, Beni Hasan, Twelfth Dynasty. (From Summers, *Real Spaces*, fig. 223.)

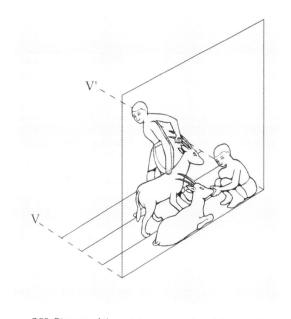

7.29. Diagram of the metric segmentation of the virtual coordinate plane in the vignette from the Tomb of Khnumhotep. (From Summers, *Real Spaces*, fig. 224.)

this articulation of VCP in an axonometric reconstruction; it indicates the so-called transversals and the three requisite articulations of VCP, all shown to be equal in span. The model should be understood as a strictly analytic reconstruction of a stage in pictorial succession, whether in visualizing the configuration to be painted (that is, in the work of pictorializing) or in imaging the painted picture. Because the architectural quarters of the vignette were too tight, it could not actually have been *seen* from an angle approximate to the one adopted for the purposes of Summers's projection in illustrating the operation of VCP. (The vignette was located practically at the junction of the north and west walls of the chamber. Therefore there is no viable IP in NVP from the west, the direction from which one enters.)[25]

There are reasons to favor the idea that VCP was metrically articulated; I have already discussed them extensively. But there are also reasons to doubt it. For one thing, the axonometric model of VCP in the tomb of Hesire — of "pictorializing on the parallels" in that particular case — analyzes what was actually *visible* to a beholder in visual space (Figure 7.22): "what Hesire saw," as I put it. In the case of Khnumhotep, however, VCP is *invisible* as such. And if it was involved in the pictorial succession — in pictorializing the little narrative episode intended by the painter — it is unlikely that its depth-dimension fully emerged. In the frame of Egyptian visuality, in fact, Khnumhotep and other beholders could probably see the painter struggling to image VCP as a virtual dimension of the depiction — a dimension visibly *resisting* its full presencing. The painter's difficulty lay squarely in coordinating the metric identity of emergent VCP with the *visible* configuration in [ADO \lozenge MVA] as ordered in canonical proportions. Summers's reconstruction, then, might model radical pictoriality in the pictorialist's imaging, *not* the picture he made — what Khnumhotep *saw*.

To be sure, Khnumhotep's pictorialist indicated gaps between the crouching oryx (in the first register of VCP in Summers's model) and the standing oryx (in the second register) and between the standing oryx and the man behind it (in the third register). They are implied by the occlusions. And he tried to *picture* the second gap — a gap deeper/more distant in the scene — by spreading the standing man's shoulders and arms such that his right hand grasps the horns of the beast and his left presses on its withers. (In the real action, then, the head of the beast would have to be twisted around behind the man's backside — a posture the beholder struggles to interpret, recursively pressing VCP into service in order to do so.) In virtue of [MVA | VV], the resulting distance on the plane between right and left shoulders — their twist — enables us to imagine the plane on which man and beast are standing. But the painter could not fully depict the *interlocking* of the two figures, and thus the virtual *measure* of the span of the second register. Nothing in the construction indicates that the first and second registers are *equal*.

Moreover, if the picture harbors an incipient VCP it was not "always respected." The canon of proportions would dictate that the standing man must be (seen as) perched on a mound hidden from us behind the crouching oryx: his legs are much too long for him to be standing on the *same* groundplane on which the other man crouches. Without some such pictorialization on our part, he is visibly noncanonical — severely mispro-portioned, a giant deformed in his lower limbs. (Even *with* a hidden mound, his legs would still be slightly too long. And where has his right foot gone?) Representations of uneven ground do appear in canonical Egyptian depiction, notably in scenes of men hunting animals in the desert. But because these planes appear on the upright plane of the format (that is, on the plane of pictorialization), they can be metrically controlled on the plane of the format, *not* in VCP. These fully visible hillocks are objects of depic-tion, configurations on the plane of pictorialization. They are not methods *of* pictorial-ization — constructions of VCP.

7.30. Vignette of wrestlers from the Tomb of Baket III, Beni Hasan, Twelfth Dynasty. (From Newberry and Griffith, *Beni Hasan I*, pl. 18.)

By the same token, canonical Egyptian pictorialists could stack figures to suggest "behindness" while drawing them in proper proportions at the desired scale. But to preserve proportions and scale — usually the metric fact that all the figures in the group are the same height, and isocephalous — the individual figures had to be spread out laterally. In turn, this construction could create an ambiguity on the two-dimensional plane, whatever its virtual three-dimensional coordinate plane: it would tend optically to suggest a file or a procession rather than a rank of figures, let alone a knot of figures. Indeed, any virtualization of a knot of figures spatialized as volumes on an emergent VCP in Egyptian depiction must be informal or unformal in proportions, relatively noncanonical. (A number of examples can be found at Beni Hasan, notably the groups of wrestlers in the tombs of Amenemhet and Baket III [Figure 7.30].) This tension in pictorial succession was an unavoidable disjunction in canonical Egyptian bivirtuality, essential to its visual productivity — its latent capacity to generate different variants of virtual pictorial space in NVP. In the terms of a general theory of visuality and pictorial bivirtuality, it is best, then, to describe the DC-pictorial construction of section-contour and proportional scalings and the AC-pictorial possibility of VCP as mutually *resistant* though interdetermined in the pictorial succession (cf. *GTVC* 164–67). In Egypt, VCP was a stutter of depiction, as it were.

9. THE RECURSION OF SCULPTURE IN PLANARITY

Given the several three-dimensional operations in ostensible planar pictorialization, can we integrate the phenomena of VCP in the production of three-dimensional sculptures and "two-dimensional" paintings and reliefs — see them as interdetermined? As noted in §4, in certain contexts in three-dimensional pictorialism one could see VCP as metrically controlled. Indeed, it *must* have been so imaged if we are to make phenomenal sense of certain material practices of pictorialism in sculpture in the round. And these practices could have recursively shaped Egyptian planarity *tout court*. VCP emerged in imaging Hesire's reliefs because the *architecture* of the reliefs in visual space generated it. But *within* it, Hesire could see the pictures as figures in the round (with full VV), standing on groundplanes or floors (that is, on VCP). Stated another way, the architectonics of Hesire's reliefs preserved, even privileged, the sightlines and standpoints on AOO in which VCP would have been constructed in making free-standing sculpture — and would have been fully visible (to skilled draftsmen and sculptors at any rate) as metrically controlled for the purposes of scaling.

In turn, the sculpturality of depicted objects on the plane encouraged translocation of IP, seeking to "look around" the depicted things. In ancient Egyptian pictorialism, as Summers noted, these recursions might not have visually constituted VCP as

anything more than "barely explicit," what Hesire and Khnumhotep would see askance as it were. In picking their way through the radical-pictorial horizons of planarity and inherent disjunctions and resistances in their resolution, however, Egyptian image-makers coordinated not only a distinctive pictorial bivirtuality. They also consolidated the visuality in which it could be seen — the full circuitry of succession and recursion of picture and image.

10. ASPECTIVE VIRTUAL COORDINATE SPACE — IN PERSPECTIVE

I will sum up the results of these phenomenologies of pictorial succession in canonical Egyptian depiction as presented in Chapters Six and Seven. As early as 2800 BCE, we find a pictorial bivirtuality in which (1) a plane of pictorialization and (2) a virtual coordinate plane (3) meet at right angles, making visible a region of virtual space — a volume — defined by the two coordinate planes *as they are imaged to be coordinate*: virtual coordinate space. In principle, virtual coordinate space can be imaged (perhaps even pictorialized in part or in full) as a virtual "box" containing the volume (Figure 7.31). The "floor" of the box (or one level of its floors at any rate) is defined by VCP. And its face (or one of its facing planes at any rate) is defined by the plane of pictorialization.

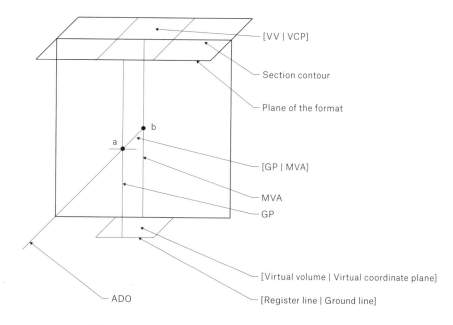

7.31. Summary diagram of the "box" of virtual coordinate
space in canonical Egyptian depiction — the virtual
pictorial space.

Other levels, "sides," and planes of the box can be defined in relation to the plane of pictorialization ◊ VCP.

On the depth plane (the plane of the Z-axis in X/Y/Z coordinate space), the box of virtual coordinate space has the virtual dimension of the "distance" of the line between point *a* (at ADO ◊ GP) and point *b* (at VVA ◊ MVA) as extended or "completed" in any emergent VV in the depicted figure and any emergent VCP below, behind, and around the figure. Indeed, as in the case of Hesire, potentially it has the dimension of emergent VCP constituted *in front of* the plane of the format and *below* the beholder (IP), pictorializing his *entire* visual space — a matter of particular standpoints, orientations of the visual axis, and ratios of PS : ID. Of course, on the plane of the format, *a* and *b* are graphically identical. In imaging, however, they are virtualized as disjunct — as lying apart. In *geradvorstellig* pictorial bivirtuality, this succession is the partial equivalent of the identity of the "eyepoint" on the picture plane in linear-perspective projection (so-called painter's perspective) and the "vanishing point," virtualized as lying an "infinite" distance apart — as it were an absolutely indefinite distance (see Chapter Nine).

If the beholder's line of sight never passes through VCP at any point, then the box of virtual coordinate space will remain invisible as such — as a virtual ground- or skyplane and especially as a "room" that could be pictorialized *as* a stretch of ground or sky or as a room-object. As we have seen, however, outside the threshold of pure planarity the beholder's visual axis cannot *always* remain perpendicular to the plane of pictorialization; in some cases it can *never* be perfectly perpendicular to it. Therefore the box of virtual coordinate space remains immanent in any birotational configuration on a plane that is visibly delimited in visual space; the box is a horizon of its radical pictoriality, and depending on IP it can emerge in pictorialization. Considered as a coordinate frame, the box of virtual coordinate space is *both* "object centered" (insofar as it is constituted in such crucial axes as [register | groundline | VCP] ◊ [GP | MVA]) *and* "viewer centered" (insofar as it is constituted in such crucial axes as [ADO | VVA] ◊ [GP | MVA]).

(The frequent distinction between object-centered and viewer-centered coordinate frames can be highly misleading. Object-centered coordinate frames *can* be used to construct depictions of objects. But viewer-centered coordinate frames, that is, NVP, *must* be used to apprehend such depictions, whatever the orientation of the virtual visual axis relative to the principal plane[s] of the depiction. This relationship is independent of the controversial hypothesis, identified with the computationalist visual psychology developed by David Marr, that viewer-centered coordinate frames subsist at a lower, earlier, or simpler phase of the neurocognitive processing of information contained in intensity gradients of light registered in photoreception — information

supposedly recomputed into an object-centered coordinate frame in the higher, later, and final phases that are experienced phenomenally as the visual field as such. For my purposes in historical phenomenology, the final stage[s] of visual computation must be treated as the field of imaging in my sense, of phenomenal visual space as such—the field in which depictions presented to photoreception are perceived and processed, and in which object-centered and viewer-centered coordinate frames are recursively interdetermined in such pictorial successions as the ones reviewed here. See the "Note on Marr" in §11.[26])

I have already evaluated the presence of any metricization of VCP in ancient Egyptian pictoriality: it is obvious that any metricization could be a step in recursively configuring (1) the plane of pictorialization in terms of (3) its virtual coordinate space. And any metricization of (1) the plane of pictorialization could recursively generate (3) its virtual coordinate space if it is carried into (2) VCP. Finally, of course, the metricization of (3) virtual coordinate space can be applied in both (1) the plane of pictorialization and (2) VCP. Indeed, *all* these recursions must be compounded to create the virtual pictorial space with which observers have become familiar in modern Western traditions of bivirtuality in painter's perspective (Chapter Nine).

As we have seen, ancient Egyptian pictorialists understood that the proportional modules used to construct a figure on one plane could be used to construct the same or another figure (that is, the same or another depicted object) on a plane perpendicular to it. Canonical Egyptian sculpture was made in just this way: a grid based on the *same* module was used to project both the plan and the elevations of a three-dimensional figure to be carved from a dressed block of stone. But it would seem that in constructing depictions in notional *two dimensions* the pictorialists were not interested in a regular metric-numerical articulation of visible virtual coordinate space as an aspect of its virtuality in visual space. Depicted objects on the plane of pictorialization, on the one hand, and conformations in VCP potentially succeeding to virtual coordinate space, on the other, did not become fully visible as numerical-proportional expressions of one another.

Still, this negative description of Egyptian visuality—a description in terms of what it is not—remains somewhat unsatisfying. In a sense it might put the cart before the horse. Egyptian pictorialists working in notional two dimensions had good reason to *avoid* arithmetic unification of the plane of pictorialization and VCP potentially succeeding to virtual coordinate space.

How so? There is no *logical* reason why a *geradvorstellig* configuration could not apply the proportions used to construct figures pictorialized on the notionally two-dimensional planes of the format and the plane of pictorialization to the definition of VCP as well. In turn, these proportions could be carried throughout a virtual space

coordinated three-dimensionally and measured by the common module. But this metric harmonization of the plane of pictorialization *and* VCP—coordinating aspective bivirtuality in one module applied uniformly throughout the plane of pictorialization and VCP—perhaps too readily generates insuperable *perspectival* ambiguities in the resulting picture, overly resistant radical pictorialities.

In traditional pictorial arts, reducing the size of a depicted object on the plane of pictorialization can sometimes imply that it lies further away from IP on VCP (as virtualized on ADO) than the same object presented on the plane at larger scale. But it would quickly have become obvious to the pictorialists that down-sizing the shapes of depicted objects strictly as a modular function of depth on a virtual coordinate plane (as if that plane were divided by the same modules as the plane of pictorialization facing the observer on ADO) would not simply create an impression of measurable diminution in the recession *on* ADO, that is, of "distance" in the "depth." It could quickly lead to the effective *disappearance* of the depicted objects. Consider this model example (Figure 7.32). On the [register | groundline] on the plane of pictorialization, one could construct an object (in ADO) that is six modules high. "Behind" it, the same module can be used to construct six transversals of [register | groundline | VCP]. On each transversal, in turn one can construct an object that is one module shorter than the figure immediately in "front" of it, and one module taller than the figure immediately in "back." Beyond the sixth transversal, any object pictorialized in this system must be zero modules high—at a virtual distance that is equal only to the height of the foremost figure, namely, six modules. Of course, this need not be a problem if the six objects are "really" scaled 6 : 5 : 4 : 3 : 2 : 1. But it is pictorially unworkable if the objects are (for example) ordinary human figures (of more the less the same real height), or indeed any series of objects that are really scaled 1 : 1, that is, as having the same size and volume-shape despite "distance": if both figures are the same size, a second figure standing only as far away as a first figure is tall is not *one-sixth* its height. (The situation can be improved by constructing each figure, regardless of its height in modules applied to VCP, by using a uniform proportional system—say dividing GP into 12 units—that is scaled down relative to each reduction in height on transversals on VCP, as in the first two figures on VCP in Figure 7.32a.) To reconcile this, one might have to reimagine (see-as-*as*) the transversal intervals of distance on VCP—see them, for example, as intervals not of one module but of three (Figure 7.32c). The resulting pictorialization might be more acceptable to the extent that the volume of virtual space on VCP seemed more natural—capable of encompassing the diminution of things experienced in natural visual perspective. But it will have its own ambiguity and radical-pictorial ramifications and resistances. For example, in ADO the objects might seem to be arrayed side-by-side on the plane of pictorialization yet to be separated

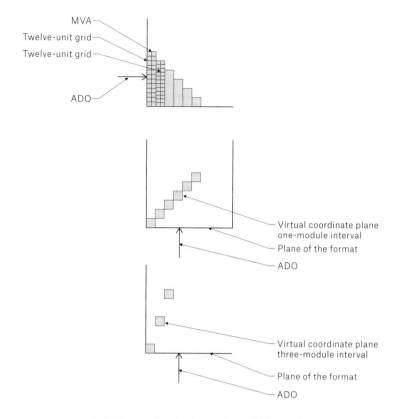

7.32. Diagram of scalar downsizing on VCP; a, profile
section through VCP showing reduction "in depth" in
one-module increments (after sixth increment, objects
"disappear"), also showing construction of the objects
using a twelve-unit grid similarly down-sized; b, plan of
the same construction on VCP; c, plan of a construction
on VCP using scalar down-sizing in a three-module
increment (after third increment, objects "disappear").

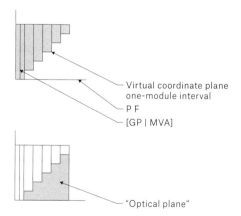

7.33. Diagrams of stacking; a, figures stacked in
one-module increments from the groundline, creating
impression of "depth"; b, emergence of an "optical
plane" apparently receding into "depth."

7.34. Diagram of a contemporary method of "false
construction" of a perspective projection described
by Leon Battista Alberti (1435).

from one another in depth by distances that seem increasingly greater relative to their heights. (Relative to 6, 5 is one module shorter and three modules distant; relative to 3, 2 is one module shorter and three modules distant: what is seen in this seeming dilation, seen-as-*as*?) Further permutations could be explored. For example, the reduced object need not be set on the register line ([| groundline | VCP]). It can "float" in the virtual space, with or without its own special groundline (Figure 7.33a). Given natural visual expectations organized in NVP, these choices might tend to virtualize something like an optical plane—a stretch of ground rising *from* groundline *to* the places of the reduced objects on VCP, their locations on its transversals. Perhaps this plane is only a radical-pictorial horizon in imaging the picture. But it can readily be pictorialized: one can depict it *as* visible ground (Figure 7.33b). To take another example, in *De pictura* (1735) Leon Battista Alberti mentioned a pseudo-perspectival method that was seemingly used in his day (Figure 7.34): a parallel is drawn to a baseline, and the distance between them divided into thirds; a third parallel is drawn above the second, two-thirds of the distance between the first and the second; a fourth parallel is drawn above the third, two-thirds of the distance between the second and third, and so on. This "false construction" is, as it were, intermediate between Egyptian-style aspective and Alberti-style perspective.[27]

11. NOTE ON MARR: VIEWER-CENTERED AND OBJECT-CENTERED COORDINATE FRAMES

In *Vision*, his pioneering book of 1982, David Marr illustrated an early stage in the "computation" of information transmitted in reflected light to visual proprioception: a leaf on one stalk hanging in front of a leaf on another stalk, or as he put it an "image of two leaves" (Figure 7.35). Marr's illustration modeled information in photoreception—what he called the "gray level" of the "image" (color has not yet been computed at this stage of visual processing). The table accompanying his simulation of the image at photoreception assigned numerical values to the discrete units of the image (designating discrete incidents of photoreception): the measurable "intensity value" of luminance at these locales in the image. *But where in the numbers can we find the distinct edge of the leaf, or the boundary or gap between the leaves, that we can see with just a bit of work?* As Marr contended, "there is *not* a sufficient intensity change everywhere along the edge … to allow for its complete recovery on the basis of intensity values alone, yet we have no trouble perceiving the leaves correctly."[28] Marr explicated this observation in a complex model (what he called a "representational framework for vision") of the hierarchical computation of information in reflected light sequenced into three "representational stages" *beyond* the primitive gray-level image that merely "represents intensity"

7.35. Model of intensity gradients in an "image of
two leaves"; discrete incidents of photoreception at
the level of the "gray scale" of the image to which
numerical values can be assigned. (After David Marr,
*Vision: A Computational Investigation of the Human
Representation and Processing of Visual Information*
[New York: W. H. Freeman, 1982], 273.)

7.36. Radical pictoriality: three leaves, not two.

(as modeled in his illustration of the "image of two leaves"): what he called (1) the "primal sketch," (2) the "2½-D sketch" (a "viewer-centered coordinate frame" in which the edge is getting computed by way of perceived discontinuities in the surface and in "distance from the viewer"), and (3) the "3-D model representation" (an "object-centered coordinate frame" in which the edge has been fully computed as a *spatial* distance in depth—what we *see* if we were actually looking at Marr's leaves).

Marr's model was complex, and he stated it in several ways. To use his own words, "The overall framework ... divides the derivation of shape information from images into three representational stages ... (1) the representation of properties of the two-dimensional image, such as intensity changes and local two-dimensional geometry [that is, primal sketch]; (2) the representation of properties of the visible surfaces in a viewer-centered coordinate system, such as surface orientation, distance from the viewer, and discontinuities in these quantities; surface reflectance; and some coarse description of the prevailing illumination [that is, 2½-D sketch]; and (3) an object-centered representation of the three-dimensional structure and of the organization of the viewed shape, together with some description of its surface properties [that is, 3-D model representation—recognition of object-world]." Marr took the primary theoretical problem to be the transition from (2) to (3). Given the information encoded in the image (by stereopsis, shading, texture, contours, and visual motion), the sequence of early visual computations from the image to the primal sketch and the 2½-D sketch (that is, from image to [1] to [2] above) is "unsuitable for recognition tasks" (that is, insufficient for identifying what the shape is the shape of) *because it depends crucially on the vantage point*. As Marr trenchantly observed, "It must be remembered that coordinates referring to the line of sight are not very useful to the viewer" precisely because "one must continually allow for the angle of the line of sight, ... a difficulty that is compounded by the effects of eye movements." (Throughout this book I have investigated this dynamic, though with the crucial revision that in NVP at IP we must bring a natural viewer-centered coordinate frame to seeing depictions in which recognizable shapes might be pictorially constructed in *object*-centered coordinate frames—a recursion in Marr's hierarchy *from* viewer-centered *to* object-centered.) According to Marr, then, the crucial final step of visual computation (that is, from [2] to [3] above) likely "consists of transforming the viewer-centered surface description into a representation of the three-dimensional shape and spatial arrangement of an object that does not depend upon the direction from which the object is being viewed." Seeing, we might say, is always subject to the visual angle; it is always coordinated in natural visual perspective. Nonetheless, it supposedly extracts recognition of objects partly by computing a representation *away* from the vantage point, as it were *around* it. Is this

a *pictorial* operation within vision?—a recursion of aspective pictoriality in natural vision?[29]

Marr proposed that we see the edge (or the gap) between the two leaves more or less easily because of what he called "consistency-maintaining processes in the 2½-D sketch."[30] Still, we can see the edge in several ways—radical pictoriality. (The image in Marr's sense is ambiguous.) I might see the leaf on the lefthand side of the image as "behind" the leaf (or leaves) on the righthand side of the image in virtue of the apparent continuity of its contour with the stretch of leaf to the right of the *middle* stretch of leaf—one of Marr's "consistency-maintaining processes." I see lefthand and righthand stretches of leaf, then, as parts of the *same* leaf—recognizing the (unitary) leaf behind the middle leaf. At the bottom of the leaf in "back," this continuity seems readily computable; the curve connecting them is smooth. At the top, however, no smooth continuity can be constituted. Moreover, there is a stark contrast in intensity values along *both* connecting curves ("bottom" and "top" in the image), smooth or not. Given this, we might compute (in my terms we might radically pictorialize) the left-most stretch of leaf as a *third* leaf arising from a stalk that is not visible—a leaf *abutting* the middle leaf, lying *in the same plane* across the line of sight (Figure 7.36). Therefore the boundary or "discontinuity in the surface" (supposedly seen as the *one* edge of the leaf "in front," silhouetted as contour against the leaf "in back") is where these different leaves are *touching along both their edges.*

Whether there really *is* a third leaf can probably be resolved in visual space by moving around the objects; as noted, Marr claimed that coordinates "referring to the line of sight" (that is, a viewer-centered coordinate frame) are actually "not very useful to the viewer," at any rate according to Marr's terms and in his model, and even though viewer-centered coordinates can be continually enriched and disambiguated in the motion of the viewer and the consequent smooth translocation of IP and birotationality of objects viewed—perhaps the most "useful" visual activity there is. But assuming no motion of the vantage point, in Marr's model evidently the viewer-centered representation of the image *feeds into* the object-centered one, and helps to constitute it. And that particular representation, as just demonstrated, could have *two* three-dimensional versions—at least two radical-pictorial compliants computed from the same intensity values of the image (see Chapter Two, Table 2.2). One is objectively correct and the other is incorrect. To get us to the one and not the other, visual processing according to Marr integrates the intensity contrasts and primal (dis)continuities represented in the 2½-D sketch in order to give "rough depth" and "distance from the viewer"—thus *two* leaves, not *three*. This is the very idea of Marr's two-*and-a-half-dimensional* representation. And a strange animal it is: for some critics, too strange quite literally by half, a sleight of hand in Marr's model of three-dimensional visualization.[31]

But in a recursion in vision, and especially in visuality, the 2½-D representation in visual computation might be perfectly viable. As commentators on Marr's model of the representational framework of vision have pointed out, 2½-D pictorialization is a widely used technology of orthographic projection, usually designated as axonometric projection in "paraline drawing."[32] Equally important, and as we have seen in this chapter, it is a common way in which two-dimensional renderings on the plane "three-dimensionalize" when *the visual angle at vantage point* constructs a "virtual coordinate plane," that is, a *Z-axis*-plane visibly coordinate with the plane of the X and Y axes. If this capacity of depiction loops recursively into visual processing at Marr's second stage, then Marr's foundational problem takes care of itself in the modern human case. The Z-axis-plane would seem to be rarely encountered, if ever, *as a visible plane* in nature *outside* pictures. (Where, for example, is the flat "floor" in the arboreal space of the forest in which the leaves will likely be seen in natural primate vision?) It only becomes fully visible in *virtual pictorial spaces*. Hypothetically, once the brain computes visually (in Marr's terms, once it represents the image) by way of this plane, if it does, it can readily spatialize intensity contrasts, surface (dis)continuities, and so on, in terms of "rough depth" and "distance from the viewer," just as Marr wanted to require of the 2½-D sketch as one of the sequential representations of the gray-level image in visual processing!

What Phidias Saw

Virtual Coordinate Space in Classical Greek Architectural Relief

1. PLANAR BIVIRTUALITY IN ANCIENT EGYPTIAN
AND CLASSICAL GREEK CONFIGURATION

Emergent virtuality in Egyptian-style planarity (see Chapters Six and Seven) need not be identified exclusively with the canonical procedures of ancient Egyptian pictorialists. Indeed, David Summers moves rapidly from canonical Egyptian painted relief to Classical Greek relief sculpture. According to his world art history in *Real Spaces*, it was the ancient *Greeks* who brought Egyptian-style virtuality in planarized configuration to its full notional realization (as he puts it).

It is not quite enough, however, to stop after noting that the virtual pictorial space constructed in Greek relief sculpture "does not differ in principle from the Egyptian" (449). There may have been no difference in principle in certain well-defined respects, but there was considerable difference in practice. To use Summers's terms, Greek sculptural pictorialists constructed the imagistic "dependence" of the configuration—the dependence of the picture on the beholder's imaging point (IP)—in ways that the "independent" picture in Egypt did not (see Figure 7.2). As Summers puts it, in Classical Greek sculpture "relief space simply but surely pushes planar presentation in the direction of the optical" (450). True as far as it goes, this description is not, however, an *explanation* of the transformation. And "relief space" as such cannot have been its *agent*. Greek relief sculpture must have been coordinated architectonically and pictorially to succeed to the "dependence" noted by Summers, zippering the image in order to *pictorialize* spatial relations that probably remained "barely explicit" in canonical Egyptian configuration.

In part the transformation can be traced, I suggest, to architectural formats in Greece and their architectonics in visual space. Egyptian relief sculpture—it was either a very low relief, often painted, or a "sunk relief"—could be placed high up in a building relative to the real-spatial locations of observers. But its canonical configuration did not originate in this kind of visual space: it assumed the axis of direct observation (ADO) at about eye-level. By contrast, Greek architectural relief could be designed to accommodate steep vertical angles of imaging—taking into account the fact that, once the sculptures were installed, most imaging points would be well below the pictures themselves. In fact, as we will see, it was probably in part the challenge of securing the visibility of pictoriality outside ADO that led to fuller refinement of its "dependence" on IP; that is, to a higher quotient of apparently continuous pictoriality (AC-pictoriality) in the axis of oblique observation (AOO).

This was not only a question of mimesis, of supposed naturalism, in the *style* of carving human, animal, and supernatural figures—of producing a figure that would seem lifelike in its surface features, anatomical structure, pose, and proportions. It was

also a question of coordinating the figure, especially its pose on the virtual coordinate plane (VCP), to share the observer's visual space in a way that rendered it continuous with the pictorial space — an "immersive" AC-pictorialization. Classical architectural sculpture zippered the image in new ways.

These were delicate calibrations — fugitive and unstable. Let us consider Summers's principal example, dated to 442–438 BCE, namely, the complex depiction of human actors (horseback riders, charioteers, marshals, and others) and divine figures on the frieze of the Parthenon on the Acropolis in Athens — one of its many Ionic flourishes (Figures 8.1, 8.2). The frieze has often been identified as a depiction of the procession organized in the course of the annual Greater Panathenaic festival, whether it shows the festival in a mythical time or in contemporary historical time or in both. Still, there are several difficulties with this identification (including the fact that what we

think we know empirically about the procession comes in part from the frieze itself), and a number of different iconographies have been proposed in what has become an immense scholarly literature. Some attempt to resolve anomalies in the frieze seen as a depiction of a Panathenaic procession, some go in other directions altogether.

Very little that I will say about questions of the visibility and virtuality of the frieze, and specifically about virtual coordinate space, will depend on wholly resolving the vexed iconological issue of its fullest and deepest cultural "meaning," that is, the status of the frieze in a fully consolidated visuality or visual culture. Many individual motifs on the frieze—individual figures and groups of figures—have obvious, stable, and relatively undisputed configurations, despite iconographic peculiarities (for example, the figures bearing *hydriai* [water vessels] are male, not female as would be usual), and the postures and gestures of the figures can, for the most part, be interpreted visually.

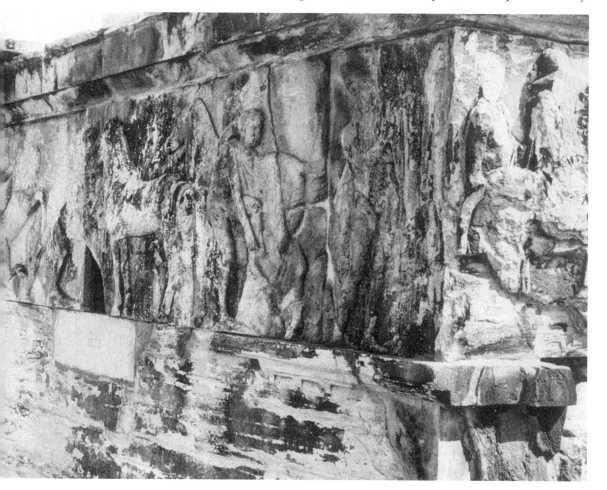

Indeed, as we will see, in the visual space of the frieze the question of the very possibility of a full iconographic succession, of the emergence of a completed pictorial symbol (see *GTVC* 187–229), must be kept open. As in the rest of this book, I will focus primarily on the constitution of pictoriality in bivisibility — including radical-pictorial possibilities and resistances and recursions of pictoriality as such — as a phenomenological precondition as much as an outcome of visuality. A minimalist approach to "meaning" would take the frieze to be an affirmation of Athenian historical, political, and moral identity in the context of its time of making, that is, during the consolidation of Athenian democracy and empire under the leadership of the statesman Perikles; as Richard Neer has put it, the frieze "shows how the imperial democracy liked to imagine itself." Further and more specific, complex, and sophisticated resolutions of the narrative, allegorical, and symbolic functions of the frieze can be projected in a number of ways (not always mutually exclusive) from this basis.[1] A sensible contextual procedure that is generally consistent with the analytic framework advocated in this book is followed by Jenifer Neils in her study of the frieze: though recursions are inevitable, analytically she moves from *polis* ("the framework of ritual") to *paradeigma* ("designing the frieze") to *techne* ("carving the frieze") to *mimesis* ("the high classical

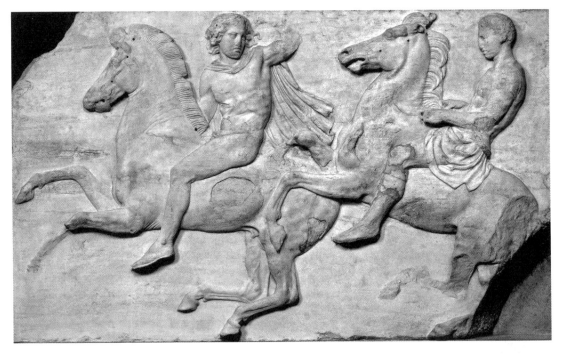

8.2. Riders W2 and W3, British Museum.

style") to *iconographia* ("identifying the players") to *iconologia* ("interpreting the frieze") to *kleos* ("the impact of the frieze").[2]

In these terms, and to return to the overall question of virtual pictorial space with which I began this chapter, we can assume *polis* (the Athenian context) to look at more closely at *paradeigma*, *techne*, and *mimesis*. Partly in order to solve challenging problems of its visibility in real and visual space, or at any rate to mitigate insuperable difficulties, the designer(s) of the frieze (possibly the state sculptor Phidias, perhaps assisted by Alkamenes) constructed both virtual volume (VV) and VCP in a complex interplay of ADO and AOO, resulting in (and recursively requiring) the rotation of figures — a very particular "naturalism" of stance, gesture, and action that incorporates the emergent virtual space in the very style of shaping the stone. This development has often been attributed to the rise and refinement of what classical archaeologists sometimes call "ponderation" (that is, *contrapposto*). But this term is chiefly descriptive of the effect in question — and not explanatory. The particular orientations and torsions of figures on the frieze seem to have been coordinated as much in relation to the space in which they are sited on VCP as in relation to independent canons for managing ponderation in free-standing sculpture, supposing such canons were even available. I will work step by step through this subtle succession and its recursions. I begin with the beginning: the planar order of the frieze.

2. PLANNING VCP ON THE PARTHENON FRIEZE

As Summers has put it, the sculptors of the frieze constructed Egyptian-style planarity in "the multiplication of shapes into virtual depth along a virtual coordinate plane according to divisions parallel to the plane of the format itself" (448–49). It is in this sense that the frieze, in his words, "does not differ in principle" from a canonical Egyptian rendering of figures in a group, whether human or animal — moving, for example, in processional ranks and files. (As we have seen in Chapter Seven, I question the extent of the emergence of virtual "divisions parallel to the plane of the format itself" in canonical Egyptian pictorial bivirtuality, such as in the vignette in the tomb of Khnumhotep II [Figure 7.34]. But there is no need to repeat those considerations here.) In this respect, the captions to the parts of the frieze now displayed at the British Museum (the "Elgin marbles") compare it to Egyptian and Assyrian reliefs, presumably in order to highlight the structural similarity of their "plans" as much as their stylistic differences and divergent conventions in depiction.

Indeed, and regardless of ancient Egyptian practice, Ian Jenkins and his colleagues at the British Museum have suggested that the master designer of the Parthenon frieze — henceforth I call him "Phidias" — must have laid out a bird's-eye-view plan of

the figures massed in their groups, many of which are compositionally coherent within the frame of the individual slabs on which they are carved (Figure 8.3), especially on the west frieze.[3] (The one-meter height of the slab was most likely dictated in part "by the proportions of the columns of the porches" at the west and east, over which it was set,[4] and in part by computing the ratio of picture size to image distance [PS : ID], assuming certain standpoints beyond the stylobate of the building—a thesis I will explore below.) By "plan," I denote something possibly as simple as an arrangement of pebbles on the ground that enabled the craftsman to "see" the configuration on VCP in abstract aerial view, and not necessarily the kind of highly formal two-dimensional virtualization imagined by Jenkins. (The special "plan" perhaps used to organize the virtual pictorial space of VCP must be distinguished from full plans and elevations made to scale, if any, that were generated in order to design the building; this is a different matter.[5] Still, as we will see, the plan probably needed to contain certain information about the architectural context of the frieze, and would have required a mapping of elements of the groundplan of the building itself, however informal.) Only in this way, Jenkins speculates, could Phidias have managed the overall composition of the depicted procession, which enfolded over 350 human and divine figures as well as numbers of horses and cattle, so as to relay an astounding quantity of anecdotal, narrative, and figurative information. Guiding the stonecarvers working on the blocks, the plan would have been a diagram of the groundplane virtually coordinate with the *tableaux*, though that plane could nowhere be pictured *as* visible ground, except when a heap of earth or a rock *on* the groundplane was depicted jutting up into the figures' space.[6] Simply put, the plan represented the layout of the procession on VCP—how one might marshal it, and actually did. In its exhibition of casts taken from Lord Elgin's set of molds of the west frieze, currently displayed in a small gallery outside the majestic Duveen Gallery, the British Museum includes such layouts (all would presumably have been found in the master plan) as guides for the present-day museum-goer, explaining what we see on the frieze, or in it, and giving us the very same kind of diagrammatic instructions (and/or their results in sketches) as were likely provided to the carvers themselves by the mastermind Phidias.

But we must be careful here. In Jenkins's reconstruction of the plan, as in Summers's reconstruction of virtual pictorial space in the tomb of Khnumhotep (see Figure 7.29), the "divisions parallel to the plane of the format itself" are identified analytically as *equal in width*, that is, in their implied measure of "distance" into "depth" on any axis of direct observation (ADO) that succeeds to a virtual visual axis (VVA) (that, is [ADO | VVA]) perpendicular to the plane of the format. However, I can see no reason for treating them as metric constants. In fact, many planes of supposedly "background" figures on VCP visibly lie in the *foremost* register—parallel, that is, with the foremost

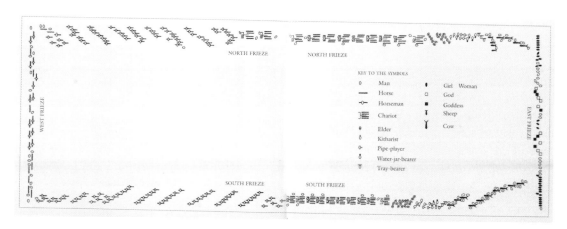

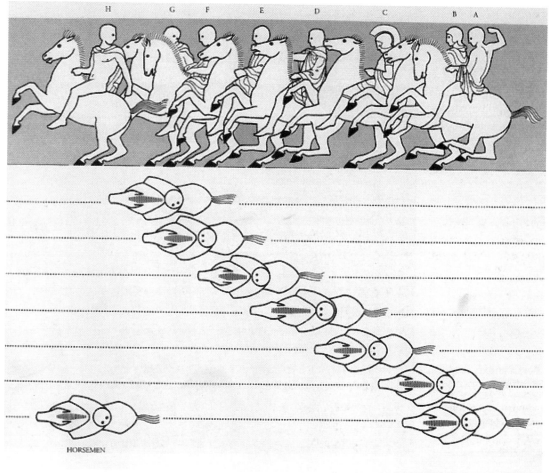

8.3. a, Reconstruction of the virtual coordinate plane
of the Parthenon frieze by Ian Jenkins and Sue Bird; b,
reconstruction of one rank of riders. (From Ian Jenkins,
*Greek Architecture and Its Sculpture in the British
Museum* [London: British Museum Press, 2006], fig. 86.)

planes of *all* depicted objects located on VCP. On the plane of pictorialization, this was unavoidable, of course, when the feet of human figures and the hooves of animals visibly had to seem to touch the ground—a succession of the ground*line* or bottom edge of the plane of the format in visual space—*regardless of their position in a register that spatially disallows that very location in plan.* Even though the [edge | groundline] virtualizes in the pictorial succession as VCP, it does so *recursively* in the visible relations between the figures and their orientation to IP. And if many figures do not seem wholly to lie in their appropriate register on the plan for VCP, this must raise the question whether the plan wholly governs the virtual pictorial space—the coordinate space.

Moreover, even if they were metrically planned, the registers of VCP could not have been virtualized—visualized in the making—as metrically equal in "depth" *all around the frieze.* For then Phidias would have been unable pictorially to coordinate those parts of the composition in which six or more registers of VCP were needed with those parts in which only *two or three* were needed. Jenkins's reconstruction has to fudge this somewhat. It balances the rigor of computation in the plan against the narrative sense relayed *not only* by the plan *but also* by the sizing and shaping of the figures, as well as their visible location regardless of the spatial location assigned to them on VCP.

In the case of the files of chariots and charioteers on the south and north friezes, for example, part of what lies in the visibly "forward" or "front" register has been situated partly in the *second* register in the reconstruction, probably because one human figure in the entire procession of chariots on each side (S66, N45) has to be planned to lie in the first register, partly occluding a chariot in the second. In turn this requires that *all* chariots, if interpreted as following one another in file, must be partly in the second register, even if their wheels always touch the groundline (at [edge | VCP]) in what seems to be the *same* visible place, one rut in the ground(plane). But in visual space, no observer could see this slight "set-back" in the virtual pictorial space assigned to the depicted file of chariots, even if it was required in order to coordinate the system of their occlusions.

Conversely, some groups of human figures and animals are brought into the first register of the plan because they cannot visually be located two or three registers deep on VCP, even if the procession itself likely placed them there. On the north frieze, the five hindmost ranks of horsemen (ranks of two, three, or four riding abreast) begin at the first register on VCP, even if they were probably riding in a *different* place. (In the procession, they probably rode as a "taper," behind the ranks of horsemen riding six or seven abreast. To indicate this more fully, however, the five hindmost ranks would have had to be carved in lower relief than they were, in turn creating an ambiguous and unaccountable spatialization insofar as one could not easily *see* the equivalence of this

depth of relief to the depth of relief used for the riders two or three deep in the larger ranks — the register on the groundplane in which the taper of riders actually rode.)

Indeed, Phidias found ways to prevent these ambiguities and disjunctions from becoming too visible. On the plane of pictorialization, he not only scaled all the figures in six or more registers of VCP at the same size as figures in only one, two, or three registers. (For iconographic and narrative purposes, he readily *could* scale figures to different virtual sizes, as on the east frieze "peplos scene" flanked by groups of gods — beings larger than the "human-size" scale assigned to the human figures on the frieze). He also distributed them laterally such that at any standpoint in any one glance we can mostly *see* only the relations on VCP between two or three horsemen rather than all six or seven in the ranks to which they belong. Thereby he equivalenced them in visual space to VCP divided into only two or three registers; in imaging, all six or seven riders in a rank occupy the same "distance" on ADO at right angles to VCP (ADO ◊ VCP) as only two or three. (Stated another way, VCP itself compresses and distends in its "depthiness," though this pulsation of pictorial space is not directly visible.) Conversely, the lateral distribution promotes the visibility of occlusions that define the relations between any two contiguous riders. This in turn allowed for crucial effects in AOO, to be considered momentarily: to *see* the lateral spread of a group defined by its occlusions we must look at it obliquely.

Handled with tremendous virtuosity by Phidias and the carvers, all these tremors and tensions derive from the fact that regardless of the location of a figure or an object on VCP, one or more of its feet, hooves, or wheels has to touch [edge | groundline { | groundplane | VCP}], which *always* has to be in the first register on VCP. None of this obviates the plan as such. At all ADOs perpendicular to the registers on the plan of VCP, on the plane of pictorialization Phidias could coordinate the relations of occlusion between figures, whether ADO passes over two registers, three, or more. And none of it obviates Jenkins's reconstruction of the plan; the reconstruction could not have been done any other way. It is only to say that the reconstruction does not tell us the whole story of the virtual pictorial space in the visual space in which the frieze was imaged. The plan of occlusions on VCP had to be integrated with *another* computation. And it is there that we will discover the real difference between the pictorial succession of VCP in ancient Egypt and in Classical Greece.

3. PICTORIALIZING IN THE PARALLELS

Above all, in the real and visual space of the frieze as it was installed on the building, there was no accessible ADO, even if ADO was often deployed in planning, designing, carving, and painting it at the makers' eye-level on the ground and/or on the scaffolding

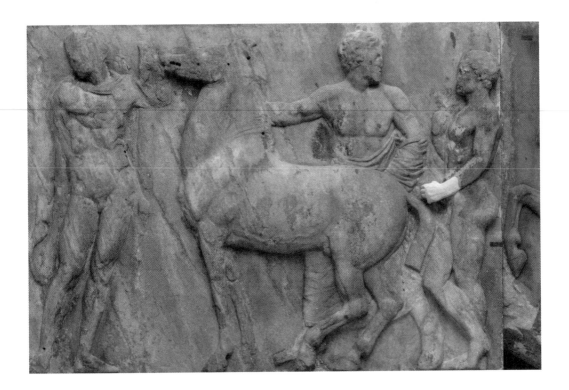

needed to work at the architectural level of the frieze as installed. Correlatively, then, the frieze cannot be zippered *only* in the constant relative motion of [ADO | VVA] as the beholder passes along beside the frieze—all that the plan of VCP requires. The frieze *also* begins to zipper the image *by recursively coordinating any available [ADO | VVA] used to design the picture with the [AOO | VVA] required to image it*. Therefore it pictorialized objects configured on axes of [AOO | VVA] *as well as* on the axes [ADO | VVA] that set their spatial relations on VCP. Indeed, [AOO | VVA] adds spatial information about the individual orientation and action of all figures without altering the spatial relations of figures given by the construction of VCP in [ADO | VVA]. In turn this anticipated "obliquity" could be registered in the very shaping of the figures: they could be carved to turn more or less freely on their median vertical axis (MVA) at their appointed spot on VCP as coordinated in the plan, *regardless* of the axis on which they might be imaged (ADO *or* AOO).

Figures on the frieze were often configured to face other figures, or at any rate to seem to look at other figures (regardless of mutual facing), whether or not a narrative and symbolic sense can be made of their orientations and glance(s) (Figure 8.4). This "facing" and "fronting" could be handled in apparent *Geradvorstelligkeit*, that is, in a seemingly perpendicular intersection of the planes of depicted things, such as heads and torsos, with ADO setting their spatial relations on VCP. Throughout the frieze, then, the heads of two figures that can be understood to be facing (and/or looking at) one another seem to be in full *profile*, as if looking ahead of them in the procession or even as if looking (in a tilt of the head) at something somewhere else. But sometimes the *geradvorstellig* configuration of such figures—they seem both to *be in* and to *look at* things in the very same plane relative to the plane of the format—must conflict with the construction of VCP in ADO (equally *geradvorstellig*). The plan would require them

to have a virtual mutual sightline — a sightline pictorialized on the plane of pictorialization — that is *oblique* to ADO (and to the plane of the format) because the figures sit in different registers in VCP, implicitly requiring visible deviation from profile on ADO. Stated the other way around, their spot on VCP would seem to *disallow* the straight-ahead facing and/or the straight sightline parallel to [edge | groundline | groundplane] that they seem to have in ADO, as if both figures are situated in the same register on VCP.

Phidias was not much bothered by this conflict, and simply let it be. We have already seen that he could not entirely convert spatial relations on the plan into visible orders in virtual pictorial space. Probably he judged that the glance of a figure was best visible, if visible at all, if it was parallel to [edge | groundline] and to the plane of the format. Iconographic and narrative context would have to supply the "content" of the glance on VCP — its pictoriality. Still, the *deus ex machina* of iconographic and narrative context (all too common in culturological art history) would transfer explanation of the visual and virtual space from pictoriality (and its resistances) to visuality (and its putative priority) — a transfer that we should always be reluctant to make given the inherent parameters of radical pictoriality and bivisibility. The current exhibition in the British Museum of casts of the west frieze involves this disjunction, whether wittingly or not I do not know. The plans displayed to guide the present-day beholder show the oblique orientations of the glances of figures relative to the parallel registers of VCP produced from the [edge | groundline], even though what one *sees* on the frieze (in ADO in the gallery) are figures looking "straight ahead" in seeming full profile. The plans, then, identify what was specifically *not* pictured, even if it was originally envisioned in the succession to pictoriality — visualized by Phidias. Are we to suppose that narrative context allowed ancient Greek beholders to image the picture differently, that the disjunction simply took care of itself in Attic visuality — the fully totalized visual culture of depiction in which all was resolved? Or does this put the cart of pictorial succession before the horse?

4. PICTORIALIZING *IN* AOO AND PICTORIALIZATION *OF* AOO

A *geradvorstellig* approach is prevalent on the frieze. But if it were pervasive it would be unsatisfactory: like it or not, "planar" figures and "parallelizations" of spatial relations ultimately must be imaged in AOO. And another way to handle the tension between an invisible VCP and the visible planes of relief (meeting one another at right angles at the [edge | groundline]) lay ready to hand. The sculptor could "turn" the head of a figure (or another part of the body engaged in action) into real and visual space, as opposed

to counting on a virtualization of the turn in visible relief that actually lacks any such apparent conformation.

The Parthenon frieze is absolutely packed with such turns, whether or not a turn is accompanied by a tilt. The most notable include horsemen turning around and/or turning back to glance at something "beside" them or "behind" them and participants dressing themselves and adjusting their equipment, as if turning out of the main action of the procession. Depending on the scope of these actions, only the head might turn, or a stretch of the torso and limbs, or much of the entire body.

Regardless, *almost every head of every human figure on the frieze* turns slightly, virtually engaging a complementary [AOO | VVA] on which its "detachment" from the plane of the format would be visible. In other words, there are virtually no "pure" profile heads anywhere on the frieze, despite the fact that all spatial relations among figures on VCP were visualized in ADO. In the previous section, then, I was careful to describe "seeming" profile. At some standpoints, especially at an AOO that images the head from a place spatially "behind" it in the procession as planned on VCP, almost-profile *appears* to be pure profile. Phidias counted on this simple effect of birotationality for purposes already described. This flowed from his foundational decision, obeyed throughout the frieze, to detach the nose of every head more or less fully from the secondary plane. Of course, in a museum setting that has been lighted fairly evenly (such as the Duveen Gallery at the British Museum), the requisite undercutting of the nose is not readily visible on either ADO or on AOOs that have only a modest angle of inclination. But it can be activated in ADO in raking light and in the bright light of photography.[7] And it is readily visible at an acute angle in AOO, though sometimes only at a *very* acute angle — for example, an angle in which the observer looks back along the procession to see the figures "coming up" to his IP.[8] The frieze must have been planned and carved in full awareness and activation of such AOOs, though as yet it is an open question in our phenomenology of the pictorial succession whether IPs of this kind were accessible in real space and to what degree the undercutting was visible.

Whether dramatic or subtle, these turns might be explained in aesthetic terms — as efforts, for example, to create visual variety, a Classical Greek equivalent of the canonical Egyptian pictorialist's willingness to admit flickers of foreshortening in figures constructed on the guiding perpendicular (GP) used to set figures in proper proportion (see Chapter Six). But *geradvorstellig* configuration makes it possible to vary pattern on the surface in many ways. And in any case, imaging must explain aesthetics as much as the other way around. Some of the most dramatic turns on the Parthenon frieze had pictorial functions, indicating that a figure glances at something elsewhere on VCP. But here too *geradvorstellig* configuration can cope in its own way.

More to the point is the way in which rotating figures on their relevant spot on VCP helps compensate for the fact that VCP is invisible in the steep vertical angle of vision in which the frieze would be seen from below. It not only helps stitch the figures to a *correlate* VCP, a skyplane, transmuting it from an architectural ceiling of the relief to a virtual "high above" in the pictorial world (lying above it from *all* angles of vision). It also helps stitch the figures to the *observer's* groundplane. From below, we will see volumes that are turned out of the principal planes of pictorialization to project slightly over our own real ground. Our real groundplane, then, becomes correlate, parallelized, with VCP in the pictorial world, *even if these correlate planes are not contiguous.* One plane is quite literally reflected in the other. Thus they tend to merge.

Rotating figures or parts of some figures situated on VCP in plan, then, helps VCP to materialize in the picture. It spatializes their actions and mutual interactions in visible relation to VCP when VCP is so plotted in two dimensions and the renderings are so shaped in three. In this range of aspects, planar bivirtuality (Summers's "planarity") shifts decisively from an apparently discontinuous pictoriality (DC-pictoriality) to an AC (Summers's "virtuality") with respect to the emergence of virtual coordinate space, regardless of its integration with *geradvorstellig* construction and planarity.

Still, the material shaping of rotation, the carving-out of the figures in relief, cannot escape ambiguities of VCP—unavoidable oscillations between imaging the depicted figures as located *at* the [edge | groundline], as located *on* the [groundline | ground-plane], and/or as located *in* the [groundplane | "depth"]. All these locations would be encompassed by VCP when it has fully emerged in visual space. But they are rather different locations in the space it maps.

Moreover, rotation of figures or parts of figures (whether or not fully visible as located on VCP) introduces ambiguity—a horizon of radical pictoriality all its own. Turning the figure out of seeming profile on the secondary plane establishes not only a groundplane—the observer's—correlate with VCP in the pictorial world. It also potentially constructs a *sightline for the observer* in which he engages the figure, "facing" it or as if being fronted by it—the axis, that is, on which the figure seems to be most fully turned toward him *regardless* of its putative orientation and direction of action and address in the virtual space plotted by VCP. Indeed, the sightline in visual space on which the observer engages a figure turned/tilted as if to face him disjoins the sight-line in virtual space in which the figure seems to be looking at something else. Visibly rotated figures virtualize both sightlines simultaneously. This ambiguity activates and animates the frieze as one passes along it, completely re-zippering ADO in AOO.

For example, on the west frieze the standing figure W1 is shaped in "Egyptian" planarity, with a frontal body and a virtually profile face "turned back" (on ADO at

any rate) (Figure 8.5). He would seem to be looking at the rider W3, whose glance seems to meet his own. Still, on AOO his glance can be met by *ours*—he seems to be looking at us—when we are standing at W5 such that ADO intersects [edge | groundline { | VCP }] there. Here, W5 *also* virtualizes as having a frontal body and a virtually profile face, also looking back; *he* seems to be looking directly at rider W7, though that man does not return the glance. (Rather, W7 seems to be looking down slightly, seemingly at W6, though VCP disallows this in plan even if it seems plain on the vertical plane of pictorialization.) But on AOO the glance of W5 can also be met by ours—he looks at us—when we are standing at W10 such that our ADO intersects [edge | groundline { | VCP }] there. At the same time, on AOO the glance of W2 (his head is strongly rotated from the secondary plane into "three-quarters" view on ADO and tilted down about forty-five degrees on the plane at his spot on VCP) can meet our own at W4 (his torso is oriented in the same way). A more fully ponderated figure, W4 seems (on the plane in ADO) to look at something on the ground quite far ahead of him—specifically, at marshal W1's rotating right foot, which appears to be about to turn the corner into the north frieze (block XLVII). And we can meet this very glance on AOO at a point to the left of that spot on VCP—the place, in fact, where *both* faces of this corner block are *equally* visible to us, if equally foreshortened (W1 = block WI = block NXLVII). The rotated torso of W4 is oriented in the other direction, however. The observer can most fully front it where it seems to be turned to face us—at a point between W6 and W7. And so on: the glance of W9 can be met at W11, just before the spot at W12 (a swordsman), where we can meet the glance of W15 (a senior bearded horseman often identified, along with W8, also bearded,

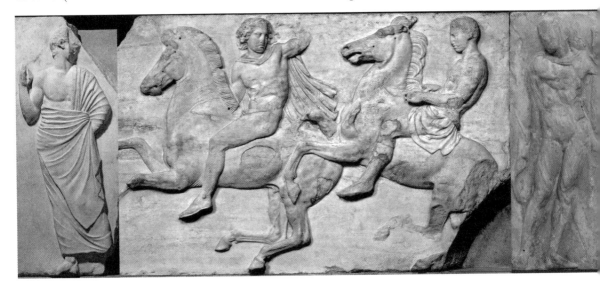

as one of the two commanders-in-chief of the Athenian cavalry newly established in Perikles's term), whose torso will front us at W17....

It would require dozens of pages to describe all of these interactions, repeated several times in the frieze. In Table 8.1, I give a partial list of the relevant rotations (turns and tilts) of all human figures throughout all stretches of the frieze now displayed at the British Museum. The two lefthand columns give the orientation of the heads and bodies of figures in ADO—that is, where they seem to be oriented (e.g., facing "straight ahead to the right " [→ 90°]; "down to the left" [← 45°], etc.; body in profile, etc.), regardless of their actual location on VCP (Figure 8.3). As noted, many figures have "two" orientations, one internal to the lateral left/right organization of the plane (figures apparently facing/fronting *one another*) and one external (figures facing/fronting *the beholder* in AOO). The latter rotations are given in the two righthand columns of Table 8.1. (Note that many apparently "profile" faces in ADO reveal themselves to be slightly detached from the secondary plane, that is, slightly rotated. But these rotations can be detected only at extremely oblique angles at very close quarters, and therefore can play little or no role in zippering; they are not counted, then, in the righthand columns of the table, partly for reasons that will emerge below.)

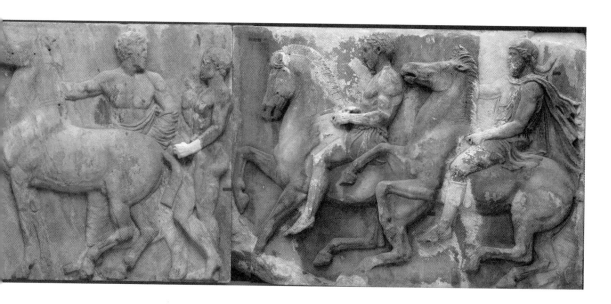

TABLE 8.1. SUMMARY OF MAJOR ROTATIONS IN ZIPPERING THE PARTHENON FRIEZE

FIGURE	ADO HEAD	ADO BODY	AOO from LEFT	AOO from RIGHT
W1	90 →	Frontal		from 5, head → 30
W2	45 →	Frontal		from 4, head → 45
W3	← 90	Profile		
W4	← 45	Frontal	at left of 1, head ← 35	from 6 head ← 90 to W2 from 7, body → 45
W5	90 →	Frontal	at 4 head → 10 to W6	from 10, head → 20
W6	← 90	Profile		
W7	← 90	Profile		
W8	← 90	Profile		
W9	45 →	Frontal		from 11, head → 45
W10	← 90	Profile		
W11	← 90	Profile		
W12	90 →	Profile		
W13	← 90	Profile		
W14	← 90	Profile		
W15	← 90	¾	at 12 ← 20 body (ventral)	from 17, body (dorsal) → 45
W16	← 90	Profile		
W17	← 50	Profile		
W18	← 35	Profile		
W19	← 90	Profile		
W20	← 90	Profile		
W21	← 50	Profile		
W22	→ 45	¾	at 20 ← 45 body (dorsal)	from 23, body (ventral) → 45
W23	up ← 20	¾		
W24	← 45	Profile		
W25	← 45	3/4 back		From 26, body (dorsal) → 45
W26	→ 90	Profile		
W27	← 90		at 26 ← 45 body (ventral)	
W28	→ 45	3/4 ?		from 29, head → 45
W29	→ 90	Profile		
W30	→ 45	¾	at 27 ← 45 cloak	
N136	← 45	Profile		from 133, head ← 50
N135	← 45	3 /4		from 131, head ← 45
N134	← 90 to N133	Profile		
N133	45 → to N136	3 /4	at right of 136, head ← 40	from 129, body ← 35

FIGURE	ADO HEAD	ADO BODY	AOO from LEFT	AOO from RIGHT
N132	← 90	Profile		
N131	→ 45	3 /4	at 136, head← 35	from 124, body ← 90
N130	← 90	Profile		
N129	← 90 to N127	Profile		
N128	← 90 to N126	Profile		
N127	← 45	Profile		
N126	45 → to N127	?	at 131, head ← 15?	
N125	← 90 to N124	Profile		
N124	← 90 to N122	Profile		
N123	← 90 to N120?	Profile		
N122	← 45 to N120/N119	Profile		
N121	← 20? to N120?	Profile		
N120	← 90 to N117	Profile	at 124, body (dorsal) ← 30	
N119	← 90 to N117	profile		
N118	← 45 to N117?	Profile		from 114, head ← 30
N117	← 90	Profile		
N116	← 90	Profile		
N115	← 90	Profile		
N114	45 →	3 /4?	at 120, head → 45	
N113	45 →	3 /4	at 116, head→ 45	from 108, body (ventral) ← 45
N112	← 90 to N111	Profile		
N111	← 90 to N110	Profile		
N109	← 90?	Profile		
N108	← 90 to N107	Profile		
N107	← 90 to N105	Profile		
N106	← 90?	Profile		
N105	45 →	3 /4	at 108, head → 45	from 101, body (ventral) ← 45
N104	← 90 to N102?	Profile		
N103	← 90 to N102	Profile		
N102	?	3 /4	at 108, body (dorsal) → 30	
N101	← 90 to N98	Profile		
N100	← 90 to N98	Profile	at 98, head ← 45	
N99	← 45 to N98	Profile		
N98	→ 40	3 /4	at 93, body(ventral) ← 45	from 102, head → 45
S130	→ 45	frontal/ 3/4		from 135, head and torso → 45
S131	→ 10	Profile		from 138, head → 30
S132	?	?		

FIGURE	ADO HEAD	ADO BODY	AOO from LEFT	AOO from RIGHT
S133	← 45	3 /4	at 130, head ←45	
S134	90 → to S135	Profile		
S135	← 90 to S134	Profile	at Block XLII, head ← 30?	
S136	→ 90	Profile		
S137	→ 90 to S138	Profile		from 144, head → 20
S138	← 45	Frontal	at 130, head ← 35	
S139	→ 40?	Profile		from 144, head → 45
S140	→ 90	Profile		
S141	→ 90 to S143	Profile		
S142	← 45	Frontal	at 139, head ← 50	
S143	← 90 to S141	Profile		
S144	→ 90	Profile		
S145	→ 90 to S146	Profile	at 138, head	
S146	← 90 to S145	Profile	← 30	

All of its blocks were captured in Lord Elgin's molds of the west frieze, now installed in the British Museum though unfortunately not in one continuous length (they are wrapped around three walls of a small gallery), enabling a complete reconstruction of the zipper on this façade. The list in Table 8.1 has to be less complete with respect to the other façades. Only two stretches of the frieze on façades other than the west are sufficiently continuous to enable partial reconstruction of the zipper, namely, figures N98–136/blocks NXXXVI–XLVII and figures S130–46/blocks XLIII–XLVII. (If the results from the west frieze are any guide, the observer in AOO can meet the glance—or other fronting of a figure—from as far away as five blocks. A realistic reconstruction of the zipper, then, requires a continuous stretch of ten or more blocks). And even in these continuous lengths of frieze we cannot explore all activations in AOO when IP is located beyond their termini. Still, the list does suggest that the zipper had the same overall structure throughout the frieze, with some internal differences in the kinds of groupings.

I have made two assumptions throughout. First, the results assume the imaging point (IP) to be level with a line bisecting the frieze horizontally. If the visual axis engages certain points on that line directly (ADO), one can *also* meet the glance and/or fronting of a figure in AOO there, as described in the previous section.

Second, I place the *standpoint* of that IP—its location in real space—at a constant 1.5 meters from the secondary plane, whether we identify this as a location on the ground, on the scaffolding *in situ*, or on both.

To some extent these two assumptions are arbitrary. The first can be warranted, however, because it places the perpendicular intersection of ADO and the secondary plane at points where in principle the greatest planarity in PS : ID would be present. Therefore this is the level of IP at which the maximum visibility of resulting (and intended) effects in ADO can be attained. Arguably, it is also the level at which VCP would first become visible *on AOOs* oriented downwards toward the [edge | groundline] in the vertical angle of vision — where the registers parallel to the plane of the format in the plan could virtualize as groundplane in the picture. (Such views could only be attained in carving the blocks, of course. But they can be *visualized* elsewhere — for example, in making sense of the downward glances of many of the figures as seen from below.) Because the plan coordinated locations and relations on VCP to be rendered as occlusions and interactions on the plane, AOO in the vertical angle of vision at this standpoint can be given analytical privilege: it is the horizon-line, as it were, of the succession of virtual pictorial space in the image. The bisection might have been laid out in the composition, and it seems to have been incorporated in the shaping of the figures.[9]

Admittedly, for his purposes of pictorial construction Phidias could have situated the requisite eye-level at [edge | groundline], as imagined in Lawrence Alma-Tadema's perceptive *mise-en-scène* in *Pheidias and the Frieze of the Parthenon* (1868–69),

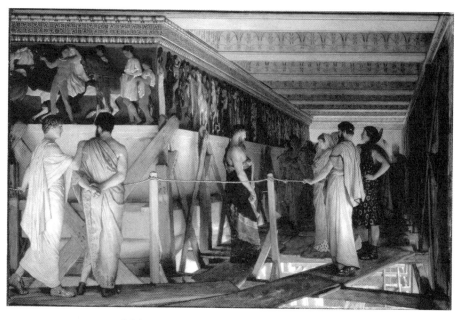

8.6. Lawrence Alma-Tadema, *Pheidias Showing the Frieze of the Parthenon to His Friends,* 1868–69. Birmingham City Museum and Art Gallery (1923.P118).

which depicts the statesman Perikles and other citizens inspecting the artist's work (Figure 8.6). At the [edge | groundline], the carvers had to manage the preponderance of the most complex occlusions that were plotted on VCP coordinate with it. But they could not have conveniently and comfortably worked the stone from there.

The second assumption is easy to justify. Assuming ADO at the horizontal bisection of the frieze, in the vertical angle of vision an IP at 1.5 meters from the secondary plane can encompass its entire *height* — the IP at which designer and carvers, stepping back from plotting and/or working the surface, could begin to judge the shaping of the renderings in terms of their visible effects. Of course, they could have stepped back further, though if they were on scaffolding not more than another two meters or so. But stepping back would have delivered increasingly less pertinent information in PS : ID — less pertinent, at any rate, if it was not accompanied by dropping IP far below the level of the horizontal bisection of the frieze in order to simulate the angles of vision that would ultimately be required in imaging the frieze installed on the building.

In practice, designer and carvers must have moved around among many standpoints, though some decisions were made and resolutions achieved at very particular standpoints. The data, then, provide only snapshots of the visual spaces in question. Still, the two assumptions probably come close enough to the visual situation(s) involved in producing the frieze in the workshop and/or *in situ* on the building; they more or less average the variance in the real, visual, and virtual spaces in question.

As already intimated, however, the data do have a major limitation. They diagram what designer, carvers, and beholders could see at natural standpoints in working the blocks. They do not analyze the zippering of the image when the completed frieze was visible (or not) from the observer's ground *down below*. This is true whether we speak of IP/standpoints:

(1) in the colonnade underneath the ceiling sheltering the frieze (here the vertical angle of vision is so steep that little of the mere picture is visible, and pictoriality would be barely present if at all);

(2) in the spaces between the columns of the façade (intercolumniations);

(3) on any of the steps of the stylobate, looking up (in AOO) between the columns to the frieze;

(4) on the terrace in a "zone or belt of observation," as Richard Stillwell has called it, that was set 26-to-32 feet away from the top step of the stylobate (AOO again looking up between the columns) and parallel to its rectangle (assuming an eye-level of 5'1", because at more than 32 feet from the stylobate the abaci of the columns interfere with the view) — the "path," as Summers would call it, that was probably traversed by most visitors to the temple; and possibly:

(5) in another "zone or belt of observation" at the bottom of the steps of the terrace on the
 west, about 46-to-48 feet from the stylobate, and a little more than 10 feet below its
 lowest step.

At any of these standpoints the full height of the frieze, however acutely foreshortened
in the angle of vision, can be visible — if only just. (Remember that this does not in
itself mean the *pictoriality* of the frieze was visible.)

 As Stillwell has shown, "the furthest distance from which the frieze can be viewed
[in its full height in one glance] is determined by a line drawn from the top of the frieze
tangent to the inner edge of the soffit of the main epistyle" (Figure 8.7).[10] (The two
last-mentioned "zones of observation" assume this distance on the terrace and below
it, respectively.) At the west façade of the Parthenon, what might be called a "zoom-
ing-in" on the frieze could partly be realized by climbing *from* the last spot where the
full height of the frieze remains visible in the vertical angle of vision (below the steps
from the terrace about 46 feet from the stylobate) onto the terrace and in turn onto
the stylobate and into the colonnade — traversing about 65 feet of absolute distance
in the coordinate space in question. Given PS : ID in this set-up, however, to halve the
absolute distance between the furthest standpoint and the frieze by climbing onto the

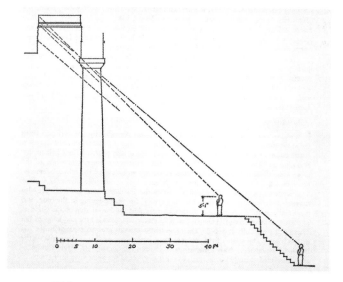

8.7. Reconstruction by Richard Stillwell of two privileged
angles of vision and "zones of observation" in viewing
the Parthenon frieze. (From Richard Stillwell,
"The Panathenaic Frieze: Optical Relations," *Hesperia*
38 [1969], fig. 1.)

terrace from below and to halve it again by climbing from the terrace into the colonnade does not *double or quadruple* the size and correlated visibility of the frieze. The frieze simply becomes more and more foreshortened in the vertical angle of vision. In fact, because the ideal "zoom" for imaging the picture is on a line exactly 45 degrees *above* the observer's ADO at the furthest standpoint, in the real approach an observer who is 5'1 tall will "fall below" or "drop out" of that line just when he reaches the top step of the stairs to the terrace. Henceforth he must move on a line at 45 degrees to the line of the "zoom" that can be imaged at the furthest standpoint. On this line of movement across the terrace and onto the stylobate, the vertical angle of vision in encompassing the full height of the frieze — regardless of what can be seen of its pictoriality — steadily increases from 45 degrees above ADO to 80 degrees above ADO when standing in the center of the colonnade. Still, the stairs to the terrace were constructed to promote the observer's imaging along the "zoom" — giving the observer a good start by moving him about 20 feet along its full 90-foot extension before he falls out of alignment, that is, falls out of the alignment of any IP in which he can *maintain* his sightline to the frieze at 45 degrees above ADO. In this regard, it could be significant that the angle of the downward-tilted glances of many figures on the frieze (as Table 8.1 shows) is about 45 degrees (or slightly more) below their level sightlines, as it were zippering the sightlines to/from the ground from the other end (that is, frieze-to-observer rather than observer-to-frieze). But I am jumping ahead analytically.

At any of the five zones of standpoints mentioned above, and/or on "zooms," it would have been difficult to identify figures and gross actions depicted in the frieze (though for different optical reasons at each standpoint), let alone details of attributes, gestures, and glances, even granting that the bold coloring of the relief could have helped to clarify who's who and what's what (flesh was left as the unpainted white marble). For one thing, no ADO was available on the floor and steps of the temple or from the ground, however active — even essential — it was in the pictorial successions involved in designing and carving. For another, on all real AOOs at standpoints on the floor, steps, and terrace, one might only be able to see (at best) that figures on the frieze, whoever they are and whatever they are doing, interact with one another *and* address the observer himself.

There is no easy way to escape this conundrum. Many scholarly accounts of the frieze have passed over it lightly, chiefly by treating the frieze as a votive or dedication — which it was — that did not really need to be fully visible as pictoriality, "present" as visible world, after it was installed and finished. (A typical formulation, in this case by John Boardman describing the "intricate patterns" depicted on dress: "Little matter that they would no longer be seen when on the building. For the perfect building the execution and finish claimed perfection too. What the human eye might miss, the divine might

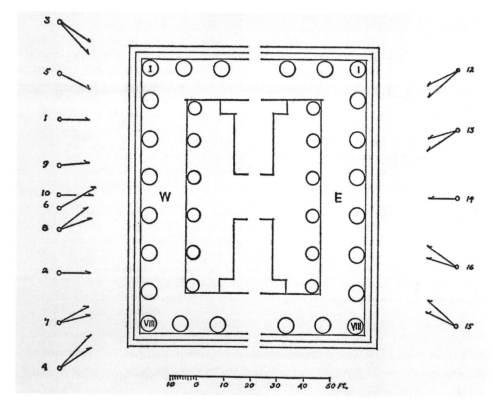

8.8. Reconstruction by Richard Stillwell of fifteen "station points" for viewing the Parthenon Frieze between intercolumniations from a privileged "zone of observation." (From Stillwell, "The Panathenaic Frieze," fig. 2.

criticize."[11]) And maybe we should not even try to escape the conundrum. The Parthenon frieze is hardly unique in having been hard to see: in many contexts in world art, pictures specifically made to be imaged from certain real standpoints would not be fully *visible* there. The succession of pictoriality was only partial. (Yet again we must wrestle with the deep problem of the presence of pictoriality—when, where, to whom, and to what extent [see Chapter Three].) It was sufficient, it seems, to make a picture that *would* be visible if IP could be transported to the standpoint at which what had been pictorialized could be imaged, as if IP could travel along the sightline(s) in PS : ID in which the mere picture (or an artifact that is more mere picture than pictoriality) succeeds to depiction (or an artifact that is more pictoriality than mere picture)—as it must actually have done in the history of its material production *as* pictoriality, namely, in the visual making. A person could envision this picture even if he could not actually *see* it at certain standpoints. And someone, namely, the maker, certainly *had* imaged it in the fullest possible

presence of its pictoriality. As noted in the Introduction, a general theory of the succession of visuality in visual culture suggests that it might be enough for the historian to focus on this one particular agent of vision—what *Phidias* saw. The theory predicts that it will not be readily possible—in fact it is methodologically undesirable—to totalize from him to other agents of vision at the time, especially those imaging the picture from other standpoints.

5. THE VISIBILITY OF THE FRIEZE AND THE ARCHITECTURE OF THE PARTHENON

At the Parthenon, Phidias and the carvers of the frieze had to contend with disruptions of the image from their perspective in planning it—namely, interruptions caused by the columns through which the frieze would have to be seen. As Stillwell has shown, Phidias seems to have composed his arrays on the [edge | groundline] in order to create coherent units that could be seen between any two columns at a series of "station-points" in a "zone or belt of observation," a path parallel to the rectangle of the stylobate and about 26-to-32 feet away from its top step (Figure 8.8). These units are not always the same as the *blocks* of the frieze; Stillwell calls them "panels," "definitive sets of compositions." According to Stillwell, each is visually "well-balanced"; it has harmonious if sometimes counterthrusting axes of movement, gesture, and rotation internal to its group of figures. And it is "closed"; ideally it contains no partly visible figures or objects. Nonetheless, it can also be anticipatory, narratively proleptic: the action of figures can suggest their—and our—movement to either side, that is, into a space of the frieze that at that station-point is obscured by a column. For the west frieze, which remains on the building, Stillwell identifies ten such station-points. At several of them, more than one coherent panel of the frieze can be seen through different intervals between columns (so-called intercolumniations). For example, at station-point 3, located about 14 feet from the north end of the platform, one panel is visible between columns I and II and another panel is visible between columns II and III. Stillwell has identified fourteen visible panels at ten station-points on the path parallel to the west frieze, which has seven intercolumniations. (Not all of them are illustrated, however, in his drawings of the phenomena.)

Many of the panels include figures that are visible in *other* panels as well, though grouped there with different figures. For example, at station-point 3, a panel visible between columns I and II groups together W1, W2, and W3 and another panel visible between columns II and II groups together W9, W10, W11, and W12. Elsewhere in the zone of observation, however, W4–W9 form a panel between columns II and III at station-point 5, located about two feet south of the axis of column I. W7–11 form a panel between columns III and IV at station-point 9, located about eleven feet north of

the central axis of the temple. And W12–15 form a panel between columns IV and V at station-point 8, located about 12.5 feet south of the central axis of the temple. For this reason, as Robin Osborne has emphasized, beholders might have virtualized different compositional, narrative, and symbolic possibilities in the depiction — different presences relayed in pictoriality — depending on their stopping point(s), that is, at which of Stillwell's station-points they imaged the frieze.[12]

Stillwell's analysis breaks the frieze into "episodes," as he calls them. In his words, "the rhythm of the figures was calculated with an episodic effect in mind and the spacing adjusted to the apparent visual spaces between columns."[13] Some of these have obvious compositional, narrative, and symbolic coherence *without* the intercolumnar definition, though they are aided or "framed" by it; they include W1–6, visible between columns II and III at station-point 1 on the west, which might be seen as the "beginning" of the entire pictorialization, and the "peplos scene" visible at station-point 14

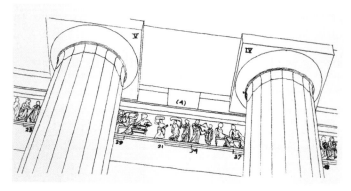

8.9. Reconstruction by Richard Stillwell of viewing the "peplos scene" on the east frieze through an inter-columniation. Note the assumption of the "zoom" of the beholder's imaging point. (From Stillwell, "The Panthenaic Frieze," fig. 61.2.)

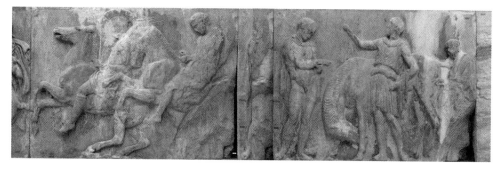

8.10. W20–W24, Acropolis Museum, Athens.

in the center of the intercolumniation of columns IV and V on the east frieze, which might be seen as the "end" (Figure 8.9).[14] Some of these "episodes" have coherence only *given* the intercolumnar definition. For example, there is a compositional and narrative "break" between W20–21, two riders, and W22–24, a group of three figures arrayed around a horse (Figure 8.10), and indeed W20–21 and W22–24 were composed and carved on different blocks (WXI and WXII respectively). But a panel visible between columns II and III at station-point 4 encompasses W20–23 only. And some episodes have less coherence than one would desire even in strictly intercolumnar terms, as Stillwell acknowledges (station-point 8, panel between WIV and WV; perhaps station-points 9 and 10).

All these considerations might lead us to conclude, to quote Jeffrey M. Hurwit, that "typical visitors to the Acropolis would have had only an obscured, fragmented, and thus discontinuous experience of the continuous frieze."[15] It is important to note, however, that Hurwit, like Osborne, does not refer only to Stillwell's results, though he extrapolates from them. He also means to recall the differential *social* accessibility of the standpoints (whether Stillwell's station-points or not) that would be needed to stitch up a complete understanding of the entire frieze (whether "interrupted" by columns or not), especially if such an image was intended for some privileged or special beholders in the *polis*. But in the present analysis I am not totalizing questions of visibility, virtuality, and visuality to "typical visitors to the Acropolis." I focus on what Phidias saw.

In this regard, Stillwell's analysis, though complete in its purview, does not tell the whole story. It depends heavily on the condition—both an assumption and a conclusion—that Phidias envisioned beholders in the zone of observation "moving parallel to the façade and looking up at the frieze in a diagonally forward direction," whether north or south (west and east frieze) or east or west (north and south frieze). If Stillwell's identification of coherent panels can be accepted, however, his own results suggest that sometimes beholders would stop at a station-point and turn to face the frieze *head-on* (though still in the steep vertical angle of vision), addressing it on an axis centered between two columns (namely, panel W1–6 visible between columns II and III at station-point 1; panel W14–18 visible between columns IV and V at station-point 10; and panel W26–30 visible between columns VI and VII at station-point 2). Such axes were not ADO, but nevertheless they were not the "diagonally forward" AOOs identified by Stillwell; they demanded, as it were, a righthand turn out of the path.[16]

Moreover, "diagonally forward" AOOs that bring panels/episodes into view predominate on the west facade in the south-to-north direction, that is, when the beholder's direction of movement on the path is the same as the overall direction of the depicted procession, as if he were following along beside it. (Narratively speaking, the entire

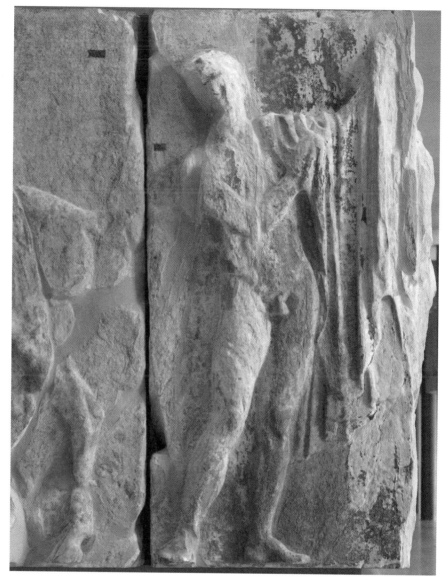

8.11. W30, Acropolis Museum, Athens.

8.12. Reconstruction by Richard Stillwell of viewing W30
as one of the corner blocks of the west frieze. (From
Stillwell, "The Panathenaic Frieze," fig. 63.14.)

composition "begins" at the southwest corner.) Moving north-to-south, Stillwell finds only two such panels, both visible at his station-point 3, located about fourteen feet from the north end of the platform (namely, W1–3 visible through columns I and II and W9–12 visible through columns II and III). But station-point 3, at the northwest corner of the building, is the place from which any beholder of the Parthenon perforce began to walk around it, and possibly to look at the frieze, from *any* direction.[17]

Like the central stretch of the east frieze (E18–52), the west frieze can be "read" as much left-to-right (north-to-south) as right-to-left (south to north); in W1–30, the procession is getting under way, and the figures can face/front in either direction, toward intermediate spaces, or in both directions, turning and twisting. It seems odd, then, that the visual presencing of panels that commenced in the "diagonally forward" direction north-to-south at station-point 3 was not carried on beyond station-point 5, immediately south of it. (Here, W4–9 is diagonally visible between columns II and III.) Was this because the spacing and poses of the figures had been *configured* to be visible in diagonal AOOs south-to-north (at station-point 6, just below the central axis of the temple, W4–9 is visible — again — through columns III and IV), and it was too difficult to integrate the *oppositely* diagonal visibility? Maybe — but it seems unlikely, precisely because W4–9 were successfully made visible as panels in *both* diagonal directions, that is, AOO north-to-south at station-point 5 and AOO south-to-north at station-point 6.

Moreover, if we loosen Stillwell's thesis that "definite sets of compositions" were configured on the west frieze predominantly to be visible south-to-north, it seems plain that *individual figures* were carved to enfold north-to-south AOOs, often highly oblique. Some of them are dramatic — quite literally so. For example, W30 (Figure 8.11), on the west face of the southwest corner block (WXVI = SI), can be understood as the first personage in one way of narrating the procession (though he is not the "first" in its spatial virtualization on VCP) — a nude youth draping his mantle over his raised left arm and shoulder, as if preparing to take part though he has not yet joined the file organizing ahead of him (south-to-north). As Jenkins points out, the figure is "carefully designed to introduce the south frieze" in a "strong *contrapposto* inclining to the right"; that is, leading the eye north-to-south around the southwest corner. At the same time, the youth looks outward and downward to the south, as if engaging an observer coming around the corner — diagonal AOO south-to-north at, say, station-points 4 and 7 (in the latter he becomes visible as a lone figure on a panel visible between columns VII and VIII [Figure 8.12]). In fact, in a striking configuration on AOO north-to-south, when one stands at W27 a full block away (block XIV) the mantle of W30 is strongly foreshortened, evidently arranged in order to create an effect of animation. On the secondary plane, the folds of the mantle have been shaped

as increasingly thick ridges north to south, thus virtualizing — as we move north to south — as the mantle opening out (at W27), swinging fully out away from the body (at W30), and finally wrapping back around to enclose it (at the spot to the south at which the youth is looking: here the thick ridges of the mantle visible on AOO south-to-north obscure the rest). This virtuoso configuration might be taken to be a paradigm of the entire frieze, perhaps produced by the hand of Phidias. Regardless, it only makes full sense *as* sculpture if we view the figure, or envision doing so, while navigating an *arc* of AOOs — some *highly* oblique — in both directions. The figure seems to teach us this very means of pictorialization — it stage-manages it — at the same time as it embodies the resulting pictoriality, a complex birotation on MVA ◊ VCP succeeding to a pictorialized space within which observer and W1 both stand.

Finally, perhaps the entire configuration could be managed most easily on [edge | groundline | VCP] by planning and shaping all panels predominantly to be visible from one "diagonally forward" direction, namely, moving south-to-north up to W4. Nonetheless, one can still direct "diagonally backward" AOOs when moving in the same direction, even if these, as already noted, did not visually supply coherent panels (north-to-south, such panels only extend as far as W9). For the rotated figures throughout the west frieze face and/or front in directions that engage AOOs that can be placed *either* ahead of the beholder on his line of forward movement *or* behind him, or *both* before him *and* behind him in the case of the several figures whose heads and glances are oriented in one direction and their torsos in another. All fourteen panels identified by Stillwell (however they partition the procession) usually contain two such figures — one facing/fronting diagonally *ahead* and one diagonally *behind*, regardless of the observer's line of movement south-to-north or north-to-south and irrespective of the orientation of his AOOs on that line ("forward" or "behind").

This leads us to a second gap in Stillwell's analysis. It does notice the torsion and rotation of figures — the multidirectionality of their poses, gestures, and/or glances. But it treats the configuration of panels to be made visible between the columns mostly as a problem of "spacing" the figures on the [edge | groundline]. And no refinement of spacing could surmount the fact that in looking between the columns from many standpoints, no panel in Stillwell's sense could be made visible at all — all those standpoints, in fact, that are not defined as one of his ten station-points. In directing the carvers, Phidias had to do much more than simply "space" the figures on the [edge | groundline], just as he had do more than simply "spot" their location on VCP. He had to integrate the spacing *with* the spotting to construct a virtual world that could be imaged from the ground on continuous sightlines despite the columnar punctuations.

6. PONDERATION, ROTATIONS ON VCP, AND
VIRTUALIZING THE OBSERVER'S VISUAL SPACE

As we have seen, occlusions in the architecture demanded that the picture dodge them to reattach and reengage the observer's sightlines into the world visible on the plane of pictorialization succeeding from VCP. Without this pressure, the frieze could well have achieved a high degree of naturalistic mimesis in rendering the surfaces and volumes of things, as do the metopes and pedimental sculptures of the building and like the free-standing dedicatory statues, often ponderated, that were set up all around it. But it would have remained more DC-pictorial than it was—a highly AC-pictorial effort to immerse the beholder in the picture.

In the standard model (see Chapter Five), the distinctive AC-pictoriality of Greek naturalism has often been attributed specifically to the supposedly revolutionary ponderation, the *contrapposto* or "chiastic balance," of Classical Greek representations of the standing human figure, whether in two dimensions or in three—in wall painting and vase painting or in sculptural relief and free-standing statuary. When Phidias and his collaborators conceived the Parthenon frieze, these figurations had been available for two or three decades. Some of them could be seen on the Acropolis itself (see Figure 5.20). In W4 and W9, the frieze seems to "quote," perhaps even emulate, free-standing figures sculpted by one of the innovators of the style, Polykleitos of Argos (Figure 8.13; see Figure 5.5); some historians have argued that Polykleitos had a hand in carving the frieze. Still, these replications were probably not *duplications*. W30 comes close to full-blown Polykleitan "chiastic balance." But it is not a transcription of any existing work that we know. Equally important, W30 has a rationale wholly internal to the visibility of the frieze.[18]

Merely to place ponderated figures, figures with visible *contrapposto*, on the shelf of a plinth or a pediment does not in itself make that place a virtual space shared with the observer—just as, inversely, placing certain figures organized in strong frontality *can* help constitute that very kind of space. If the Polykleitan *Doryphoros* and *Diadumenos* had simply been transcribed into the frieze, they would not have satisfied the required AC-pictorial parameters (namely, $\{[\text{ Turn } > 30° < 45°] + [\text{ Tilt } > 30° < 45°]\}$). Compared to the Polykleitan figures, then, both W4 and W9 turn their heads more strongly *away* from the fronting of their torsos, and both palpably "look down" at the observer in AOO rather than "away from" him.

Moreover, not all constructions on VCP need take the form of the naturalistic ponderation in ADO. Many cannot do so, yet they can be found throughout the frieze, not least in highly rotated figures that visibly *violate* chiastic *contrapposto* in ADO, perhaps even resist it. In ADO, some rotated figures on the Parthenon frieze look to be just as

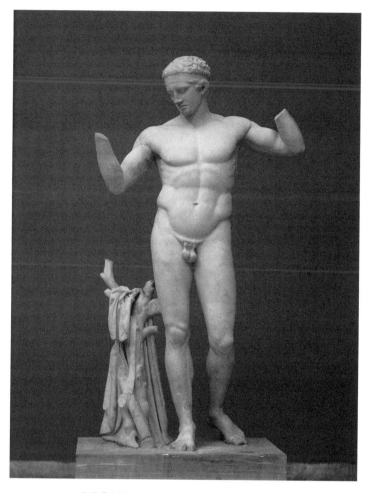

8.13. Polykleitos, *Diadumenos*, c. 430 BCE, Roman
copy, c. 100 BCE. National Archaeological Museum,
Athens (1826).

neck-wrenchingly "unnaturalistic" as any Egyptian frontal-profile figure—DC picto-rial. But in AOO and weaving the image between the columns, the anatomically impos-sible torsion becomes visible on the frieze in a more "naturalistic" way—AC-pictorial. The head of W1 (Figure 8.14), for example, has been yanked almost a full 180 degrees in the direction opposite to that in which his right foot is pointing (compare W30). Given his complex cross-stitching function on the northwestern corner block, he faces/fronts standpoints both in front of him and behind him down below in AOO in the emergent overall coordinate space. We might call this para-*contrapposto*, even hyper-*contrapposto*. Unlike the supposed prototypes of W4 and W9 (and possibly W30) that might be found in free-standing statuary, W1 does not have the unified *contrapposto* of *one* natural pose in real space as rendered in virtual pictorial space. Rather, he has the bizarre rotational conformation required to set him on VCP in a space shared between him and the observer—an effect of the pictorialization itself.[19]

At this point we must return to birotation in planarity. With or without creating "panels" (groups that cohere in "episodes"), if one deplanarizes a sufficient number of figures shaped in the right way at the right place he can reorganize Egyptian-style planarity, that is, the continuous relative motion of pictorial configuration in ADO *regardless* of interruption. One can create the continuous relative motion of picto-rial configuration on VCP in AOO *despite* interruption—a new zippering achieved in Greek-style planarity. If the columns of the frieze obscure and fragment the visi-bility of the entire frieze at any one standpoint, they do not then dismember it for *all* standpoints. Beholders can thread around and in-and-out of what occludes the frieze, retrieving sightlines between their standpoints and the figures facing and/or fronting them there. And on these sightlines they can see that a figure looks ahead and/or fronts behind (or vice versa) to a place to which they can *re*locate imagisti-cally—a place where the same virtual world will be visible from a different angle. Spatializing *outwards*, rotation on VCP begins to produce a total coordinate space: the observer virtualizes the figures as both interacting among themselves (mutually facing and fronting one another) *and* as interacting with him. At the same time, the partly rotated virtual world recursively spatializes *inwards*: the figures turn and tilt as if in a space shared between them and with the observer, presences in the same space. In this way the discontinuous space of planar bivirtuality (DC) folds out and folds in to become continuous with visual space (AC)—enfolded in it.

This kind of zippering of the image might be analogized to stitching cross-wise in a torsion, as if suturing across the surface of a double helix. The metaphor of an actual zipper—with tangs engaging one another at right angles—was useful to us in under-standing *Geradvorstelligkeit* (see Chapter Seven). But it becomes less applicable here.

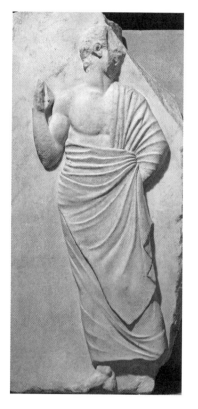

8.14. W1 (BM photo).

On the Parthenon frieze, designer and carvers not only had to dodge the columns by posing and shaping figures to be looking *around* the columns or *past* the columns along sightlines not interrupted *by* the columns. They also had to cantilever this network, dropping it cross-wise into the observer's groundplane parallel to VCP, in such a way as to engage standpoints for AOO located far below the plane of VCP. But Phidias could readily visualize this coordination once he had grasped the pictorial succession in architectonic and architectural context—how it would have to work in visual space. Probably he drew it up explicitly in his plan as *a map of the virtual pictorial world subsisting in the real architecture*. In the plan, he would simply need to include a token for each *column* as just another object with MVA and an area on VCP, extending VCP not only into its three or more registers behind the [edge | groundline], but also into (any number of) registers in front of it. (More exactly he might have included a token for each column capital: as the widest element of the columns, the capitals were the maximum constraint on the horizontal angle of vision in AOO from below.) Here the inherent ambiguity of VCP as pictorialized on the plane, especially at [edge |

groundline], became an asset: even if figures sit in "depth" on VCP, they are spaced on the [edge | groundline] on the plane of pictorialization. In rotation they seem visibly to face and/or front out from *that* plane—not, or not only, from more "distant" planes identified with interior registers in invisible VCP.

In this limited sense, the plan of VCP, whatever its material nature and degree of formalization, was also partly a rough groundplan of architectural features. But this does not commit us to the controversial notion that full groundplans and elevations were used to design the entire building. The augmentation of a map of VCP with information about salient elements of architecture in visual space would have been a special device motivated not so much by architectural design as by the dynamics of a pictorial succession; after all, the design and construction might have been substantially settled by the time the sculptural programs were underway. Possibly Phidias built a simple three-dimensional model in which the plans of VCP and of relevant architectural features were calibrated, to scale, on parallel planes. Stretching a few strings from point to point in this model would tell him everything he needed to know to work out the configurations of figures (possibly in sketches on the unworked blocks) and to give relevant instructions to the carvers. Stillwell has urged that "if ... models were not used, we must argue for an excellent working knowledge of perspective" on the part of the designer.[20] I would rather say, however, that the excellent working knowledge of natural visual perspective on the part of the designer enabled him to visualize the birotation of figures on VCP, whether or not he planned and modeled them in two- or three-dimensional representations. Indeed, it could have been sufficient to observe the behavior of three-dimensional sculptures installed at different heights, or for that matter to pose human models on a couple of plinths.

The rest would take care of itself. One could visualize the angular detachment of any figure from the secondary plane that would be needed to dodge a column—the *turn* or *turns* of a figure or its parts. Simultaneously one could visually compute the optimal angular deviation of that shape *from VCP* (treated as a *coordinate* plane) to engage AOO at standpoints in the architecture and on the ground below—the *tilt* or *tilts*. Not surprisingly, many of the turns deviate from the secondary plane at about 45 degrees or less, though not much less than about 30 degrees, and the majority of tilts deviate from VCP at about 30 degrees or more, though not much more than about 45 degrees. In this pose in the emergent overall coordinate space these figures look and/or front down to a place in the zone of observation at least one intercolumniation away from the one in which they are spotted and spaced in ADO on [edge | groundline | VCP]—in AOO, weaving past the columns whether or not a panel in Stillwell's sense becomes visible.

Phidias envisioned the overall emergent coordinate space, then, such that the sight-lines of the glances of the figures *from* the frieze become coterminous with beholders' sightlines *to* the figures. In extending the depiction throughout the visual spaces of the temple and its precinct he could virtualize the entire place more or less limitlessly to the farthest horizons and beyond — unlimitedly extend its real space by cross-stitching the virtual pictorial world throughout it. In Classical Greek visuality, this virtual space — pictorialized by the Parthenon's frieze and the temple's other representational elements — might have extended well beyond the real-spatial grounds I have considered here; namely, the temple building and the sightlines to it and paths around it, especially the proximate "zones of observation" at which the full height of the frieze can be visible from below. References to Attic topography and its history in the frieze, metopes, and pedimental sculptures, as well as sightlines from spots near and in the building to distant landmarks could have projected the pictorialized space to the very limit of visual space — that is, to the horizon. This matter goes far beyond the specif-ically phenomenological considerations adumbrated in this chapter — considerations that must precede any reconstruction of the "meaning" of the Parthenon and its sculp-tures in iconographic and symbolic terms. For iconographic and symbolic meaning (visuality) partly succeeds *within* the virtual pictorial space (virtuality) made present at standpoint — and in part made possible by what Phidias saw.

What Brunelleschi Saw

Virtual Coordinate Space and Painter's Perspective

1. THE PICTORIAL SUCCESSION OF PAINTER'S PERSPECTIVE

In early modern Italy, effects of perspective were achieved by painters in the fourteenth century, notably by Giotto di Bondone (1266–1337) (Figure 9.1) and Ambrogio Lorenzetti (c. 1290–1348). But I reserve the term "painter's perspective" for the systematic application of a method for constructing unified perspectival projections—that is, for practices that were stabilized in the early fifteenth century and given an initial discursive formalization by Leon Battista Alberti (1404–72) in his 1435 *De pictura* (briefly discussed in §4), though they were ultimately founded in medieval Arab optical theory (briefly discussed in §7) (Figures 9.2, 9.3, 9.4).

Seemingly so different, virtual coordinate space in ancient Egyptian aspective configuration (see Chapters Six and Seven) and virtual pictorial space in fifteenth-century Italian painter's perspective were in certain respects not far apart. Operating partly by way of aperspectival metric and modular constructions, both modes of depiction virtualize an emergent "box" of space on the virtual coordinate plane (VCP) (Figure 9.5, and see Figure 7.31). (For the relations between the "box" and the sightlines of perspective, I cannot do better than the analytic diagram devised by Günther J. Janowitz, which I adapt here.[1]) Both use the intersections of vertical and horizontal guidelines on the plane to do so. And both depend on an axis of direct observation (ADO) succeeding to a virtual visual axis (VVA) in pictorial space ([ADO | VVA])—a line of sight into virtual pictorial space—that is perpendicular to the plane (the "face") of the object imaged and/or envisioned for depiction, to the plane of the format, and to the plane of pictorialization (usually called the "picture plane" in the case of perspective projections). In particular, as David Summers has put it, "the orthogonals in a perspective construction are 'really' parallel lines perpendicular to the baseline, and all modules marked off by transversals in the grid are 'really' perpendicular to them."[2] In other words, the box of a "perspectived" virtual pictorial space (the pictorial bivirtuality of painter's perspective), as in aspective bivirtuality, is a succession within VCP treated in terms of the plane of pictorialization and its perpendiculars. To be sure, painter's perspective *pictorializes* the perpendiculars differently—involving a pictorial succession that results in a projection of a virtual spatial field unified around a viewpoint (correlated within the picture with an eyepoint [| "vanishing point" (VP)]) placed opposite it on a virtual line of coincidence. In this regard I will emphasize that the pictorial succession of painter's perspective unfolded most readily and found its first fully articulated realization in well-defined and highly restrictive visual spaces—perhaps initially in *one* such visual space.

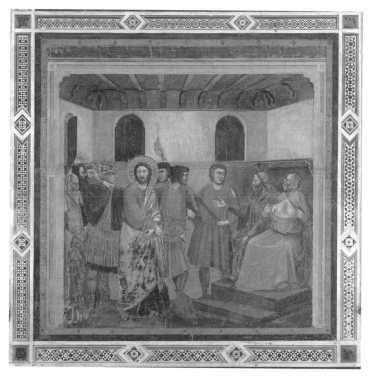

9.1. Giotto di Bondone (1266–1336), *Christ Before Caiaphas*, Scrovegni Chapel, Padua, c. 1305.

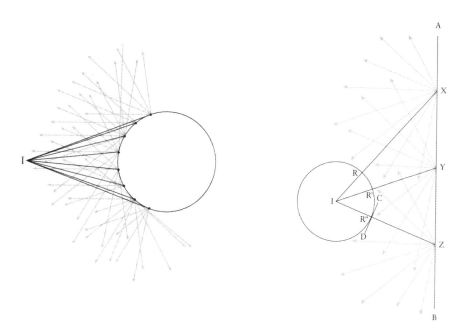

9.2. Alhazen's theory of vision: all points on the surface of a lighted body (here there are only eight) radiate infinite non-interfering rays in straight lines; point of view I selects among these rays in a manner explained in fig. 9.3). (From Summers, *Real Spaces*, fig. 284.)

9.3. Alhazen's theory of vision: the eye (I) admits light rays from points X, Y, and Z on AB that are continuous with its own radii (IR, IR′, IR″) and perpendicular to tangents to points on the eye's surface (CD). (From Summers, *Real Spaces*, fig. 285.)

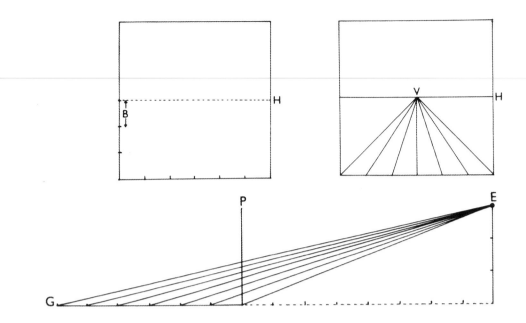

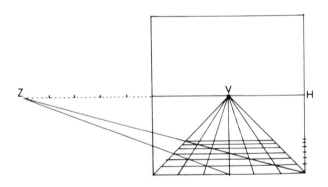

9.4. Diagram of Alberti's perspective construction. Top
left; B = one *braccio* module (one-third of the height of a
man). The base of the picture is divided into *braccia*. The
height of the man at the front plane of the picture gives
the level of the horizon, H. Top right; the *braccio* divisions
are joined to the perspective focus, V, to give the orthog-
onals. Middle; lateral elevation; lines are drawn from
braccio divisions behind the picture plane P to the eye at
E. The points of intersection on P are noted. Bottom; the
levels of the points of intersection are marked at the side
of the picture plane, and locate the horizontal divisions
of the tiles. Z is the "distance point." (After Martin Kemp,
*The Science of Art: Optical Themes in Western Art from
Brunelleschi to Seurat* [New Haven: Yale University Press,
1990], fig. 24.)

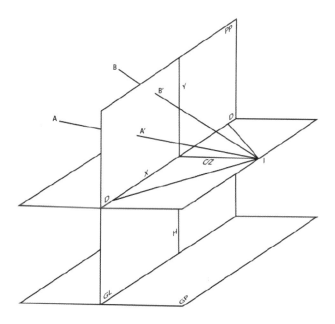

9.5. Analysis of the "box" of virtual coordinate space in perspective projection. A, B = points on objects; AI = sight-line to A; BI = sightline to B; A', B' = perspective picture of A, B, represented on the projection plane; C = centric sightline; D = distance points; GL = groundline, base of the projection/picture plane; GP = groundplane; I = eye; PP = projection/picture plane; X = X-axis; Y = Y-axis; Z = Z-axis. (After Günther Janowitz, *Leonardo da Vinci. Brunelleschi. Dürer: Ihre Auseinandersetzung mit der Problematik der Zentralperspektive* [Einhausen: Hübner, 1986], 6–8, and fig. 1.)

2. BRUNELLESCHI'S PICTURE OF THE BAPTISTERY

In Florence in the first decades of the fifteenth century, likely around 1413 and probably no later than 1425, the goldsmith, clockmaker, and engineer Filippo Brunelleschi (1377–1446), also a stage designer and a designer of buildings, made a picture of the Baptistery of San Giovanni as it could be seen from a standpoint in the nave just inside the central west portal of the Duomo (the Cathedral of Santa Maria del Fiore) standing opposite it in the Piazza del Duomo (Figures 9.6, 9.7, 9.8). (Brunelleschi is sometimes called an "architect," but the use of that term to denote a specialized profession dates at earliest to the sixteenth century.[3]) At the time, the Baptistery was thought to be an ancient Roman building erected in a local classical style. In designing new buildings, Brunelleschi and his fellows likely hoped to learn from its elegant proportions and systematically to understand how its careful geometries presented optically on the ground. The Duomo was still under construction when Brunelleschi made his picture; in 1404, for example, he and the sculptor Lorenzo Ghiberti (1378–1455) served on a committee that devised a new design for the tribunes. In context, beholders of Brunelleschi's picture in its early years could have been recollecting both the earlier church on the site of the Duomo, Santa Reparata, and the model of the new cathedral

made by the mid-fourteenth-century designer Arnolfo di Cambio, as well as antic-ipating the emerging plans for the future, which ultimately included Brunelleschi's design for the spectacular dome.[4]

Brunelleschi's picture of the Baptistery, then, was not just *any* picture, and it certainly was not the pure elevation that an ancient Egyptian pictorialist might produce — even though it likely made use of elevations. Brunelleschi pictorialized the natural visual perspective, that is, his image — the visual space of the "view" itself, his visual prospect of the Baptistery when standing in the portal of the cathedral. And this pictorialization could be taken — indeed, it could be *seen* — as a simulation of the view, presencing **BAPTISTERY** (see Chapter Three) in an optically veridical fashion in certain striking respects, especially in terms of the angular geometry of the building within the natural perspectival geometry of visual space. Depending on exactly how it was painted — on its descriptive detail and coloration and broadly speaking on its overall "realism" — it could have been a picture that under certain conditions was effectively *indiscernible* from the view, a *trompe l'oeil*. Fortunately the black-and-white marble façades of the octagonal Baptistery were symmetrical around their central vertical axes, which made it comparatively easy to draw the building.

The picture itself does not survive, and we have no direct evidence from Brunelleschi about how he made his picture. He left no statements about it. But the evidence suggests that he aimed at an effect of *trompe l'oeil* within certain parameters, and that in the eyes of his contemporaries he achieved it spectacularly. Indeed, it suggests he aimed at *showing that* he had pictorially achieved the effect, as it were *proving* that the picture presented a virtual pictorial space which could be used to do certain things as if it were NVP itself, the prospect, at the same time as it supervened *in* NVP, picto-rialized *it*, by enfolding a metric and modular analysis into it. Brunelleschi was not a painter, however. In his picture he probably did not set out to teach anything especially useful to painters, who were less concerned at the time with depicting architectural structures than with depicting the human actions occurring within and around them. Instead it was Alberti who systematized a method for making pictorial simulations that was suitable for painters. Still, insofar as Brunelleschi made a picture, he worked through a pictorial succession — the topic of this chapter.

In order to pictorialize the visual prospect, Brunelleschi in principle had to do nothing more than set up a grid to transcribe the scene before his eyes. Such a device could be made out of interwoven strings or strips of parchment; indeed, we are told by his first biographer, Antonio di Tuccio Manetti (1423–97), that Brunelleschi (working with the sculptor Donatello [1386–1466]) employed such strips to measure build-ings in Rome. If his "drawings on parchment with their notations of dimensions were nothing other than perspective views of the ancient monuments," however, as has been

9.6. The Baptistery of San Giovanni, Florence, viewed
from the central portal of the Duomo (Cathedral of S.
Maria del Fiore). (From David Summers, *Real Spaces:
World Art History and the Rise of Western Modernism*
[London: Phaidon, 2003], fig. 287.)

9.7. Reconstruction of the sightlines from the Duomo
to the Baptistery. (After Hubert Damisch, *The Origin of
Perspective*, trans. John Goodman [Cambridge, MA: MIT
Press, 1994], fig. 6.)

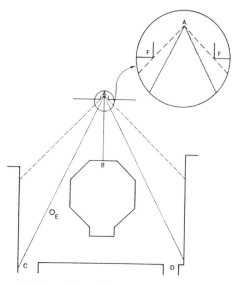

9.8. Plan of the sightlines from the Duomo to
the Baptistery. A, observer in the central portal of the
Duomo; B, Baptistery; C, Canto alla Paglia; D, Volta
de' Pecori; E, Column of St. Zenobius; F, edges of the
central portal. (After Kemp, *The Science of Art*, fig. 7.)

suggested, he must have folded the procedure of measurement into a *pictorial* proce-
dure of the kind he used to depict the Baptistery.[5] Manetti's text was written in the
1470s, well after Brunelleschi's death in 1446. But the author recounted his personal
experience of his protagonist's activities, including the production of the picture of the
Baptistery, which he says that he himself saw and handled. Indeed, without too much
strain (and as we will see) we can suppose that Manetti himself was one of the actors
in the pictorialization.

Conveniently, the central west portal of the Cathedral could have provided the
appropriate physical frame for a scenographic apparatus. In fact, this might be one of
the background reasons why the standpoint of Brunelleschi's perspective — a "perspec-
tive" that was both natural (NVP at an imaging point [IP]) and pictorial (a viewpoint
projected in virtual pictorial space) — was said by Manetti to be located "three *braccia*
or so" inside the portal (about 1.8m or seven feet), and on that basis, it has been
suggested, sixty *braccia* from the east façade of the Baptistery. (The façade of the Duomo
that exists today was erected in the nineteenth century, but its original design is known
with fair precision; the width of the central west portal was probably fixed by 1355.[6])
But it makes sense to suppose that Brunelleschi would have maneuvered to secure the
most complete prospect possible on the Baptistery — "as much as could be seen at one
glance," according to Manetti. Standing three *braccia* inside the portal, one could look
out through the portal to the Baptistery already fully presenting itself "in perspective"
(Fig 9.2). The forwardmost (east) façade of the building and the roof as high as the top
of the lantern would be seen to occupy almost the entire height of the doorway (thir-
teen *braccia*), filling the vertical angle of vision on the world beyond the doorway with
the exception of a stretch of sky behind and above and a stretch of the piazza in front
of the building. And the two lateral northeast and southeast façades of the building,
receding at 45 degrees from the east façade, would occupy almost the entire width of
the doorway (six and a half *braccia*), almost filling the horizontal angle of vision. (Some
contemporary structures to the northwest and southwest of the Baptistery would have
been partly visible as well [see Figures 9.7, 9.8], and the entire Column of St. Zenobius
immediately to the north of the building would have been fully visible; still, there is
room for dispute about which if any of these features Brunelleschi could include in his
picture, or did.) The doorway, then, could well "frame" the view (of the Baptistery in
perspective). In principle, if Brunelleschi moved back far enough into the nave (about
6.5 *braccia* or 4m from the inner threshold of the portal), it could become a "picture"
that he could simply copy into *his* picture, a wooden panel said to be half a *braccio*
square (about fourteen inches; 29.18 cm) on which he could duplicate the [image
| portal-picture] square by square — thereby producing a picture of "what he sees"
when standing at the selected spot in the nave (or at any rate on the selected sightline)

and directing his gaze at the Baptistery. (About 12m back from the inner threshold, one could see *only* the east façade of the Baptistery; the roof and the receding lateral façades would be occluded.)

We do not know, however, whether Brunelleschi used a straightforward transcriptive procedure. Indeed, it is likely that he did not, even though the portal-picture was a part of the entire pictorial succession of perspective — of the pictorialization of the prospect-as-seen. For one thing, as already intimated, we know that Brunelleschi's pictorial experiments found a formal systematization and theoretical representation, a "neat codification," in Alberti's synthetic recipe for the graphic construction of one-point linear-perspective projections defined as a "cross section of the [visual] pyramid" formed by rays extending from the eye to the object; they formed part of the practical and technical background of Alberti's recipe (see Figure 9.4). (Alberti dedicated the vernacular version of *De pictura*, probably written before the corrected Latin version, to Brunelleschi.) And Alberti could not have extracted his procedure from a completed copy-transcription that had already been secured simply by gridding a visual prospect onto the plane — that is, simply from its transfer. Artificial and arbitrary in several ways, Alberti's recommended procedure formalized and generalized certain stages of the operation *leading up to* the transfer, and it organized them differently.[7]

For another thing, we might assume that Brunelleschi, a builder and engineer, would have found a mere copy-transcription of quite limited use, not only for ordinary geometric and metric purposes, such as recording the relationship between the planar and proportional configuration of objects and their volume-shape in visual space — "architectural" interests that scholars have argued must have been his dominant concerns.[8] For it would also be quite limited for many purposes of demonstration and exhibition, such as displaying what a visible volume-shape (when depicted) involves in its planar configuration (when a real mass or solid). In itself, the copy-transcription does not render the *aperspectival* (aspective) plane geometry and absolute measures of the object depicted. Therefore it cannot provide a reliable method for engineering this information out of the perspectival pictorialization, or at any rate of formally guaranteeing that the geometric and metric information is "in there" and could be recovered for certain purposes, including the reconstruction of *other* possible perspectives — projections of different prospects in visual space on the same object. The copy-transcription merely renders the natural visual perspective — how the object *looks* at IP as reproduced within the transcriptive system for depicting visual space. Of course, one might be seeking to do nothing more than register this "look," and perspective renderings have often been thought to be both motivated and bounded by a supreme interest in "look" alone. But actually they render the look *as* a regular (rule-governed) transformation of plane geometry and absolute measures at IP in visual space, reconstructed in the

perspective projection as the monocular viewpoint. In other words, they can have their full aspective cake and eat it too.

As noted, Brunelleschi's painted picture of the Baptistery does not survive, and unfortunately Manetti, though he describes it, says nothing about the procedure used to make it. But assuming Brunelleschi's concerns as surveyor, engineer, and pictorialist working at the site, the Piazza del Duomo, we can reconstruct a way of generating a pictorialization of the prospect that subserved *both* the planar-geometric *and* the optical-perspectival contexts and purposes, and integrated their phenomenologies. (Indeed, as the philosopher Karsten Harries has pithily remarked, "the theory of perspective *is* phenomenology."[9]) Despite the "sense of converging perspective" created in such pictures "before perspective" as Giotto's paintings of interiors (Figure 9.1), apparently the procedure did not yet exist in full in Brunelleschi's day. So far as possible, then, our reconstruction should make minimal assumptions about its technical and intellectual circumstances and about the theoretical learning of our protagonist, the putative inventor of the procedure.[10]

More exactly, the procedure itself might have been available in (or as) one of the methods of cartographers, surveyors, and/or builders and in stage design, in which Brunelleschi was a flamboyant innovator. The simple constructions that it involved might have been used by such practitioners. Moreover, its deeper conceptual background — the science of perspective (*perspectiva*) based on medieval Arab and Western optical theory — was taught in contemporary abacus schools, such as the one administered in Florence by the Goldsmiths' Guild, to which Brunelleschi belonged. But the important point for my purposes, as Hans Belting has put it in his study of Renaissance art and Arab science, is not so much that the "laws [of Brunelleschi's picture] were already *mathematical*" — the existing rules and theories of *perspectiva*. It is that in Brunelleschi's procedure for making his picture, whatever it was, they "now became *iconic*": they were reimagined pictorially in the innovation that Brunelleschi's contemporaries credited specifically to him.[11] And that pictorial succession of virtual space is what we really want to know about.

3. PUTTING PLANS AND ELEVATIONS IN PERSPECTIVE

In what follows I pursue an analytic reconstruction of the pictorial succession of a procedure that has been attributed to Brunelleschi by several art historians, including Erwin Panofsky, Richard Krautheimer, and Summers, though with different emphases and including in each case different elements and some divergences.[12] My aim is not to repeat their full and lucid expositions, which my readers can consult for themselves. Nor is it to reconcile differences and adjudicate disputes, which I am not competent to

do. Rather, I will emphasize the recursive interdeterminations of emergent images and collateral pictorializations—including radical-pictorial phenomena—in the succession from an initial "real" visual space (though one carefully selected and stage-managed—an artifact of urban topography and architectural design) to the completed "perspectived" painting, a virtual pictorial space. Because the procedure completes a full internal transformation from aperspectival plans and elevations (aspective pictorial bivirtualities) to perspectival projection, in turn consolidated in painterly realism and demonstrated as optically veridical, it has special interest for the purposes of the thought-experiments in this book.

I reiterate that we do not know exactly how Brunelleschi made his picture. The most we can say is that he *could* have made it in this particular way. In fact, *several* different methods could have produced the picture and its effects as described to us by Manetti; an entire book could be devoted to listing the possibilities that have been proposed in more than a century of highly imaginative and painstaking scholarship, in which "almost all the conceivable methods" have been reviewed. "The problem," as Martin Kemp has emphasized, "is that all these methods will theoretically deliver the same results, and there is no secure way of working back from Manetti's description to the method that was actually used."[13]

By definition, then, my reconstruction of Brunelleschi's procedure—my reenactment—is inherently speculative. It is an analytic archaeology of one possible image-succession. Treated as a *pictorial* succession, the procedure requires several operations in sequence, though it also involves recursions in the succession—as befits an investigation of visual and virtual spaces that probably involved considerable trial-and-error and back-tracking. If Brunelleschi used a different procedure, such as the method ultimately recommended by Alberti in 1435, we would still have to treat it as a pictorial succession, albeit one that had different inputs, elements, sequences, recursions, and outputs than the procedure I have chosen to track here. And here I have enough space for one reconstruction only.

(1) To start, and most basic, Brunelleschi makes a plan and an elevation of the Baptistery (Figure 9.9). If he was merely interested in mapping the building, we might assume that he made an elevation of the east façade facing the Duomo, more or less parallel to its west façade, and of the two lateral southeast and northeast façades receding from it at 45 degrees (see Figure 9.6). (The longitudinal median axis of the Baptistery is about 0.45m to the north of the median axis of the Duomo; if this disparity was a matter of attention and investigation, it would not greatly affect the pictorialization, which could include it or not.) But he could have made an elevation of *any* three faces of the Baptistery and would still have been able to construct a picture that could represent its gross conformation, its overall silhouette and volume-shape;

9.9. The pictorial succession of painter's perspective—plan and elevation of the Baptistery.

9.10. The succession—plan and elevation of piazza, west façade of Duomo, etc.

on my diagram, he makes an elevation of the south façade. As a regular octagonal volume-shape, the Baptistery looks more or less the same when one is facing any one of its façades, except the west (where the chamber of the font projects). Perhaps this is partly *why* Brunelleschi chose the building for his pictorial experiment; or, alternately, why he discovered that his experiment permitted special results—a point to which I will return.

Perhaps Brunelleschi was initially interested only in the plan and elevation, the aperspectival renderings and in the geometric and metric information about the building that they recorded—the octagonal footprint, for example, or the dimensions of the octagonal volume-shape of the building relative to the dimensions of the similarly shaped volume of its lantern. He would have been motivated to draw the plan and elevation *to the same scale*—as on my diagram—if he was interested in such relations as the *proportions* of heights to widths. And if his selected viewpoint in the Duomo (as virtualized in the picture) was to be sixty *braccia* from the Baptistery—that is, if he was already working within the pictorial succession of painter's perspective—he would likely have made his drawings in the scale of 1 : 60, the modular metric he has adopted in my diagram. If he did not make this specification in advance, he could draw at any scale, later correcting to the most practical one (such as 1 : 60) in rendering the proportional relations of the topographical, architectural, and visual situation. In making the plan and elevation—and any perspective drawings derived from them—he probably used the gridded or "graph" paper that he had devised during his investigations of buildings

in Rome, in which the horizontal and vertical coordinates, Manetti says, were "marked by numbers and letters," a crucial matter to which I will return.[14]

So far we have Brunelleschi making a plan and elevation of the Baptistery. Now let us consider that he might make a plan of the *entire* Piazza del Duomo, including the steps, platform, and portal of the Duomo to the east of the Baptistery, the Column of St. Zenobius to the north, and the streets and buildings to the southwest and north-west (Figure 9.10). Manetti tells us that the *view* from the standpoint in the cathedral included "on the one side [the left/south side], that which extends to the Misericordia as far as the arch and the canto de' Pecori; and on the other [the right/north side] that from the column commemorating the miracle of St. Zenobius all the way to the canto della Paglia," though he does not explicitly say that these features were reproduced in the picture (see Figures 9.6–9.8).[15] For simplicity, and at risk of simplification, I have excluded all of these features except the façade of the building on the north side of the piazza. The reasons for this, and the problems with it, will become clear in due course. (Most important, the features northwest and southwest of the Baptistery are asymmetrically distributed.)

In other words, Brunelleschi could have been interested specifically in the geometry and measures of spatial relations *between* the Baptistery *and* the Duomo — in their mutual proportions in the real space of the Florentine urban fabric. The distance between the east façade of the Baptistery and the inner threshold of the central west portal of the Duomo, for example, is almost exactly the same as the *width* of the Baptistery itself, and therefore its *depth* given its octagonal footprint, that is, its east-west width; at the threshold standpoint, the Baptistery is as far away as it is wide. (The *height* of the Baptistery to the lantern is equal to the distance between its east façade and a point in the nave somewhat behind the spot inside the portal where Brunelleschi is said to have organized his prospect and picture. This raises the intriguing possibility that at certain times of day and year the Baptistery would cast a shadow that darkened the doorway. Was Brunelleschi interested in this phenomenon — making diagrams of it?) Of course, this metric equality of width and distance is not *visible* from anywhere, however evident and orderly it might seem in plan and elevation. From the portal of the Cathedral, the Baptistery does not *look* to be "as far away as it is wide." Nor, indeed, does it *look* to have an octagonal footprint, or to possess any number of other geometric and metric characteristics that could readily be mapped on the plan and elevation. How, then, *does* it look? It's easy enough for Brunelleschi to find out: all he has to do is identify the spot inside the portal of the Cathedral where the Baptistery is as far away as it is wide, and see for himself. This is the architecturally framed "portal-picture" I have already described (Figure 9.6) — the standpoint for an image of the Baptistery (potentially

transferable to a copy-transcription) that can be compared to the plan and elevation (in and as a transformation of them).

I have said Brunelleschi makes a plan and an elevation — singular. If he is specifically interested only in the Baptistery, he makes a west-facing elevation — or, more or less indifferently, one facing north, or south, or east. If he is specifically interested instead in the metric and proportional relations between Baptistery and Duomo, he could make an east-facing elevation, with the west façade of the Baptistery silhouetted against the west façade of the cathedral (whether under construction or imagined as complete). But this could not explicitly show their distance from one another, and thus the particular metric equivalence already mentioned — that the Baptistery is as far away as it is wide. (In Chapter Seven I considered this property of aspective pictoriality in detail in the case of an ancient Egyptian sculptor's working drawing [Figure 7.24].) For this Brunelleschi must make a "side elevation" facing north (ADO on south façade) or facing south (ADO on north façade). Finally, he could be interested in the (visibility of the) architectonics of the entire piazza — including structures on the sides — in relation to the Baptistery and the Duomo *as the one is visible from the other*. In this case, he makes *three* elevations facing north, south, and west. In the operations to come, this would help him to capture features of the structures surrounding the piazza (if he did intend to include them) in the vertical angle of vision at standpoint. But this might assume the recursion of later steps in the procedure (Stages 2 and 3) in an earlier (the present Stage 1 under discussion here). It assumes, that is, that Brunelleschi's procedure was substantially governed in advance by a complete concept of the method as applied to the particular architectonics of visibility in this particular real and visual space.

And indeed this was Krautheimer's hypothesis: that the making of plan and elevations in Stage 1 (Figure 9.10) was part and parcel of marking asymmetrically distributed points in the vertical and horizontal angles of vision in Stages 2 and 3 — one integrated stage of the procedure based on a preexisting method. Assuming that Brunelleschi depicted not only the northeast, east, and southeast façades of the Baptistery but also three sides of the piazza (north, west, and south) with streets and buildings, Krautheimer posited the production and superimposition of three elevations; his reconstruction of the procedure shows the plan and a *synthetic integration* of information that would be made available in the west-facing elevation with a north-facing elevation and a south-facing elevation. (Most discussions, however, tend to elide the sense in which the "side elevation" was already a composite — an elevation of real things that could never be seen together, that is, in one image.) In due course, we will see (for the sake of argument) that the very process of producing and superimposing different elevations opens radical-pictorial possibilities that might have helped drive

the synthesis, helping us to see why Brunelleschi might have looped back through an initial project of making a scale plan and elevation(s) by integrating elevations with different cardinal orientations. Still, this amounts to a complete recognition of the structure of three-dimensional coordinate space that one might not wish fully to attribute to him in advance, like an Athena sprung full-grown from the head of Zeus. In the present discussion, then, I have taken a step back in order explicitly to fill in prehistories that might have motivated the adoption of the complete concept, if available to him, or alternately could have organized its practical and partly radical-pictorial realization in the next operations.

(2) In the next steps, Brunelleschi "superimpose[s] visual angles," as Summers has put it, on the plan and side elevation, respectively.[16] This too is a complex succession and recursion. (In a complete lemmatic presentation of the constantly bifurcating options spreading out before Brunelleschi, we can work with an elevation derived from one image [say north-facing], as I will do here, or with a composite elevation [north-*and* south-facing] not derived from one image, as most expositions have done. And we can work with a plan and elevation that represent the Baptistery and Duomo only, as I do here for the sake of simplicity in pursuing the thought-experiment, or with a plan and elevation(s) that include all four sides of the piazza, substantially complicating Brunelleschi's task, but attributing a guiding theory to him.)

It would have been natural enough to mark the location of the viewpoint on both the plan and the elevation. Indeed, Brunelleschi might have *already* done so (in Stage 1) when indicating the real measures and proportional relations, likely by drawing a line from the east façade of the Baptistery to the west façade of Duomo that was equal in length to the width of the Baptistery (north-south on the plan, east-west on the elevation). In theory, to indicate the metric-proportional relation as such (as might be in Stage 1) he could draw this line from *any* point on the east façade of the Baptistery on the plan to the correlate point on the line of the interior of the west wall of the cathedral, passing over the inner threshold of the central west portal (Figure 9.11). On the elevation, he can draw the correlated line, but, of course, it will locate no definite point on the north-south axes of the east façade of the Baptistery and interior west wall of the Duomo, though it must locate definite points in the vertical dimension of the façade.

But if he was motivated by the query I have already attributed to him—how do the metric-proportional relations *look?*—he would have wanted to adjust for the natural foreshortening inherent in the visual space relative to the regular octagonal footprint of the Baptistery: there is only *one* point on the relevant north-south axis of the Duomo in plan at which the northeast and southeast façades of the Baptistery appear in visual space to have equal width in elevation *despite* their recession in NVP. (Put another way, only at this point can he be sure that his "look" encompasses the largest possible *visible*

9.11. The succession—on plan, zone of
sightlines from the central west portal
of the Duomo.

9.12. The succession—on plan, the "centric
line" from *a*, a spot three *braccia* inside the
central west portal of the Duomo.

9.13. The succession—on plan, extensions of
the "centric line" to the font of the Baptistery
and the altar of the Duomo.

9.14. The succession—on elevation, location
of *a* at *b*, the height of the "centric line."

quotient of the real width of the Baptistery, relaying the greatest possible "octagonality" of the footprint despite the foreshortening at IP.) Overlooking the negligible north-ward displacement of the longitudinal median axis of the Baptistery, he would likely draw what might be called the "centric line" of the distance, then, as a perpendicular bisecting the width of the east façade of the building on the plan (Figure 9.12). In turn this automatically centers the eastern terminal point of the line in the middle of the inner threshold of the portal (point *a* on Figure 9.12) — the point that must be the place (the imaging point [IP]) of the "look" of particular proportional relations embodied in the three dimensions of the architecture and urban space and recorded in two dimensions on the plan and elevation. This sightline has great importance in assessing the *visibility* of the proportional geometries of the building and the overall site. But it might also have had independent status in contemporary Florentine *visuality*: it is a segment of the intangible but constitutive line — certainly imaginable and likely visualized — between the high altar at the opposite end of the nave from the portal and the font of the Baptistery, opposite the east door of that building (its lip was about 2m about the level of the piazza at the time) (Figure 9.13).[17]

Notionally, the viewpoints on plan and elevation, respectively, are the *same* point in real space. But there is a catch. The points are not *visibly* the same on the plan and on the elevation (Figure 9.14). On the plan, point *a* indicates only how far away the standpoint is from the façade, measured in whatever units were used to make the plan and the elevation. On the elevation, point *b* indicates how *high* the viewpoint (IP) is from the floor of the nave, the beholder's physical groundplane, and, of course, from such other strata as the level of the piazza. Point *a* therefore has to be *seen as* being at the height of *b* — a crucial pictorialization in the entire succession. In other words, the plan gives a horizontal plane section through the building at the height of *b* — a recursion in the succession in the sense that the plan (Stage 1) follows logically *from* what is indicated in Stage 2. The potential "gap" between *a* and *b* — and the need for the recursion of Stage 2 in Stage 1 — does not trip up the pictorialist only because there is no meaningful architectural difference between the horizontal section of the building planned in Stage 1, where the configuration would ordinarily be seen as the plan of the building at ground level (that is, its footprint), and in Stage 2, where it becomes a plan of the building at the height of *b*. But this is not a feature of perspective geometry as such. It is a strictly contingent characteristic of the object depicted — of the architectural shape of the site.

Of course, Brunelleschi has not yet reached the full graphic construction of the visual angle, though he has imaginatively (and likely corporeally) enacted it. He has found its apex at a compound point {*a*, *b*} on the plan and elevation — the eastern terminal points of the centric line of the distance from the east façade to the west

portal. But on the plan as augmented he has an obvious motivation to go on. He has constructed the perpendicular bisection of the width of the Baptistery. And the width is the distance between the north and south façades of the building. He knows that the length of the centric line of distance between the buildings is equal to it. It is graphically constructed on the plan, however, as a horizontal bisection of the vertical of the *east* façade. What is the distance from its eastern endpoint to the endpoints of the *visible* width?—the phenomenon he has stabilized in visual space (literally "perpendicularized") as the most complete possible *visual* registration of the plane geometry and absolute measures recorded on plan and elevation?

Easy enough to find out (Figure 9.15): draw the lines from the point terminating the centric line of distance in the portal to the relevant endpoints of the line of width (a north-south axis of the Baptistery) on the plan. Brunelleschi now has the minimally necessary triangle of the horizontal angle of vision, with apex at the terminal point *a* in the Duomo and base—a north/south axis in the Baptistery—in a line between the angles of the two visually receding façades (northeast and southeast) and the two "invisible" ones (north and south). (Of course, the angle could be greater than the relatively narrow angle he has drawn on the plan—the minimally necessary angle.) Naturally he then goes on to draw the sightlines from the apex *a* to the north and south angles of the east façade where it meets the northeast and southeast façades, creating an inner triangle within the larger angle—four triangles in all. Assuming that Brunelleschi is discounting the slight northward displacement of the Baptistery relative

9.15. The succession—on plan, construction of a horizontal angle of vision in viewing the Baptistery at *a*.

9.16. The succession—on plan, drawing the base of the triangle of the horizontal angle.

to the apex — a displacement that likely is not visible in visual space anyway — the two interior triangles must be mirror-identical across the centric line of distance, recursively confirming the trueness of the original perpendicular bisection.

Brunelleschi need not actually *draw* the base of the triangle of the visual angle. But likely he would do so (Figure 9.16), because it indicates the width of the building he is facing — one of the original parameters of the geometric and proportional relations being mapped. The base is, of course, parallel to the line of the east façade and perpendicular to the centric line of distance.

At this juncture, something extraordinary happens. A radical-pictorial graphic phenomenon emerges in the pictorial succession, and in the natural imaging of the emergent perspective pictorialization. (To my knowledge it has not been remarked before.) On the plan as graphically marked up to locate the points, lines, and angles of the "look" at standpoint of the proportional relations in the plane geometry of the site, the east façade of the Baptistery suddenly rears up *three-dimensionally* in a kind of "bird's-eye perspective." (The grapheme might be considered to virtualize an "impossible object" — an "object without content," such as a round square, to use the terms of the phenomenologist Alexius Meinong.[18]) It makes visible as a plane what had to be invisible in the plan, which renders the plane as a line. Moreover, it also makes visible as a plane what had to be invisible as a plane *even in the elevation* — for the elevation does not render the *plane* of the east façade, only the line of the angle of the east façade and the southeast (and/or northeast) façade(s). (Instead it renders the planes of the southeast, south, and southwest façades and/or their complements on the north.) By way of the strictly two-dimensional construction of the plane geometry of the horizontal angle of vision on the plan, a three-dimensional foreshortened configuration of an elevation has become visible — on the plan!

Of course, there is a catch. An unexpectedly vivid grapheme that is highly ambiguous both in its geometric identity and its optical object, the dramatically foreshortened plane on the plan does not render the "look" of the elevation at the standpoint. Nor does it register the octagonal footprint of the building, which has become ambiguously sexagonal (at the level of the radically pictorial "roof" onto which we seem to be looking down in a bird's-eye view). Still, it immediately suggests other three-dimensionalizing operations on the plan — other radical-pictorial graphemes imaged and pictorialized along the same lines (quite literally), if only as playful explorations of the initial grapheme. If the grapheme radically pictorializes a foreshortened view from high above (though not in a true perspective projection), how *would* the actual Baptistery look from a high point directly above it? Easy to envision, and to construct graphically (Figure 9.17): draw the lines from each of the interior angles of the octagon to its center. And compared to the highly ambiguous initial grapheme, how would a relatively *un*ambiguous structure look

from high above—a structure having the base of its foreshortened side in the line of the east façade in plan? Easy to draw, and to find out (Figure 9.18): eliminate the sexagon, and simply draw the line between the northwest and southwest angles in the plan and parallel to the base of the visual triangle (repictorialized as the edge of the "roof" high above the piazza), completing the rectangle of a roof.

In turn, this radical-pictorial grapheme can perform a remarkable double duty in foreshortening: it can pictorialize a tall rectangular structure (with height greater than width) seen from above, or alternately a long rectangular structure (with length greater than width) seen from the side. (Or both: the grapheme has oscillating orientations and dimensionalizations akin to a "Necker Cube"; each option is a radical-pictorial revisualization of the other. Compare my discussion of the duck/rabbit grapheme in Chapter Two, §1.) In the latter case, radical pictorialization spontaneously rotates to the "look" of the elevation explored in the initial construction of the perpendicular intersection of the width and the centric line of distance on the plan—that is, the look of the *actual* foreshortening that had supervened in our pictorialist's image of the metric and proportional relations in the plane geometry of the site, motivating him to "plan" it in the first place by constructing the horizontal angle of vision. A single additional line suffices to bring something like it into visibility on the plan: when the octagon is restored graphically, draw the line between the northwest and southwest angles of the Baptistery, parallel to the base of the triangle and the line of the east

9.17. The succession—graphic construction of the Baptistery as seen from above, showing octagonal configuration of roof.

9.18. The succession—graphic construction of a figure commensurate with a radical-pictorial visualization of a "three-dimensionalized" east façade.

façade (Figure 9.19). Pictorialized three-dimensionally, as the grapheme permits, we now seem to be *facing* the structure that is *looked at* from the standpoint, the apex of the visual angle! On the plan alone, radical-pictorial rotational phenomena that emerge in Brunelleschi's graphic operations on the "look" of the plane geometry of the building mapped in plan seem to have spontaneously given him *a dramatically foreshortened rendering of the plane geometry of its elevation*.

But what is its optical status? (After all, I am supposing that throughout Brunelleschi is partly interested in the "look" of the absolute measures and plane geometry — what he *sees*.) The radical-pictorial rotation from a plan to an elevation embeds a graphic transformation from a frontalized and aspective pictorialization to a foreshortened and perspectival one. However, does the emergent foreshortened pictorialization adequately render the actual look of the elevation at standpoint? Clearly not: the pictorialization does *not* look like what Brunelleschi sees from the portal; that is, at point *a* on the plan and point *b* on the elevation. If he extends the centric line of distance from *b*, the height of his viewpoint (Figure 9.20), he finds that he is looking directly at a point on the east façade of the Baptistery that seems to be considerably lower than the point looked at in the foreshortened grapheme on the plan, which one might intuitively identify by extending the centric line from *a*. Moreover, relative to the actual look of the elevation — to its volume-shape — the grapheme is both stretched and unfolded: though of the correct width, its "east" façade is too tall, and the flanking

9.19. The succession — graphic construction of a "three-dimensionalized" figure (foreshortened relative to a view from the south) commensurate with a radical-pictorial visualization of the octagonal footprint of the Baptistery.

9.20. The succession — on elevation, the "centric line" from *b*.

façades, though receding, are too wide. Though foreshortened, the grapheme renders a building with a different volume-shape and footprint, perhaps most readily completed intuitively as a sexagon.

(3) Much of this radical-pictorial proliferation and ambiguity emerging in the plan can be sorted out on the *elevation* when Brunelleschi maps the vertical angle of vision of the "look" of the elevation at b — his next step (Figure 9.21). The centric line of distance can be drawn from b to the east façade of the Baptistery — the equivalent of the centric line of distance from a on the plan. But the lines of the vertical angle of vision have a different geometric identity and optical status than the lines of the horizontal angle. The lines of the horizontal angle express the fact that a is optically centered relative to the width of the Baptistery — the apex of a triangle with a perpendicular that bisects the base. The lines of the vertical angle, however, cannot be centered relative to the *height* of the Baptistery; b is not opposite a point midway up the elevation. Moreover, whereas the angle at a maps everything visible to the left and right on a horizontal plane (whether an octagonal groundplane of the building or a section through it at the height of b), almost everything that lies below the centric line of distance on the elevation is not mapped in the angle at b because there is literally nothing to see; with the exception of the lowest parts of the façades of the Baptistery and a stretch of the piazza in front of it, it's all underground. (If Brunelleschi had wanted to map underground structures and spaces, in theory he could have eventually pictorialized a perspectival

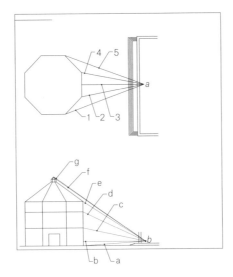

9.21. The succession—on elevation, lines indicating reference points on the east façade of the Baptistery in the vertical angle of vision at *b*.

"X-ray" of the spaces below ground, showing in a picture what could not actually be seen *in situ*. I will stick to my assumption, however, that he was interested throughout in what he could *see*.)

As on the plan of the horizontal angle of vision, to complete the elevation of the vertical angle of vision Brunelleschi next draws the lines from *b* to relevant features of the "look" of the elevation—likely such real architectural features of the Baptistery as the angles between the principal plane surfaces and/or the principal visual articulations of those planes. Of course, in his maps of the horizontal and vertical angles he could connect *a* and *b* to *any* point on the Baptistery as rendered in plan and elevation, including points not obviously identified with any distinctive architectural feature or boundary. And in fact mapping a greater number of points will eventually provide a greater density of pictorializing information in the emergent perspective projection, in turn probably adding to the simulative value of the picture relative to the prospect—its local detail, its finer shapes, and the like. Still, as we will see, a dense point field will have its drawbacks; paradoxically, it can make it more difficult to see in the projection what the pictorialist sees as the prospect. Part of Brunelleschi's pictorial experiment could consist, in fact, in seeing what would become visible in the drawing under this open graphic condition—that is, in mapping *a* and *b* into a greater or a lesser number of points (independently identified in real space in various kinds of ways) in the fields of the visual angles on the drawings. At the very least, we can probably assume a degree of recursion in this phase of the pictorial succession: Brunelleschi can add or can eliminate a "connector" from *a* and *b* to any particular point in this phase of the operation, depending on the results deriving from transferring that connector into *later* stages of the construction.

To capture the "look" of the Baptistery in the vertical angle of vision, it is intuitively obvious that at minimum Brunelleschi would want to connect *b* to major architectural features and boundaries in the building as visible in the prospect: most obviously, and moving from top to bottom, (1) the top of the roof of the lantern (*g*), with only sky visible above; (2) the bottom of the roof of the lantern (*f*); (3) the bottom of the lantern's cupola, which is also the "top" of the octagonal roof of the Baptistery (*e*); (4) the bottom of the roof (also *e*); (5) the bottom of the upper articulation of the façade (*d*); (6) the bottom of the lower articulation of the façade (*c*); (7) and the base of the building at a right angle with the piazza (*a*). (Lines 2, 3, 4, and 5 were not labeled in Krautheimer's and Summers's reconstructions of the vertical angle, probably for the sake of graphic simplicity, though the lines must be absorbed into the perspective pictorialization; indeed, they are required for it.) Notice that given the natural visual perspective of the prospect, two different architectural points can be identified using the *same* connector: line *f* passes through both (4), a point at the bottom edge of the

roof of the Baptistery, and (3), a point at the bottom of the lantern's cupola (also the point at the top of the roof), traversing the slope of the roof. (Eventually this will mean that the body of the lantern is not visible in the pictorialization — only the roof.)

So far, so good. Just as the horizontal angle on the plan maps the prospect of the Baptistery from side to side, with its width centered in standpoint at a, the vertical angle on the elevation maps the prospect from top to bottom, with the height of IP placed at b. But we now reach a crucial rotation in the pictorial succession, foreshadowed — perhaps motivated — by the radical-pictorial three-dimensionalized graphemes that have already emerged as ambiguous parameters of the graphic operations.

All of the points enumerated so far — all the connectors from b to points on the elevation — lie on a line perpendicular to the centric line of distance and bisecting the east façade of the Baptistery. (Stated another way, all these connectors could be drawn *as* the one connector 3 in the plan when extended to the center of the octagon, though on the elevation they actually indicate lines at an *oblique angle to it*, roving up and down the east façade, roof, and lantern in the vertical angle.) They carry a good deal of information about the prospect from top to bottom, including the foreshortening of the roof and lantern. But they do not yet give adequate information about the prospect from side to side — that is, about the foreshortening of the northeast and southeast façades in the vertical angle of vision. Additional connectors are needed (Figure 9.22). These must connect b to points identified on the plan by lines 1, 3, 4, and 5 (specifically *not* on 3): namely, the uppermost and innermost visible corner of the southeast (and/or northeast) façade(s) with the east façade (e', colinear with e); the uppermost and outermost visible corner of the southeast (and/or northeast) façade(s) (e''); the innermost visible point of the upper articulation of the southeast (and/or northeast) façade(s) (d', colinear with d); the outermost visible point of the upper articulation of the southeast (and/or northeast) façade(s) (d''); the innermost visible point of the lower articulation of the southeast (and/or northeast) façade(s) (c', colinear with c); the outermost visible point of the lower articulation of the southeast (and/or) northeast façade(s) (c''); the outermost visible point of the bottom of the southeast (and/or northeast façade(s) (b'); and the innermost visible point of the bottom of the southeast (and/or northeast) façade(s) (a', colinear with a). (None of these lines is labeled by Krautheimer and Summers.) In addition, the innermost and outermost corners of the junction of the octagon of the lantern with the roof of the Baptistery (g', g'') and the innermost and outermost corners of the junction of the roof of the lantern with its octagon (f',f'') could be marked, even though Brunelleschi might already have realized that some of this data will not become *visible* in the virtual pictorial space eventually produced by the completed pictorialization.

In principle, all these architectural points in the prospect in the vertical angle of vision are to be found *both* on the southeast façade *and* on the northeast façade in relation to the east façade. But assuming that Brunelleschi makes only one "side elevation"—quite possible if he was initially mapping the Baptistery and Duomo only—*only the southeast façade is represented on the elevation.* Therefore the connectors locate points in the visual space to the "left" of the bisection of the east façade by the centric line from *a* and *b*; strictly speaking, what is to the "right" is not indicated. Nonetheless, given the bilateral symmetry of the regular octagonal building as seen at { *a, b* } as well as the connector lines already mapped on the plan, Brunelleschi finds that *one and the same line* on the elevation—indeed all the lines that are notionally oblique to the centric line of distance—can be seen as mapping two different points not only in the horizontal angle of vision *but also in the vertical angle.* For example, *e″* connects *b* to the same visible architectural feature on *both* the southeast *and* the northeast façade, namely, the uppermost and outermost visible corner of each façade, which *share* a graphic point on the elevation even though they lie on opposite sides of the building as mapped in the plan of the prospect at *a*, where two *different* connectors are required (that is, both *1* seen as *1′* and *5* seen as *5′*). (This realization would be helped along if Brunelleschi were to make two "side elevations," as Krautheimer supposed: though in principle the north-facing one would be reversed relative to the south-facing, the points on *e″*, though located on the western side of the building in the south-facing supplement, would

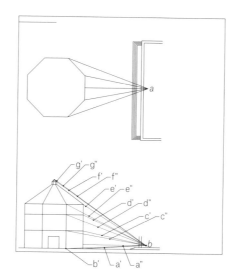

9.22. The succession—on elevation, lines indicating reference points on the south and/or north façades of the Baptistery in the vertical angle of vision at *b*.

nonetheless be shared in both renderings—for in strictly graphic terms they are the *same* point though they incorporate an internal succession [NE" | SE"], and vice versa. Recursively, then, and because of this pictorial succession of a graphic identity between optically different points, elevations of the Baptistery itself would not actually need to be superimposed at all—only the elevations of features that are asymmetrically distributed in the scene, such as other buildings visible from the portal of the Duomo.) In other words, in mapping *b* to the oblique points of the prospect at *a*, the elevation three-dimensionalizes: in the elevation we are notionally "facing" the south façade, but the emerging pictorialization can now suggest that we are *also* facing the foreshortening of the southeast façade. For the elevation now contains radical-pictorial lines and shapes (triangles) that can be seen as (seen as-*as*) something like that foreshortening, namely, the shape emergent in the graphic net $e' - d' - d'' - c' - c'' - b' - a'$.

To stabilize all of this complex and ambiguous geometric, optical, graphic, and radical-pictorial information, it is a simple matter to rotate the three-dimensionalized elevation a full quarter-turn clockwise, creating elevation B' (Figure 9.23)—a rotation in which we now face a three-dimensionalized elevation of the *east* façade, which had been entirely invisible in the original elevation. Here the connectors from *b* of course "switch over" from identifying points on the southeast façade relative to the east façade to identifying the same points on the northeast façade—as it were unfolding the spatial succession embedded in the previous operations. And point *b* on B' is now identified in visual space not merely as a location in the cathedral, the standpoint/IP

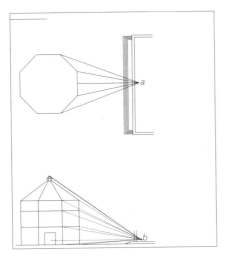

9.23. The succession—transposition of the centric line from east façade to three-dimensionalized figure.

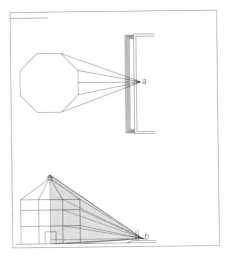

9.24. The succession—radical-pictorial visualization of a figure "folded" to transpose viewpoint from *b* to the beholder's viewpoint on the three-dimensionalized figure; possible schema for a three-dimensional model.

{ a, b }, occupied by Brunelleschi in securing a certain visual prospect of the Baptistery. It is also identified as the location from which elevation B' is itself sensed to be viewed: point b as it were rotates in the radical-pictorial visual space of the pictorialization to become the virtual location of IP in facing the elevation. Brunelleschi can interpret the vertical angle in B' to be—seeing it *as*—a triangle with its apex at IP "folded down" to lie at right angles to his line of sight, as it were externalizing the location of his new prospect in B' b to the original prospect of the beholder mapped in b (Figure 9.24). At this juncture, maybe he will make a simple three-dimensional model of the aspective or parallelized virtuality generated in the latest operation, perhaps using flanged cut-outs and strings: with the plane of the elevation at right angles to the emergent pyramid of the vertical angle.

4. ON THE THEORY OF THE VISUAL ANGLE

So far I have described the succession of a "perspectived" pictorial projection as what Summers has called a "simple virtual construction" on the plane, and possibly in three-dimensional models setting two material planes at right angles.[19] More exactly, it is a series of simple transformations of such constructions motivated by metrical, optical, graphic, and radical-pictorial phenomena in recursive interaction with one another. I have tried to attribute the most minimal preconceived theory to Brunelleschi himself, though implicitly I have endowed him with a powerful capacity to spatialize two-dimensional forms in three dimensions (and vice versa), a high degree of imaginative responsiveness to visual and pictorial ambiguity, and a creative willingness to engage radical pictoriality. But I have pursued this direction of analysis partly for purely methodological reasons: namely, in order to reconstruct a pictorial succession—retrospectively considered to be an astonishing invention—as a largely internal self-generating succession and recursion of images and pictures in emergent virtual pictorial spaces.

Obviously, however, the circumstantial historical situation might have been somewhat different. It is possible—indeed likely—that Brunelleschi already possessed some elements of a formal recipe for painter's perspective, such as Alberti's method of construction (Figure 9.4)—a recipe Alberti in part abstracted from graphic practices and virtual constructions like those I have reviewed.[20] For the sake of the argument, however, I have assumed that Alberti's method *followed upon* Brunelleschi's and like pictorial successions, including works by Donatello, Ghiberti, and Masaccio, and to generalize them. "Alberti's achievement," Kemp has said, "was to supersede Brunelleschi's dependence on actual buildings," crucial as it was to the logic of Brunelleschi's demonstration, "and to extract their underlying rationale in terms of the general case of an archetypal construction."[21] Overall, then, I have proceeded

from Hubert Damisch's remark that Brunelleschi the pictorialist (around 1413) stood to Alberti (the systematizer in 1435) as the mensurator Thales (around 600 BCE) stood to the geometer Euclid around 300 BCE (the case cited by Edmund Husserl)—namely, as "practice" stands to "theory."[22]

Still, even if Brunelleschi did not apply a fully theorized method of perspective pictorial projection—but rather helped to inaugurate it—it is possible that background visual theory guided his practical operations. As Kemp has summarized the intricate history, "the concept of the visual pyramid"—a possible conceptual precursor of Brunelleschi's operations in Stages 2 and 3 in superimposing the visual angles—"was drawn from medieval optical science, the *perspectiva* on which a number of Islamic and Christian authors had written."[23]

In particular, we can identify a logical congruence (and possibly a circumstantial historical connection) between Brunelleschi's pictorial experiment at the Baptistery and the theory of the visual angle developed by the Arab philosopher Ibn al-Haytham (965–c. 1040), known in the West as Alhazen.[24] As Summers has put it, Alhazen "provided the principles by which anything visible—the world, but also the heavens and the universe taken together—might be described geometrically as a set of points in relation to the surfaces of the organ of sight" (Figures 9.2, 9.3).[25] An Italian exponent of Alhazen, Biagio Pelacani da Parma, had taught in Florence two decades or more before Brunelleschi made his picture of the Baptistery; a copy of Pelacani's *Quaestiones Perspectivae* (c. 1390) was owned by the mathematician Paolo Toscanelli, a friend of Brunelleschi.[26]

Alhazen himself wrote nothing about picture-making, though the third book of Ghiberti's *Commentaries* "devised an elaborate and substantial collage of translated texts from the leading authorities on optical science," including Alhazen.[27] But if Summers and other historians are right, both Alberti and Leonardo da Vinci formalized their own versions of Alhazen's theory specifically for painters and picture-making, though their contributions followed in the wake of Brunelleschi's demonstrations and possibly in part as a response to them, giving them (and to reiterate my main point) a "theoretical expression."[28]

If Brunelleschi self-consciously and explicitly applied Alhazen's principles, it would help to explain how he leaped imaginatively through certain relay-points in the pictorial succession that might otherwise have been difficult to motivate. It is easy to see, for example, why he would have undertaken the very first of the operations: probably he simply wanted to make metrically accurate two-dimensional plans and elevations of the Baptistery in relation to the Duomo and maybe other features of the cityscape. It is less easy, however, to see why he would have pursued certain other operations in the requisite sequence (especially if he lacked something like Alberti's innovative concept

of a picture as a "*cross-section* of the [visual] pyramid"), unless he knew that he could combine them in order to picture the Baptistery as if observed from a single standpoint in real space—that is, by superimposing the [visual angles | visual pyramid] and constructing its [cross-section | perspective projection]. Still, perhaps he could only confirm that such a picture could be made *after* experimentally pursuing the operations that transformed the initial visual prospect—the portal-picture—by enfolding aspective metric data and modular constructions into its projection. As Belting has put it, "whereas the visual theory investigated the distance to a *real object*, the pictorial theory calculated the *object in the picture*, so that we see things that are not there at all as if they were present."[29] And it is only in tracking the succession of this presencing that the complex recursion can be identified, whatever pictorial theory based on visual theory Brunelleschi had in advance of his actual investigations in pictorialization.

5. THE SUCCESSION OF THE INTERSECTION

I resume my reconstruction of the succession.

(4) In a series of graphic operations and radical-pictorial visualizations, both plan and elevation have now three-dimensionalized. And it has become clear intuitively, and to some extent visually, that they can be rotated and/or folded into one another insofar as they both map some of the *same* points with *different* lines (for example, the uppermost and outermost corner of the southeast façade mapped by *1* from *a* and by *e"* from *b*) and use the same lines to map different points (for example, line *3* on the plan, ostensibly mapping the point on the east façade on a direct line of sight at *b*, can *also* map the points on the façade on lines *e, d, c,* and *a* on the elevations). While the plan explicitly maps a side-to-side visual sweep (the horizontal angle of vision), it can also implicitly pictorialize a top-to-bottom sweep (a verticalized angle). And while the elevation maps a top-to-bottom sweep (the vertical angle of vision), it also explicitly includes points side-to-side (a horizontalized angle). Now for the folding itself—the intersection. Essentially this involves a simple transfer of a virtually three-dimensionalized plan and elevation (perhaps already modeled in three dimensions with cut-outs) to a single two-dimensional representation—a representation that by definition should pictorialize as three-dimensionally perspective, rendering the prospect.

Brunelleschi now constructs sections through the visual angles on the plan and the elevation at the same distance from the apex (*a* and *b*) as measured in the units of the drawings (Figure 9.25). If both plan and elevation had initially been drawn into a uniform grid, as seems likely, a plethora of such sections—strictly speaking an unlimited number of sections—would readily present themselves to be drawn in the shaded field indicated in my diagram. But one of these sections can be selected for the plan

and elevation because it marks a feature in the environment — a particular visible place or a particular visible object, or perhaps a visual event, that is, an emergent "perspectival" value in pictorialized visual space. In the most plausible scenario, Krautheimer proposed that the sections were taken through the point at which the piazza was nearest to Brunelleschi in visual space — as it were most proximate to him in visual space — when standing three or so *braccia* inside the portal of the Cathedral, namely, at a point some way out in the piazza from the bottom of the west steps of the platform of the building (the steps were invisible at the standpoint because they lay below the vertical angle of vision) and the east façade of the Baptistery (Figures 9.26, 9.27). According to Krautheimer, this line had a regular value in the overall proportional scheme of the visual/pictorial space relative to the real space: "the line that marked what was for [Brunelleschi] the piazza's near boundary, was 30 *braccia* long, exactly half the distance from his eye to the Baptistery; thus it corresponded in scale to the width of the panel, which was one half *braccio*." (Krautheimer assumed Brunelleschi's drawings were done in the scale of $1 : 60 [= 0.5 : 30]$.) On the plan, then, Krautheimer constructed the section through the horizontal angle where its width equaled the distance to *a* on the centric line — a relation that on the plan cannot be shown directly by the section through the vertical angle. In this way Brunelleschi supposedly "forced [the observer of the picture] to occupy the exact point from which he himself had viewed the façade of the Baptistery." In other words, recursively "Brunelleschi established in scale both distance and base line of his painting. Since the panel was square, the proportions of both distance to width and height were 2 : 1 : 1."[30]

In relation to the framework Brunelleschi has constructed so far (in my reconstruction of the pictorial succession of perspective), this scenario is broadly correct in its approach to the *outcome* of painter's perspective — its end-product is a correctly "perspectived" picture. As such it has been repeated by other commentators working in this direction, that is, in terms of this overall reconstruction. But phenomenologically it might seem to jump the gun; assuming the consequent, it embeds an internal succession and recursion that Brunelleschi must have unfolded.

To be specific, the horizontal angle of vision on the plan is wholly agnostic about the extent of visibility at *a* of the platform and steps of the Duomo and of the piazza. On the elevation, however, the construction of the vertical angle shows that the steps to the platform would have been invisible and the piazza would have been most proximate in visual space to Brunelleschi at *b* at a point *closer* than Krautheimer conjectured (Figure 9.26). Krautheimer included no connector from *b* to the point of the perpendicular intersection of his section and the piazza (my line *a″*), though he did include connectors from *b* to two points closer to it, seemingly representing Brunelleschi's "eyepoint(s)" at the bottom of his vertical angle of vision. No point on these lines lies

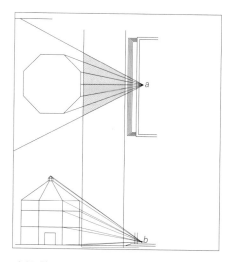

9.25. The succession—on plan and elevation, a zone of possible "intersections" of the horizontal angle perpendicular to the centric line.

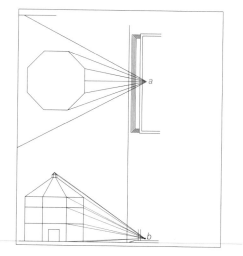

9.26. The succession—on plan and elevation, an intersection constructed at the point where the piazza is first sighted in the vertical angle of vision from the Duomo.

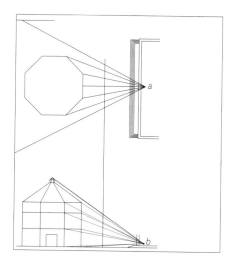

9.27. The succession—on plan and elevation, an intersection constructed midway between { a, b } and east façade of the Baptistery.

on the section on the elevation. But the relation is entirely tautologous: the section on the elevation *assumes* the point on the plan.

I can find no fully consistent way to rationalize this anomaly in Krautheimer's analysis. If we lower the height of *b*, the bottom of the vertical angle will intersect a point further out in the piazza — perhaps at the point of Krautheimer's section. But the geometry suggests that this adjustment would have to put *b* at the level of the floor of the Duomo — a possibility that can be indicated by *a* on the plan (and indeed in a phase of the succession it *is* indicated by *a* on the plan) but cannot render any possible "look" of the Baptistery: no one sees it from the Duomo's floor level.

A second solution assumes a sophisticated recursion. Whether or not Brunelleschi had already worked through the pictorial succession to the construction of a perspectival plane of projection (a "picture plane") at any section through the vertical angle, he certainly could construct a section at a point that had always interested him (I have supposed) from the very beginning, namely, the point where the distance of the Baptistery from $\{ a, b \}$ is equal to its width — an invisible feature of the perspectival "look" of the site in visual space that is nonetheless folded aspectively into the construction. Enfolding the relevant metric, he could construct the section at the eyepoint on *a*, namely, where he sees the bottom of the east façade of the Baptistery meeting the piazza at a right angle — a phenomenon succeeding to the baseline transversal in the eventual perspective. But to ensure it will actually be *seen as* that visual space and its proportions, he would eventually have to eliminate a few *braccia* of depicted foreshortened piazza (namely, the stretch closer to *b* than the bottom of the section through a'). To recapture the proportions, the "missing bit" of piazza could be restored at a later stage in the pictorial succession. When stated this way, however, we can see why he would split the difference and construct his section (Figure 9.27) midway between the eyepoint on a' (the *metric* point *in* the piazza where the proportional parity is located: distance = width) and the eyepoint on a'' (the point at which the proportions *of* the piazza as seen in visual space are first *visible*) — in the process discovering (as distinct from *assuming*) the visually meaningful point on a' where the section *renders* the metric proportions.

Given the operations in Stage 3, the sections constructed in this stage (4) of the succession (Figure 9.28) will be lines with a series of points marking the intersection of the sections and the lines drawn in Stage 3 from the apexes of the vertical and horizontal visual angles to the building rendered in plan and elevation. Notionally the two sections intersect at right angles at $\{ 3, b \}$ in three-dimensional coordinate space — or in a simple three-dimensional model.

(5) Next, Brunelleschi transfers the two sections to a single sheet and combines them in a single two-dimensional configuration. Indeed, in keeping with the

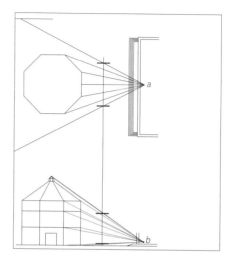

9.28. The succession—identifications
of intersections to integrate.

three-dimensionalizations already attained, he transfers the points for the vertical
angle of vision (from the elevation) to one vertical side of the sheet (or to a line parallel
with it) (Figure 9.29) and the points for the horizontal angle of vision (from the plan)
to the horizontal bottom of the sheet (or to a "baseline" parallel with it) (Figure 9.30).
(This is the crucial operation originally reconstructed by Panofsky as the supposed first
stage of the Albertian construction.[31]) On my diagram, I assume that the point at the
bottom of the section through the vertical angle is transferred to the bottom edge of
the sheet—therefore eventually constructing the baseline transversal of the perspec-
tive picture. As we have already seen, however, this might require adjustment at later
stages in the succession; if the baseline transversal is constructed at the eyepoint of
a' (namely, where the base of the building intersects the piazza), the piazza visible at
$\{a, b\}$ that will now "drop out" of the construction will have to be restored. In other
words, I assume this recursion—even if folded back in a process of trial and error
from the final stages of the intersection to this penultimate stage.

 At this stage, the configuration could be drawn to a new scale—any feasible scale.
If the construction so far had been relatively small, it might be desirable to scale it up,
thus easing the next stage of the operation. Still, in order for Brunelleschi to evaluate
the results of the entire operation, it would be best to draw the new configuration at
the same scale as plan and elevation and into the same grid.

 (6) Next, Brunelleschi produces vertical and horizontal lines through the points
on the lines at the side and baseline—verticals through the points on the baseline
and horizontals through the points on the side (Figure 9.31). In the visual and graphic

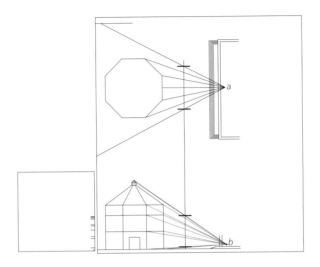

9.29. The succession—transfer of the intersection
of the vertical angle of vision.

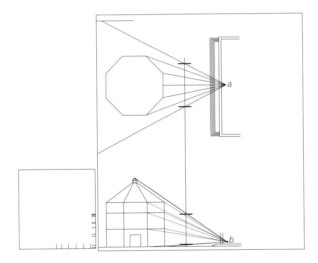

9.30. The succession—transfer of the intersection
of the horizontal angle of vision.

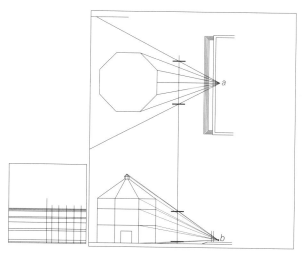

9.31. The succession—construction of the perpendiculars from horizontal and vertical edges of the transfer, creating a "grid."

field of their intersections, these lines in turn immediately produce a thicket of points, more or less dense and variously spaced depending on the array set in the preceding sections—that is, depending on choices made in the preceding stages.

(7) In the final stage, Brunelleschi connects the dots within this network such that the "bare skeleton of the Baptistery comes into view" in a new configuration (Figure 9.32)—the "unification" of plan and elevation(s) in a rendering of the foreshortened object under the visual angle at { a, b }.[32] If its outermost outline was not already visible to him as a "digital" figure on the plane (that is, as a radical-pictorial shape constituted by certain dots in the field), it could be brought forward visually by connecting the outermost dots with straight lines. It would be less obvious, however, how to connect outer dots to inner dots, inner dots to one another, and outer and inner dots to any other points beyond the emergent figure. If he had not already taken account formally of the stretch of piazza in front of the east façade of the Baptistery, he could now add it, whether informally or geometrically (Figure 9.33).

The new two-dimensional configuration that has now emerged in the succession is "perspectived" in two crucial ways.

First, in height and width it will be *smaller* than the configuration of the building rendered in the elevation, for the sections constructed in Stage 5 lie closer to the faces of the object than does the apex of the visual angle set in Stage 2. Relative to the original rendering on the elevation, then, the integrated configuration appears to fall "back into the distance"—to be *diminished*. (The *proportion* of the diminution relative to the

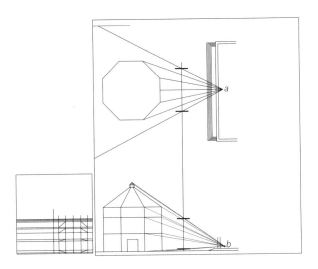

9.32. The succession—"connecting the dots" commensu-
rate with the reference points on the sightlines at { a, b };
emergence of the perspective projection.

9.33. The succession—possible addition of a
baseline transversal to capture the "missing" piazza
in the projection.

original is set by the proportionality already recognized by the section, where distance : height : width = 2 : 1 : 1.) Of course, if the integrated figure had been scaled up relative to earlier configurations in the procedure, then the metric and optical implications of this difference in its absolute size might not be immediately evident — immediately visible. But if the rescaling used the same modules as the preceding configurations, as seems likely, then the absolute size of the figure would have a regular (geo)metric value relative to the plan and elevation that could be stated. In turn this value could potentially be *transferred into* what the new figure can be *seen-as* relative to its predecessors and as pictorial, namely, seen-as [diminished because of its distance | at proportional scale given its distance]. This might be the most important succession in the pictoriality of the perspective intersection.

Second, the deviations from the "planarity" of the façade that had been recorded in the plan as interpreted in the preceding stages of the operation have now been transferred into the new *elevation* — an elevation that now pictorializes the *recession* of those planes on lines orthogonal to the centric line of the visual pyramid with its apex at { a, b }. Recession had been rendered on the plan as well, but aperspectively: the plan placed the oblique facades of the structure at the proper angles to one another in an "object-centered" coordinate frame, of which the plan renders the "floor." (More exactly — at any rate in the succession as it unfolds — the plan renders the horizontal plane through the building at the height of b.) In the integrated configuration, the obliquity of the receding façades plotted in the plan is transformed into an elevation in a coordinate frame centered on the implied *viewer* placed at { a, b }.

On the integrated configuration, the eyepoint opposite { a, b } on the plan and elevation succeeds in principle to the perspectival "vanishing point." To be sure, in the succession Brunelleschi did not need to have any concept of the latter. And he did not start with it in the way in which Alberti's method, for example, requires the painter (in the very first operation of the Albertian succession) to identify the azimuth on the horizon line as three *braccia*-modules above the baseline transversal (a length defined as the height of a man pictured as standing at the front of the foreshortened optical plane). Nonetheless the vanishing point is also a point *on* the plane, succeeding pictorially as a spot on the east façade of the depicted Baptistery perpendicular to the sightline (the perspectival ADO) — perhaps even succeeding pictorially *from* such a spot, whether or not it is marked depictively as a feature of the façade, such as a feature on the east door of the building or a feature visible within the interior space beyond the east door, such as the lip of the font on the western side of the interior of the building (see Figure 9.13). Given the operations he has conducted so far, Brunelleschi could easily locate it geometrically (Figure 9.34) at the intersection of a perpendicular through the transversal on 3 (transferred from the horizontal section of the visual angle in the plan and

9.34. The succession—geometric identification of the
[eyepoint | vanishing point] on the centric line at { a, b }.

9.35. The succession completed—disaggregation
of the perspective figure.

representing the centric sightline in the visual angle at *a*) and line *b* (transferred from the vertical section in the elevation and representing the centric sightline in the visual angle at *b*).

For simplicity of exposition, I have not carried out the connections that specifically produce the roof of the lantern — the only part of that structure visible in the projection. But by-now-self-evident operations on the thicket of intersections in this area of the figure can complete the pictorialization.

At this juncture, I have completed a reconstruction of the pictorial succession through which Brunelleschi might have constructed his painted perspective (Figure 9.35). It is a speculative reenactment that can appeal to no direct evidence from the maker. But so far as possible it observes the general logic of a plausible historical phenomenology of his experience of the visual space of the site, of his aspectival maps of it, of his radical-pictorial visualizations, and of his pictorializations.

6. BRUNELLESCHI'S DEMONSTRATION OF THE PICTURE IN PERSPECTIVE: I, THE SET-UP

Brunelleschi's procedure allowed him to depict visual-spatial phenomena that could be described both metrically and geometrically as being "in perspective" once the construction had been produced. But the locations and relations in question were also *parametric*. They had their own grounds and determinations in the pictorial succession. Above all, Brunelleschi chose to observe the Baptistery from a spot three *braccia* inside the main portal of the Cathedral because it presented him with a pre-pictorialized but architecturally framed perspective — the portal-picture. He proceeded to make a perspective picture of this image — "what he sees" — by de- and recomposing it on the plane.

We must be careful with this formulation, however. *Picture* what he sees? It seems that Brunelleschi was interested instead, or in addition, in *presencing* something he could see by way of a picture of it — a *picture that could succeed to the phenomenon* at the same time as it could serve as a veridical representation of it, *phenomenon succeeding to picture* (see Chapter Three). As a perspectival rendering of a naturally "perspectived" visual prospect, his construction of virtual pictorial space in the painting harbored the possibility of absolute AC-pictoriality — of picture visually indistinguishable from world depicted. Nonetheless, there was no way fully to liberate this potential directly from the bivirtual pictorial compound alone, a small painted board — a lifelike picture in some respects, to be sure, but not one he would likely mistake for what he saw when standing in the Duomo looking over to the façade of the Baptistery. Surely the

grandeur of the prospect — a salient aspect of the architectonics of the site — would only highlight the pictorial reduction.

Brunelleschi needed not so much to compare the panel-picture and the portal-picture as to *replace* portal-picture with panel-picture — seeing *then* that he was seeing the (pre-pictorialized) Baptistery in (a picture of) the same NVP at standpoint, *regardless of which of the two "pictures" he was actually looking at*. And to do this, he had to place the panel-picture on the very same line of coincidence between viewpoint and eyepoint that he had adopted in the portal-picture's prospect. Insofar as the panel-picture (with its highly particular proportions) was a perspectively correct rendering of that prospect (albeit scaled down in all dimensions by certain proportions — the central issue of his investigations as they unfolded), they should match. And this match would not so much be a proof of the geometrical correctness of the rendering — a matter internal to the rendering, and handled, for example, by Alberti's later method of checking the diagonal(s). It would prove, rather, that the proportional geometry was optically veridical in this case. The picture passes through a succession of images to which it has identity.

We now reach the second phase in the overall pictorial succession of "what Brunelleschi saw" — namely, his optical demonstration of the visual presencing of **BAPTISTERY** in his picture and therefore of the procedure of the intersection and its background and emergent principles, including any formal principles that he had imported into the operation (such as Alhazen's optical theory).

According to Manetti, the artist bored a small peephole through the picture; "it was as small as a lentil on the painted side, and on the back of the panel it opened out in a conical form to the size of a ducat or a little more, like the crown of a woman's straw hat." The beholder placed one eye at the conical opening (in the back of the painting) and looked through the hole to the representation on the painted side (fronting away from him) as it was reflected back to him in a mirror placed opposite to the panel (Figures 9.36, 9.37). Manetti specifically says that the mirror was held in the hand; it must have been no more than a few inches square. If so, the panel might have been mounted into a contraption that kept it upright and steady and enabled the beholder to adjust it relative to his posture. If taken literally, Manetti's description of the use of the device seems to require the beholder to have *three* hands — one to hold the mirror opposite the panel, one to hold the panel itself, and one (Manetti says) to shade his eye (the eye *not* placed at the peephole) or more likely to cover it. Perhaps the panel was mounted on a stand. Or perhaps mirror and panel were joined by battens in a supporting frame that held everything together; otherwise the image of the reflected painting would surely be a wavering one "however steady and sober the viewer."[33]

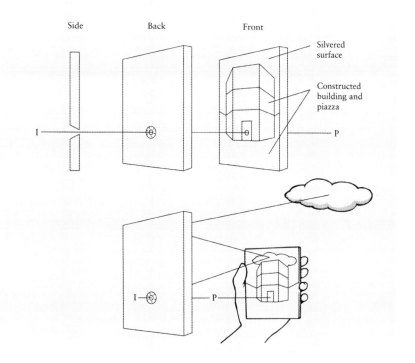

9.36. Reconstruction of Brunelleschi's demonstration in
a mirror-reflection of the painting in perspective. (From
Summers, *Real Spaces*, fig. 289.)

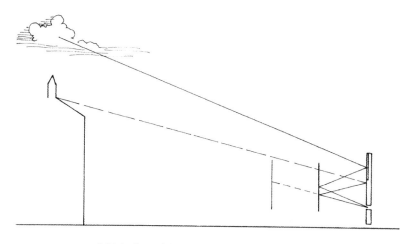

9.37. Analysis of the geometry of the mirror-reflection
demonstration. (After Janowitz, *Leonardo da Vinci.
Brunelleschi. Dürer*, fig. 123.)

Before moving on, it is worth addressing a notion sometimes encountered in explications of Brunelleschi's demonstration of the simulative power—possibly the absolute AC-pictoriality—of his picture of the Baptistery. Belting has written, for example, that "Brunelleschi's experiment succeeded only because the painting depicted a building that was symmetrical about its vertical axis."[34] (We can set aside the possibility that the painting did not depict *only* that building—and that asymmetrically distributed features could be found in the scene. Manetti explicitly recorded that all these structures were visible in the portal-picture—the motivating image—whether or not they were included in Brunelleschi's picture of the scene.) Evidently Belting thinks the bilateral symmetry of the Baptistery enabled Brunelleschi to sidestep the fact that a mirror-reflection would *reverse* the object reflected, creating an insurmountable optical obstacle for any asymmetrical distribution of objects on a mirror-reflected pictorial field that is itself presented as a simulation of the unreversed image. But in this case the notion is inapplicable. Brunelleschi had already turned the *picture* around on itself front to back—reversed it. What was on the right side in the "front" (unreflected) image of the picture would jump to the left side on the "back" (reflected) image-in-the-mirror, and vice versa. In turn, then, the mirror-reflection *de*-reversed that very reversal, preserving (or restoring) the original bilateral distribution of features in the motivating image, whether symmetrical or not. As we already have seen, the bilateral symmetry of the Baptistery certainly simplified the task of the pictorial rendering in Stages 1 through 7. But it was not the condition of the success of the *mirror-demonstration* of that rendering.

This brain-twister has contorted several reconstructions and conferred on them certain counterintuitive phenomenological aspects that are hard to reenact visually. For example, Krautheimer and Summers do not present reconstructions of the picture and its perspective construction as such, despite what their analytic diagrams of Brunelleschi's method and results might suggest. In their diagrams, the picture seems to flow directly from the intersection of plans and elevations without the introduction of mirroring—that is, unreflected, as in the first phase of the succession. Instead, however, their diagrams actually reconstruct the picture *as mirror-reflected in the device*—a feature of the second phase of the succession that might trip up an unwary reader. (To be specific, and because their reconstructions assume that Brunelleschi included the bilaterally asymmetrical distribution of streets and buildings to the west of the Baptistery in his picture of it, their diagrams show what was on the right in the image on the left of the picture, and vice versa.) In Summers's case, this elision of discrete phases of the succession from portal-picture all the way through to mirror-demonstration might be valid: he contends that all along Brunelleschi

intended the picture *for* the mirror-reflection — its opposition of "facing surfaces in light" — which exemplified the basic principle of Alhazan's optics.

But other scholars have not wished to furnish Brunelleschi's practical tool-kit with such sophisticated if pervasive optical theory. Not surprisingly, then, Kemp — a minimalist in this matter of historical method — presents a reconstruction of an *unreflected* picture. In *The Origin of Perspective*, Damisch has recognized the crucial importance of the mirror-reflection in Brunelleschi's completed demonstration of the subjective status of his pictorialization. But he also recognized that rule-governed perspective projections were mostly made thereafter *without* the condition that they be viewed in mirror-reflections of themselves — and therefore that effects peculiar to Brunelleschi's mirror-demonstration had to be transposed to, and transformed in, effects that could be attained in *un*reflected projections. His argument gains traction if we suppose, as he suggests, that Brunelleschi's procedures had "worked their way into the imaginary of the time" and helped constitute the visuality, the forms of likeness, within which the visibility of perspective projections was historically secured.[35]

7. ON ALHAZIAN OPTICS IN THE MIRROR DEMONSTRATION

Again, a brief excursus on Brunelleschi's theory, if any. As Summers has noted, the painted picture and the plane mirror in which it was reflected were arrayed as "facing surfaces in light," a material phenomenon theorized in Alhazen's optics, such that "every point on one is visible from every point on the other, and the eye may be placed at [any] one of these points" (Figures 9.2, 9.3). In these terms, it was Brunelleschi's peephole-and-mirror demonstration of the optical veridicality of his picture of the Baptistery that obeyed Alhazen's principles, whether or not his pictorial construction of the perspective rendering had done so (above, §4). Still, the demonstration was intended, Summers contends, "to show the underlying principles according to which the [perspectival] unification" of the picture had been achieved in the first place. If Brunelleschi's device suggested an Alhazian general equivalence — "every point on one [surface] is visible from every point on the other, and the eye may be placed at one of these points" — in the very same construction it also affirmed the *particularity* of the "one point" of the projection: a unique visual angle. In the projection, then, the immanent clash of two "fundamentally incompatible geometries" — the visual angle [| the tunnel of "perspectived" space] on the one side and the grid [| three-dimensional coordinate spatial extension] on the other side — found a unique mediation: as Summers aptly puts it, "the geometry of vision and the geometry of space developable from the planar frame [that is, virtual coordinate space], the field of vision modeled as planar, meet only in the framed surface itself."[36] We can treat this intention as the

guiding idea in the entire succession from initial image, the view-at-portal, to final image, the picture-seen-through-peephole, as Summers does. Or we can treat it as a *recursion* in the succession at the phase specifically of the mirror-demonstration—an emergent intention applying the background knowledge.

Still, we should not overdo the "Alhazianism" of the demonstration. According to Alhazen's model of vision, strictly speaking we see an object by "sweeping the centric ray over [it]" in a continuous movement of the eye—a continuous translocation of the eyepoint of the centric ray that "sends to the mind a series of verified or veridical impressions," each under a different visual angle, that is, under a continuous smooth transformation of the angle.[37] This model of the sweeping of the eye mitigates a crucial difficulty that is internal to Alhazen's optics: because only light intromitted in the centric ray can "pass into the optic nerve without any refraction whatsoever," a sweep of the eye can carry "the axis of the vanishing point *over* the visible body so that *each* of its points is perceived through this central ray," side-stepping the refractions and/or sublating them in a sufficient series of unrefracted centric impressions.[38]

By contrast, Brunelleschi's device obviously tried to fix a *single* visual axis/cone—the image of the [real | painted | reflected] building under the particular visual angle permitted to the eye at the peephole. Some movement of the eye (sweeping the centric ray over the prospect) might still have been possible. Regardless, the centric ray as *more or less* immobilized—more or less arrested in its sweep—had to do all the work of self-verifying its seeing. Overall, then, it seems possible that Brunelleschi's device was actually *unable* to deliver "a series of verified or veridical impressions" in Alhazen's terms. Instead, it delivered an unverified impression proved as veridical on different grounds, maybe not Alhazian—namely, the apparent persistence of the visual image in its succession through pictorialization to its (re)appearance at the end of the series. This was not so much a geometrical or theoretical proof as a phenomenological and optical-corporeal one.

8. BRUNELLESCHI'S DEMONSTRATION OF THE PICTURE IN PERSPECTIVE: II, THE PARAMETERS

Assuming Brunelleschi's intention visually to display and phenomenologically to "prove" a perspective projection, his device had several parameters intrinsic to its effects and their success. First, the beholder's sightline (ADO) was directed at the reflection of the peephole, perhaps visible as a small patch located on the depicted building as reflected—almost certainly on its east door. Most important, then, the peephole had to be set at the eyepoint [| VP] that was originally identified on the plan and elevation if Brunelleschi is to demonstrate that the picture veridically renders natural visual

images of the building at the viewpoint { a, b }—a point that cannot be shown *in* the picture though it has been pictorialized in [{ a, b } | eyepoint | VP]. It would not be obvious how to locate the eyepoint [| peephole] on a mere scenographic copy taken from the portal-picture. But we have already seen that Brunelleschi had a geometrical method for finding it on—recovering it from—the panel-picture constructed using the intersection of the plan and elevation (Figure 9.34).

Second, as Manetti emphasized, the distance from the mirror to the eye at the peephole—the distance between the opposed planes—"had to be in a given proportion to the distance between the point where [Brunelleschi] stood in painting his picture [that is, { a, b }] and the church of San Giovanni": "the painter of such a picture assumes that it has to be seen from a single point which is fixed in reference in the height and width of the picture, and that it has to be seen from the right distance: seen from any other point, there would be distortions." This "margin of manoeuver" had to be "carefully calculated," whether on theoretical and geometric grounds understood in advance, or by trial-and-error as the investigation unfolded, and working, for example, at the scale of 1 : 60 (whether pre-set or emergent in the operations) and in terms of the known architectonic proportions of distance : height : width [| *pictorialized* distance : *depicted* height : *depicted* width] :: 2 : 1 : 1. It set the crucial viewing distance realized in the simulation—an optical relation that Brunelleschi could not fudge too much. In the reconstruction I have tracked here, the crucial parameter must be the proportional relation (whether pre-set or emergent) between the distance of panel and mirror in the extension of the beholder's arm (or as set in some kind of supporting contraption) and the distance between viewpoint and eyepoint in virtual pictorial space.[39]

Third, the device suppressed the stereoscopy of natural vision (and therefore certain stereometric features of NVP) by physically imposing a one-eyed visual perspective at the peephole (IP in the demonstration). In the pictorialization, this parameter was now presented (if perhaps only retrodictively) as a transformation of the visual image at standpoint { a, b } originally identified in the plan and elevation, and in turn formalized as an inherent characteristic of the perspectival unification as intrinsically cyclopean. In a sense, Brunelleschi was simply being rigorous with himself: to see "what he saw" in the portal with two eyes *as* that prospect had been projected in a perspective pictorialization, the latter had to be viewed with one eye. Moreover, there would have been nothing especially strange about taking a look at the Baptistery from the portal of the Cathedral with a hand covering one eye—that is, nothing especially strange about starting with a cyclopean image in the first place. There are many reasons to experiment in this way with the stereoscopic perception of depth, which many human beings (including me) cannot fully attain, and in particular to investigate a monocular [image | pictorialization]. They could include not only a curiosity about "what a one-eyed

person sees" and, of course, "what perspective sees," at any rate after the formalization of painter's perspective. They could also include an interest in what kinds and degrees of impressions of depth(s) and of three-dimensional solidity (*rilievo*) can be created in (and/or restored to) a cyclopean perspectival projection viewed with one eye (as in the device) *or* in natural stereoscopy (as in viewing the unreflected picture). Brunelleschi's interests might have been practically motivated—perhaps a self-conscious empirical investigation of the monocular parameter that the existing optical science of *perspectiva* could impose on the modern painter of pictorial perspectives. What damage does it really do, if any? What are the best adjustments and correctives?

Given the success of Brunelleschi's device in proving the simulative power of perspective projections—more on this in a moment—the problem really arose only when Alberti's more artificial method (Figure 9.4) formalized the cyclopean parameter, abstracting from the specific conditions and concerns of Brunelleschi's demonstration. As Damisch has written, in the case of *every* perspective picture Alberti's method structurally "obliges [the viewing subject] to adopt a stance that has nothing in common with the effective conditions of perception, any more than it does with the goals of painting as properly understood."[40] (For the sake of argument, we can set aside Damisch's assumption that the subject has full stereoscopic ability.) Needless to say, Damisch ventriloquizes the original criticisms of Leonardo da Vinci, who objected not only to the cyclopean parameter of Albertian perspective but (equally or more important) to the simulative substitution it helped effect. According to Leonardo, "an artist does not paint for one-eyed observers with their eye in a fixed position, and he may not want the surface of his painting *to disappear from sight*: a picture viewed by people who walk up and down in front of it and recognize it *as* a picture must be constructed in a different and as yet unknown way." (I quote Paul Feyerabend, who recognized Leonardo's concern about the visibility of the painting qua painting—what I called the "presence of pictoriality" in Chapter Three—to be as important as his concern about the monocular reduction, which is more technical and can often be overdone.[41])

But Brunelleschi was not working only as an "artist" (a category that hardly existed for him)—a painter. He was also working as an engineer and a geometer, and (we can say) as a phenomenologist and epistemologist of depiction. The "rigorously specified conditions" to which Leonardo objected were likely part of what Feyerabend has called a "simple and rather straightforward scientific experiment."[42] Without this experiment and its later formalizations in the perspective methods of Alberti and others, the very critique of geometric-pictorial perspective as highly unrealistic—even deeply counter-visual—adumbrated by Leonardo and his many successors would have had far less purchase. Indeed, the power of the demonstration and its theoretical

aftereffects — notably in Cartesian analytic geometry and the "metaoptical" theory of the infinite extension of three-dimensional coordinate space — called forth the vigor of the phenomenalist and aesthetic rebuttals. And anyway there was no looking back: above all, "having gone through the experience of perspective, later painters could no longer see their work as part of reality itself."[43]

9. BRUNELLESCHI'S DEMONSTRATION OF THE PICTURE IN PERSPECTIVE: III, THE EFFECTS

What, then, of the simulative effect of the demonstration, its reality-effect? We must notice a final parameter. In the picture painted on the panel, so Manetti tells us, the sky above and around the Baptistery was represented by a reflecting surface, produced by a silvering of some kind. This supposedly captured an image of the real clouds floating in the sky above the Baptistery when the device was being used to simulate a beholder's image of the building *in situ*. In other words, the reflection highlighted the impression at the viewpoint — the beholder's eye at the peephole — that he was looking at the real Baptistery in real time and real space. The effect would partly compensate for the flaw in any picture in the device demonstrated *without* the animated importation of real-time phenomena — namely, that it would likely show the Baptistery at a different time (with different cloud forms) than any visual image with which it could be matched. [44]

But the cloud-reflection was not the main *cause* of the simulation. In careful calibration of the ratio of the size of the picture to the distance of the depicted object (PS : ID; see Chapter Seven, §3), its main cause was the fact that the picture had been painted in a perspective that could be matched by a real visual image of the Baptistery seen at a standpoint *which the user of the demonstration device could actually adopt in using it as intended*. Looking into the device at the standpoint three *braccia* or so inside the portal of the Cathedral, all the observer had to do was to drop the mirror opposite the reversed picture to see that what he continued to see was the same scene as was projected in the picture he had been looking at (in its reflection), and in exactly the same way, namely, without any change in its conformation or at any rate *continuous with* certain inevitable changes in the situation, such as the movement of clouds. (Remember that the one-eyed view would still be enforced at the peephole-*without*-mirror.) In context, this must have felt like magic — a moment of "lo and behold!" justifying Alberti's description of the painter as a second god creating the world all over again, or a new god fashioning worlds afresh.[45] The beholder could now see that the picture was true to the object as imaged, continuous with a visual prospect in certain pictorial respects and visual aspects — respects and aspects now imbued with a new kind of certainty. For example, he could take the picture anywhere else and use it there (along with an explanation of

its method) as a "proved" representation of the Baptistery along certain salient axes: true to the "real thing" in the rendering of the geometric configuration of objects; of their scale and proportions; of their distance and foreshortening; and of their interactions with some real-time phenomena. He could, for example, take measurements off the picture (measuring *it*) that could also be claimed as valid measures *of the building*. Or he could display it to people elsewhere (not *in situ*) to show them how the building might look from the standpoint in the Duomo.

In a second demonstration of his methods and ideas, Brunelleschi made a perspective picture of the Palazzo della Signoria in Florence (now Palazzo Vecchio) as viewed from the opposite corner of the square—-an experiment I have not tried to address here. "Instead of silvering the sky, as he had done in the picture of the Baptistery, in this second picture Brunelleschi cut away the panel along the line of the top of the buildings, so that the picture could be seen against real sky. This would, of course, have allowed him to verify the accuracy of the roof line by viewing the picture against the real scene."[46] This second magical moment was less constrained than the first. But it also would have been somewhat less particularized in fixing the viewpoint of the beholder — which was perhaps its purpose.

Needless to say, the imagistic continuity of [prospect | perspective | prospect]— the extreme AC-pictoriality of the pictorial bivirtuality secured in the demonstration — need not be taken to be absolute, a matter I have already explored in detail in Chapter Three. As Feyerabend has put it, "a structure that corresponds to the laws of physical optics does not *automatically* produce an analogous (realistic, or illusionary) experience."[47] (Indeed, I suspect the entire set-up — one-eyed and three-handed and dependent on the strict opposition of planes and the clarity of reflection — was somewhat ornery.[48]) If Brunelleschi phenomenally demonstrated the method of intersection by presencing the continuity of geometric configuration, proportion, scale, distance, diminution, and recession between image and picture — that is, by presencing the continuity sufficiently well, despite some *discontinuities* — he likely would have wanted to undergird it in as many of the ways of pictorial realism as possible, above all by the local detail, modeling, and color he could give to his Baptistery-in-paint. As Manetti says, then, "the panel was made with much care and delicacy and so precisely, in the colors of the black and white marble, that there is not a miniaturist who could have done better."

This was not just mere geometry. At risk of retrodiction, if we apply the three operations required of painters by Alberti in Book II of *De pictura* — Book I having dealt with the optical geometry of NVP and its representation on the plane — Brunelleschi's method of perspective construction would have fulfilled only the first, namely, what Alberti called "circumscription," "the delineation of the outlines of objects and their

proportional distribution on the spatial armature." It would have been Alberti's *third* operation, "the reception of light," that fully consolidated the "sense of tangible reality"—of presencing—relayed in the picture. (Alberti's second operation, the decorous composition of the *historia*, would have been irrelevant for the purposes of Brunelleschi's essentially non-narrative pictorialization.)[49] If we apply the three operations of depiction defined by Piero della Francesca in the first book of *De prospectiva pingendi*, which was "dedicated in a remorselessly specialized way to perspective constructions," Brunelleschi's procedure conducted the first operation defined by Piero, namely, *commensuratio* or measurement and commensuration, though no doubt it partly depended as well on Piero's second operation, *disegno* or draftsmanship. Piero's third operation, *colorare*, "the application of colors under the influence of light and shade," would have consolidated such optical realism as could enhance the perspective.[50]

Overall Brunelleschi probably pursued painterly realisms of detailing, coloring, and modeling in order to enhance the reach of the pictorial simulation throughout as many visible aspects of the scene as possible. A magic moment of absolute AC-pictoriality was immanent. Still, insofar as the picture remained visible, present, as such—an open question—DC-pictorial disjunctions would resist its full emergence. The overall graphic clarity and the even visual resolution of a picture intended to display a spatial geometry under particular optical conditions (though not in every perceptual respect) must always subsist in tension with the disparity of the beholder's focus across the real visual field. In the real scene (the portal-picture), for example, the east doorway (at the eyepoint) would be in focus and the lantern probably not at all. In a painting of that image intended to simulate it, a later pictorialist could partly overcome this *dis*continuity by toning, chiaroscuro, and *sfumato*—continuously rendering the visual disparities, and maintaining *trompe l'oeil*. But Brunelleschi's style likely did not incorporate such effects.

10. WHAT MANETTI SAW

Brunelleschi's device enabled a sophisticated investigation of the relation between the presencing of certain phenomenal registers of "what we see," on the one hand, and, on the other hand, continuities and discontinuities of pictoriality relative to it—an investigation both perceptual-aesthetic and metrical-geometrical, an integration. More exactly, it enabled investigation of what *he* sees with reference to the complex and compound pictorial succession of that image and especially with reference to its ultimate recursion, namely, the way it might work its way into the visual spaces of its imaging, of its visuality, including the visual space of its imagistic "origin" in looking over to the Baptistery from the Duomo, but by no means limited to it.

What *he* sees: the natural visual perspective of the image at standpoint { *a, b* } is defined not only by the distance of the viewpoint from the east façade of the Baptistery, indicated on both plan and elevation. It is also defined by its height, indicated only on the elevation (though recursively assumed in the plan's horizontal [section | plan-at-height-of-*b*] of the building). And whereas *a* is invariant in this image for all beholders of that prospect — for everyone standing at that spot on the floor of the nave inside the central west portal of the Cathedral — *b* is not. *A* directs everyone's sightline to a point on a line that vertically bisects the east façade of the Baptistery (so far as the plan indicates explicitly), "centering" the width of the building in the beholder's horizontal angle of vision and most fully revealing its bilateral symmetry, while *b* specifies *which* point on that line must be at stake in the image (and in question in the picture), depending not at all on the bilateral vertical symmetry of the building (or not) but instead and wholly *on the beholder's own vertical dimension* relative to it.

Whether or not Brunelleschi worked from the start with a systematic method of perspective construction, "it matters little," as Damisch has pointed out, "whether he went about producing his construction *in situ*, standing on the spot indicated by Manetti — the same spot upon which the text ... states that any observer wishing to represent for himself the Baptistery as it appeared on the panel should stand. What was essential was that the chosen point of view could be *deduced* from the painting itself. And more: that the place be locatable in real space with relative precision ... such that anyone at all who came to the spot might verify the accuracy of the designation."[51] (Presumably Damisch does not mean that the viewpoint could be deduced geometrically by a beholder, which would require considerable mastery of the construction method, whatever it was — and even though Brunelleschi himself could easily make the deduction in the pictorial succession. Rather, it could be deduced optically with fair certainty; in theory the beholder could go to that very spot.) But this final phase of the full pictorial succession of painter's perspective — the phase in which a beholder could be motivated to confirm the depiction by reenacting *it* in real space *in situ* — harbors the very point and paradox of the entire project, namely, the *absolutely irreducible visual-spatial specificity and peculiarity of the viewpoint.* For in real space *in situ*, of course, the specificity of the viewpoint [| eyepoint | VP] — the place Brunelleschi "forced the beholder to occupy" in the pictorial bivirtuality in the demonstration device — is wholly identical with *his own actual corporeal height at standpoint*, and specifically the height of his IP.

In the biography of Brunelleschi in his *Lives of the Most Eminent Painters, Sculptors, and Architects* of 1550, Giorgio Vasari wrote that "nature has created many men who are small and insignificant in appearance but who are endowed with spirits so full of greatness and hearts of such boundless courage that they have no peace until they undertake

difficult and almost impossible tasks and bring them to completion, to the astonishment of those who witness them. No matter how vile or base these projects may be, when opportunity puts them into the hands of such men, they become valuable and lofty enterprises."[52] Of course, Vasari was using highly rhetorical language. But he was also, evidently, making circumstantial reference to what was empirical knowledge at the time: a common awareness that Brunelleschi was "small"—short—relative not only to his literally lofty enterprises of architectural engineering, notably the soaring dome of the Duomo, but also, as Vasari's metaphorics imply, to the astonished gaze of other people who witnessed the completion of such mighty tasks by a man seemingly so small.

If we set the height of b as Brunelleschi's height at his IP, as the entire logic of his experiment suggests, then his picture-in-perspective (as we have seen) will presence visual continuity with it, as proved in the demonstration regardless of the geometric and reflective transformations worked within it. In using the device, then, throughout the entire pictorial succession Brunelleschi himself is continuous imagistically with what *he* sees in well-defined respects; the succession simulatively (and in retrospect apparently seamlessly) reenacts the natural continuity of the image initially given, that is, [IP | NVP]. At the same time, anyone else using the device (say Manetti, who tells us he did use it) can (also) be imagistically continuous with what *Brunelleschi* sees in well-defined respects—surely a matter of interest to a community that had entrusted the small man with architectural projects realizing the most basic forms of likeness of the shared urban and architectural space he had been tasked to investigate and to which he would contribute some of its greatest landmarks (that is, common images). But these beholders could be continuous with this image *only* pictorially, that is, only in the presence of Brunelleschi's picture presencing his [image | virtual pictorial space | pictorialized visual space]. And it is this pictorial supervention in disjunct NVPs that matters most.

In other words, in the dramatic succession of images and pictures in the device (insofar as it was demonstrated *in situ*) it would be plainly visible to pretty much everyone *but* Brunelleschi—no magic here!—that in their natural visual perspectives they had been and almost always would be *dis*continuous with his perspective, both natural *and* pictorial, regardless of common visuality—any integration of their sociocultural understandings and intentions—that might emerge for them under the primary and thorough-going condition of disjunction implicitly specified by Brunelleschi's pictorial bivirtuality. (I say "thorough-going" because extraneous beholders of the picture—beholders who are not the origin of its image—are discontinuous *throughout* the succession: in *both* the original image in the succession, their own visual prospects at $\{ [a \mid b', b'', \text{etc.}] \}$, *and* in the ultimate images, the removal

of the mirror — that is, the presences of the picture — from the scene of their imaging points at b', b'', etc.) To be sure, all of these disparities could be given precise and discursively shared metrical and geometric values (especially if we assign to everyone a shared and stable preexisting theory of the visual angle) *before* the perspectival unification as such. Still, as my phrasing suggests, I doubt that any such epistemology was commonly available before painter's perspective became a widely-shared endowment of Italian visuality in the Renaissance — a visual culture succeeding from a pictorial succession in which *the conditions and the very possibility of shared visual experience* were subjected to a rigorous phenomenological investigation.

Moreover, the *unreflected* perspective picture sublates the disjunct values of different corporeal IPs implicitly captured (in the negative) by perspective pictorialization. Because the [eyepoint | VP] belongs specifically to virtual pictorial space, in its succession it becomes agnostic about the *actual* height of the [real IP | pictorial viewpoint] that originally lies on a line of coincidence with it in Brunelleschi's experiment. Indeed, depiction in painter's perspective has often been pleased to detach and translocate its virtual pictorial view to physically inaccessible coordinates — corporeally impossible IPs. Still, Brunelleschi's procedure allowed him to make a perspective of the prospect that *Manetti* could experience as natural visual perspective at standpoint and that corporeally he, Brunelleschi, could *not* experience — at any rate could not experience without some kind of prosthetic augmentation. Indeed, perhaps the best phenomenological "proof" of the procedure of painter's perspective would be Manetti's discovery of the discontinuity of Brunelleschi's picture of the prospect with *his* image, "what Manetti sees," and at the same time of Brunelleschi's startling ability — despite the unavoidable disjunction of their natural visual images — to produce a continuous picture of *Manetti's* image, an image that Brunelleschi can only "see" in his seeing of a pictorial perspective he could construct as the projection of "what Manetti saw," albeit using the very method adopted for an optically veridical pictorialization of "what *he* sees."

In the perspectival projection and reflection-removal that Brunelleschi performed in his device, the disparity — the unavoidable measures and proportions of our natural visual differences from other image makers, that is, of our visual spaces — can attain virtual specificity for all beholders *despite* the differences. In principle this extraordinary supervenience enables exacting assessments of the aesthetic and affective status *of* the disparity newly brought into visibility for all — that is, of whether the emergent bivirtual compound of succession, recursion, and resistance has negligible consequences for visuality or world-shattering ramifications, as the case may be. Perhaps Brunelleschi sees the absolutely straight and level line — and not *as* a metaphor — between baptism (the font) and salvation (the altar), and constructs a picture

that reflects to him his standpoints and sightlines in inhabiting this visuality. By the same token, perhaps Manetti cannot quite do so. He needs — maybe he applauds and maybe he abhors — Brunelleschi's pictorial virtuality in presencing a social visuality for him as a natural visibility to him. This is not a question, however, for a general historical phenomenology of visibility, visuality, and virtuality. It is a question for its historical sociology — a sociology in which every image maker one to the next gets his due — and for our present-day critical assessment of its politics of sight. Historical phenomenologies of the world that we make to be visible must insist on its unconquerably radical openness.

NOTES

INDEX

ILLUSTRATION CREDITS

INTRODUCTION: IMAGES
AND PICTURES

1. I have some supplementary information about Urquhart's drawing—art-historical information. My drawing seems to be stylistically related to other drawings by Urquhart, albeit smaller ones (see Tony Urquhart, *Sketch Book: Canadian and European Sketches* [Toronto, 1962]). As "sketches," collectively they suggest something about Urquhart's visual travels and pictorial habits—activities that cannot be visible to me if I have seen only one drawing by the artist. I was not aware of these drawings until recently.

2. Throughout this book, *A General Theory of Visual Culture* (Princeton, 2011) will be cited in the main body of the text and in notes as *GTVC* followed by relevant page numbers.

3. Joseph Eichmeier and Oskar Höfer, *Endogene Bildmuster* (Munich, 1974).

4. See Michael Baxandall, *Painting and Experience in Fifteenth Century Italy: A Primer in the Social History of Pictorial Style* (Oxford, 1972). As John Onians has pointed out, Baxandall understood the "period eye" to have a neuropsychological basis in social history, that is, to be neurally shaped in social practices and relations, though many readers have taken his concept to be a nonneurological and even an antinaturalistic one (John Onians, *Neuroarthistory: From Aristotle and Pliny to Baxandall and Zeki* [New Haven, 2007], 178–88, and "Michael David Kighley Baxandall 1933–2008," *Proceedings of the British Academy* 166 [2010], esp. 34–35). In addition to using Freudian concepts, Gombrich derived his model of "mental set" in part from the experimental zoological ethology of Konrad Lorenz and Niko Tinbergen, the environmental behaviorism of Egon Brunswik and Edward Tolman, and the proto-cognitivist psychology of Jerome Bruner. He assumed that mental set in perception (the system of one's expectations and habits) is shaped by the functions and purposes of depiction in social contexts. But his underlying theory of visual perception simply asserts that perceptual expectations are naturally shaped in a visual environment—possibly naturally selected.

5. Elsewhere I have considered the relations between memories (and such other psychic events or phenomena as fantasies) of things seen in the past and pictures seemingly produced in their wake, even if the pictures depict something other than those things; see Whitney Davis, *Drawing the Dream of the Wolves: Homosexuality, Interpretation, and Freud's "Wolf Man" Case* (Bloomington, IN, 1996). I adopted a specifically psychoanalytic account of this relation. (In the book cited, it is a psychoanalytic account of Freud's psychoanalytic account of such a relation in one of his patients.) But this is not required—not demanded by the psychology of the relation between memory (or fantasy) and depiction. A nonpsychoanalytic account of the replication of visual memories (as well as discursive, notational, and/or diagrammatic articulations of the significance of the things seen and remembered) has been proposed by Horst Bredekamp in an intriguing account of the imagistic interdeterminations of Charles Darwin's quasi-pictorial graphic visualizations of organic transmutation (*Darwins Korallen: Die frühen Evolutionsdiagramme und die Tradition der Naturgeschichte* [Berlin, 2006]).

 The relationship between verbal descriptions and pictorial representations has been explored in English-language writing, most notably by Michael Baxandall, who considered not only the role of verbal descriptions for things to be pictured in the picturing of them (see especially *Giotto and the Orators* [Oxford, 1971] and *Words for Pictures* [New Haven, 2003]), but also the role of verbal descriptions of things pictured in our imaging of the resulting depictions (see especially *Patterns of Intention* [New Haven and London, 1985]). For commentaries, see *Michael Baxandall, Vision and the Work of Words*, ed. Peter Mack and Robert Williams (Farnham, Surrey, 2015).

6. W. J. T. Mitchell, "What Is An Image?" *New Literary History* 15 (1984), 503–37; James Elkins, *The Domain of Images* (Ithaca, NY, 1999).

7. Taken literally, the term "world art history," sometimes used in this regard, does not quite capture what I have in mind. As noted, this book is not about art, and it makes no claim about a supposed worldwide—a panhuman—transhistorical occurrence of art-making (see Whitney Davis, "World Without Art," *Art History* 33 [2010], 710–16). But a modified "world art studies"—world art studies extended to include the non-art objects, pictures, and images addressed in visual-culture studies and

NOTES

INDEX

ILLUSTRATION CREDITS

NOTES

INTRODUCTION: IMAGES AND PICTURES

1. I have some supplementary information about Urquhart's drawing—art-historical information. My drawing seems to be stylistically related to other drawings by Urquhart, albeit smaller ones (see Tony Urquhart, *Sketch Book: Canadian and European Sketches* [Toronto, 1962]). As "sketches," collectively they suggest something about Urquhart's visual travels and pictorial habits—activities that cannot be visible to me if I have seen only one drawing by the artist. I was not aware of these drawings until recently.

2. Throughout this book, *A General Theory of Visual Culture* (Princeton, 2011) will be cited in the main body of the text and in notes as *GTVC* followed by relevant page numbers.

3. Joseph Eichmeier and Oskar Höfer, *Endogene Bildmuster* (Munich, 1974).

4. See Michael Baxandall, *Painting and Experience in Fifteenth Century Italy: A Primer in the Social History of Pictorial Style* (Oxford, 1972). As John Onians has pointed out, Baxandall understood the "period eye" to have a neuropsychological basis in social history, that is, to be neurally shaped in social practices and relations, though many readers have taken his concept to be a nonneurological and even an antinaturalistic one (John Onians, *Neuroarthistory: From Aristotle and Pliny to Baxandall and Zeki* [New Haven, 2007], 178–88, and "Michael David Kighley Baxandall 1933–2008," *Proceedings of the British Academy* 166 [2010], esp. 34–35). In addition to using Freudian concepts, Gombrich derived his model of "mental set" in part from the experimental zoological ethology of Konrad Lorenz and Niko Tinbergen, the environmental behaviorism of Egon Brunswik and Edward Tolman, and the proto-cognitivist psychology of Jerome Bruner. He assumed that mental set in perception (the system of one's expectations and habits) is shaped by the functions and purposes of depiction in social contexts. But his underlying theory of visual perception simply asserts that perceptual expectations are naturally shaped in a visual environment—possibly naturally selected.

5. Elsewhere I have considered the relations between memories (and such other psychic events or phenomena as fantasies) of things seen in the past and pictures seemingly produced in their wake, even if the pictures depict something other than those things; see Whitney Davis, *Drawing the Dream of the Wolves: Homosexuality, Interpretation, and Freud's "Wolf Man" Case* (Bloomington, IN, 1996). I adopted a specifically psychoanalytic account of this relation. (In the book cited, it is a psychoanalytic account of Freud's psychoanalytic account of such a relation in one of his patients.) But this is not required—not demanded by the psychology of the relation between memory (or fantasy) and depiction. A nonpsychoanalytic account of the replication of visual memories (as well as discursive, notational, and/or diagrammatic articulations of the significance of the things seen and remembered) has been proposed by Horst Bredekamp in an intriguing account of the imagistic interdeterminations of Charles Darwin's quasi-pictorial graphic visualizations of organic transmutation (*Darwins Korallen: Die frühen Evolutionsdiagramme und die Tradition der Naturgeschichte* [Berlin, 2006]).

 The relationship between verbal descriptions and pictorial representations has been explored in English-language writing, most notably by Michael Baxandall, who considered not only the role of verbal descriptions for things to be pictured in the picturing of them (see especially *Giotto and the Orators* [Oxford, 1971] and *Words for Pictures* [New Haven, 2003]), but also the role of verbal descriptions of things pictured in our imaging of the resulting depictions (see especially *Patterns of Intention* [New Haven and London, 1985]). For commentaries, see *Michael Baxandall, Vision and the Work of Words*, ed. Peter Mack and Robert Williams (Farnham, Surrey, 2015).

6. W. J. T. Mitchell, "What Is An Image?" *New Literary History* 15 (1984), 503–37; James Elkins, *The Domain of Images* (Ithaca, NY, 1999).

7. Taken literally, the term "world art history," sometimes used in this regard, does not quite capture what I have in mind. As noted, this book is not about art, and it makes no claim about a supposed worldwide—a panhuman—transhistorical occurrence of art-making (see Whitney Davis, "World Without Art," *Art History* 33 [2010], 710–16). But a modified "world art studies"—world art studies extended to include the non-art objects, pictures, and images addressed in visual-culture studies and

Bildwissenschaft—would seem to be possible (see Whitney Davis, "Radical WAS: The Sense of History in World Art Studies," *World Art* 3 [2013], 201–10). It would differ from visual-cultural studies because it would not confine itself to culturalist frameworks and sociological methods (see Whitney Davis, "Visual Culture," in *Encyclopedia of Aesthetics*, 2nd ed., ed. Michael Kelly [Oxford, 2014], vol. 6, 240–44).

8. See Whitney Davis, "World Series: The Unruly Order of World Art History," *Third Text* 25 (2011), 493–501. Stated another way, though a global history, such as a history of the globalization of a particular visual culture, is always a world history, a world history need not always be a global history, or about a globalization.

CHAPTER 1. VISUALITY AND VIRTUALITY: ANALYTICS OF VISUAL SPACE AND PICTORIAL SPACE

1. For Wittgenstein's extensive and suggestive but sometimes cryptic considerations of visual space, see especially *Philosophical Remarks*, trans. Raymond Hargreaves and Roger White, ed. Rush Rhees (Oxford, 1975), 252–72.

2. Wittgenstein's example could be a generalization of an actual situation in visual space that he encountered in helping to design and build a house in Vienna in the 1920s. For a full account, see Whitney Davis, "Fitted Like A Glove: Wittgenstein's House for His Sister," in *Space, Time, and Depiction*, in progress.

3. Paul Feyerabend, *The Conquest of Abundance: A Tale of Abstraction versus the Richness of Being*, ed. Bert Terpstra (Chicago, 1996), 104.

4. For a sophisticated recent art-historical investigation, see Adrian W. B. Randolph, *Touching Objects: Intimate Experiences of Italian Fifteenth-Century Art* (New Haven and London, 2014).

5. I quote from Behnke's helpful exposition in "Edmund Husserl's Contributions to Phenomenology of the Body in Ideas II," in *Issues in Husserl's Ideas II*, ed. Thomas Nenon and Lester Embree (Dordrecht, Boston, and London, 1996), 136–60 (quotation from p. 147); see also Rolf J. de Folter, "Reziprozität der Perspektiven und Normalität bei Husserl und Schutz," in *Sozialität und Intersubjektivität*, ed. Richard Grathoff and Bernhard Waldenfels (Munich, 1983), 157–81.

6. In his lectures on "object and space" in 1907, Husserl suggested that the "zero point" is "in the head, in or behind the eyes" (*Ding und Raum: Vorlesungen 1907*, ed. Ulrich Claesges, in *Gesammelte Werke*, vol. 16 [The Hague, 1973], 227–28). But elsewhere he described it as the "core body" (*Kernleib*), presumably the trunk or thorax, to which movements of the hands, feet, head, etc. are felt as (sometimes seen as) relative (see Behnke, "Phenomenology of the Body," 146, and John J. Drummond, "On Seeing A Material Thing In Space: The Role of Kinaesthesis in Visual Perception," *Philosophy and Phenomenological Research* 40 [1979–80], 19–32).

7. Edmund Husserl, *Ideas Pertaining to a Pure Phenomenology and to a Phenomenological Philosophy, First Book, General Introduction to a Pure Phenomenology*, trans. F. Kersten, in *Collected Works*, vol. 2 (The Hague, Boston, and London, 1982), 51–53.

8. *Ideas ... Second Book, Studies in the Phenomenology of Constitution*, trans. Richard Rojcewicz and André Schuwer, in *Collected Works*, vol. 3 (Dordrecht, Boston, and London, 1989), 165–67. As Behnke points out ("Phenomenology of the Body," 146), Merleau-Ponty adopted this last notion, along with other Husserlian proposals (see Merleau-Ponty, *Signs*, trans. Richard McLeary [Evanston, IL, 1964], 159–81).

9. *Ideas... Second Book*, 183.

10. *Ideas... First Book*, 114.

11. Theodor W. Adorno, *Against Epistemology: A Metacritique — Studies in Husserl and the Phenomenological Antinomies* [1956], trans. Willis Domingo (Cambridge, MA, 1983), 196.

12. *Ideas... First Book*, 93. A different translation reads: "The spatial thing that we see is, along with all its transcendence, something perceived, as it is in person; it is something given consciously. No picture or sign is given in place of it. Placing a consciousness of signs or pictures at the base of perceiving is illegimate. Between perception, on the one hand, and presenting something in a pictorially symbolic or signitively symbolic manner, on the other, there is an unbridgeable essential difference" (*Ideas... First Book*, trans. Daniel O. Dahlstrom [Indianapolis, 2014], 76).

13. *Ideas... First Book*, 261–62. As his example, Husserl took Albrecht Dürer's 1513 engraving *Knight, Death, and the Devil*—a famous icon of

German visual culture—though he did not elaborate on the ways in which it contributed to "depictured reality" in the artist's time and place or later and elsewhere (see *GTVC* 230–74).

14. A similar nonculturological perspective lies at the heart of the work of David Summers. "It is not necessary," he has written, "for the Haida of British Columbia to be defined by their art, as if every Haida, in possessing a putative Haida-ness, were for that reason alone a Haida carver *in potentia* with intuitive access to the meaning of Haida art. Such an explanation of culture as deriving from a shared essence, which has been so important for twentieth-century nationalism, may have the very real institutional consequence in this case of limiting the Haida to the replication and sale of the characteristic forms of their culture, thus in turn restricting their freedom in accommodating themselves to the present world to which we are in fact all trying to accommodate ourselves. At the same time,…it is possible for the Haida to take satisfaction in the fact that some of their ancestors, responding to a variety of specific conditions, invented forms and refined skills that have continued to shape fundamentally Haida life, and eventually, under very different specific conditions, have earned the Haida heritage a place among the great traditions of world art" ("Arbitrariness and Authority: How Art Makes Cultures," in *Time and Place: The Geohistory of Art*, ed. Thomas DaCosta Kaufmann and Elizabeth Pilliod [Aldershot, 2005], 212; see also David Summers, "What Is A Renaissance?" in *Bill Reid and Beyond: Expanding on Modern Native Art*, ed. K. Duffek and Charlotte Townsend-Gault [Vancouver and Seattle, 2004], 133–54.

15. For representationality, see Richard Wollheim, *Art and Its Objects*, 2nd ed. (Cambridge, 1980), 205–26, elaborating Ludwig Wittgenstein's ideas about aspect perception or "seeing-as" in *Philosophical Investigations*, trans. G.E.M. Anscombe, 2nd ed. (Oxford, 1968), 193–229 (Bk. II, Pt. xi). Wollheim deployed his model of representationality with powerful effect in his critique of formalism; see *On Formalism and Its Kinds* (Barcelona, 1995), with comments by Whitney Davis, "Fantasmatic Iconicity: Freud, Formalism, and Richard Wollheim," in *Queer Beauty: Sexuality and Aesthetics from Winckelmann to Freud and Beyond* (New York, 2010), 271–95,

and *GTVC* 45–74. For what Hofmann called his "push-pull" theory of representationality, see Hans Hofmann, *Search for the Real, and Other Essays*, ed. Sarah T. Weeks and Bartlett H. Hayes (Cambridge, MA, 1967).

16. See Donald Judd, *Complete Writings 1959–75* (Eindhoven, 1987); David Raskin, *Donald Judd* (New Haven and London, 2010).

17. Absolute abstraction can be analyzed in terms of logical relations of representation or representativeness other than representationality in Wollheim's sense, even as I have extended it—in terms, for example, of relations of visible substitutability or exemplification. Such relations might function in systems of visual notation or calculation—domains within which notional or practical avirtuality might be required (even if it only means overlooking emergent virtuality).

If a plastic red tile is to serve as a replacement for a similar tile that has fallen out of a wall—if it is to be effectively indiscernible from the tile it replaces—its absolute abstraction will be paramount. What matters to us in imaging it qua plastic red tile is that it looks to be a sample of the relevant tiles and/or an adequate substitute, that is, to be just the configuration it is seen to be (or not—in which case we cannot use it). At the same time, however, the red tile might have a quotient of representationality that is not directly relevant to the status of the tile as a sample of tiles of a certain kind and a substitute for a certain tile of that kind. It might be seen, for example, as having the redness of certain red-painted wooden boards used to construct walls in certain houses. Indeed, we might even see such red-painted wooden walls on such houses in the tile. In such recursions the tile can virtualize the red wooden boards of that world, giving us a glimpse of it. Indeed, and as noted, the absolute abstraction of the tile (regardless of the representativeness of this property in this case) and its representationality likely subsist in a continuum in imaging it. Perhaps, in fact, they interact with one another: the plastic-tiled wall into which the tile in view can be inserted (as a substitute for another tile) may have been built to picture wooden walls.

Regardless, it will be difficult to detach the absolutely abstract property of the tile qua visual configuration from its representationality. This is not because the plastic tile in question

pictures wooden walls; perhaps in this case it does, but in this case we also care only about whether it substitutes for other such tiles. It will be difficult because the tiles will likely be seen not only as the configurations they are (plastic, red, tile-shaped, and so on — all that is required for them to function as samples of plastic red tiles and as substitutes for one another). Likely they will also visibilize for us, or virtualize, as particular glimpses of worlds: in this case, and at minimum, of a world in which certain plastic red tiles visibly can substitute for one another in repairing the wall. (This is true whether or not the substitution is governed by any depictiveness of the configuration of the wall in its redness or any other visual property; if I can succeed in the substitution I want to make simply by visually comparing one plastic red tile to another, the pictoriality of the wall of red plastic tiles is not directly relevant.)

18. See Whitney Davis, *Pacing the World: Construction in the Sculpture of David Rabinowitch* (Cambridge, MA, 1996).

19. According to some eighteenth-century art theorists, the "abstract" quotient of a picture partly derived from what Sir Joshua Reynolds described as the portrait-painter's correction of "the accidental deficiencies, excrescences, and deformities" of the sitter, making out "an abstract idea of [the] forms more perfect than any one original" — a process of generalization (Joshua Reynolds, *Discourses on Art*, ed. Robert R. Wark [San Marino, CA, 1959], 44; full discussion in Charles A. Cramer, *Abstraction and the Classical Ideal, 1760 — 1920* [Newark, DE, 2006]).

CHAPTER 2. RADICAL PICTORIALITY: SEEING-AS, SEEING-AS-*AS*, SEEING-AS-AS-*AS*...

1. "We all know the process of sudden change of aspect; — but what if someone asked, 'Does A have the aspect *a* continuously before his eyes — when, that is, no change of aspect has taken place?' May not the aspect become, so to speak, *fresher*, or *more indefinite*? — And how queer it is that I *ask* this! There is such a thing as the flaring up of an aspect. In the same way as one may play something with more intense and with less intense expression. With stronger emphasis

of the rhythm and the structure, or less strong. Seeing, hearing *this* as a variant of *that*. Here there is the moment at which I *think* of B at the sight of A, where this seeing is, so to speak, acute, and then again the time in which it is chronic. *Not* to explain, but to *accept* the psychological phenomenon — that is what is difficult" (Ludwig Wittgenstein, *Remarks on the Philosophy of Psychology*, vol. 1, ed. G.E.M. Anscombe and G. H. von Wright, trans. G.E.M. Anscombe [Oxford, 1980], 96e-97).

2. Recent research has shown that in modern human populations there is a correlation between absolute latitude of habitation and "orbital volume, an index of eyeball size," translating into "enlarged visual cortices at higher latitudes." Nonetheless, "visual acuity measured under full-daylight conditions is constant across latitudes, indicating that selection for larger visual systems has mitigated the effects of reduced ambient light levels" (Eiluned Pearce and Robin Dunbar, "Latitudinal Variation in Light Levels Drives Human Visual System Size," *Biology Letters* 27 July 2011 (accessed at rsbl.royalsocietypublishing.org, March 13, 2013).

3. Ludwig Wittgenstein, *Remarks on the Philosophy of Psychology*, trans. C. G. Luckhardt and M.A.E. Aue, ed. G. H. von Wright and Heikki Nyman (Oxford, 1980), vol. 2, 79e, no. 433. Possibly Wittgenstein was referring to Archimedes's method for finding the value of *pi* (the ratio of the circumference to the diameter of a circle) by using a ninety-six-sided polygon inscribed in the circle.

4. In their "representationality" (see Chapter One, §5), all straight lines on a plane probably have some radical-pictorial potential to seem more "frontal" and "flat" or more foreshortened and "receding," whatever pictoriality or depiction might devolve from this (see Chapter Six). Still, representationality and radical pictoriality must be distinguished. Representationality of configuration (especially two-dimensional configuration) is a function of first-order seeing-as in natural vision; flat things look to have volume, depth, and so on. As Table 2.2 suggests, radical pictoriality of representationality, whether "representational" or "abstract" in the sense specified in Table 1.2, is another step; the voluminous, distant, partly occluded things (seeing-as) are seen as this thing or that thing (what I will call "seeing-as-*as*").

5. Arthur C. Danto, "Animals as Art Historians: Reflections on the Innocent Eye," in *Beyond the Brillo Box: The Visual Arts in Post-Historical Perspective* (Berkeley and Los Angeles, 1992), 23; Danto cited a paper by K. M. Kendrick and B. A. Baldwin, "Cells in the Temporal Cortex of Conscious Sheep Can Respond Preferentially to the Sight of Faces," *Science* (April 24, 1987), 448–50. In an experiment that has been interpreted to show that capuchin monkeys "recognize" familiar conspecifics in photographs, the parameter of immobilization was relaxed (J. J. Pokorny and F.B.M. De Waal, "Monkeys Recognize the Faces of Group Mates in Photographs," *Proceedings of the National Academy of Sciences* 106, no. 51 [2009], 21539–21543).

6. Though it was perhaps merely a slip on the part of his editors, Wittgenstein might have used a reduced version of the grapheme, eliminating the interior hatching, that had been published by Jastrow in *Fact and Fable in Psychology* (London, 1901), 295. Perhaps this is why he overlooked certain striking recursions of ambiguous pictoriality in the grapheme, or so they seem to me.

7. See Richard Wollheim, *Art and Its Objects*, 2nd ed. (Cambridge, 1985), 205–26. Wollheim's analysis has been refined (and sometimes contested) by many other writers. Dominic McIver Lopes, for example, has proposed a typology of seeing-in that sorts its behavior with respect to different kinds of pictorial arrays (*Sight and Sensibility: Evaluating Pictures* [Oxford, 2005], esp. 39–45). These include troublesome *trompe l'oeils* that visually do not have to have the "twofold" pictorial structure that supports seeing-in (as distinct from seeing-as) in the seeing of pictures as the visible interaction of a marked surface and virtual (depicted) objects.

Here I cannot discuss Wollheim's philosophy of pictorial representation, pictorial structure, and pictorial organization. But he always treated the twofoldness of (the seeing of) depiction as a species of the threefold relation between an object of consciousness (stimulus) and its psychic depths—depths understood by Wollheim in psychoanalytic terms to be divided between an archaic or primary "bodily ego" and an unconscious self. Elsewhere I have described this as the "psychic seeing-as" that primordially governs pictorial seeing-in as a response to the traumatic ambiguity of seeing-as, or in it; see Whitney Davis, "Freudianism, Formalism, and Richard Wollheim," in *Queer Beauty: Sexuality and Aesthetics from Winckelmann to Freud and Beyond* (New York, 2010), 271–95.

8. I am not going to speculate about the causes of individual and/or social and/or cultural variation in radical pictoriality, though I think variation can safely be assumed. This is a matter for empirical natural history and empirical historical sociology undertaken within the frame of the general historical phenomenology presented in this book. One factor, surely, is the preexisting structure of visual space. A trio of psychologists and anthropologists, Marshall H. Segal, Donald T. Campbell, and Melville J. Herskovits, examined cross-cultural responses to the Müller-Lyer Illusion with which I began my considerations in this chapter; they investigated whether perceivers sensitive to (visually sensitized in) effects of plane recession in what they called "carpentered" architectural environments—an environment containing many receding walls erected at right angles to the groundplane and increasingly distant from the vantage point—would transfer this sensitivity to spontaneous interpretation of the two-dimensional graphic stimulus. See M. H. Segal, D. T. Campbell, and M. J. Herskovits, "Cultural Differences in the Perception of Geometric Illusions," *Science* 193 [1963], 769–71, and *The Influence of Culture on Visual Perception: An Advanced Study in Psychology and Anthropology* (Indianapolis, IN, 1966). Compare V. M. Stewart, "Tests of the 'Carpentered World' Hypothesis by Race and Environment in America and Zambia," *International Journal of Psychology* 8 (1973), 83–94: susceptibility to "carpentered" interpretations of the illusions was greater among children raised in urban contexts regardless of nationality and racial identification. In the copious literature commenting on the original hypothesis, I single out Jan Deregowski, *Illusions, Patterns, and Pictures: A Cross-Cultural Perspective* (London, 1980), and Onians, *Neuroarthistory*, 150–58. The thesis has usually been stated as a strictly psychological hypothesis about cultural relativity in visual perception, not as a thesis about a historically evolved visuality activated in contexts of visual affordance similar to the ones in which the neural circuits were laid down. Indeed, John Onians has

emphasized that the original studies depended on an overly narrow (and ideologically shaped) hypothesis — namely, that perception can be influenced by culture — rather than a "broader" one, one that he says "goes further" — namely, that perception is influenced (neurally shaped) by environment, "whether cultural or natural" (*Neuroarthistory*, 156–57).

9. Ludwig Wittgenstein, *On Certainty*, trans. Denis Paul and G.E.M. Anscombe, ed. G.E.M. Anscombe and G. H. von Wright (Oxford, 1969), 21. For one possible use of Wittgenstein's metaphor in the analysis of visuality and visual culture, see *GTVC* 36–37, 326–28, 337–38. Of course, Wittgenstein did not discuss the dawning of aspects as radical pictoriality — the active visual revisibilization of aspects seen. Radical pictoriality in my sense is one route of the dawning of aspects. There may be others.

10. See Simon Blackburn, *Spreading the Word: Groundings in the Philosophy of Language* (Oxford, 1984).

CHAPTER 3. WHAT THE CHAUVET MASTER SAW: ON THE PRESENCE OF PREHISTORIC PICTORIALITY

1. For documentation and copious illustration of the Grotte de Chauvet, see Jean Clottes, *Return to Chauvet Cave: The Final Report* [2001], trans. Paul G. Bahn (London, 2003). Readers might also wish to screen Werner Herzog's film *Cave of Forgotten Dreams* (2010). For earlier questions and doubts, see Paul Pettitt, Paul Bahn, and Christian Züchner, "The Chauvet Conundrum: Are Claims for the 'Birthplace of Art' Premature?" in *An Enquiring Mind: Studies in Honor of Alexander Marshack,* ed. Paul G. Bahn (Oxford and Oakville, 2009), 239–62. For the recent discussion of 259 available radiocarbon dates, see Anita Quiles et al., "A High-Precision Chronological Model for the Decorated Upper Paleolithic Cave of Chauvet-Pont d'Arc, Ardèche, France," *Proceedings of the National Academy of Sciences* 113, no. 17 (2016), 4670–75. For other decorated caves in southwestern Europe, see Jean Clottes, *Cave Art* (London, 2008). In the interest of economy I will not provide extensive bibliography; full references can be found in the publications cited.

2. Dietrich Mania and Ursula Mania, "Deliberate Engravings on Bone Artefacts of *Homo Erectus*," *Rock Art Research* 5 (1988), 91–97. For further investigations of these artifacts, see Barbora Puta, "Proto-art and Art: Art Before Art," in *The Genesis of Creativity and the Origin of the Human Mind,* ed. Barbora Puta and Václav Soukup (Prague, 2015), 48.

3. John Pfeiffer, *The Creative Explosion: An Inquiry into the Origins of Art and Religion* (New York, 1982); Jill Cook, *Ice Age Art: Arrival of the Modern Mind* (London, 2013); E. H. Gombrich, "The Miracle at Chauvet," *New York Review of Books*, November 14, 1996, 8–12. Neither Pfeiffer nor Cook claims specifically that picture-making diagnostically characterizes the supposed Upper Paleolithic creative explosion, whether as one of its causes or as one of its consequences. Rather, the supposition seems to be that it is "art" that did so, and possibly the "religion" that the art might have subserved. But the "art" in question was partly pictorial.

4. Ludwig Wittgenstein, *Philosophical Remarks*, trans. Raymond Hargreaves and Roger White, ed. Rush Rhees (Oxford, 1975), 133.

5. See Christopher Henshilwood, Francesco d'Errico, Royden Yates, et al., "Emergence of Modern Human Behaviour: Middle Stone Age Engravings from South Africa," *Science* 295, no. 5558 (2002), 1278–80; Pierre-Jean Texier, Guillaume Poraz, John Parkington, et al., "A Howiesons Poort Tradition of Engraved Ostrich Shell Containers Dated to 60,000 Years Ago at Diepkloof Rock Shelter, South Africa," *Proceedings of the National Academy of Sciences* 107 (2010), 6180–85. More generally, see Christopher Henshilwood and Francesco d'Errico, *Homo symbolicus: The Dawn of Language, Imagination and Spirituality* (Amsterdam, 2011). A survey that is quite complete up to the date of publication (2015) can be found in Michelle C. Langley, "Symbolic Material Culture in the Late Pleistocene: Use in Prehistory, Appearance in the Archaeological Record and Taphonomy," in *The Genesis of Creativity*, 57–75.

6. According to Alexander Marshack, an engraved Mousterian flint cortex from the Levant, dated to c. 54,000 BP, was the "earliest known 'depictive' symbolic engraving" at the time of his writing ("A Middle Paleolithic Symbolic Composition from the Golan Heights," *Current Anthropology* 37 [1996],

357–64). But nowhere did he establish, or even propose, what the engraving depicts. His scare quotes suggest, of course, that he was well aware of this lacuna. I have been unable to evaluate the statement that an engraved mammoth scapula from a Mousterian level at a site on the banks of the Dnestr River in Siberia displays "animal figures" in addition to lines, zigzags, and squares (see Elenea A. Okladinova, "Chasing Thoughts Lost Thirty Millennia Ago," in *An Enquiring Mind*, 215).

7. Alexander Marshack, "Some Implications of the Paleolithic Symbolic Evidence for the Origin of Language," *Current Anthropology* 17 (1976), 274–82.

8. Robert G. Bednarik, "Micoquian Engravings from Oldisleben, Germany," *Rock Art Research* 23 (2006), 268; see also Robert G. Bednarik, "The Middle Palaeolithic Engravings from Oldisleben, Germany," *Anthropologie* 44 (2006), 113–21. It is not clear whether the little pit — the "head" of the figure? — is a "natural" feature of the bone and its taphonomy or an "artificial" man-made mark. This issue comes up repeatedly in the paleoanthropological scholarship as supposedly relevant to identifying symbolism, pictoriality, etc. (as "artificial"). But the question is wholly irrelevant to the issue of pictorial succession, and indeed of symbolism. All pictures inherently incorporate "natural" features of the materials from which they are generated, and there is no theoretical reason a picture — or a symbol — cannot be an entirely "natural" thing.

9. Raymond A. Dart, "The Waterworn Australopithecine Pebble of Many Faces from Makapansgat," *South African Journal of Science* 70 (1974), 167–69; Robert G. Bednarik, "The 'Australopithecine' Cobble from Makapansgat, South Africa," *South African Archaeological Bulletin* 53 (1998), 4–8. Bednarik enrolls the pebble in the category of "paleoart" because "it conveyed non-inherent properties to its collectors that were imposed by neural processes and involved an incipient form of consciousness" ("Manuports and Very Early Paleoart," Auranet, http://www.ifrao.com/manuports-and-very-early-palaeoart/ [accessed August 10, 2016]). This "aesthetic" possibility is not the issue here.

10. Naama Goren-Inbar, "A Figurine from the Acheulean Site of Berekhat Ram," *Mitekufat Haeven*

19 (1986), 7–12; Marjolein Efting Dijkstra, *The Animal Substitute: An Ethnological Perspective on the Origin of Image-Making and Art* (Delft, 2010), 249. A color photograph can be found in Robert G. Bednarik, "Hominin Mind and Creativity," in *The Genesis of Creativity*, 40, figure 1. For detailed analysis, see Francesco d'Errico and April Nowell, "A New Look at the Berekhat Ram Figurine: Implications for the Origins of Symbolism," *Cambridge Archaeological Journal* 10 (2000), 123–67. Though widely spread in time, comparable artifacts might include the so-called Venus of Tan-Tan from Morocco, dated to between 500,000 and 300,000 BP, and a Neanderthal artifact from La Roche-Cotard Cave sometimes known as the Mousterian Protofigurine, dated to c. 35,000 BP: see Robert Bednarik, "A Figurine from the African Acheulian," *Current Anthropology* 44 (2003), 405–13, and Jean-Claude Marquet and Michel Lorblanchet, "A Neanderthal Face? The Proto-figurine from La Roche-Cotard, Langeais (Indre-et-Loire, France)," *Antiquity* 298 (2003), 661–70.

11. In a highly suggestive essay comparing the regimes of picture-making in natural daylight and the lamp- or torchlit "darkness" of caves, and without denying the special sensory and affective activations, spaces, and connotations of caves, Tilman Lenssen-Erz has argued that pictorial art must have been "invented" by modern humans in the daylight ("Art in the Light of Darkness," in *The Genesis of Creativity*, 271–79).

12. Stephen Davies, "Psychological Modernity," lecture at Department of Philosophy, University of California at Berkeley, May, 2015. Like others, Davies accepts that Middle Paleolithic pictures do not survive in the archaeological record, but he argues that they must have been made: they were part of the very constitution of the suite of perceptual and cognitive capacities identified with the emergence of the modern human species. A number of paleoanthropologists have suggested, as does Davies, that modern human groups in the Middle Paleolithic were small and scattered — perhaps too small and scattered to preserve and transmit regular, robust, concentrated, and highly differentiated practices and traditions of making pictures that perdured in lasting materials. This hypothesis is fully consistent with the notion of a creative explosion (of pictures) in the Upper Paleolithic. Indeed, it

would seem to suggest a partial explanation for it in terms of population growth, increased social interaction, and the stabilization of mechanisms and routes of preserving and communicating information at the time of the "Middle/Upper Paleolithic transition." In southwestern Europe, social and cultural innovations and adaptations to the newly extreme glacial conditions would seem to be part of the story. See especially C. Michael Barton, Geoffrey A. Clark, and Allison E. Cohen, "Art as Information: Explaining Upper Palaeolithic Art in Western Europe," *World Archaeology* 26 (1994), 185–207, and Geoffrey A. Clark, C. Michael Barton, and Allison E. Cohen, "Explaining Art in the Franco-Cantabrian Refugium," in *Debating Complexity, ed.* Daniel A. Meyer, Peter C. Dawson, and Donald T. Hanna (Calgary, 1996), 241–53.

13. Ludwig Wittgenstein, *Philosophical Investigations*, trans. G.E.M. Anscombe, 3rd ed. (Malden, 2001), 159.

14. Michael Baxandall described the "historical explanation of pictures" as "inferential criticism" leading to a "reconstruction" of the maker's "patterns of intention"—orderly purposes and practical skills in managing the "dialectic of process" (*Patterns of Intention: On the Historical Explanation of Pictures* [New Haven and London, 1985]). For comments on this influential model, see Whitney Davis, "Art History, Re-Enactment, and the Idiographic Stance," in Michael Baxandall, *Vision and the Work of Words*, ed. Peter Mack and Robert Williams (Aldershot, UK, 2015), 69–90.

15. I will not offer a historiography and bibliography of this debate, widely distributed in art history, anthropology, and philosophy. Relevant and diverse cultural examples (with bibliography and commentary) are explored in Hans Belting, *The Anthropology of Images: Picture, Medium, Body* [2001], trans. Thomas Dunlap (Chicago, 2011); Nigel Wentworth, *The Phenomenology of Painting* (Cambridge, 2004); *Presence: The Inherence of the Prototype within Images and Other Objects,* ed. Robert Maniura and Rupert Shepherd (Aldershot, 2006); *Heidegger and the Work of Art History*, ed. Amanda Boetzkes and Aron Vinegar (Aldershot, 2014); and Caroline Van Eck, *Art, Agency and Living Presence: From the Animated Image to the Excessive Object* (Boston, 2015). For a pointed engagement in the debate as it can be found in classical archaeology,

see Richard Neer, *The Emergence of the Classical Style in Greek Sculpture* (Chicago, 2010), 14–19, challenging Jean-Pierre Vernant's claims about the presence of Greek sculptures (supposedly not statue-pictures) in *Figures, idoles, masques* (Paris, 1990) and elsewhere. In the recent theoretical literature (and to mention only titles in English), influential inquiries include Graham Harman, *Tool Being: Heidegger and the Metaphysics of Objects* (La Salle, IL, 2002), Hans Ulrich Gumbrecht, *Production of Presence: What Meaning Cannot Convey* (Stanford, 2003), and Alva Noë, *Varieties of Presence* (Cambridge, MA, 2012).

16. For a striking reconstruction of the stages of the palimpsest of claw-marks and human-made pictures, see Clottes, *Chauvet*, figure 111. Michel Lorblanchet has written an intriguing brief essay on Upper Paleolithic man-made "ritual traces" that "imitate bear claw marks"; "Claw Marks and Ritual Traces in the Paleolithic Sanctuaries of the Quercy," in *An Enquiring Mind*, 165–70.

17. Josef Augusta, *Prehistoric Man*, illus. by Zdenek Burian (London, 1960). Augusta himself held this view, it seems, because he understood Paleolithic paintings of animals to be a species of "hunting magic," requiring that the pictorial simulation function conceptually as a substitute for—or a relay to—the real creature, though it is not clear why this would require that the representation actually *is* the creature.

18. "What Is Presence?" in *Presence*, ed. Maniura and Shepherd, 166. Harrison uses Nelson Goodman's analysis of exemplification and sampling in *Languages of Art: An Approach to a Theory of Symbols*, 2nd ed. (Indianapolis, IA, 1976).

19. For acoustic, performative, and kinaesthetic horizons of experience in decorated paleolithic caves, see Iégor Reznikoff and Michel Dauvois, "La dimension sonore des grottes ornées," *Bullétin de la Société préhistorique française* 95 (1988), 238–46, and Yann-Pierre Montelle, "Paleoperformance: Investigating the Human Use of Caves in the Upper Paleolithic," in *New Perspectives on Prehistoric Art*, ed. Günter Berghaus (Westport, CT, 2004), 131–52.

20. Whitney Davis, "Climatic Variability and Pictorial Oscillation," *Res* 63/64 (2013), 20–38, with apologies to David Lack's *Natural Regulation of Animal Numbers* (Oxford, 1954); R. Dale Guthrie, *The Nature of Paleolithic Art* (Chicago, 2005).

See also Brigitte Delluc and Gilles Delluc, "Eye and Vision in Paleolithic Art," in *An Enquiring Mind*, 77–98, who concentrate on examples of closely observant "realism." A suggestive environmental explanation of the "highly naturalistic representation" at Chauvet has been offered by John Onians; he proposes that the Aurignacian people at Chauvet spent "more time looking at animals than their contemporaries elsewhere" because an "exceptional procession of animals" would have been visible twice a year when the creatures traversed the natural rock bridge near the cave — the Pont d'Arc, a funnel for faunal migrations (see "Neuroarchaeology and the Origins of Representation in the Grotte de Chauvet," in *Image and Imagination: A Global Prehistory of Figurative Representation*, ed. Colin Renfrew and Iain Morley [Cambridge, 2007], 307–22). A useful review of approaches to "naturalism" in the study of Upper Paleolithic cave art can be found in Oscar Moro Abadía, Manuel R. González Morales, and Eduardo Palacio Pérez, "'Naturalism' and the Interpretation of Cave Art," *World Art* 2 (2012), 219–40.

21. Gumbrecht, *Production of Presence*, 17.

22. For a suggestive analysis of the deliberately constructed and culturally salient tension between tactile investigations and optical inspections of possible pictorial illusions in the case of the nineteenth-century American *trompe-l'oeil* painter William Harnett (my Figure 0.9), see Michael Leja, "Trompe l'Oeil Painting and the Deceived Viewer," in *Presence*, ed. Maniura and Shepherd, 173–90. See also Wendy Bellion, *Citizen Spectator: Art, Illusion, and Visual Perception in Early National America* (Chapel Hill, NC, 2011).

23. Jean Clottes and David Lewis-Williams, *The Shamans of Prehistory: Trance and Magic in the Painted Caves* [1996], trans. Sophie Hawkes (New York, 1998), 18.

24. J. D. Lewis-Williams, *Believing and Seeing: Symbolic Meanings in Southern San Rock Paintings* (London, 1981), and J. D. Lewis-Williams and Thomas A. Dowson, "The Signs of All Times: Entoptic Phenomena in Upper Paleolithic Art," *Current Anthropology* 29 (1988), 201–45. A comparison between entoptics and prehistoric rock arts was first made, so far as I can tell, by Eichmeier and Höfer in their pioneering *Endogene Bildmuster*, 151–70; an explicit theory of entoptic

externalization was proposed by Robert G. Bednarik in 1986 (see "Parietal Finger Markings in Europe and Australia," *Rock Art Research* 3 [1986], 30–61), then incorporated by Lewis-Williams and his collaborators into an interpretation of San and other rock arts that they partly based not only on San folklore but also, for example, on ethnographies of the vision quests of the indigenous Coso people of the Mojave Desert. See also Jeremy Dronfield, "Migraine, Light and Hallucinogens: The Neurocognitive Basis of Irish Megalithic Art," *Oxford Journal of Archaeology* 4 (1995), 261–75, and "Subjective Visions and the Source of Irish Megalithic Art," *Antiquity* 69 (1995), 539–49.

25. J. D. Lewis-Williams, *The Mind in the Cave: Consciousness and the Origins of Art* (London, 2002). In itself this proposal does not require the hypothesis of entopic externalization but it is compatible with it, and Lewis-Williams applies it (see also David Lewis-Williams and David Pearce, *Inside the Neolithic Mind: Consciousness, Cosmos and the Realm of the Gods* [London, 2005]). For a different (and in some respects a more sophisticated) exploration of the issues, see Lambros Malafouris, "Before and Beyond Representation: Towards an Enactive Conception of the Palaeolithic Image," in *Image and Imagination*, ed. Renfrew and Morley, 287–300.

26. This was the title of an influential conference held at the Institute of Fine Arts of New York University in September, 2012. See also Malafouris, "Before and Beyond Representation."

27. Frank Ankersmit, *Meaning, Truth, and Reference in Historical Representation* (Stanford, 2012), 163–64. Ankersmit provides lucid expositions of Arthur Schopenhauer's doctrine that "in art, above all in music, something of transcendental Will can be perceived, and that this is what grants to works of art their presence," and Friedrich Nietzsche's account of the presence of artworks — the "daylight" of the fictive world of Greek tragic drama as distinct from the "lamplight" of mundane human reality (*Meaning, Truth, and Reference*, 168, 170). For Ankersmit, presence is best defined as the "sublimity" of the artwork, which exceeds rational comprehension. But our question is not directly about artworks. It is about pictures. And most strong anthropological theories of presence (including some accounts of prehistoric depiction)

do not derive the presence of the objects from their status as artworks in Schopenhauer's and Nietzsche's senses. In fact, theories of the presence of objects produced in many historical visual cultures often also deny that said objects were produced as art and/or that the presences have arthood/artness. Indeed, one frequent overall aim of the anthropology is to reconstruct the indigenous ontology in which the objects were something *other* than art.

28. For primary documentation, see Claude Barrière and Ali Sahly, *L'art pariétal de la Grotte de Gargas = Paleolithic Art in the Grotte de Gargas* (Oxford, 1976); a briefer conspectus in Claude Barrière, "Gargas," in *L'art des cavernes: Atlas des grottes ornées paléolithiques françaises*, ed. André Leroi-Gourhan (Paris, 1984), 514–22; Pascal Foucher, Cristina San Juan-Foucher, and Yoan Rumeau, *La grotte de Gargas* (Saint-Laurent-de Nest, 2007). I provide an extensive description of the problematics of depiction in the flutings in "Replication and Depiction in Paleolithic Art," in *Replications: Archaeology, Art History, Psychoanalysis* (University Park, PA, 1996), 66–94, and I will not repeat it here. For discussion of flutings in later caves, see Michel Lorblanchet, "Finger Markings in Pech Merle and Their Place in Prehistoric Art," in *Rock Art in the Old World*, ed. Michel Lorblanchet (New Delhi, 1992), 451–90; Kevin Sharpe and Leslie Van Gelder, "Four Forms of Finger Flutings as Seen in Rouffignac Cave, France," in *An Enquiring Mind*, 269–286. These studies provide useful morphological typologies that take account of body movement and locomotion. But a fine-tuned internal differentiation of flutings is not necessary for my purposes here.

29. See Kevin J. Sharpe, et al., "Fluted Animals in the Zone of Crevices, Cave of Gargas, France," in *Methods of Art History Tested Against Prehistory … European Cave Art* (Oxford, 2010), BAR International Series 2108, 93–104, with further references.

30. This thesis was urged by Hallam L. Movius, Jr. and Sheldon Judson, *The Rock Shelter of La Colombière* (Cambridge, MA, 1956). Surprisingly few of the broken fragments retrieved from the sites in question can be put back together to reconstitute whole plaquettes. Therefore the breakage mostly occurred elsewhere; only some of the broken pieces were transported to the place of final use and/or deposition. Wherever it occurred, breakage does not seem to have been due to trampling or to frost action; there is too much of it to suggest it was accidental. Therefore it seems that deliberate breakage was incorporated into the primary situation of use; to use the engravings was sometimes to break them and maybe to seek to put them back together, if only in the imagination.

31. We should not assume, however, that the engravings were quite as difficult to see in their original contexts of use as they are now. As Ann Sieveking has pointed out in her painstaking study of the corpus of engraved plaquettes from Saut-du-Perron, the whitish lines would stand out from the brownish limestone when it was first engraved, and apparently paint was sometimes used, likely clarifying distinct lines. The principal recent sources (all superbly detailed) are Léon Pâles and Marie Tassin de Saint Péreuse, *Les gravures de La Marche*, Pt. 1, *Félins et ours*, 2 vols. (Bordeaux, 1969); Ann Sieveking, *Engraved Magdalenian Plaquettes: A Regional and Stylistic Analysis of Stone, Bone, and Antler Plaquettes from Upper Paleolithic Sites in France and Cantabric Spain* (Oxford, 1987), and *Les plaquettes de schiste gravées du Saut-du-Perron* (Oxford, 2001); Gerhard Bosinski, *Die Ausgrabungen in Gönnersdorf 1968–1976 und die Siedlungsbefunde der Grabung 1968* (Wiesbaden, 1979), and *Tierdarstellungen von Gönnersdorf: Nachträge zu Mammut und Pferde sowie die übrigen Tierdarstellungen* (Mainz, 2008); Gerhard Bosinski and Gisela Fischer, *Die Menschendarstellungen von Gönnersdorf* (Wiesbaden, 1974), and *Mammut und Pferdedarstellungen von Gönnersdorf* (Wiesbaden, 1980). I said pictures of animals "real or imaginary." We do not know, for example, how the engravers of La Marche visually encountered the feline predators of the Vienne. But they seem to have stabilized a pictorialization of a particular beast that cannot be identified with any actual feline species — and perhaps served pictorially as some kind of prototype felinity or superfeline? See Pâles and Tassin de Saint Péreuse, *Gravures de La Marche*, figure 22, identifying a feline-like pictorialization replicated on four different plaquettes (pls. 19, 20, 32, and 36).

32. For a reconstruction, see Bosinski, *Tierdarstellungen von Gönnersdorf*, Abb. 2, 6.

33. See Bosinski, *Tierdarstellungen von Gönnersdorf*, figure 11. In presenting this observation to

audiences in North America and Europe, I find that some beholders see the third head right away, and had noticed it even before I mentioned it. Others, however, find it difficult to see even when its parts are fully described in relation to other visible figures.

34. See Clottes, *Cave of Chauvet*, 132, 149.

35. Clottes, *Cave of Chauvet*, 132.

36. According to Brigitte Delluc and Gilles Delluc, who have made special studies of the matter, each wick in the fat-burning lamps that were found at Lascaux "would more or less provide the same light as one of our candles. The power of such lamps is about ten watts, with surfaces receiving lighting of a few lux." (They note, however, that several wicks could be used in one lamp.) "In relation to daylight, an artificial light from the flame of a lamp, a torch or a fireplace lowers the temperature of color and provides a light rich in red" ("Eye and Vision in Paleolithic Art," in *An Enquiring Mind*, 85–86).

CHAPTER 4. BIVISIBILITY: BETWEEN THE SUCCESSIONS TO VISUALITY

1. Whitney Davis, Masking the Blow: *The Scene of Representation in Late Prehistoric Egyptian Art* (Berkeley and Los Angeles, 1992).

2. My Figure 4.2, a superbly crafted statue of the official Khonsu-ir-aa dated to the Twenty-Fifth Dynasty (c. 670–660 BCE), does not use the later canon (21 rather than 18 units for the height of the standing figure to the hairline) that emerged in the Saite Period (Twenty-Sixth Dynasty) and which has been taken to have been the canon replicated by the Greek sculptor of the Metropolitan *kouros* (Figure 4.3). Nonetheless, in a sensitive examination Bernard V. Bothmer suggested that it embodied an "ideal of beauty which lastingly influenced the beginnings of monumental Greek sculpture half a century later" (*Egyptian Sculpture in the Late Period* [Brooklyn, 1960], 10, no. 9, with figures 20–22). Of course, it is perfectly possible that Greek visitors to Egypt saw many examples of pre-Saite sculpture.

3. Erwin Panofsky, "Die Entwicklung der Proportionslehre als Abbild der Stilentwicklung," *Monatsheft für Kunstwissenschaft* 14 (1921), 188–219, translated as "The History of the Theory of Proportions as a Reflection of the History of

Style," in *Meaning in the Visual Arts: Papers In and On Art History* (New York, 1955), 55–107. Panofsky had earlier applied this lesson in his detailed investigations of Albrecht Dürer's theories of beauty as expressed in his studies of proportion.

4. Margaret Iversen and Stephen Melville, *Writing Art History: Disciplinary Departures* (Chicago, 2010), 23.

5. James Elkins, "Can We Invent a World Art Studies," in *World Art Studies: Concepts and Approaches,* ed. Kitty Ziljmans and Wilfried van Damme (Amsterdam, 2008), 107–18. See also Wilfried van Damme, et al., "Art History in a Global Frame: World Art Studies," *Brill's Studies in Intellectual History* 212 (2012), 217–30.

6. David Hulks, "World Art Studies: A Radical Proposal?" *World Art* 3 (2013), with comment by Whitney Davis, "Radical WAS: The Sense of History in World Art Studies," *World Art* 3 (2013), 201–210.

7. Ellen Dissanayake, "The Arts After Darwin: Does Art Have an Origin and Adaptive Function?" in *World Art Studies*, 241–63. The large neo-Darwinian literature on evolutionary-developmental and adaptationist-functional approaches to artifacts, pictures, and art has recently been critically assessed by Matthew Rampley, *The Seductions of Darwin* (University Park, PA, 2016), with fulsome references.

8. John Onians, "Neuroarthistory: Making More Sense of Art," in *World Art Studies*, 265–68. Onian's *European Art: A Neuroarthistory* (New Haven and London, 2016) is a massive art-historical synthesis of this approach.

9. Eleanor G. Guralnick, "Proportions of Kouroi," *American Journal of Archaeology* 82 (1978), 461–72; I have offered my summary of the implications and contexts in "Egypt, Samos, and the Archaic Style in Greek Sculpture," *Journal of Egyptian Archaeology* 67 (1981), 61–81, though this study is now outdated. Of course, there had been many treatments of this matter in Egyptological and classical scholarship going back as far as Winckelmann, and several authorities had come close to Guralnick's conclusion, which was based on just the right examples (not all *kouroi* deployed the Egyptian system, and not all Egyptian systems were used). For the purposes of argument here, I will accept that Guralnick's conclusions remain undisputed; at any rate, they have not been disputed by the classical art historians I will cite

momentarily. But see Jane B. Carter and Laura J. Steinberg, "Kouroi and Statistics," *American Journal of Archaeology* 114 (2010), 103–28.

10. Helene J. Kantor, *The Aegean and the Orient in the Second Millennium B.C.* (Bloomington, IN, 1947); William Stevenson Smith, *Interconnections in the Ancient Near East* (New Haven and London, 1965).

11. See Marian Feldman, *Diplomacy by Design: Luxury Arts and an "International Style" in the Ancient Near East, 1400–1200 BCE* (Chicago, 2006).

12. See Whitney Davis, "Scale and Pictoriality in Ancient Egyptian Painting and Sculpture," *Art History* 38 (2015), 268–85, for one approach.

13. Andrew F. Stewart, *Classical Greece and the Birth of Western Art* (New York, 2008), 29–31. However, in *Greek Sculpture: An Exploration* (New Haven and London, 1990), vol. 1, 108–109, Stewart noted the "Egyptian connection" in the case of the Metropolitan kouros and its application of the Egyptian proportional grid "in the vertical dimension only." As he went on to say, "Many other [Greek] sculptors adopted the principle of the grid but either did not know or — individualistic, experimental, and competitive as ever — chose to ignore actual Egyptian practice in applying it." As Stewart sees it, the motive for a Greek sculptor to study and adapt Egyptian techniques would have been to satisfy rich cosmopolitan clients who were "astounded at the wonders of Egypt and want[ed] statues that looked like theirs."

14. Richard T. Neer, *Art and Archaeology of the Greek World: A New History, c. 2500 — c. 150 BCE* (London, 2012), 115; *The Emergence of the Classical Style in Greek Sculpture* (Chicago, 2010), 20–69.

15. Of course, we should take account of the rhetorical context of the descriptions in question. Neer's survey of 2012 was intended to be a textbook for classroom use — where there might be pressure on the teacher to provide cross- and intercultural perspectives and to relate the material to topics taught in other courses the students might take. Still, Stewart's book, though not exactly a textbook, is also a survey meant to be accessible to general readers interested in "the birth of Western art." Neer's monograph of 2010 is the most technical of the three publications — focused on complex historical, historiographical, and theoretical matters. But it is not directed only at classicists; it also reaches out broadly as art theory, taking account of work done

by historians of cultural traditions other than the Greek.

16. On Wölfflin's procedure, see also Whitney Davis, "Succession and Recursion in Heinrich Wölfflin's *Principles of Art History*," *Journal of Aesthetics and Art Criticism* 73 (2015), 159–66, and "Bivisibility: Why Art History Is Comparative," in *Comparativism in Art History*, ed. Jas Elsner (London and New York, 2017), 47–59.

CHAPTER 5. BIVIRTUALITY: PICTORIAL NATURALISM AND THE REVOLUTIONS OF ROTATION

1. Calculations by Margaret Livingstone have helped identify parameters of this kind in several examples. In Rembrandt's *Meditating Philosopher* (1632), for instance, the window at left (with sunlight streaming in) is only fifteen times brighter than the darkest shadow in the bottom left corner of the painting (in the beholder's near left foreground), though it seems much lighter to us (as it would be in real life) because of Rembrandt's handling of transitions and contrasts between the areas. As Livingstone notes, "if this were a real scene, the luminance of the window would probably be hundreds of times that of the left corner" (*Vision and Art: The Biology of Seeing* [London, 2002], 125). It is not wholly impossible, of course, to make a picture that actually duplicates the values and proportions of the real-world luminance gradient that it depicts; one could, for example, simply reproduce the real-world set-up in a context that pictorialized it. But it could be quite difficult if the work is not such a duplicate. And for Rembrandt it was well-nigh impossible given his surface, pigments, and glazes.

2. For Plato's comments on Egyptian art, see Whitney Davis, "Plato and Egyptian Art," *Journal of Egyptian Archaeology* 65 (1979), 121–27; for Hegel's treatment of Symbolic Art in Egypt, see Whitney Davis, "The Absolute in the Mirror: Symbolic Art and Cosmological Perspectivism," in *Hegel's Aesthetics and Art History*, ed. Paul Kottman and Michael Squire (Munich, forthcoming). It should be noted that Hegel's "Symbolic Art" is not intrinsically unnaturalistic; Hindu sculpture could be highly naturalistic. But the Symbolic Art of Egypt was highly schematized — virtually hieroglyphic, Hegel thought.

There is an intriguing analogy between Plato's view of the epistemology and ontology of Egyptian depiction and Arthur Schopenhauer's appreciation of the "realism" of early-modern Dutch still-life painting: it managed, Schopenhauer thought, to achieve the production of "Platonic Ideas" in art, what I have called "representative representation" (see "Schopenhauer's Ontology of Art," in *Queer Beauty*, 83–98). For Schopenhauer, in ontological terms Dutch still-life in a sense was the "Egyptian" art of the modern Western world, especially in view of the way in which the Dutch painters—seeking to depict *sub specie aeternitatis*, "under the aspect of eternity"—sometimes constructed the *trompe l'oeils* that Plato claimed the Egyptians had abjured. By contrast, for Hegel the Dutch and Spanish genre painting of the seventeenth century exemplified the essential tendency of "Romantic Art" in expressing—in pictorially capturing—the "inwardness" of human self-consciousness, its *Gemüt* or "heart." Excellent treatments of this matter can be found in *Hegel on the Arts*, ed. Stephen Houlgate (Evanston, IL, 2007).

3. E. H. Gombrich, *The Story of Art*, 1st ed. (London, 1950), 49–66 ("the great awakening"); *Art and Illusion: A Study in the Psychology of Pictorial Representation*, 1st ed. (Princeton, 1960), 116–45 ("the Greek revolution"). I will present a full account of Gombrich's terms and arguments in "Substitute, Schema, Stereotype: E. H. Gombrich and the Psychology of Pictorial Representation," in *Inquiry in Art History* (forthcoming). As Jeremy Tanner has written, "Gombrich was perhaps the last art historian to present a full-fledged version of this grand narrative of Greek naturalism" ("Rethinking the Greek Revolution," in *The Invention of Art History in Ancient Greece: Religion, Society and Artistic Rationalisation* [Cambridge, 2006], 31–96 [quotation from p. 38]). More recent scholars, not least including Tanner himself, have developed revisionary alternatives (for example, see Richard Neer, *The Emergence of the Classical Style in Greek Sculpture* [Chicago, 2010]).

4. Edith Hamilton, *The Greek Way*, 1st ed. (New York, 1930).

5. G. W. F. Hegel, *The Phenomenology of Spirit*, trans. A. V. Miller (Oxford, 1977), 421–26; *Hegel's Aesthetics: Lectures on Fine Art*, trans. T. M. Knox (Oxford, 1975). Following Greco-Roman reports,

Hegel cited the Colossi because one of them was reported by beholders to "sing"; according to him, the Egyptians supposedly mistook an outside natural force for an indwelling spirit. For a sensitive and imaginative exposition of Hegel's obscure paragraphs on ancient Oriental and Egyptian art and architecture, see Beat Wyss, *Hegel's Art History and the Critique of Modernity*, trans. Caroline Dobson Salzwedel (Cambridge, 1999), 1–11.

6. The first quotation is from Kathleen Dow Magnus, *Hegel and the Symbolic Mediation of Spirit* (Albany, NY, 2001), 115; the remainder are from Hegel, *Lectures on Fine Art*, vol. 1, 300, 305.

7. The first quoted sentence is G. W. F. Hegel, *Philosophy of History*, trans. J. Sibree (New York, 1900), 199; the second and third are Hegel, *Lectures on Fine Art*, vol. 1, 213, 361.

8. Hegel, *Lectures on Fine Art*, vol. 1, 313; *Philosophy of History*, 216.

9. Jon Stewart, *The Unity of Hegel's Phenomenology of Spirit: A Systematic Interpretation* (Evanston, IL, 2000), 407.

10. Hegel, *Lectures on Fine Art*, vol. 2, 784; as Hegel put it, Egyptian spiritual life "posed to itself the spiritual task of self-deciphering [*der Selbstentzifferung*] without really achieving the deciphering," condemning itself to "wander among problems" (*Lectures on Fine Art*, vol. 1, 320, 352).

11. G. W. F. Hegel, *Introductory Lectures on Aesthetics*, trans. Bernard Bosanquet, ed. Michael Inwood (Harmondsworth, 1993), p. xix. Inwood does not spell this out in terms of any particular prehistoric artifacts, though he writes of a hypothetical "bison-carver." Perhaps he partly had in mind the bison carved and painted in relief on the ceiling of the cave of Altamira.

12. We have already encountered the thesis that **BISON** depicted in Upper Paleolithic cave art presenced a spiritual emanation, aspect, avatar, and/or ancestor of Paleolithic beholders—a thesis partly derived from the ethnography of the transformational identification of the San shaman and such beasts as the eland (Chapter Three). In ancient Egypt, the identification of the king and the lion is plain to see in such monuments as the Great Sphinx. On the identification of the Olmec warrior and the jaguar, and an iconography of "were-jaguar" identities, see Whitney Davis, "So-called Jaguar-Human Copulation Scenes in Olmec Art," *American*

Antiquity 43 (1977), 453–57.

13. Peter Fenves, "Alterity and Identity," in *The Routledge Encyclopedia of Philosophy*, ed. Edward Craig (London and New York, 1998), vol. 1, 187–92 (quotations from p. 187).

14. Sam Rose, " 'Global' Post-Impressionism," lecture at the Department of History of Art, University of California at Berkeley, September, 2016.

15. I present a more comprehensive analysis of Löwy in Whitney Davis, "Nature Returns: The Very Idea of Conceptual Images," in *Inquiry in Art History*.

16. *Die Naturwiedergabe in der älteren griechischen Kunst* (Rome, 1900); *The Rendering of Nature in Early Greek Art*, trans. John Fothergill (London, 1907); see also *Die griechische Plastik* (Leipzig, 1911) and *Ursprünge der bildenden Kunst* (Vienna, 1930).

17. *Untersuchungen zur griechischen Künstlergeschichte* (Vienna, 1883); *Inschriften griechischer Bildhauer* (Vienna, 1885); *Polygnot* (Vienna, 1929); *Der Beginn der rotfiguren Vasenmalerei* (Vienna, 1938). On his career and publications, see Emanuel Löwy: *Ein vergessener Pionier*, ed. Friedrich Brein (Vienna, 1998).

18. Löwy's theory of "memory pictures" and their graphic-pictorial expressions did not directly appeal to neurological considerations, unlike Freud's "Psychology for Neurologists," prepared in the mid-1890s and first published in 1950 as *Entwurf einer Psychologie*, translated as *Outline of a Scientific Psychology*. But Löwy clearly intended it to be compatible with them. Freud published his psychoanalytic model of the sediment of unconscious memories — conceived as "repressed" — between perception and discharge into action in 1900, the same year as Löwy's essay appeared. Of course, the multiple connotations of *Bild* — picture, image, etc. — mean that "memory-picture" could be an inexact, even misleading, translation of *Erinnerungsbild*. Löwy also used the term *Gedankensbild*, best translated as "conceptual image"; another translation, "thought-picture," could make sense in certain contexts too. I will accept "memory-picture" insofar as the form of the *Erinnerungsbild* that interested Löwy is a collation of visual impressions mnemically preserved — as it were their picture.

19. Louis Rose, *The Survival of Images: Art Historians, Psychoanalysis, and the Ancients* (Detroit, 2001), 64–72 (quotations from pp. 68, 70). See also Alice Donohue, "New Looks at Old Books: Emanuel Löwy," *Journal of Art Historiography* 5 (2011), 1–16

(for exposition and contextualization), and Mary Bergstein, *Mirrors of Memory: Freud, Photography, and the History of Art* (Ithaca, NY, 2010) (for some of Löwy's intellectual affiliations and practices of curating, photography, etc.).

20. Despite his debt to Löwy, however, "schema" for Gombrich is not a mental image of any kind but a cognitive template, not a visualization of an egg formed from egg-sightings but the set of eggnesses — a matrix of morphologies necessary to see eggs and many other things as sufficiently eggy to be taken as eggs (in the full set of egg-substitutables).

21. Julius Lange, *Die Darstellung des Menschen in der ägyptischen und griechischen Kunst* (Strassburg, 1899); published in Danish in the early 1890s, Lange's research was not widely known until this publication in German. Adolf von Hildebrand, *The Problem of Form* [1893], in *Empathy, Form, and Space: Problems in German Aesthetics 1873–1893*, intro. and trans. by Harry F. Mallgrave and Eleftherios Ikonomou (Los Angeles, 1994).

22. *Rendering of Nature*, 57 n. 21.

23. I have revised Fothergill's translation, which gives "mental image"; *Gedankenbild* is "conceptual image."

24. For the "pregnant moment," see especially E. H. Gombrich, "Moment and Movement in Art," *Journal of the Warburg and Courtauld Institutes* 27 (1964), 293–306; for treatments of Classical Greek art in these terms at the end of the nineteenth century, see Whitney Davis, "Eternal Moment: Walter Pater on the Temporality of the Classical Ideal in Art," in *Pater the Classicist*, ed. Stefano-Maria Evangelista, Charles Martindale, and Elizabeth Prettejohn (Oxford, 2017), 81–98.

In a ubiquitous rhetoric in world art history, the more a pictorial style confers virtual rotatedness in its renderings of things typically imaged with some degree of visible rotatedness, the more "free" it can be said to be. Gombrich made a deep equation between virtual rotatedness achieved in pictorialization, its empirical and rational objectivity, and its role in freeing the human mind of stereotypes — and possibly the human polity. But it would be possible to define a kind of noetic freedom to be secured, quite conversely, in the frontalized rendition of the rotatedness of things in natural vision — a pictorial structure that can virtualize empirical and objective structures such as geometric and architectonic relations. Gombrich

thought we can be freed from the picture by an image — "matching." But equally we can be freed from the image by a picture — schematizing.

25. *Lysipp und seine Stellung in der griechischen Plastik* (Hamburg, 1891); an earlier version of this study had appeared in 1884.

26. *Rendering of Nature*, 40, 95. Of course, the line of sight need not be trained axially on the sculptural plane or planes replicated as the parallels of the faces of the original "block" (if block there had been: see Neer, *Emergence of the Classical Style*, 33–38). In the "Farnese Bull" as staged in Löwy's photograph, the preferred aspect of the group — the one "exhaustive" plane in which it is visible — is not parallel with any original single face of the block at all (if block there was). Instead it cuts diagonally through the two opposite angles of the block located to the beholder's left and right, and indeed possibly "lies back" on a diagonal line between the other two opposite angles of the block, the forward one of which is the closest point to the beholder on his or her axis of direct observation. According to Löwy, it was the chief aesthetic achievement of later Classical Greek and Hellenistic sculpture to break out of a direct axial relation (both in visualizing the sculpture and in carving it) to the "sidedness" of the sculptural block, which had reached its visual culmination (as it were its end game) in the four-sidedness of Polykleitan and similar sculptural styles in the later fifth century BCE.

27. *Rendering of Nature*, 105–106.

28. Roger Fry, "Bushman Painting," *The Burlington Magazine for Connoisseurs* 16, no. 84 (March, 1910), 334–38; Fry was reviewing *Bushman Paintings Copied by M. Helen Tongue*, pref. by Henry Balfour, with E. and D. Bleek, *Notes on the Bushmen* (Oxford, 1909). I thank Sam Rose for this reference. See Christopher Green, "Expanding the Canon: Roger Fry's Evaluations of the 'Civilized' and the 'Savage'," in *Art Made Modern: Roger Fry's Vision of Art*, ed. Christopher Green (London, 1999), 119–32.

29. Notice that Fry distinguished "memory picture" and "conceptualizing" — a matter somewhat muddled in Löwy's text as translated (*Errinerungsbild = Gedankensbild? Errinerungsbild* vs. *Gedankensbild?*). Fry evidently placed all visual impressions and memories, however schematic, in the perceptual domain, and "classifications"

in the conceptual — at least in the notional psychohistorical *Urgeschichte* to which the San paintings supposedly give witness. In a sense, the first revolutionary historical process in Fry's world history was the Neolithic feedback of concept into percept — setting up the conditions for the Greek revolution of *returning* concept to percept that had originally been routed directly into pictorial form in *pre*-Neolithic times. Fry worked within the most general terms of the standard model but gave it his own world-historical ordering.

30. Rhys Carpenter, *The Esthetic Basis of Greek Art of the Fifth and Fourth Centuries BC* [1921] (Bloomington, IN, 1957); for an evaluation of Carpenter as "one of the great formalists of the mid-twentieth century," see Neer, *Emergence of the Classical Style*, 90, an assessment with which I agree. For further comments, see Whitney Davis, "Did Modernism Redefine Classicism?" in *The Wiley-Blackwell Companion to Modern Art*, ed. Pamela Meecham (London, 2017), 73–89.

31. Meyer Schapiro, "Rendering of Nature in Early Art," *The Arts* 8 (1925), 170–72. I thank Charles Oliver O'Donnell for the reference. Schapiro commented on Löwy again in "Style," in *Anthropology Today*, ed. Alfred L. Kroeber (Chicago, 1953), 300–301, repeating the opinions presented in the earlier review.

32. In this context, as Rainer Mack has suggested, the sculptures might have been figures of the social power of the Archaic aristocrats, and especially of transregional affiliations transcending the relationality between the local beholder *in situ* and the virtual body: Rainer Towle Mack, *Ordering the Body and Embodying Order: The Kouros in Archaic Greek Society*, PhD dissertation, University of California at Berkeley, 1996.

33. See Elsie Christie Keilland, *Depth and Movement: Geometry in Greek Art Studied in the Light of Egyptian Methods* (Oslo, 1984), 42–50; for example, Kielland addressed "the relationship between the slight deviations from the strictly mathematical rectangle apparent in the plinth, and the suggestion of movement perceptible in the figure" in the case of the famous *kouros* inscribed "to Aristodikos" (c. 500 BCE, Athens NM 3938; she follows the exacting measurements in Christos Karusos and K. Rhomaios, *Aristodikos* [Stuttgart, 1961], and see G.M.A. Richter, *Kouroi: Archaic Greek Youths*, 3rd ed. [New York, 1970], 139).

34. Neer, *Emergence of the Classical Style*, 52.

35. Heinrich Schäfer, *Von Ägyptischer Kunst, besonders der Zeichenkunst* (Leipzig, 1919). The fourth German edition, edited with an epilogue by Schäfer's disciple Emma Brunner-Traut (Wiesbaden, 1963), has been translated as *The Principles of Egyptian Art*, trans. and ed. with an introduction by John Baines (Oxford, 1974), 310–34. Full references to Borchardt's many studies can be found in Whitney Davis, *The Canonical Tradition in Ancient Egyptian Art* (Cambridge, 1989).

36. Heinrich Schäfer, "Die Leistung der ägyptischen Kunst," *Der alte Orient* 28, nos. 1–2 (1929), 34, my translation. For comments on Löwy and Schäfer, see Sylvia Peukert, *Hedwig Fechheimer und die ägyptische Kunst* (Berlin, 2011), 125–30.

37. For this evidence, see *Principles of Egyptian Art*, 259–76; see also Heinrich Schäfer, "Scheinbild oder Wirklichkeitsbild? Eine Grundfrage für die Geschichte der ägyptischen Zeichenkunst," *Zeitschrift für ägyptische Sprache und Altertumskunde* 48 (1911), 134–42, and "Ungewöhnliche ägyptische Augenbilder und die sonstige Naturwiedergabe," *Zeitschrift für ägyptische Sprache und Altertumskunde* 74 (1938), 27–41.

38. See especially Ludwig Borchardt, "Die Darstellung innen verzierten Schalen auf ägyptischen Denkmälern," *Zeitschrift für ägyptische Sprache und Altertumskunde* 31 (1893), 1–9, and "Studien und Entwürfe altägyptischen Künstler," *Kunst und Künstler* 6 (1910), 34–42; Luise Klebs, "Die Tiefendimension in der Zeichnung des alten Reiches," *Zeitschrift für ägyptische Sprache und Altertumskunde* 52 (1914), 19–34; compare Herbert Senk, "Vom perspektivischen Gehalt in der ägyptischen Flachbildnerei," *Zeitschrift für ägyptische Sprache und Altertumskunde* 69 (1933), 90–94.

39. Heinrich Schäfer, "Ägyptische Zeichnungen auf Scherben," *Jahrbuch der preussischen Kunstsammlung* 38, Hefte 1–2 (Berlin, 1916); for references to the large literature on the figured ostraca, see Davis, *Canonical Tradition*, 39–41. The figured ostraca have often been described as "artists' sketches" and/or "trial studies" made by trained artists and/or as casual figurations (perhaps caricatures and illustrations of folk-tales) made by trained scribe-artists as well as untutored draftsmen. Some of them were evidently used in the training of draftsmen. Most of them can be dated to the New Kingdom. In a lively chapter on figured ostraca

("Sketching Lifeworlds, Performing Resistance"), Lynn Meskell gives a persuasive account of what I would call "resistance" in the pictorial succession to canonical depiction, speculating about some of its political, social, and erotic causes (*Object Worlds in Ancient Egypt: Material Biographies Past and Present* [New York, 2004], 147–76).

40. See *Principles of Egyptian Art*, 117–18, 172–77, 259–76, chaps. 4.1, 4.2, and 5.

41. William Stevenson Smith, *A History of Egyptian Sculpture and Painting in the Old Kingdom* [1940] (Cambridge, MA, 1949). For similar formulations, omnipresent in Egyptological art history, see Cyril Aldred, "Foreword," in William H. Peck, *Drawings from Ancient Egypt* (London, 1978), 7–11; the aim of "conceptual images" was "clarity of exposition of the forms of nature as they were perceived in the understanding" (p. 9).

42. Emma Brunner-Traut, "Aspective," in Heinrich Schäfer, *Principles of Egyptian Art*, 4th ed., ed. and trans. J. R. Baines (Oxford, 1974), 421–46; see also "Aspektive," in *Lexikon der Ägyptologie*, ed. Wolfgang Helck, Eberhard Otto, and Wolfgang Westendorf (Wiesbaden, 1972–84), vol. 1 (1972), 474–88, and "Perspektive," in *Lexikon der Ägyptologie*, vol. 4 (1982), 987–88. Like Schäfer, Brunner-Traut devoted a considerable amount of her specialist research to figured ostraca: see *Die altägyptischen Scherbenbilder (Bildostraka)* (Wiesbaden, 1956), and *Egyptian Artists' Sketches* (Leiden, 1979), with comments by Herbert Senk, review of *Die altägyptischen Scherbenbilder (Bildostraka)*, *Orientalistischen Literaturzeitung* 53 (1958), 35–41; "Zur Kunstgeschichtliche Bedeutung altägyptischer Scherbenzeichnungen (Bildostraka)," *Forschungen und Fortschritte* 31 (1958), 50–56; "Zum aspektivischen Formcharakter der ägyptischen Kunst," *Forschungen und Fortschritte* 39 (1965), 301–3.

CHAPTER 6. BIROTATIONALITY: FRONTALITY, FORESHORTENING, AND VIRTUAL PICTORIAL SPACE

1. Richard Hamann, "Das Wesen des Plastischen," *Zeitschrift für Aesthetik und allgemeine Kunstwissenschaft* 3 (1908), 1–46, and *Ägyptische Kunst: Wesen und Geschichte* (Berlin, 1944); see Brunner-Traut in Schäfer, *Principles of Egyptian Art*, 268. In turn, Herbert Senk criticized

Brunner-Traut for overlooking features of the
phenomenology of Egyptian art that Hamann
would have recognized (see Chapter Five, note
42).

2. Carl Richard Lepsius, *Denkmaeler aus Aegypten
und Aethiopien, nach den Zeichnungen der von Seiner
Majestaet dem Koenige von Preussen Friedrich Wilhelm
IV nach diesen Laendern gesendeten und in den
Jahren 1842–1845 ausgefuehrten wissenschaftlichen
Expedition*, 6 vols. (Berlin, n.d. [1849–56]),
esp. *Text*, vol. 1, 233–38 (with pls. 65 and 68);
see Schäfer, *Principles of Egyptian Art*, figure
323. The term "laborious" is Caroline Ransom
Williams's in *The Tomb of Per-neb: The Technique and
Color Conventions* (New York, 1932), 9. In 1884,
Lepsius published a protean investigation into the
metrological basis of pictorial constructions in
ancient arts (including proportions) under the title
Die Längenmasse der Alten. To my knowledge, no full-
dress critical scrutiny of his art and image theory
has been written, though considerable attention
has been paid to the ways in which his publications
(along with the Napoleonic *Description de l'Égypte*)
shaped modern understandings of ancient Egyptian
civilization. Other early treatments of the technical
methods and procedures of Egyptian pictorial
construction included E. Prisse d'Avennes and P.
Marchandon de la Faye, *Histoire de l'art égyptien
depuis les temps les plus reculés jusqu'à la domination
romaine* (Paris, 1879), 117–37; G. Perrot and C.
Chipiez, *Histoire de l'art de l'antiquité* (Paris, 1882–
1914), vol. 1, *L'Égypte*, 741–76, on sculpture, 781–
92, on painting; and Gaston Maspero, *L'archéologie
égyptienne*, 2nd ed. (Paris, 1907), 170–202. Perrot
and Maspero downplayed Lepsius's "fundamental
observation that the relationship between the
[depicted] height [of the figure], length of the
arms, length of the foot, etc., simultaneously
expressed units of the Egyptian measuring system"
(Erik Iversen, *Canon and Proportions in Egyptian
Art* [Warminster, 1955], 11; for them the grids
were simply copying or transfer devices (*mise au
carreaux*).

3. C. C. Edgar, *Sculptors' Studies and Unfinished Works
(CCG nos. 33301–33506)* (Cairo, 1906); see also
"Remarks on Egyptian 'Sculptors' Models'," *Recueil
de travaux rélatifs à la philologie et à l'archéologie
égyptiennes et assyriennes* 27 (1905), 137–50.

4. Margaret A. Murray, *Egyptian Sculpture* (London,
1930), 20. The standard bibliography to its date

of publication is Hermann Graf, *Bibliographie zum
Problem der Proportion* (Speyer, 1958). An excellent
compact survey can be found in the entry on
"proportion" in the *Encyclopedia of World Art*. Its
author succinctly makes the crucial point that "a
proportional canon always leaves a large margin
of ambiguities. … Moreover, the movement of
the depicted figure, which unbalances and often
deforms it, or else the position of the viewer, who
often has to submit to distortions produced by
perspective, by distance, or by vantage point, all
these are enough to bring out the insufficiencies of
objective canons and to cause their modification
time and again" (Eugenio Battisti, "Proportion,"
Encyclopedia of World Art [New York, 1959], vol. 11,
723).

5. William H. Peck, *Drawings from Ancient Egypt*,
102–103, nos. 30 (Brooklyn 36.876), 31 (Walters
32.1) (cf. no. 37). The famous "master drawing" of
the pharaoh Tuthmosis III (BM 5601), executed on
a wooden board covered with gesso, was "probably
intended to serve as a standard reference for the
layout and proportion of the seated figure, …
[accompanied] by a series of drawings meant to
illustrate the basic units of measurement" (Peck,
Drawings from Ancient Egypt, 32; see Erik Iversen, "A
Canonical Master-drawing in the British Museum,"
Journal of Egyptian Archaeology 66 [1960], 71–79).

6. Erik Iversen, *Canon and Proportions in Egyptian
Art* (London, 1955), 2nd ed. with Y. Shibata
(Warminster, 1975); see also "The Canonical
Tradition," in *The Legacy of Egypt*, ed. J. R. Harris,
2nd ed. (Oxford, 1971), 55–82. The many small
variations and vicissitudes of style and expression
in the application of the canons are treated in
detail in Gay Robins, *Proportion and Style in Ancient
Egyptian Art* (Austin, TX, 1994).

7. Rosemarie Drenkhahn has identified six stages in
the making of painted relief ("Artists and Artisans
in Pharaonic Egypt," in *Civilizations of the Ancient
Near East*, ed. J. M. Sasson [New York, 1995], 331–
43); for convenience, I will consider the outline
draftsman to be the master artisan.

Summers describes the plane of the format
as follows: "format, from the Latin verb *formo,
formare*, means something like 'having been shaped,'
and refers to culturally specific conditions of
presentation. Any format is already a significant
artifact before it is used in one way or another.
Wooden panels and canvases are familiar formats

34. Neer, *Emergence of the Classical Style*, 52.
35. Heinrich Schäfer, *Von Ägyptischer Kunst, besonders der Zeichenkunst* (Leipzig, 1919). The fourth German edition, edited with an epilogue by Schäfer's disciple Emma Brunner-Traut (Wiesbaden, 1963), has been translated as *The Principles of Egyptian Art*, trans. and ed. with an introduction by John Baines (Oxford, 1974), 310–34. Full references to Borchardt's many studies can be found in Whitney Davis, *The Canonical Tradition in Ancient Egyptian Art* (Cambridge, 1989).
36. Heinrich Schäfer, "Die Leistung der ägyptischen Kunst," *Der alte Orient* 28, nos. 1–2 (1929), 34, my translation. For comments on Löwy and Schäfer, see Sylvia Peukert, *Hedwig Fechheimer und die ägyptische Kunst* (Berlin, 2011), 125–30.
37. For this evidence, see *Principles of Egyptian Art*, 259–76; see also Heinrich Schäfer, "Scheinbild oder Wirklichkeitsbild? Eine Grundfrage für die Geschichte der ägyptischen Zeichenkunst," *Zeitschrift für ägyptische Sprache und Altertumskunde* 48 (1911), 134–42, and "Ungewöhnliche ägyptische Augenbilder und die sonstige Naturwiedergabe," *Zeitschrift für ägyptische Sprache und Altertumskunde* 74 (1938), 27–41.
38. See especially Ludwig Borchardt, "Die Darstellung innen verzierten Schalen auf ägyptischen Denkmälern," *Zeitschrift für ägyptische Sprache und Altertumskunde* 31 (1893), 1–9, and "Studien und Entwürfe altägyptischen Künstler," *Kunst und Künstler* 6 (1910), 34–42; Luise Klebs, "Die Tiefendimension in der Zeichnung des alten Reiches," *Zeitschrift für ägyptische Sprache und Altertumskunde* 52 (1914), 19–34; compare Herbert Senk, "Vom perspektivischen Gehalt in der ägyptischen Flachbildnerei," *Zeitschrift für ägyptische Sprache und Altertumskunde* 69 (1933), 90–94.
39. Heinrich Schäfer, "Ägyptische Zeichnungen auf Scherben," *Jahrbuch der preussischen Kunstsammlung* 38, Hefte 1–2 (Berlin, 1916); for references to the large literature on the figured ostraca, see Davis, *Canonical Tradition*, 39–41. The figured ostraca have often been described as "artists' sketches" and/or "trial studies" made by trained artists and/or as casual figurations (perhaps caricatures and illustrations of folk-tales) made by trained scribe-artists as well as untutored draftsmen. Some of them were evidently used in the training of draftsmen. Most of them can be dated to the New Kingdom. In a lively chapter on figured ostraca ("Sketching Lifeworlds, Performing Resistance"), Lynn Meskell gives a persuasive account of what I would call "resistance" in the pictorial succession to canonical depiction, speculating about some of its political, social, and erotic causes (*Object Worlds in Ancient Egypt: Material Biographies Past and Present* [New York, 2004], 147–76).
40. See *Principles of Egyptian Art*, 117–18, 172–77, 259–76, chaps. 4.1, 4.2, and 5.
41. William Stevenson Smith, *A History of Egyptian Sculpture and Painting in the Old Kingdom* [1940] (Cambridge, MA, 1949). For similar formulations, omnipresent in Egyptological art history, see Cyril Aldred, "Foreword," in William H. Peck, *Drawings from Ancient Egypt* (London, 1978), 7–11; the aim of "conceptual images" was "clarity of exposition of the forms of nature as they were perceived in the understanding" (p. 9).
42. Emma Brunner-Traut, "Aspective," in Heinrich Schäfer, *Principles of Egyptian Art*, 4th ed., ed. and trans. J. R. Baines (Oxford, 1974), 421–46; see also "Aspektive," in *Lexikon der Ägyptologie*, ed. Wolfgang Helck, Eberhard Otto, and Wolfgang Westendorf (Wiesbaden, 1972–84), vol. 1 (1972), 474–88, and "Perspektive," in *Lexikon der Ägyptologie*, vol. 4 (1982), 987–88. Like Schäfer, Brunner-Traut devoted a considerable amount of her specialist research to figured ostraca: see *Die altägyptischen Scherbenbilder (Bildostraka)* (Wiesbaden, 1956), and *Egyptian Artists' Sketches* (Leiden, 1979), with comments by Herbert Senk, review of *Die altägyptischen Scherbenbilder (Bildostraka)*, *Orientalistischen Literaturzeitung* 53 (1958), 35–41; "Zur Kunstgeschichtliche Bedeutung altägyptischer Scherbenzeichnungen (Bildostraka)," *Forschungen und Fortschritte* 31 (1958), 50–56; "Zum aspektivischen Formcharakter der ägyptischen Kunst," *Forschungen und Fortschritte* 39 (1965), 301–3.

CHAPTER 6. BIROTATIONALITY: FRONTALITY, FORESHORTENING, AND VIRTUAL PICTORIAL SPACE

1. Richard Hamann, "Das Wesen des Plastischen," *Zeitschrift für Aesthetik und allgemeine Kunstwissenschaft* 3 (1908), 1–46, and *Ägyptische Kunst: Wesen und Geschichte* (Berlin, 1944); see Brunner-Traut in Schäfer, *Principles of Egyptian Art*, 268. In turn, Herbert Senk criticized

Brunner-Traut for overlooking features of the phenomenology of Egyptian art that Hamann would have recognized (see Chapter Five, note 42).

2. Carl Richard Lepsius, *Denkmaeler aus Aegypten und Aethiopien, nach den Zeichnungen der von Seiner Majestaet dem Koenige von Preussen Friedrich Wilhelm IV nach diesen Laendern gesendeten und in den Jahren 1842–1845 ausgefuehrten wissenschaftlichen Expedition*, 6 vols. (Berlin, n.d. [1849–56]), esp. *Text*, vol. 1, 233–38 (with pls. 65 and 68); see Schäfer, *Principles of Egyptian Art*, figure 323. The term "laborious" is Caroline Ransom Williams's in *The Tomb of Per-neb: The Technique and Color Conventions* (New York, 1932), 9. In 1884, Lepsius published a protean investigation into the metrological basis of pictorial constructions in ancient arts (including proportions) under the title *Die Längenmasse der Alten*. To my knowledge, no full-dress critical scrutiny of his art and image theory has been written, though considerable attention has been paid to the ways in which his publications (along with the Napoleonic *Description de l'Égypte*) shaped modern understandings of ancient Egyptian civilization. Other early treatments of the technical methods and procedures of Egyptian pictorial construction included E. Prisse d'Avennes and P. Marchandon de la Faye, *Histoire de l'art égyptien depuis les temps les plus reculés jusqu'à la domination romaine* (Paris, 1879), 117–37; G. Perrot and C. Chipiez, *Histoire de l'art de l'antiquité* (Paris, 1882–1914), vol. 1, *L'Égypte*, 741–76, on sculpture, 781–92, on painting; and Gaston Maspero, *L'archéologie égyptienne*, 2nd ed. (Paris, 1907), 170–202. Perrot and Maspero downplayed Lepsius's "fundamental observation that the relationship between the [depicted] height [of the figure], length of the arms, length of the foot, etc., simultaneously expressed units of the Egyptian measuring system" (Erik Iversen, *Canon and Proportions in Egyptian Art* [Warminster, 1955], 11); for them the grids were simply copying or transfer devices (*mise au carreaux*).

3. C. C. Edgar, *Sculptors' Studies and Unfinished Works (CCG nos. 33301–33506)* (Cairo, 1906); see also "Remarks on Egyptian 'Sculptors' Models'," *Recueil de travaux rélatifs à la philologie et à l'archéologie égyptiennes et assyriennes* 27 (1905), 137–50.

4. Margaret A. Murray, *Egyptian Sculpture* (London, 1930), 20. The standard bibliography to its date

of publication is Hermann Graf, *Bibliographie zum Problem der Proportion* (Speyer, 1958). An excellent compact survey can be found in the entry on "proportion" in the *Encyclopedia of World Art*. Its author succinctly makes the crucial point that "a proportional canon always leaves a large margin of ambiguities. ... Moreover, the movement of the depicted figure, which unbalances and often deforms it, or else the position of the viewer, who often has to submit to distortions produced by perspective, by distance, or by vantage point, all these are enough to bring out the insufficiencies of objective canons and to cause their modification time and again" (Eugenio Battisti, "Proportion," *Encyclopedia of World Art* [New York, 1959], vol. 11, 723).

5. William H. Peck, *Drawings from Ancient Egypt*, 102–103, nos. 30 (Brooklyn 36.876), 31 (Walters 32.1) (cf. no. 37). The famous "master drawing" of the pharaoh Tuthmosis III (BM 5601), executed on a wooden board covered with gesso, was "probably intended to serve as a standard reference for the layout and proportion of the seated figure, ... [accompanied] by a series of drawings meant to illustrate the basic units of measurement" (Peck, *Drawings from Ancient Egypt*, 32; see Erik Iversen, "A Canonical Master-drawing in the British Museum," *Journal of Egyptian Archaeology* 66 [1960], 71–79).

6. Erik Iversen, *Canon and Proportions in Egyptian Art* (London, 1955), 2nd ed. with Y. Shibata (Warminster, 1975); see also "The Canonical Tradition," in *The Legacy of Egypt*, ed. J. R. Harris, 2nd ed. (Oxford, 1971), 55–82. The many small variations and vicissitudes of style and expression in the application of the canons are treated in detail in Gay Robins, *Proportion and Style in Ancient Egyptian Art* (Austin, TX, 1994).

7. Rosemarie Drenkhahn has identified six stages in the making of painted relief ("Artists and Artisans in Pharaonic Egypt," in *Civilizations of the Ancient Near East*, ed. J. M. Sasson [New York, 1995], 331–43); for convenience, I will consider the outline draftsman to be the master artisan.

 Summers describes the plane of the format as follows: "format, from the Latin verb *formo*, *formare*, means something like 'having been shaped,' and refers to culturally specific conditions of presentation. Any format is already a significant artifact before it is used in one way or another. Wooden panels and canvases are familiar formats

in European art, as are screens and scrolls in Far Eastern art. Murals, paintings on walls, are less specific, and as we approach natural objects and surfaces, we move away from formats toward more early universal conditions of presentation" (*Real Spaces: World Art History and the Rise of Western Modernism* [London, 2003], 684–85).

The plane of the format is one of the principal physical or material conditions of picture-making. But we should take care not to assume that it is therefore the primary condition of imaging the picture or of the picture as virtual visual space. Though pictorialists often receive a "given" plane of the format in Summers's sense as (part of) the material extension of the artifact that will conduct the depiction, often they will make the plane of the format — the physical extension of what I have called the "mere picture" (Chapter Two) — in terms of the plane of pictorialization. The plane of pictorialization, in other words, can extend beyond the plane of the format, stitching the plane of the format into a wider visual space that might include other pictures (with their own formats), architectonic features, and the beholder's standpoint; crucial operations of pictorialization occur outside the plane of the format as such. In Part Three I will deal with several examples in detail.

8. The latter proposal was developed by Alexander Badawy with reference to the chapel of the mastaba of Kagemni at Saqqara (Sixth Dynasty) and chapels in tombs nearby (Khentika, Mereruka, Mery Teti, and Ankhmahor), as well as the offering chamber of the pyramid of Pepi II; according to Badawy, a ratio ("module") of 1 : 20 was modified at Kagemni to "conform to a larger room than originally planned" ("Compositions murales à système modulaires dans les tombes égyptiennes," *Gazette des Beaux-Arts*, 6th series, 97, no. 1345, February, 1981, 49–52). Whether or not such "modular systems" for laying out registers were used — a matter I will not address — the point here is that a modular system of 1 : 20 would entrain severe foreshortening, not to speak of narrative and iconographic potentials that arise in segmenting the pictorial content of the register to take advantage of the roving IP. Badawy seems to have assumed that the modular system and the canon of proportions for rendering the figure were interdigitated, even metrically continuous.

However, he did not specify the geometrical-numerical nature of the mesh, and in an analysis of the "harmonic" composition of one of the panels of Hesire (see Chapter Seven) he proposed a "construction diagram" using a modular system different from the canonical grid, though it yields many of the same significant relationships (*Ancient Egyptian Architectural Design: A Study of the Harmonic System* [Berkeley, CA, 1965], 178–79, pl. 55). Overall, Badawy explores the possibility that "harmonic systems," often based on the square and the 8 : 5 isoceles triangle, were used in laying out monumental architecture in both plan and elevation and implicitly in spatial "volume." For objections to Badawy's speculations, see Barry J. Kemp and Pamela Rose, "Proportionality in Mind and Space in Ancient Egypt," *Cambridge Journal of Archaeology* 1 (1991), 103–29.

9. One of the most perspicuous discussions of this matter can be found in Henry G. Fischer, *L'écriture et l'art de l'Égypte ancienne* (Paris, 1986), though it is a staple of almost all treatments of the quasi-hieroglyphic character of Egyptian depiction (highlighted by Hegel in his treatment of "Symbolic Art" in Egypt; see Chapter Four) and the pictorializing potentials of Egyptian writing. Abundant examples are unraveled by Richard H. Wilkinson in *Reading Egyptian Art: A Hieroglyphic Guide to Ancient Egyptian Painting and Sculpture* (London, 1992) and *Symbol and Magic in Egyptian Art* (London, 1994).

10. Examples of one GP carried between two or more registers are not so rare as to be deemed anomalous; examples are cited by Williams, *Per-neb*, n. 29. Obviously any vertical guideline carried over two or more horizontal registers could help the pictorialist to lay out the entire field in terms of desired alignments or, alternately, to avoid the aesthetic dullness of *too much* alignment. But insofar as GP was produced anyway for other reasons it served this purpose readily.

11. Badawy has called GP a "vertical line of reference for the human figure used as an axis, with significant points marked on the axis and symmetrically about it," "the reference line of symmetry," and the "vertical line of reference or axis" (*Harmonic System*, 2, 36, 62). According to his reconstruction, it organizes proportional relations in the figure that are specifically "harmonic" (*Harmonic System*, 62–64); see above, note 8. And

it would seem that it could be different from
the vertical axis which he believed was used to
lay out harmonic compositional relations on
the rectangular plane as a whole — an axis that
typically would vertically bisect the entire plane
into equal (symmetrical) areas (see *Harmonic
System*, 178–79 and pl. 55). No verticals of
the latter kind seem to be found, however, on
unfinished and/or pedagogical works.

Badawy has identified what he calls a "harmonic"
system in the canonical proportions organized on
the vertical axis: in the earlier canon, the total
height of the figure : height of the figure from
ground to navel = 18 : 11; and the distance from
the junction of both legs to the hairline : distance
from junction of both legs to armpits = 9 : 5.5;
"giving a good approximation of a constant ratio,"
namely 1.63, "with the distances from the armpits
to the hairline (3.5) and from the junction of
the legs to the hairline (9) [being] respectively
half those from the navel to the hairline (7)
and from the ground to the hairline (18)." (The
same result holds for the later canon, though
the value of the ratio becomes 1.615.) This is a
"close approximation of the golden section (=
1.618), which is the ratio for the same distances
as actually found in a well-built male body and
which was followed by the Greek and Renaissance
artists. The Egyptian design of the human figure
was accordingly essentially naturalistic and hence
harmonic. ... Both canons were based on a very
accurate representation of the body" (*Harmonic
System*, 62–64). According to him, the canon
was "probably based on the length of the foot,"
though Iversen had already shown otherwise and
Badawy's own diagram (*Harmonic System*, figure 18)
also suggests otherwise; the reason for Badawy's
supposition is unclear, but it might have to do with
his way of reconstructing a "modular system" used
in overall compositional layout. At any rate, it
does not affect his observations about the ratios of
segments of the vertical, whether or not we accept
the notion of their harmonic integration in the
golden section. Elsewhere Badawy notes that the
harmonic system "was basically a graphic process in
which mathematics played an unimportant role," as
distinct from the planar geometry described here
(*Harmonic System*, 56). But then it is difficult to see
how the Egyptians extracted the "golden section"
relationship, that is, the relation in which 18/11

= 9/5.5 = 1.63 (approximates 1.618), even if, as
he thought, architectural layouts (using the 8 : 5
isoceles triangle) embodied it.

12. Williams, *Per-neb*, 9.
13. Edgar, *Sculptors' Studies*, ii; Williams, *Per-neb*, 13.
14. Williams, *Per-neb*, 12, pl. 6.
15. Williams, *Per-neb*, 14, pl. 3.
16. Gerhard Krahmer, *Figur und Raum in der ägyptischen und griechischen Kunst* (Halle, 1931). See also his *Die einansichtige Gruppe und die späthellenistische Kunst*, Nachrichten der Gesellschaft der Wissenschaften zu Göttingen, Phil.-hist. Kl. 1927, Heft 1 (Göttingen, 1927).
17. Adolf Erman, *Life in Ancient Egypt* [1885], trans. H. M. Tirard (London and New York, 1894), 171.
18. Schäfer, *Principles of Egyptian Art*, 283–86.
19. Sigfried Giedeon, *The Eternal Present: A Contribution on Constancy and Change*, vol. 2, *The Beginnings of Architecture* (New York, 1964), 172.
20. Williams, *Per-neb*, 9.
21. From Lange's original Danish as translated by Else Christie Kielland, *Geometry in Egyptian Art* (London, 1953), 23; see also Giedion, *Beginnings of Architecture*, 481. A useful discussion can be found in Sylvia Peukert, *Hedwig Fechheimer und die ägyptische Kunst* (Berlin, 2014), 151–59.
22. Giedion, *The Beginnings of Architecture*, x, 171, 465.
23. The supposed parallels between canonical Egyptian depiction and Cubist pictorializations have often been remarked (for example, by Giedion, *The Beginnings of Architecture*, 437–39); see especially the sections on "*ägyptische Kunst und Kubismus*" and on the Egyptological art historian Hedwig Fechheimer's responses to Schäfer's approach to Egyptian art in light of modern arts and art theory in Peukert, *Hedwig Fechheimer und die ägyptische Kunst*, 116–32, 187–206.
24. Peck, *Drawings from Ancient Egypt*, 41.
25. George A. Reisner, *Mycerinus* (Boston, 1930), 112–13, nos. 25–39, pl. 62.
26. Peck, *Drawings from Ancient Egypt*, 41. Reisner identified the unfinished statuettes as the work of his so-called Sculptor B, a master artisan working in a "softer and more delicately modeled" style compared to an elder artisan, Sculptor A, and/ or as the work of B's apprentices. "Whatever may have gone before them, these two men [Sculptors A and B] were without doubt the teachers of the swarm of sculptors in the round who flourished in Dynasty V, and were responsible for the great

expansion of Egyptian statuary which followed immediately on their activity under Chephren [Khafre] and Mycerinus [Menkaure]" (*Mycerinus*, 129).

27. Edgar, *Sculptors' Studies*, viii.

28. Edgar, *Sculptors' Studies*, 39.

29. Edgar, *Sculptors' Studies*, 44, pl. 18. Unfortunately I have not been able to inspect this object; one might wonder if the lines are ancient. Guiding-line "crosses" can be found on the top sections of models of feet and legs (for example, CCG 33377, on section above knee; CCG 33378 and 33379, on sections through ankle). Presumably these helped to visualize the location of the body part in the overall three-dimensional coordination of the statue.

30. Edgar, *Sculptors' Studies*, 41, pl. 16, my emphasis.

31. Erwin Panofsky, *Perspective as Symbolic Form* [1925–26], trans. Christopher S. Wood (New York, 1991), 105, n. 24; in turn, Schäfer took the example from John Gardner Wilkinson, *The Manners and Customs of the Ancient Egyptians*, new ed. by Samuel Birch (London, 1878), vol. 2, 212 (reproduced here).

32. Peck, *Drawings from Ancient Egypt*, no. 37, now in the Cairo Museum (CCG 25002).

33. See Davis, *Canonical Tradition*, 82–93.

34. See H. A. Groenewegen-Frankfort, *Arrest and Movement: An Essay on Space and Time in the Representational Art of the Ancient Near East* (London, 1953); Henri Asselberghs, *Chaos en Beheersing: Documenten uit aeneolithisch Egypte* (Leiden, 1961); Davis, *Canonical Tradition*, 116–91 and *Masking the Blow: The Scene of Representation in Late Prehistoric Egyptian Art* (Berkeley and Los Angeles, 1992). To be sure, few examples of predynastic parietal depiction have survived, in which the shape and plane of the format might encourage the "verticalizing" pictorial succession. In the objects that do survive, notably rock pictures, painted vessels, and carved mobiliary artifacts (such as the so-called ceremonial palettes), the formats are not rectilinear.

CHAPTER 7. WHAT HESIRE SAW: VIRTUAL COORDINATE SPACE IN ANCIENT EGYPTIAN DEPICTION

1. David Summers, *Real Spaces: World Art History and the Rise of Western Modernism* (London, 2003); page references to quotations from this book will be given in the body of the text. For an exposition and evaluation of Summers's quasi-Aristotelian approach, see Whitney Davis, "Abstraction to the Notional: David Summers's Principle of Art History," in *Inquiry in Art History*.

2. Summers treats alignments and centering in Chapters 2 and 3 of *Real Spaces*; Egyptian architecture is considered in Chapters 2.12, 3.4, and 3.5. See Sigfried Giedion, *The Eternal Present: A Contribution on Constancy and Change*, vol. 1, *The Beginnings of Art* (Princeton, 1962), vol. 2, *The Beginnings of Architecture* (Princeton, 1964); Vincent Scully, *The Earth, the Temple, and the Gods: Greek Sacred Architecture* (New Haven, 1962).

3. Giedion, *Beginnings of Architecture*, 450. On the principal longitudinal axis, see Alexander Badawy, *Le dessin architectural chez les anciens Égyptiens* (Cairo, 1948), figures 231, 238, 240, 304; *Ancient Egyptian Architectural Design: A Study of the Harmonic System* (Berkeley, CA, 1965), 26, figure 3. The axis is known from so-called architectural drawings on papyri, tablets, and ostraca. "In the buildings themselves [it] is marked by an engraved line on the stones of the upper course of a foundation slab or indicated by the joints of the flagstones in the areas of the pavement around the doorways" (Badawy, *Harmonic System*, 29). Still, "the axes of most of the monumental buildings, especially temples, are curved. This is, however, not to be considered an error, but rather a conscious device gradually to alter the orientation of the building toward a set point" (*Harmonic System*, 39).

4. Needless to say, a small picture need not be planar in imaging — seen to have planarity. It can construct "virtuality" in Summers's sense — foreshortened AC-pictoriality, and even a deep spatial "perspective." Here planarity in Summers's sense might seem to have an advantage over virtuality in his sense. Perspective projection can compute proportional dimunition, spatial recession, and foreshortening at all possible scales. But a one-inch-square perspective projection held two feet away from IP will visibilize far less

of a distant object in the picture than a planar picture of the object made the same size (one inch square) and positioned in the field of view at the same place (two feet away). This may seem trivially true: perspective projection constrains us to render many objects much smaller (as if "behind" the "picture plane") than they would be drawn in *geradvorstellig* renderings, in which the planar section-contour of depicted objects can be placed on the plane coextensive with the plane of the format. But perspective projection simply is the technique of setting planar pictures into the distance along the axis of the virtual line of sight and to the sides of it with the shapes of depicted things appropriately transformed and their scale appropriately reproportioned relative to IP — the pictorial method explored in Chapter Nine.

5. See especially Clement Greenberg, "After Abstract Expressionism," in *Art and Culture* (Boston, 1962), 369: "It has been established by now, it would seem, that the irreducibility of pictorial art consists in but two constitutive conventions or norms: flatness and the delimitation of flatness. In other words, the observance of merely these two norms is enough to create an object which can be experienced as a picture: thus a stretched or tacked-up canvas already exists as a picture — though not necessarily a successful one."

6. For the reasons already identified, it is obvious that a large close-by picture can be locally planar in visual space. At two feet from the eyes, every one-to-two-inch "square" in it can "planarize." A pictorialist could make recursive use of this fact. Furthermore, a compounding of planarity and virtuality need not occur only across the area of the picture as imaged in visual space. It can occur along the corridors between the imaging point (the apex[es] of the visual angle) and points set up in the virtual depth — as the beholder virtually moves visually into the pictorial space.

7. See especially Roland Tefnin, "Éléments pour une sémiologie de l'image égyptienne," *Chronique d'Égypte* 66 (1991), 60–86.

8. Michael Fried's descriptions of modernist painting have consistently emphasized "the separateness, distancedness, and mutual facing … associated with the painter-beholder relationship in its traditional or unreconstructed form" and its modernist variants ("The Beholder in Courbet," *Glyph* 4 [1978], 121; for applications, see especially *Manet's Modernism, or The Face of Painting in the 1860s* [Chicago, 1996], with pertinent comments by Paul Smith, "Manet Bits," *Art History* 20 [1997], 477–82). The key point here is that Fried was not describing the inherent relation of painting and beholder, at least in the first instance (let alone the last), though he is often misread to be doing so; "the painter-beholder relationship" implies the inherent planarization (including the possibility of attaining pure planarity) of the painter's visual orientation relative to the plane of pictorialization and the format. Insofar as pictoriality is organized in that relationship, it must be intended to be transferred into the "painting–beholder" relationship under a set of translocations of IP and PS : ID. And that is precisely the pictorial succession in question here.

9. For "methods of rendering spatial distribution," see Schäfer, *Principles of Egyptian Art*, 159–98; see also 203–18 ("apparent passing next to, and action beside, an object"; "turns"; "looking and moving out of and into the picture") and esp. 224–27 ("the image is in correspondence with the position of the viewer"). A similar catalog of these pictorial effects was presented by William Stevenson Smith, *History of Egyptian Sculpture and Painting in the Old Kingdom*, 2nd ed. (Cambridge, MA, 1949), 273–346.

10. Edna R. Russmann, "The Anatomy of An Artistic Convention: Representation of the Near Foot in Two Dimensions through the New Kingdom," *Bulletin of the Egyptological Seminar* 2 (1980), 57–81. For another kind of conundrum that Egyptian pictorialists played with expressively, see Ann Macy Roth, "Twisted Kilts: Variations in Aspective Representations in Old Kingdom Mastaba Tombs," in *Old Kingdom, New Perspectives: Egyptian Art and Archaeology 2750 — 2150 BC*, ed. Nigel Strudwick and Helen Strudwick (Oxford and Oakville, 2011), 234–43.

11. Dimitri Laboury, "Colosse et perspective de la prise en considération de la parallaxe dans la statuaire pharaonique de grandes dimensions au Nouvel Empire," *Revue d'Égyptologie* 59 (2008), 181–230.

12. See J. E. Quibell, *Excavations at Saqqara, 1911–12: The Tomb of Hesy* (Cairo, 1913) (dated to the Third Dynasty); and Ludwig Borchardt, *Denkmäler des Alten Reiches (ausser den Statuen) im Museum von Kairo, Nr. 1295 — 1808 (Catalogue général des antiquités égyptiennes du Musée du Caire)*, vol. 1, *Text und Tafeln*

zu Nr. 1295 — 1541 (Berlin, 1937) (dated to the Fourth Dynasty).

13. For the installation and sequence of the panels in the Painted Corridor, see Wendy Wood, "A Reconstruction of the Reliefs of Hesy-Re," *Journal of the American Research Center in Egypt* 15 (1978), 9–24, and Whitney Davis, "Archaism and Modernism in the Reliefs of Hesy-Ra," in *"Never Had the Like Occurred": Ancient Egypt's View of Its Past*, ed. John Tait (London, 2003), 31–60, where I make the suggestion that two sculptors were involved. For the suggestion that Hesire was the draftsman (and maybe sculptor), see Badawy, *Harmonic System*, 178–79.

14. Both of these AC-pictorial qualities of the reliefs of Hesire — overall surface modeling and rounding of outline contour — can be appreciated in photographs taken in raking light. Indeed, such photographs sometimes suggest that some Egyptian reliefs were conceived as capable of responding in different ways to different kinds of light at different angles of incidence to the surface, as well as to changing light, in turn building in the possibility of an internal narrative in the depiction — such as the apparent "aging" of Hesire? — when it undergoes visible changes in the quality of its illumination. In the case of the reliefs of Hesire, one might compare a relatively low-contrast photograph of CCG 1427 published when it was exhibited in Boston in 1970 (the relief is moderately lit from the left; see E.L.B. Terrace and Henry G. Fischer, *Treasures of Egyptian Art from the Cairo Museum* [Boston, 1970], 35) with the high-contrast black-and-white photograph published by Borchardt in the Cairo *Catalogue générale*, my Figure 7.13. These different photographs register the visibility of the relief at two different standpoints. The former simulates the relief as visible to a beholder moving toward it in the Painted Corridor from the south, possibly carrying a means of illumination. The latter looks down into the niche strongly illuminated from above, and possibly from a standpoint to the north of it in the Painted Corridor. Of course, the artificial lights used to make both photographs were bright, white, and stable — not kinds of lighting that would have been originally used *in situ*.

15. Robins, *Proportion and Style*, 235–37; compare Schäfer, *Principles of Egyptian Art*, 283.

16. In Summers's reconstruction, IP must be on a line parallel with the outermost wall of the niche. A plausible reconstruction by Florence Friedman, which I adapt in Figure 7.22, places IP roughly at a beholder's stop-point in the middle of the Painted Corridor (see Florence D. Friedman, "The Underground Relief Panels of King Djoser at the Step Pyramid Complex," *Journal of the American Research Center in Egypt* 32 [1995], 1–42). All reconstructions must make assumptions about the roofing of the niche — its height from the floor and its depth. Unfortunately, the archaeological evidence bearing on this point is unclear, though Quibell's report suggests that the roof covered only the undecorated part of the niche at the very back. We can safely assume, at any rate, that the beholder did not have to get down on all fours to attain the crucial sightline in NVP.

17. The total height of CCG 1427 is 115 cm., but this includes a substantial uncarved part of the panel above the "frame"; it was probably built into the ceiling of the niche and would have been mostly invisible. The visible height of the lower region of the panel, then, was about 90 cm., depending on the angle of vision.

18. For the ontology of the Ka and its relation to representations of human beings, see A. O. Bolshakov, *Man and His Double in Egyptian Ideology of the Old Kingdom* (Wiesbaden, 1997); for a succinct discussion of the tomb chapel as a liminal space between the worlds of the living and the dead, see Nicola Harrington, *Living with the Dead: Ancestor Worship and Mortuary Ritual in Ancient Egypt* (Oxford and Oakville, CT, 2013), 86–97, with full references. For relationships between spiritual essences (such as the Ka) and "images" (that is, pictures — when "a statue [is] just a statue"), see Lynn Meskell, *Object Worlds in Ancient Egypt: Material Biographies Past and Present* (Oxford, 2004), 100–106, 114–15. For the symbolic and ideological parameters of tomb decoration, see Sasha Verma, *Cultural Expression in the Old Kingdom Elite Tomb* (Oxford, 2014), esp. 22–61, with full references. Ordinarily a statue of the deceased would be the vehicle of the Ka. By later Egyptian standards, however, Hesire's tomb was anomalous. There is an intriguing similarity between Hesire's panels in their niches and the "spyhole" constructions in the tomb chamber (the *serdab*) built to house his funerary statues (their bases survive) — the

vehicles of the Ka's passage in(to) the mundane world. The statues could be viewed by celebrants (and accessed by the Ka) through a narrow horizontal slit in one wall, something like the way celebrants would have viewed the carved panels at the back of the niches in the corridor. (For good illustrations of the usual set-up, see photographs of the statue of Ti — a cast from the original in the Cairo Museum — as seen in the *serdab* through the spyhole and of the statue of Djoser as discovered in the serdab facing the spyhole [in Jean-Philippe Lauer, *Saqqara: The Royal Cemetery of Memphis; Excavations and Discoveries Since 1860* (London, 1976), pls. 18, 81].) In fact, it is not impossible that Hesire's wood panels were made to be, or to substitute for, funerary statues. In an enlargement of the tomb, the serdab appears to have been built later than the interior corridor with the eleven niches and their panels. (Ordinarily niches would have been located on the exterior of the entire structure.) Perhaps, then, Hesire's interior niches had initially been intended to support the functions of a serdab. When the serdab was eventually constructed, three statues were housed in it, each probably representing Hesire.

19. Elsewhere I have described some of the idiosyncracies of Hesire's tomb and its decorations, possibly innovations, as a "modernism" (see note 13). For the precinct of Djoser, see C. M. Firth and J. E. Quibell, *The Step Pyramid*, 2 vols. (Cairo, 1935–36) and J.-P. Lauer, *La pyramide à degrés*, 3 vols. (Cairo, 1936–39), with helpful comments on the "rhythm" of its articulation in Alexander Badawy, *A History of Egyptian Architecture*, vol. 1, *The Old Kingdom* (Cairo, 1954), 190, and superbly suggestive remarks on its spatial coordinations by Giedion, *The Beginnings of Architecture*, 293–300. Summers considers the site in his Chapter 3.4. Egyptologists have supposed that the precinct of Djoser "may perhaps have represented an idealized and stylized royal and divine domain for the exercise of the king's rule after his death" (Dieter Arnold, *Encyclopedia of Ancient Egyptian Architecture*, trans. Sabine H. Gardiner and Helen Strudwick, ed. Nigel and Helen Strudwick [Princeton, 2003], 74). For the sculptural reliefs of Djoser understood in this light, see Friedman, "The Underground Relief Panels of King Djoser."

20. See Florence Dunn Friedman, "Reading the Menkaure Triads: Part I," in *Palace and Temple:*

Architecture — Decoration — Ritual: 5th Symposium on Egyptian Royal Ideology, ed. Rolf Gundlach and K. Spence (Wiesbaden, 2011), and "Part II (Multidirectionality)," in *Old Kingdom, New Perspectives: Egyptian Art and Archaeology 2750–2150 BC*, ed. Nigel Strudwick and Helen Strudwick (Oxford and Oakville, CA, 2011), 93–114. Though they are not focused on emergent VCP as such, I take the results of these careful and subtle studies to be in general alignment with my own conclusions regarding the phenomenology of birotationality in canonical Egyptian depiction.

21. Ludwig Borchardt, "Sphinxzeichnungen eines ägyptischen Bildhauers," *Amtliche Berichte aus den königlichen Kunstsammlungen* 39, no. 5 (1917–18), 106–10, with a three-dimensional reconstruction in Schäfer, *Principles of Egyptian Art*, 329–30, figures 325, 326. As a comparison, Schäfer (pl. 91) illustrated what he called an "apprentice piece" for an initial stage of the sculptural production of a sphinx, with the grid transferred to the surface of the block.

22. A good photograph of one of the sphinxes of the Serapeum is available in Jean-Philippe Lauer, *Saqqara*, pl. 1.

23. Georg Ebers, *Egypt: Descriptive, Historical, and Picturesque*, trans. Clara Bell (London, 1878), vol. 1, 156.

24. Janice Kamrin, *The Cosmos of Khnumhotep II at Beni Hasan* (London and New York, 1999), 100. Compare Groenewegen-Frankfort, *Arrest and Movement*, 75–77.

25. For "vertical layering" where "the obscured figures are at a greater distance," see Schäfer, *Principles of Egyptian Art*, 186–87; cf. his treatment of "rising forms which indicate distance without recourse to overlapping" (*Principles of Egyptian Art*, 189–98). According to Schäfer, "in the last analysis [these constructions were based] on the perception that, if a number of identical objects lying or standing on one level are seen from a higher point … the more distant ones appear higher than the nearer ones" (p. 187). This describes the plane of pictorialization, not VCP. More exactly, it describes a succession in imaging that leads to constructions on the plane of pictorialization through VCP — the particular step that Summers explicitly identifies in the complete pictorial succession.

26. David Marr, *Vision: A Computational Investigation into the Human Representation and Processing of Visual Information* (New York, 1982).

27. Leon Battista Alberti, *On Painting*, trans. and ed. Rocco Sinnisgalli (Cambridge, 2011), 40, and figures 68a-68c; see Karsten Harries, *Infinity and Perspective* (Cambridge, MA, 2003), 73.

28. David Marr, *Vision: A Computational Investigation into the Human Representation and Processing of Visual Information* (New York, 1982), 272–73 and figure 4.1.

29. In the order quoted, the quotations in this paragraph come from *Vision*, 37–38, 36, 284, 37.

30. *Vision*, 273.

31. A number of trenchant objections to Marr's concept and evidence are registered by Yehouda Harpaz, "Critique of Vision by Marr" (https: www. human-brain.org/vision.html).

32. See Saleh Uddin, *Axonometric and Oblique Drawing: A 3-D Construction, Rendering, and Design Guide* (New York, 1997), and many other handbooks. Marr modeled 2½-D representation in visual computation (*Vision*, 278 and figure 4.2) by using a pure "line drawing" of a cube (in axonometric projection) with a modeling of the surface orientations of the three visible faces in the projection and of their discontinuities (different orientations) at the line of intersection of the planes of any two of the faces.

CHAPTER 8. WHAT PHIDIAS SAW: VIRTUAL COORDINATE SPACE IN CLASSICAL GREEK ARCHITECTURAL RELIEF

1. Neer, *Greek Art and Archaeology*, 278. For a slightly-less-than minimalist approach, see Jerome J. Pollitt, "The Meaning of the Parthenon Frieze," in *The Interpretation of Architectural Sculpture in Greece and Rome*, ed. Diana Buitron-Oliver (Hanover, NH, 1997), 51–66, who takes the frieze to celebrate major cultural institutions of Athens that Perikles himself specifically cited in a famous funeral oration delivered in 430 BCE and that Thucydides described (*Peloponnesian War*, 2.35–46). As in every iconographic investigation, Pollitt has to make particular commitments to the identity and even the very presence of certain motifs (notably in interpreting the cavalry who are nowhere specifically said in the historical documents to

have participated in the procession of the Greater Panathenaia).

2. Jenifer Neils, *The Parthenon Frieze* (Cambridge, 2001). For a full account of the production process and its multiple actors and their specializations—from quarrying the marble to painting the finished sculptures—see Helle Hochscheid, *Networks of Stone: Sculpture and Society in Archaic and Classical Athens* (Bern, 2015).

3. Ian Jenkins, *Greek Architecture and Its Sculpture in the British Museum* (London, 2006), 96–98, and figure 86 (drawing by Sue Bird). John Boardman has suggested that the blocks for the west frieze were "probably carved on the ground" because "the compositions fit the slabs" (John Boardman and David Finn, *The Parthenon and Its Sculptures* [London, 1975], 238). In an iconographic interpretation of the groupings of riders—seemingly ten groups, each in part distinguished by their accoutrements—on the south frieze, Evelyn B. Harrison argued that each group represented one of the ten tribes of Athens ("Time in the Parthenon Frieze," in *Parthenon-Kongress Basel*, ed. Ernst Berger [Mainz, 1984], 230–34); Pollitt extends the proposal to the north frieze as well ("Meaning of the Parthenon Frieze," 55).

4. Boardman and Finn, *The Parthenon and Its Sculptures*, 28.

5. For different views of the much-debated question whether Classical architects (such as Iktinos, architect of the Parthenon) used reduced-scale drawings (as distinct from written numerical and metrical notations and instructions), see Robert Hahn, *Anaximander and the Architects: The Contributions of Egyptian and Greek Architectural Technologies to the Origins of Greek Philosophy* (Albany, NY, 2001), 97–162, and John R. Senseny, *The Art of Building in the Classical World: Vision, Craftsmanship, and Linear Perspective in Greek and Roman Architecture* (New York, 2011), 26–51, both with full references to earlier scholarship.

6. For this reason the depicted earth and rocks in the frieze might have had narrative and/or symbolic significance in contemporary visuality, perhaps in rendering well-defined aspects, locations, and histories of Attic topography. Several interpretations of the iconography and figurative significance of the frieze have invoked this possibility; others dismiss it.

7. Some of David Finn's characteristically dramatic photographs seem specifically lighted to bring out the undercutting of the face and strong shadowing on the secondary plane; see Boardman and Finn, *The Parthenon and Its Sculptures*, pls. V (S28, slab X) and VI (S36, XIII), both in color.

8. Good photographs of this effect can be found in Boardman and Finn, *The Parthenon and Its Sculptures*, figures 43 (four slabs on the south frieze) and 126 (slabs XVIII–XVI on the west frieze, as photographed *in situ* on the building; see my Figure 8.1). For a sensitive description of this phenomenon — it jives with my own visual sense of the frieze — see Margaretha Rossholm Lagerlöf, *The Sculptures of the Parthenon: Aesthetics and Interpretation* (New Haven and London, 2000), 20–30 ("the frieze as perceptual image"; her photographs of N133 and slabs XLIV and XLV well illustrate the effects).

9. In highly oblique angles of vision, two "composition lines," as they have been dubbed by Jenkins, become visible (see Jenkins, *Greek Architecture and Its Sculpture*, 98).

10. Richard Stillwell, "The Parthenon Frieze: Optical Relations," *Hesperia* 38 (1969), 232.

11. Boardman and Finn, *The Parthenon and Its Sculptures*, 34–35.

12. Robin Osborne, "The Viewing and Obscuring of the Parthenon Frieze," *Journal of Hellenic Studies* 107 (1987), 98–105.

13. Stillwell, "The Panathenaic Frieze," 237.

14. In the east frieze the peplos scene seems to be the only "self-contained scene," as Jenifer Neils has called it, that was framed for strictly axial approach in the architecture from one particular intercolumnar standpoint. Widely understood as the culmination of the narrative of the entire frieze, the peplos scene was configured and carved on a single extra-wide block. For illuminating discussion, see Neils, *The Parthenon Frieze*, 69–70 and figure 54, and Jenkins, *Greek Architecture and Its Sculpture*, 95–96 and figure 85. On the west frieze, the stretch of frieze seen from the comparable axialized location (station-point 10) forms a panel in Stillwell's eyes (his pl. 61.10, traversing blocks WVII–WX), but, as he acknowledges, it is one of the least coherent.

15. Jeffrey M. Hurwit, *The Athenian Acropolis: History, Mythology, and Archaeology from the Neolithic Era to the Present* (Cambridge, MA, 1999), 181.

16. Stillwell's qualification that the "frieze was intended to be seen as one would move across the face of the building while one looks up diagonally" except for the end panels ("The Panathenaic Frieze," 237) therefore does not seem to be correct; it neglects the panel visible at station-point 10.

17. In navigating their access to the Parthenon on the plain of the Acropolis, the first generations of observers approached the temple from the northwest, although their "first view of the whole west façade was at a distance of about forty meters from its center and considerably below its pavement" (Boardman and Finn, *The Parthenon and Its Sculptures*, 227–28). At the time the Parthenon was built, one's entrance onto the plateau was focalized (though not on direct axis) on the colossal free-standing statue of Athena Promakhos already sited to the north of the temple; the statue had been erected by 455 BCE. This prospect was later reorganized for beholders passing through the Propylaia; for a sensible reconstruction, see G. P. Stevens, *The Periclean Entrance Court of the Acropolis of Athens* (Cambridge, 1936), 50–57, frontispiece, and figure 47, and for comments on the alignments in question, see Vincent Scully, *The Earth, the Temple, and the Gods: Greek Sacred Architecture* (New Haven, 1962), 180.

Long ago, John Pennethorne argued that the Parthenon was designed to be seen on its northwest angle, that is, with north and west flanks receding to left and right of the observer's sightline, from a spot near the base of the statue of Athena Promakhos and another spot, specified more vaguely, that sightlined the southeast angle (*The Geometry and Optics of the Ancient Architecture* [London and Edinburgh, 1878], 36, 81). From these vantages, he thought, the "optical illusions" of curvature in the Parthenon would be most fully "corrected" by the architectural refinements of the building (see also Francis Cranmer Penrose, *An Investigation of the Principles of Athenian Architecture*, 2nd ed. [London, 1888]). But the refinements probably had no such purpose (see especially Adolf Michaelis, *Der Parthenon* [Berlin, 1871], 19; Guido Hauck, *Die subjektive Perspektive und die horizontalen Curvaturen des Dorischen Styls* [Berlin, 1879]; and especially William H. Goodyear, *Greek Refinements: Studies in Temperamental Architecture* [New Haven, 1912]). Far from retrieving visual

rectilinearity and regularity from potential disturbances, especially "curvature," they were probably intended to vary the building in "effects of light and shade" (Goodyear, *Greek Refinements*, 67, cf. 91), creating what Michaelis called an "effect of life" (*Lebendigkeit*) — an "elastic effect" that "lightened the appearance of the building" (Boardman and Finn, *The Parthenon and Its Sculptures*, 27). Still, this does not obviate the thesis that "the Parthenon was designed to be seen from special points of view" (Goodyear, *Greek Refinements*, 41; cf. Penrose, *Ancient Architecture*, 23). For example, in sightlining the northwest angle from a fair distance the "pyramidal appearance" of the Parthenon is most visible (Penrose, *Ancient Architecture*, 106; Goodyear, *Greek Refinements*, 144).

18. For a helpful comparison of W9 (supposedly nonchiastic) and "chiastic balance" in the ponderation of the Polykleitan *Doryphoros* (my Figure 5.5), a possible partial prototype, see Neils, *Parthenon Frieze*, 99–101. According to Neils, W9 is "not as advanced" as the *Doryphoros*. Still, it is almost certainly later. And it is doubtful that we need to invoke relative advancement or lack of advancement, especially when the parameters of the pictures in visual and virtual space have not been specified. It seems sufficient simply to say that W9 and the *Doryphoros* have been pictorialized in visual and virtual space in different ways. W9's zippering requires the observer's motion in a plane that is always parallel with the plane of the format on which the depiction is constructed, even if AOO will be required — not a circumambulation (as in the *Doryphoros*) in which ADO can always be maintained in facing the sculpture from any direction on the notional circle inscribed in visual space around it.

19. A good photograph of the corner block by David Finn (Boardman and Finn, *The Parthenon and Its Sculptures*, figure 112), captures the marshal's posture as well as the way in which N133, though appearing in ADO to look at two of the three youths following behind him (at N134 and especially N136), is also meeting the beholder's glance in AOO, as if to make sure that we too (along with N133, 134, and 135) have been properly "marshaled" and are following in line.

20. Stillwell, "The Panathenaic Frieze," 241.

CHAPTER 9. WHAT BRUNELLESCHI SAW: VIRTUAL COORDINATE SPACE AND PAINTER'S PERSPECTIVE

1. Günther J. Janowitz, *Leonardo da Vinci. Brunelleschi. Dürer: Ihre Auseinandersetzung mit der Problematik der Zentralperspektive* (Einhausen, 1986), 6–8, and figure 1.

2. David Summers, *Real Spaces: World Art History and the Rise of Western Modernism* (London, 2003), 526.

3. See J. V. Field, *The Invention of Infinity: Mathematics and Art in the Renaissance* (London, 1997), 20: Brunelleschi likely would have described himself as an *ingegniere* — engineer.

4. For the history leading up to Brunelleschi's work at the site as engineer and pictorialist, see Gert Kreytenberg, *Der Dom zu Florenz: Untersuchungen zur Baugeschichte im 14. Jahrhundert* (Berlin, 1974). A perspicuous timeline of the construction history of the Duomo in the fourteenth and fifteenth centuries is provided on a useful plan in Carla Pietramellara, *S. Maria del Fiore a Firenze: I tre progetti* (Florence, 1984), figure 1.

5. Antonio di Tuccio Manetti, *The Life of Filippo Brunelleschi,* intro. and ed. by Howard Saalman, trans. Catherine Enggass (University Park, PA, 1970), 52–54; quotation from Hans Belting, *Florence and Baghdad: Renaissance Art and Arabic Science* [2008], trans. Deborah Lucas Schneider (Cambridge, MA, 2011), 172. For the argument that Brunelleschi produced perspectival representations of architecture in the course of his investigations in Rome and in making the designs for his own building projects, such as the portico for the Hospital of the Innocents in Florence, see M. Boskovits, " 'Quello ch'e dipintori oggi dicono prospettiva': Contributions to Fifteenth Century Italian Art Theory, I," *Acta Historiae Artium* 8 (1962), 244–45. In Field's judgment, "it is to be presumed that even if the drawings were not done exactly to scale (as they would probably be done in our own time) they were at least marked with the required proportions." Field points out that Brunelleschi's own buildings, notably the Church of San Lorenzo in Florence, helped to construct visual spaces that are "eminently readable in simple mathematical terms"—a clear "display of mathematical proportions" (*Invention of Infinity*, 21).

6. Richard Krautheimer with Trude Krautheimer-Hess, *Lorenzo Ghiberti*, 2nd ed. (Princeton, 1970).

Based on his personal survey 'in 1951 and using a value of 0.6 m for the *braccio*, Krautheimer measured 32.8 m from the east façade of the Baptistery to the "inner boundary of the threshold" of the early fifteenth-century Duomo = 56.6 *braccia*; plus 3 *braccia* "inside the portal" (1.8 m) = 34.6 m or 59.6 *braccia*. A more accurate value of 0.584 m for the Florentine *braccio* of the period would not substantially change this analysis (Diane Finiello Zervas, "The Florentine Braccio di Panna," *Architectura* 9 [1979], 6–10). Assuming a ninety-degree angle of vision (the widest practicable angle of vision) John White has provided a careful discussion of the dimensions of the portal relative to the visual cone of the view through it to the Baptistery and other features of the site (*The Birth and Rebirth of Pictorial Space*, 3rd ed. [Cambridge, MA, 1987], 114–15). Martin Kemp has diagrammed the range of possibility from a ninety-degree angle of vision to fifty-three degrees, the narrowest practicable (*The Science of Art: Optical Themes in Western Art from Brunelleschi to Seurat* [New Haven and London, 1990], 12, figure 7, adapted in my Figure 9.8).

7. For the cross-section of the visual pyramid, see Leon Battista Alberti, *On Painting*, trans. and ed. Rocco Sinnisgalli (Cambridge, 2011), 33–35; reversing the received analysis, Sinnisgalli argues for the priority of the vernacular over the Latin version, though the Latin version represents Alberti's more final thoughts. "Neat codification" is Martin Kemp's phrase for Alberti's response to Brunelleschi's and other perspectival practices (*Behind the Picture: Art and Evidence in the Italian Renaissance* [New Haven and London, 1997], 94). Among expositions of Alberti's theory and its assumptions, precedents, and effects, and to cite only recent scholarship available in English, see Kemp, *Behind the Picture*, 94–97; Field, *Invention of Infinity*, 25–28; Karsten Harries, *Infinity and Perspective* (Cambridge, MA, 2003), 64–79; Summers, *Real Spaces*, 517–27; Belting, *Florence and Baghdad*, 21–26, 170–73. Sinnisgalli's new translation of Alberti should also be mentioned for its excellent technical diagrams.

8. The classic statements of this hypothesis remain G. C. Argan, "The Architecture of Brunelleschi and the Origins of Perspective Theory," *Journal of the Warburg and Courtauld Institutes* 9 (1946), 96–121; Rudolf Wittkower, "Brunelleschi and 'Proportion

in Perspective'," *Journal of the Warburg and Courtauld Institutes* 16 (1953), 275–91.

9. As Harries puts it, when perspective produces what might be called "convincing representations of the world" as well as understanding "the logic of these illusions," it "teaches us about the logic of appearance, of phenomena. In this sense, the theory of perspective *is* phenomenology. So understood, phenomenology lets us understand why things present themselves to us as they do. This is indeed how Kant's contemporary Johann Heinrich Lambert, to whom we owe the term, understood it. Phenomenology meant to him a 'transcendent optics,' the theory of perspective in the widest sense" (*Infinity and Perspective*, 69, my emphasis; Harries refers to Lambert's *Neues Organon* of 1764).

10. "Sense of converging perspective" is Kemp's term for Giotto's results in *Behind the Picture*, 88; see Figure 9.1. "Before perspective" is Belting's term in *Florence and Baghdad*, 135–46.

11. Belting, *Florence and Baghdad*, 168.

12. Erwin Panofsky, *Perspective as Symbolic Form* [1926–27], trans. Christopher S. Wood (New York, 1997), 28–30, and figure 1, and *The Codex Huygens and Leonardo da Vinci's Art Theory: The Pierpont Morgan Library Codex M.A. 1139* (London, 1940), 90–103, summarizing his pioneering investigations of the *Ur*-forms of modern artificial perspective; Krautheimer and Krautheimer-Hess, *Ghiberti*, chapter 10, in which the authors discuss their differences with Panofsky's approach; Summers, *Real Spaces*, 511–17.

13. For Kemp's catalogue of "almost all the conceivable methods," see "Science, Non-Science and Nonsense: The Interpretation of Brunelleschi's Perspective," *Art History* 1 (1978), 142. For his own part, Kemp argues that Brunelleschi employed "no skills more complex than those of elementary surveying," though he did something new with them; this minimalist art-historical approach, he urges, "involves the least redundancy" (Kemp, *Behind the Picture*, 94).

14. This component of Brunelleschi's procedure was originally explored by Frank D. Prager, "Brunelleschi's Inventions and the 'Renewal of Roman Masonry Work'," *Osiris* 9 (1950), 457–554.

15. In addition, there might have been features in the piazza *between* the Baptistery and the Duomo, including underground structures and the overbuilt

ruins of previous buildings; if Brunelleschi knew or could have imagined anything of the latter, he might have intended to indicate their presence, not least if they were invisible. For "the bases of the Romanesque porch in the street between the Duomo and the Baptistery, west of the steps," excavated in 1971–72, see Franklin Toker, "A Baptistery Below the Baptistery of Florence," *Art Bulletin* 58 (1976), 157–67.

16. *Real Spaces*, 515.

17. I have briefly discussed this line (I called it "a high Gothic concept of historical destinies") in assessing Hubert Damisch's brilliant observation: "It's not a point that perspective designates [that is, [viewpoint | eyepoint | VP]], but rather a line, one corresponding in projection to the plane marked as that of the eye, or the Subject" (*The Origin of Perspective*, trans. John Goodman [Cambridge, MA, 1994], 389, my emphasis). Setting aside Damisch's subtle Lacanian consideration of the "labyrinth" of this line as it "traps the Subject," the line is governed, he argues, by the "law of two infinities" constructed by systematic perspective, namely, the infinity not only of [eyepoint | VP], the usual topic of consideration, but also of "an idea of what's behind one's head" (*The Origin of Perspective*, 122, figure 17; see Whitney Davis, "Virtually Straight," *Art History* 19 [1996], 434–44). (Standing in the portal looking over to the Baptistery and its font, the altar, of course, would literally be behind one's head.)

18. On the role of such objects in the succession of pictoriality, and especially in the resistance of radical pictoriality to the consolidation of recognizable objects-with-content, see *GTVC* 226–29.

19. Summers, *Real Spaces*, 513.

20. Actually Alberti presented two methods of correct perspective construction, the second to be used as a check on the correctness of the first. In the second method, all the diagonals of the square tiles of a pavement correctly constructed in perspective (that is, foreshortened) should meet at the point on the horizon line (with the eyepoint at its midpoint) which is equal to the distance from the viewpoint to the eyepoint, that is, the distance of the eye from the picture. "Every painting with a pavement painted in accord with Alberti's construction gives us thus an easy recipe for determining the ideal point of view" (Harries, *Infinity and Perspective*, 74)—though the distance from the viewpoint to the eyepoint has already been established by the painter as he sees fit. (Therefore the second method can operate as a recursion within the first method.) As Belting has emphasized, "the painters' plane perspective could be attained easily only in the *pavimento*, the tiled floor in their pictures … [and] this created constraints," the notorious "cage" noted by Alberti, which drove painters to accept "more or less obvious deviations from an overly rigid geometry, … [such as] alternatives with distortions at the edges, in curvilinear perspective, or with a bifocal view" (Belting, *Florence and Baghdad,* 172). For my purposes, however, the question of the status of Alberti's second method is moot: in Brunelleschi's prospect, there were no pavement squares in view to be depicted, whether correctly foreshortened or not. Still, his plan of the Baptistery was undoubtedly set in a grid (as it were a pavement in the drawing if not in the prospect) that potentially could be used as a "coordinate system" in just this way (Field, *Invention of Infinity*, 28; see 35–40 on the possibility that Alberti's check relayed a practical rule used as early as the mid-fourteenth century by painters such as Ambrogio Lorenzetti).

21. Kemp, *Behind the Picture*, 94. As Kemp points out, Alberti's description of perspective construction did not mean to say "that all perspectival pictures should somehow look like the completed construction [recommended in Alberti's method]." "Rather [Alberti] is outlining those aspects of the construction that are invariant—the convergence of the orthogonals, the proportional diminution of equal horizontal intervals, the continuity of the diagonals through foreshortened squares, and the proportionality of the bodies (most especially human bodies) to their relative positions on the floor plan" (*Behind the Picture*, 94).

Field has suggested that paintings from the late 1430s onwards, which contain "many examples" of correctly constructed *pavimenti*, had adopted Alberti's method (and/or the method of his check); therefore "our best evidence for Brunelleschi's perspective must be in works made before Alberti's treatise appeared in 1435," such as Masaccio's *Tribute Money* (c. 1426–27; Brancacci Chapel, Santa Maria del Carmine, Florence) and Donatello's bronze relief of *The Feast of Herod*

(Baptistery, Siena) and relief of *St. George and the Dragon* for the base of his statue of *St. George* (Orsanmichele, Florence). Field has devoted an exactingly precise chapter to a new survey of Masaccio's *Trinity* (c. 1426; Santa Maria Novella, Florence) as the evidence on which to make "some better-educated guesses" about Brunelleschi's mathematics and perspective scheme (*Invention of Infinity,* 43–61).

22. Edmund Husserl, "The Origin of Geometry as a Problem in the History of Intentionality," in *The Crisis of European Sciences and Transcendental Phenomenology: An Introduction to Phenomenological Philosophy* [1936–37], trans. David Carr (Evanston, 1970), 354–59; Damisch, *The Origin of Perspective,* 83–85.

23. Kemp, *Behind the Picture,* 93.

24. For lucid expositions of Alhazen's optics that have been written with an eye toward its formative role in the development of perspective picture-making in Italy in the age of Brunelleschi, Ghiberti, Alberti, Piero della Francesca, and other pictorialists, see Summers, *Real Spaces,* 508–11, and Belting, *Florence and Baghdad,* 90–111, the latter with full references to the extensive scholarship. For the overarching argument, see George Saliba, *Islamic Science and the Making of the European Renaissance* (Cambridge, MA, 2007).

25. *Real Spaces,* 511.

26. For recent comments on "Pelacani's invention of mathematical space," see Belting, *Florence and Baghdad,* 146–50, with full references to the scholarship; and compare Robert Klein (*Form and Meaning: Essays on the Renaissance and Modern Art,* trans. Henri Zerner [Princeton, 1981], 102–104), who argues that Brunelleschi must have known Pelacani's ideas in considerable detail and depth. Whether Toscanelli and Brunelleschi actually communicated about perspective science — and when — has been much disputed.

27. Kemp, *Behind the Picture,* 104; see also Belting, *Florence and Baghdad,* 150–59.

28. See especially David C. Lindberg, *Theories of Vision from Al-Kindi to Kepler* (Chicago, 1976), 152, and "Alhazen's Theory of Vision and Its Reception in the West," *Isis* 58 (1987), 321–41; Claire J. Farago, *Leonardo da Vinci's 'Paragone': A Critical Interpretation with a New Edition of the Text in the 'Codex Urbinas'* (Leiden, 1992), 105–108. "Theoretical expression" is Lindberg's phrase (*Theories of Vision,* 149). In

The Judgment of Sense: Renaissance Naturalism and the Rise of Aesthetics (Cambridge, 1987), 153–71 (and esp. 164–67), Summers did not advocate direct historical links between Alhazen's optics and Brunelleschi's demonstrations of pictorial perspective. His account in *Real Spaces,* however, has assumed such links; as he has written, Alhazen's theory of vision was "well diffused by the time Brunelleschi worked" (*Real Spaces,* 514).

29. Belting, *Florence and Baghdad,* 169; "pictorial theory is applied visual theory": "through this, the factual distance at which we stand from the canvas is transformed into the fictional distance to a painted world" (*Florence and Baghdad,* 170).

30. Krautheimer and Krautheimer-Hess, *Ghiberti,* 237.

31. Erwin Panofsky, "Das perspektivische Verfahren Leon-Battista Albertis," *Kunstchronik* NS 26 (1915), 504–16; *Perspective as Symbolic Form,* 64, figure 8, top left; see also John White, *Birth and Rebirth of Pictorial Space,* 132, no. 34.

32. "Bare skeleton" is Summers's apposite term in *Real Spaces,* 515.

33. Lawrence Wright, *Perspective in Perspective* (London, 1983), 58, who suggests that a batten and support must have been used, though Manetti did not mention them. According to Samuel Y. Edgerton, Jr.'s scenario, Brunelleschi did some of the manual work for his beholders: while a beholder at the standpoint { *a, b* } of the pictorialization looked through the hole in the panel, "Brunelleschi adjusted the mirror which was to reflect the picture and reverse the right and left elements to their proper positions" (*The Renaisssance Rediscovery of Linear Perspective* [New York, 1975], 151). Edgerton supposes the right and left elements had already been reversed because the picture had been painted as a tracing of the image of the Baptistery as reflected in a mirror set up opposite to it — a reconstruction of a pictorial succession very different from the one tracked here.

34. *Florence and Baghdad,* 168.

35. Kemp, *Science of Art,* 13; Damisch, *Origin of Perspective,* 192.

36. *Real Spaces,* quotations from pp. 511, 516, and 526.

37. I quote Jack M. Greenstein, "On Alberti's Sign: Vision and Composition in Quattrocento Painting," *Art Bulletin* 79 (1997), 686.

38. I quote Lindberg, *Theories of Vision from Al-Kindi to Kepler,* 85; my emphasis. As Greenstein has pointed out, however, there are further problems in

Alhazen's model: "If every point radiates light and color in all directions, rays from different points can reach the eye at the same place. How then does visual sense sort out which ray corresponds to which point?" ("Alberti's Sign," 689).

39. The quoted sentence and phrases are Damisch's in *Origin of Perspective,* 111; see Manetti, *Life of Brunelleschi,* 42–44. I will not attempt to reconcile differences about this relation in the scholarship; as Kemp has cautioned, "the degree of precision with which [Brunelleschi] intended and succeeded in controlling the spectator's viewing distance remains a matter for vigorous debate" (*Science of Art,* 13).

40. *The Origin of Perspective,* 35.

41. Paul Feyerabend, *The Conquest of Abundance: A Tale of Abstraction versus the Richness of Being,* ed. Bert Terpstra (Chicago, 1999), 98; see *The Notebooks of Leonardo da Vinci,* ed. J. P. Richter (New York, 1970), vol. 1, sec. 3. For lucid expositions of the one-eye problem, see M. H. Pirenne, *Optics, Painting, and Photography* (Cambridge, 1970), 121–30, and Martin Kemp, "Leonardo and the Visual Pyramid," *Journal of the Warburg and Courtauld Institutes* 11 (1977), 128–49, though neither author addresses the continuum of variation in human vision between little stereoscopy and full.

42. *Conquest of Abundance,* 95.

43. *Conquest of Abundance,* 99. "Metaopticality" is Summers's term for infinitely extended three-dimensional coordinate space assumed in advance as the virtual coordinate space of depiction on the plane (*Real Spaces,* 555–64). Many historians have set out the supposed line of descent, more or less directly, from Brunelleschi's practice and Alberti's theory to Cartesian analytic geometry and coordinate (point) space.

44. I agree with Harries that a picture constructed according to Alberti's method ideally "freezes time" (*Infinity and Perspective,* 77), even though narrativizing synoptic compositions can expand the *Augenblick* ("the eye's glance") and restore temporal process. But in his demonstration Brunelleschi did not freeze time. Rather, he tried to *incorporate* time. Belting is correct to say that in general a perspective projection "depends on the belief that it arrests our gaze, as photography would do later" (Belting, *Florence and Baghdad,* 169). Nonetheless and for all that it need not be a "static image," as he claims. Brunelleschi's

construction of an imaging experience by way of the mirror-reflection device was far from static. In general, the fixing of the viewpoint needs not be at all equivalent to the fixing of the phenomena presenced in the projection. For a sophisticated theoretical consideration, see Inge Hinterwaldner, *Das systemische Bild: Iconizität im Rahmen computerbasierter Echtzeitssimulationen* (Munich, 2010).

45. Feyerabend, *Conquest of Abundance,* 95; Alberti, *On Painting,* 44–46.

46. Field, *Invention of Infinity,* 23–25.

47. Feyerabend, *Conquest of Abundance,* 99, my emphasis.

48. On this point, often skated over, see Kemp, *The Science of Art,* 13, 344. In particular, mirrors at the time would not have produced the bright, sharp, and stable reflection that can be obtained in a plane mirror today; the image would have been somewhat dark, and possibly a little blurred (depending on the smoothness of the reflecting surface and the stabilization of the surface perpendicular to the monocular sightline).

49. Alberti, *On Painting,* bk. II; I quote Kemp's characterizations of Alberti's three operations in *Behind the Picture,* 96.

50. Piero della Francesca, *De prospectiva pingendi,* ed. G. Nicco-Fasola (Florence, 1942), new ed. by E. Battisti, F. Ghione, and R. Paccani (Florence, 1984), 63–65; translations and quotations from Kemp, *Behind the Picture,* 99.

51. *Origin of Perspective,* 91.

52. Giorgio Vasari, *The Lives of the Artists,* trans. Julia C. and Peter Bondanella (Oxford, 1991), 83 (trans. slightly modified). See Frank D. Prager and Gustina Scaglia, *Brunelleschi: Studies of His Technology and Inventions* (Cambridge, MA, 1970).

INDEX

ILLUSTRATION CREDITS

Permission to reproduce illustrations is provided by the owers and sources as listed in the captions. Additional copyright notices and photography credits are as follows.

Acropolis Museum, Athens, 5.18

Adoc-photos/Art Resource, New York, 0.8

Alinari Archives, Florence, 5.5, 8.1

Trustees of the American School of Classical Studies at Athens, 8.7, 8.8, 8.9, 8.12

Art Resource, New York, 4.3

Art Resource, New York, and Artists Rights Society, 1.4

Ashmolean Museum of Art and Archaeology, University of Oxford (AN 1896–1908 E.3924). Photos © Ashmolean Museum, University of Oxford, 6.22

Birmingham City Museum and Art Gallery (1923. P118). Photo © Birmingham Museums Trust, 8.6

Boston Museum of Fine Arts, 4.2. 6.11, 6.17

Brooklyn Museum, Brooklyn, 6.6, 6.21, 6.23

Jean Clottes, 3.5

Whitney Davis, 6.1, 6.21

Fitzwilliam Museum, University of Cambridge, Cambridge, 6.24

Solomon R. Guggenheim Museum, New York, 1.2 Copyright C. Hersovici/Artists Rights Society (ARS), New York

Metropolitan Museum of Art, New York, open access collection, 0.9, 2.7, 5.4

Musée de Louvre, Paris, 7.11

National Archaeological Museum, Athens, 5.17, 8.13

National Gallery of Art, London, 0.7

Philadelphia Museum of Art, Philadelphia, 1.3

David Rabinowitch, 1.5

Scala/Art Resource, NY, 9.1

David Summers, 7.2. 7.3, 7.4, 7.17, 7.28, 7.29, 9.2, 9.3, 9.6, 9.36

Walters Art Museum, Baltimore, 6.5

Julie A. Wolf, 1.1